TATTOO

Tattoo

Bodies, Art and Exchange in the Pacific and the West

Edited by Nicholas Thomas, Anna Cole and Bronwen Douglas

REAKTION BOOKS

Published by Reaktion Books Ltd
79 Farringdon Road
London EC1M 3JU, UK

www.reaktionbooks.co.uk

First published 2005, reprinted with corrections 2005

Printed and bound in China

British Library Cataloguing in Publication Data
Tattoo : bodies, art and exchange in the Pacific and the West
 1.Tattooing - Pacific Area - History 2.Tattooing - Europe -
 History
 1.Thomas, Nicholas II.Cole, Anna III.Douglas, Bronwen
 391.6'5'099

ISBN 1 86189 225 X

CONTENTS

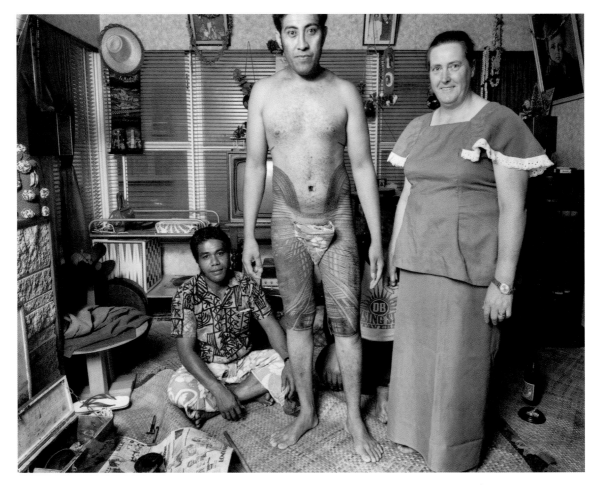

1 Mark Adams, *Farringdon Rd, Glen Innes. Auckland.*
Su'a Suluape Petelo, Tufuga Ta Tatau. Sogaimiti Faiga Mamea
and his wife Shirley, 20.2.1982, photograph.

Introduction

Nicholas Thomas

It is commonly stated, in works by academics and tattoo enthusiasts alike, that modern Western tattooing originates in Polynesia, 'with the exploratory voyages of Captain James Cook and his encounters with tribal tattooing in the South Pacific', as, for example, the sociologist Clinton Sanders put it.[1] Similarly, 'it was through the early explorations of the Pacific that tattooing entered into modern European consciousness', wrote Margo de Mello.[2] In tandem with these observations, it is often noted that 'tattoo' and associated words in European languages derive from the Tahitian *tatau*, an onomatopeic term meaning to strike, mark or tattoo. The etymological claim is correct, and 'tattowing' and 'tattooing' first appeared in English in 1771, in publications reporting Cook's first voyage.[3] However, the broader assertion that modern tattoo derives from these contacts has been disputed, and it is also widely known that tattooing has a more ancient history in Europe. The prevalence of this kind of body art among the Picts, for instance, is often alluded to in the kind of summary histories that introduce discussions of contemporary tattoo trends.[4] So, just what kind of 'beginning' was it

that modern tattooing had in the meetings between late eighteenth-century mariners and Polynesians such as Tahitians and Maori? Was this a beginning at all, or really rather a moment of stimulation, that saw an external influence reinvigorating a marginal or latent aspect of the culture of the body in Europe? Is tattoo imported *tatau*, or another kind of practice that has fortuitously acquired an Oceanic name?

These questions are historical in the sense that they raise issues of how we interpret facts and relationships in the past. But they are not merely historical, because there is a prominent dynamic in contemporary tattoo culture that recapitulates this moment of so-called origin. In the late eighteenth and early nineteenth centuries a considerable number of European seamen, and some other travellers, were tattooed by Tahitian, Marquesan, Maori, Samoan and other Pacific tattooists. It was these sailors' adoption of this form of body modification that sparked off a much wider tattoo fashion among mariners generally, which subsequently spread beyond maritime populations – or so the received story goes. Since the 1980s a highly visible and much-

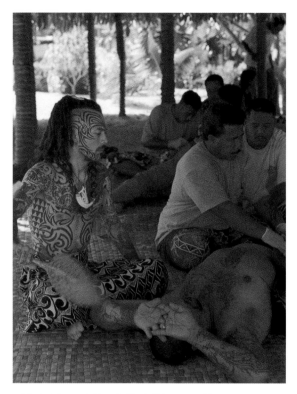

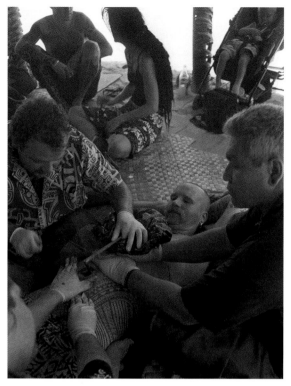

2 Mark Adams, tattoo festival, Saleapaga, Samoa, 2001: Su'a Sulu'ape Freewind.

3 Mark Adams, tattoo festival, Saleapaga, Samoa, 2001: Su'a Sulu'ape Michel Thieme, Rene Persoons, Su'a Sulu'ape Keone Nunes, Su'a Sulu'ape Inia Taylor.

discussed 'tattoo renaissance' has occurred.[5] Tattoos are now no longer chronically associated with criminals, ex-servicemen and prostitutes, but enjoy wider popularity, notably, and for the first time, among middle-class youth. One of the most conspicuous aspects of this tattoo revival has been a new interest in tribal tattoo traditions, which, since the 1980s, have been eagerly researched by a new generation of tattoo artists. When it became known that tattooing remained a living tradition in places such as Samoa, contacts were made with indigenous *tufuga ta tatau* ('priests of tattooing') there, and later with figures involved in tattoo revivals in Tahiti, New Zealand and

Hawaii, among other places. Not so long ago, these practitioners were highly respected members of their own communities, but essentially unknown outside them. Now they are celebrities of a sort, at least within an increasingly internet-based body modification world. They attend tattoo conventions and festivals in north America, Europe and the Pacific; so once again, Pacific tattooists are performing their work upon the bodies of white people, while Pacific designs, more or less adapted, are also applied by many tattooists of European, American and for that matter Japanese origin. Is this a process of exchange, appropriation, translation – or some-

thing else altogether? Is this new interaction merely resonant of what took place during the late eighteenth century, or is it more fundamentally analogous? Either way, what does the process that links *tatau* and tattoo tell us about crosscultural meetings, relationships and body modifications?

It is this book's ambition to respond to these larger questions. But we cannot interpret the Pacific-European exchanges without first documenting them, at least without documenting them more fully and critically than has been attempted so far. Both the 'fact' of modern tattooing's 'origins' in Pacific encounters and the Pacific tattoo traditions themselves are known to contemporary tattoo milieux, and also generally to scholars, through spectacular instances rather than contextualized histories. It is no doubt in the nature of tattooing that this should be the case. Tattoos, and especially the sorts of tattoos we consider here, are spectacular. In a way, they positively invite decontextualization. *Tatau* first appealed to Europeans as a 'curiosity', a singular and extraordinary thing, and many people still respond to tattooing in this way. So it is unsurprising that Maori *ta moko* is recognized above all through Sydney Parkinson's arresting sketches of Maori men, encountered in late 1769, during Cook's first visit to Aotearoa-New Zealand. One drawing in particular provided the basis of a fine engraving in the official voyage publication, was re-engraved for many subsequent travel compilations and popular encyclopaedias, and further republished in innumerable modern works on Cook, the Pacific, tattooing and Oceanic art. The 'Head of a New Zealander' is in fact almost

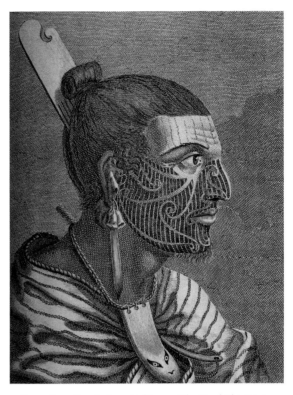

4 Engraving after Sydney Parkinson, *The Head of a New Zealander,* from John Hawkesworth, *An Account of the Voyages Undertaken by the Order of His Present Majesty for Making Discoveries in the Southern Hemisphere* (London, 1773), plate 13. (See illus. 21 for the original drawing.)

certainly the single most extensively reproduced image from the entire visual archive of eighteenth-century travel. Similarly, the astonishing full body tattoos of Marquesans are known above all from two early engravings based on drawings by artists on the first Russian circumnavigation, a Cook-style exploratory voyage of the first decade of the nineteenth century. These too have been widely reproduced, in contexts remote from any discussion of Marquesan societies, Marquesan art styles or Russian voyagers, still less from the individuals depicted. And the phenomenon of the white man

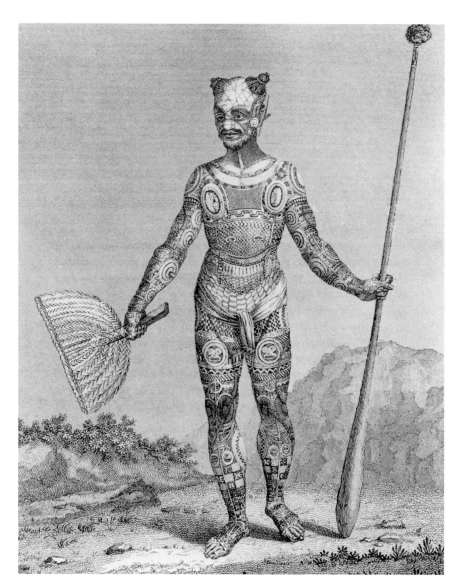

5 J. Storer, *An Inhabitant of the Island of Nukahiva*, 1804, engraving from Georg Heinrich von Langsdorff, *Voyages and Travels in Various Parts of the World During the Years 1803, 1804, 1805, 1806 and 1807* (London, 1813), plate 6.

tattooed in the South Seas has likewise been captured, for tattoo historians, in the image of John Rutherford, an English deserter who lived among Maori for some years before and after 1820.[6]

These now-iconic images of Pacific tattoos were produced in the context of Pacific-European interactions. Those interactions are fundamental to our understandings of Western tattooing, and the role of cross-cultural interactions in shaping or influencing European body arts over the last two hundred years, but have constituted only an obscure and unstudied backdrop to the 'New Zealander', the Marquesan and to Rutherford. If the pivotal importance attached to the Pacific-

European exchanges makes this surprising, the fragmented, dispersed and complex character of Pacific and maritime historical archives makes it less so. Historians and ethno-historians have found it difficult enough to characterize indigenous Oceanic political institutions – aspects of society that immediately confronted our European witnesses, that those colonists and travellers needed to understand and deal with, that they therefore reported upon extensively. A cultural practice that might have been conspicuous but was nevertheless not socially central, that therefore attracted the interest of some observers but was passed over by many others, is far harder to reconstruct and track.[7] Yet, in the last few years, the history of Pacific tattooing has assumed steadily greater importance – for Polynesian tattooists, artists and communities; for tattoo and body modification milieux elsewhere; and for others concerned with body arts and cross-cultural histories, and their implications. For these reasons, this book attempts – as it were against the archival odds – to piece together a trans-cultural history of tattooing, a history of tattooing in and out of the Pacific. We examine the contexts in which Pacific tattoos were 'discovered' by Europeans; we track the history of European tattooing in the Pacific, and Pacific tattooing as it was inflected, revalued, shaped, and often in the end suppressed, by agents of European colonization. We look at what European art has made of tattooing. We explore the contemporary manifestations of Pacific tattoo art, with particular reference to the contrasting trajectories of Samoan, Tahitian and Maori tattooing. Finally, we assess the state of play in neo-tribal tattooing today. Is this practice or

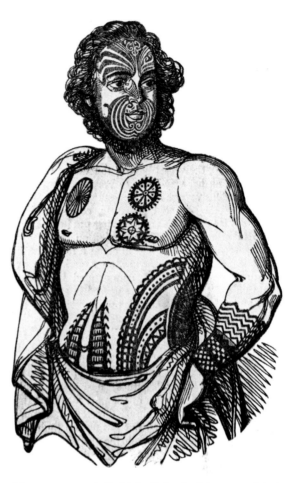

6 Anonymous portrait of John Rutherford, from an original drawing taken in 1828.

set of practices merely an effect of longstanding Western primitivism, or does it mark some more consequential process of cultural exchange?

This introduction focuses on what could be seen as the nub of the debate: the question of whether, in fact, modern Western tattooing did originate, as so many have been happy to claim, in the Pacific encounter. It is the overarching theme of one of the most important recent contributions

to the history of tattooing – Jane Caplan's edited volume, *Written on the Body* – that 'the Pacific encounter is not originary'.[8] Caplan's point is nuanced, and not intended to deny entirely the importance of Pacific contacts. She acknowledges that the evidence for the survival of Greek, Roman and Celtic tattoo practices through the early modern period within Europe is tenuous, but argues that tattooing did survive 'on the fringes of Christian Europe' and might from that peripheral location have influenced Europeans more continuously. She considers that 'the return of tattooing to European culture and/or the rein-vigoration of indigenous European practices can be pushed back two centuries before the Pacific expeditions', even if tattooing was certainly 'pro-pelled into a new quality of visibility from the end of the eighteenth century'.[9] The contributors to this book would not dispute that 'the evidence supports neither continuity nor importation alone, but rather a process of convergence and reinforcement', and we share Caplan's sense that the methodologically appropriate strategies require that we locate tattooing in terms of lateral milieux, as well as linear series; this book, in fact, tacks between the ethnographic and the histori-cal, the linear and the lateral.

To bring up methodology is to signal that the debate turns on two, or at least two, major issues. The first is on the face of it a strictly empirical one, whether or not tattooing was prevalent in the West at the time the Pacific contacts were sup-posedly so consequential, a question I come back to shortly. The second is more theoretical. Most scholars in the humanities or social sciences today would surely be more bemused than engaged by discussion around the 'origins' of any practice or institution. Does not the commonsense post-modernism that has become all but axiomatic warn us that any question framed in this way belongs more to a domain of myth-making than one of critical history? Is any such enquiry not, in other words, tainted by some sort of essentialism?

If the answer to this question must be yes, the question nevertheless arises because the parties to this debate are not all scholars – or rather, not all professional academic scholars. Much tattoo history and sociology has been done by tattooed people, tattoo artists, in other words by informed practitioners, or by people who are both practi-tioners and scholars. The stakes here, and among those in or from Pacific communities, overlap with but are not the same as those of the post-modern academy. For these communities, tattoo-ing is not necessarily best conceived of as a plural and contested practice, with no inherent quality. This interest cannot simply, nor should it simply, be deemed invalid on theoretical grounds. To see meaning in a constitutive moment in the history of tattooing (and *tatau*), or that of any other practice, is not inevitably to embrace a naïve essentialism, primitivism, exoticism or nostalgia. Moments in the past, historical trajectories and even 'origins' can be identified and celebrated for diverse reasons. It would not be defensible to claim that tattooing possesses essential, trans-historical or trans-cultural values, but it is legiti-mate to propose, as Alfred Gell has done, that the permanent, typically painful imprinting of inscriptions or designs into the skin does carry certain 'elective affinities' with a range of cultural and political processes and values. Those values

are not constant across contexts, but they may be related or at least suggestively resonant.[10]

Hence, for this book, it remains important to consider where tattooing has come from, not reductively in terms of a fetishized origin that possesses self-evident meaning, but in a critical and open-ended manner. We ask what sorts of movements and interactions coming and going has involved. Is it the case that Western tattooing, or some strands of it, can productively be seen, in either the past or the present or both, as transformations of Pacific *tatau*, or of elements of it? Or are body art traditions in the end best understood as internally generated, as formations of practice and meaning that owe little to cross-cultural influences, which have shaped them superficially if at all?

It is important to add that the debate around the seemingly empirical question cannot be considered resolved. Not only would it be unfortunate if a new orthodoxy emerged that diminished excessively the significance of the Pacific encounter, the balance of evidence arguably tends more to sustain the received story than undermine it. As Caplan notes, maritime historians have argued that tattooing must have been well-established prior to Cook's voyages, essentially on common-sense grounds.[11] The prevalence of tattoos among American sailors, known from records dating from the very end of the eighteenth century, cannot be explained, it is asserted, on the basis of diffusion from 'small' Pacific voyages that took place only some thirty years earlier. This, like much other 'common sense', is dubious. There is indeed evidence that some few sailors were 'marked' or tattooed before the 1770s (see Joanna

White's chapter, this volume). Yet the evidence relates to barely a handful of individuals. While documentation of the lives of ordinary sailors in the eighteenth century or any time before is notoriously sparse, there is nevertheless a range of more qualitative source material, drawn upon, for example, by Marcus Rediker and N.A.M. Rodger, that includes pen-portraits of typical seamen, or records of individuals' life histories.[12] While, from the late eighteenth century onwards, references to tattooing in such accounts – as well as in other naval sources, such as registers of seamen – are increasingly common, their near absence before 1769 is striking. It cannot be argued credibly that a highly distinctive form of body adornment was 'a common and well-established practice at the time of Cook's voyages and probably long before',[13] or even one that was occasionally encountered – yet never remarked upon and never depicted.

The notion that Cook's voyages were 'small' is unhelpful if it is supposed to make it obvious that they could not have been as consequential as has been assumed. The numbers of sailors and other participants were indeed relatively small (some 400 men over the three voyages), but these expeditions were immediately famous among mariners, artists, writers and the wider public; it is no exaggeration to claim that they captured the attention of the epoch.[14] Even generations later, explorers both British and of other nationalities were still 'haunted by the example of Cook' (as Dumont D'Urville put it);[15] it is harder to guess who or what haunted the ordinary sailor, but it would not be hard to understand if a practice adopted by Cook's men became more widely

fashionable, and then spread independently. Thirty years is surely more than enough time for a habit to spread amongst a highly mobile and multicultural population, such as that of maritime men.

Conversely, if we insist that the 'pricking' or 'staining' of the skin was not uncommon among seamen before Cook, it is not easy to account for the tone and the terms of writing about Tahitian *tatau* that is a striking feature, not only of Cook's description, but of virtually all the references from Cook's three voyages. The early accounts of Parkinson and Banks from the first voyage, and of various subsequent mariners and natural historians on the second and third, are distinctive for their avid interest in what is unambiguously treated as a novel and exotic practice, rather than as a local variation upon something familiar. Cook's lengthy account begins as follows:

> Both sexes paint their bodys *Tattow* as it is called in their language, this is done by inlaying the Colour of black under their skins in such a manner as to be indelible. Some have ill design'd figures of men birds or dogs, the women generally have this figure Z simply on every joint of their fingers and toes, the men have it like wise and both have other defferent figures such as circles crescents &ca which they have on their Arms and legs. In short they are so various in the application of these figures that both the quantity and situation of them seem to depend intirely upon the humour of each individual, yet all agree in having all their buttocks cover'd with a deep black, over this most have arches drawn one over another as high as their short ribs which are near a quarter of an Inch broad; these arches seem

to be their great pride as both men and women show them with great pleasure. Their method of Tattowing I shall now describe.[16]

Cook proceeds to detail the colour (a black obtained from burnt candlenut), the instruments (a flat, toothed bone or shell plate, attached to a handle, and a hammer used to strike that tool) and the technique (a series of 'quick sharp blows'). The naturalist, later President of the Royal Society and great scientific entrepreneur, Joseph Banks, composed an account on the basis of Cook's, to which he added his own observation of the practice, when the pain suffered by a girl or young woman made a considerable impression upon him, and prompted him to engage in a broader enquiry.

> What can be a sufficient inducement to suffer so much pain is difficult to say; not one Indian (tho I have asked hundreds) would ever give me the least reason for it; possibly superstition may have something to do with it, nothing else in my opinion could be a sufficient cause for so apparently absurd a custom.[17]

The curiosity and bewilderment that are palpable here do not seem apt for a practice with which Europeans were already familiar. The attitude could, just conceivably, be attributed to the extent and elaboration of Tahitian tattooing, as opposed to tattooing or marking *per se*. But it would then remain anomalous that, in these texts that make frequent and wide-ranging comparative allusions to affinities between Oceanic customs and those of other peoples, including Europeans, *nowhere* is

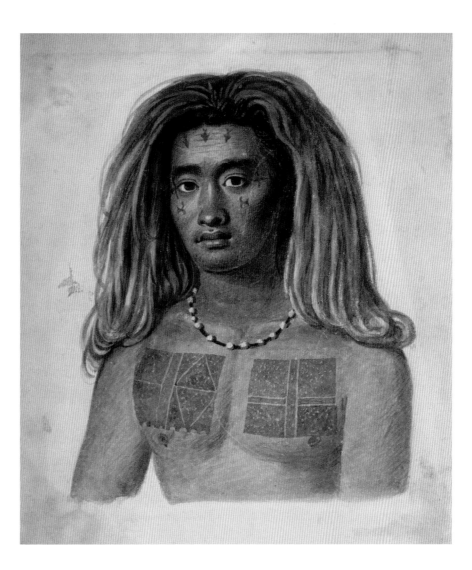

7 Augustus Earle, *A Native of the Island of Tucopea* (i.e. Tikopia), c. 1827, watercolour.

anything said such as 'they prick themselves, as some of our sailors do'. In fact, Johann Reinhold Forster's extraordinary anthropological treatise, *Observations Made During a Voyage Round the World*, written on the basis of his participation in Cook's second voyage, does cite a range of non-Pacific parallels to Pacific tattooing. His list includes 'puncturing' among the Tungus of Siberia, so-called Greenlanders, native Americans, Bedouin of Tunisia, Palestinian women and other 'Arabians'. But his only European instance is that of the 'ancient Huns'.[18] The *Observations* is a long book, which tends not to deprive the reader of any comparative insight or expression of its author's erudition. We can be fairly sure that if Forster had ever seen any more than one or two sailors, indeed more than one or two Europeans from any milieux who had been tattooed, he

8 Georg Heinrich von Langsdorff, untitled drawing of
tattoo implements and other objects from Nukahiva, 1804,
ink and wash.

would not have failed to mention them here. That
Forster does not do so, is only negative evidence,
yet the array of negative and circumstantial
evidence tends increasingly to reinforce the
proposition that I quoted at the beginning of
this Introduction. Whatever its earlier, wider
incidence in the West, pricking or staining appears
to have lapsed, or at any rate suffered marginal-
ization to the point of invisibility. Notwithstanding
the fact that some Holy Land pilgrims from
Britain and presumably elsewhere in western
Europe clearly were tattooed in Jerusalem during
the seventeenth and probably also the eighteenth

centuries, notwithstanding the fact that some
few seamen certainly marked themselves or were
marked, on ships out of British or European
ports, and notwithstanding the fact that some
few others might have obtained tattoos from
native Americans or in south or south-east Asia,
tattooing does indeed seem to have 'entered into
modern European consciousness', as Margo de
Mello put it, as a result of the Pacific voyages, and
specifically only with the return of the *Endeavour*
in 1771.[19]

To reaffirm this is not, however, to rehabilitate
or retrieve an old answer to the question of where

tattoo comes from, but to recognize new problems. Why should tattoo have been discovered or rediscovered at this time? Why should it have been not only observed and depicted but adopted and adapted? This question comes into focus in a particular way, thanks to the research of Bronwen Douglas, presented in the next chapter. Pacific exploration and contacts with Pacific peoples did not begin – as those who cite the received wisdom tend to assume – with Cook's voyages. They commenced in the late sixteenth century, not the late eighteenth. Douglas shows that tattooing was remarked upon as early as 1595 by Pedro Fernández de Quirós in the Marquesas. He noted the affinities between the practice there and a mode of body decoration in the Philippines – and indeed both belonged to anciently related Austronesian or Malayo-Polynesian cultures. Quirós was not specific about the tattooing technique, which probably was not actually witnessed during a brief and fairly bloody visit. Like later observers – participants in Roggeveen's, Wallis's and Bougainville's voyages among them – he referred to 'painting', implying the temporary application of ochres or dyes rather than the pricking in of permanent marks. This loose usage, we have seen, remains present in Cook's account, which speaks first of 'paint' before proceeding to make it clear that a distinctive puncturing technique is employed. But the accounts of Cook and his associates are extensive, whereas those of his Spanish, Dutch, French and British predecessors amount to no more than passing allusions.

The moments of early observation are not cited here out of some antiquarianism, but because they are theoretically significant. They make it apparent that meeting with tattooing did not mean that tattooing 'entered modern consciousness'. During the voyages prior to Cook's, tattooing was certainly seen, but not meaningfully encountered. Evidently, conditions that had not been present before 1769 came to exist then. It was these conditions, not the mere fact of contact, that for the first time facilitated an interested recognition of Pacific tattooing on the part of Europeans.

In seeking to identify these conditions and what changed between 1595 and 1769, it is easy to point to shifting European mindsets. The Spanish were more or less insensitive to, and intolerant of, cultural difference. In the Pacific at this time, they described indigenous custom fleetingly and superficially, and exhibited no desire to adopt any aspect of it. Cook's curiosity was the product of epochal rather than national difference. His voyages represent stereotypically enlightened ventures, driven as they were by a restless, curious, secular natural history. But so too were those of his immediate predecessors, Wallis and Bougainville. They both remarked on tattoo but neither described it extensively, nor is there any evidence that Europeans were tattooed during either visit.

The distinctiveness of the Tahitian sojourn of the *Endeavour* needs to be understood in more local terms. As Douglas explains, Wallis's visit was – in response to Tahitian resistance – notably and notoriously violent.[20] The Tahitians subsequently understood that they could not overwhelm intruders of this sort, and particular Tahitians began to see that they could instead strategically accommodate Europeans. They could entertain them, barter with them, extract goods from them,

and otherwise use them, to bolster their own prestige and power, in local political struggles. Therefore, those visitors who came after Wallis met with what they considered friendliness and benevolence; the hospitality and generosity were real, but were also certainly *interested*. For the first time during any Pacific encounter, Cook and his crew were invited to enter into Tahitian sociality. Although the visit of 1769 was not devoid of violence and tension, indeed relations were marked by awkward ups and downs, and were close to seriously deteriorating on a number of occasions, it was distinguished also by remarkable and unprecedented levels of intimacy. Notoriously, many of the European men enjoyed sex with local women. But, equally or more consequentially, they also slept on shore, very often in the houses of Tahitians; they ate with them; they toured with them; they tried to speak Tahitian; they witnessed entertainments such as dances and boxing matches, as well as many more quotidian practices; they showed Tahitians around the ship; they playfully compared their persons, their goods and their habits; and nearly all the visitors also underwent the ritual of name-exchange, forming one-to-one *taio* partnerships or friendship contracts with locals. The unusual prolongation of this visit – in the end more than three months, required by the astronomical commission of the *Endeavour* – was also unprecedented, and did much to generate a deeper level of mutual familiarity than had existed on any previous visit either to Tahiti or any other Pacific island.[21]

Under these circumstances, Tahitian tattooing was not merely casually observed. It was recognized that the practice was virtually universal, and

that it had standard elements as well as many idiosyncratic ones. Some of its social ramifications were detected though not understood, the painful process was witnessed, and the meanings of the practice inquired into. Although none of the mariners had anything approaching a fluent grasp of Tahitian, they benefited from the vocabularies obtained on Wallis's voyage, and the presence of some men who had been on that voyage. Towards the end of the ship's stay, some Europeans were certainly capable of posing more complex questions concerning social or cultural matters, even if they were not likely to have understood the answers fully. This visit was distinguished by a linguistic basis for cross-cultural observation and exchange that had never previously existed in Pacific-European interaction.

Because mariners, natural historians and artists considered the Tahitians, and specific Tahitians, somewhat naively as their true friends, they had no particular qualms about placing themselves in a situation in which they might otherwise have been considered foolishly vulnerable. They subjected themselves to the controlled violence of the tattoo ritual happily enough, and allowed Tahitians to puncture their skins and shed their blood. In a way, this mutual confidence and trust was reciprocated: Tahitian men enjoyed the novelty of being shaved with razors, and evidently did not fear the analogous vulnerability. Precisely why the Europeans sought tattoos, or acceded to requests that they were tattooed, is not documented for any of the participants in Cook's first voyage. It is possible, however, to speculate about the subjective interests of the sailors, natural historians and artists who obtained tattoos.

In this context it needs to be kept in mind that, in its experimental aims, its range, ambition and duration, the voyage of the *Endeavour* was highly unusual by eighteenth-century naval standards, and that sailors and supernumeraries alike were fully aware that they participated in an exceptional and remarkable mission. It may sound facile to suggest that they would therefore certainly want souvenirs, and that those souvenirs might include tattoos. But the rapid emergence of a novel tattoo fashion among Cook's seamen can very profitably be related to another conspicuous aspect of the shipboard culture on his voyages, namely the pervasive and episodically obsessive interest in collecting ethnographic specimens, which common sailors participated in as vigorously as the natural historians, whom we might consider as the more obvious, or legitimate, collectors on the voyage. Cook indeed remarked frequently and with a good deal of irritation that common seamen wasted time and their property in seeking things that he did not rate; he found their passionate acquisitiveness excessive and at time ridiculous. But sailors clearly felt a keen desire to privatize an aspect of the voyage's official mission. They sought to attach an aspect of scientific travel to themselves, to dignify their biographies, and certainly also to enrich themselves through the sale of South Seas curiosities, for which there was a ready market back in London.[22]

The relevance of collecting to tattooing breaks down at the point we consider the prospect of reselling the collected thing (even though, as Joanna White shows, some sailors later attempted to earn a living by displaying their tattoos, this does not appear to have taken place until the early nineteenth century, and then there is no evidence that men ever got themselves tattooed in the Pacific with future self-commodization in mind). But insofar as collecting enabled some sort of personal incorporation of the voyage, it closely paralleled the project of tattooing. It is moreover easy to see why men from the top to the bottom of the ship's social hierarchy should have got themselves 'marked'. Joseph Banks did so, as an aspect of his own relentlessly curious and exhaustive collecting; his own subordinates, and other sailors, did so because they were mimicking these operations, as well as Cook's publicly sanctioned collection of cartographic and navigational data. What they were doing was seeking to appropriate the voyage, in a form inalienable from their own bodies.

Greg Dening among others has drawn attention to the sailor's chronic paucity of privacy and possessions.[23] The fact that the sailor had little scope for the elaboration of a sense of self through personal space or property may therefore have predisposed him to get tattooed, to express himself through bodily decoration and insignia, as Joanna White points out. It is therefore not surprising that a limited degree of pre-Cook tattooing is attested to; it is as though seamen exhibited a propensity to engage in this type of body modification, before it was genuinely available to them. But the initial fascination with tattooing appears to have been more powerfully motivated, not by a sort of deprivation of ordinary ways of being in the world, which the sailor suffered, but by the simultaneity of this general propensity with the preoccupation with collecting, that so distinguished Cook's three voyages. Getting tattooed was a singular form of collecting, but

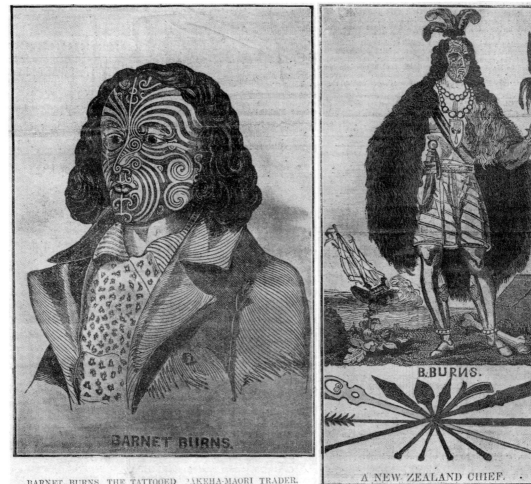

9 *Barnet Burns, the tattooed Pakeha-Maori Trader.*

10 *Barnet Burns, the tattooed trader in Maori costume,* c. 1807, photomechanical reproductions of the original wood engravings from the *Weekly Graphic and New Zealand Mail,* 5 July 1911.

also a form that exceeded the acquisition of a material object. Tattooing overlapped contingently with collecting in that both represented ways of acquiring curiosities, and tattoos were curiosities par excellence, but tattooing more fundamentally transcended collecting's normal material limitations. Whereas objects gathered might be lost, broken or sold, and could only ever be tenuously connected with one's person and uncertain in their significance, your tattoo is not only ineradicable and inalienable, it is unambiguously part of you.

If European tattooing in the Pacific thus had, in its initial stages, a peculiarly ethnographic

stimulus, sailors were always erratic ethnographers. If their subjective investments in tattooing were ultimately not motivated by the expression of some novel form of cross-cultural subjectivity – that is, they were not 'going native' – but rather by an enhancement of self and biography that took the form of the bodily inscription of a proof of their travels and voyages, it is no surprise that their interest in Pacific motifs was correspondingly erratic. Some Cook voyage participants were certainly tattooed with Tahitian designs, but many others simply had Tahitian tattooists inscribe names, dates or European motifs upon their skin.

This is to signal a further sense in which cross-cultural tattoo arose from special circumstances, in Tahiti rather than elsewhere. I have already suggested that the distinctive intimacy of relations between Europeans and Tahitians made the movement from *tatau* to tattoo possible, in mid-1769; the European sense of tattoo as an art form was enlarged by observations of *ta moko* in New Zealand, but there was no comparable intimacy, to the contrary a good deal of mutual distrust, between mariners and Maori. It might also be suggested that cross-cultural tattooing would have been less likely to emerge had Cook taken his men not to Tahiti but, say, Samoa. While Tahitian tattooing consisted of a standard set of 'arches' and associated designs around the buttocks, it also incorporated a more varied range of motifs, which marked social affiliations in some cases and individual idiosyncrasy in others, the traditional male tattoo in Samoa was an integrated, extensive and complex design that was applied to young men of higher rank, and to their lower-ranking associates, in the contexts of elaborately organized

festivals. It can therefore be suggested – as Alfred Gell has – that the sort of tattoo the sailor required was present already in the Tahitian repertoire, that it was therefore entirely straightforward for a Tahitian tattooist to apply isolated motifs or varied motifs upon the bodies of outsiders.[24] Although Samoan *tufuga ta tatau* certainly tattooed Europeans during the nineteenth century, once a demand for tattoos on the part of visiting mariners was established, it is not at all evident that seamen arriving in Samoa would have encountered tattoo as something accessible to them. This is perhaps unproductively speculative, and I do not argue that Samoans lacked the versatility to modify a practice to make it useful in a cross-cultural situation. My point is rather that the forms of Tahitian tattoo included 'samples' and 'souvenirs' as well as fully integrated, cosmologically significant modifications of the body (which is what the 'arches' around the buttocks amounted to); had the aim of Cook's first voyage been not the observation of the transit of Venus but the appropriation of tattooing, the choice of Tahiti as his South Seas destination could not have been more fortuitous.

This discussion has aimed to sustain, but also to complicate the sense that Cook voyage encounters played a vital role, at a specific moment, in stimulating a tradition of maritime tattooing. This stimulation arose not from the mere exposure of Europeans to a practice, not from their mere discovery of it, but from the circumstances of a particular encounter, an encounter unlike those that had preceded it, and those that could have, or did take place elsewhere. The remarkable move

from *tatau* to tattoo was enabled and motivated by factors that were highly singular. Later encounters were no doubt just as singular, in different ways. When sailors in European ports who had never been to the Pacific emulated the tattoos of sailors who had, their interests, and the factors that shaped this tattoo transaction, were distinct from those that shaped the transactions in the Pacific itself. And the Pacific transactions likewise changed in ways that are charted in the remainder of this book.

I have drawn already on Bronwen Douglas's chapter, which replaces the one-line version of modern tattoo's Cook-voyage discovery with a nuanced account of the successive observations of voyagers from Quirós to Vancouver. Her account draws attention to shifting perceptions over time, distinct responses to Tahitian, Marquesan, Maori and Hawaiian tattooing, and the interplay between changing observations and changing approaches to ethnographic writing and visual representation. Yet the European understanding of *tatau* was not a matter of pure representation; it was shaped as much by the varied ways in which indigenous people dealt with Europeans and presented themselves to them as by changing artistic and discursive conventions. The business of seeing tattooing was, in other words, shaped as much by what and who were seen, as by the act and the emerging technologies of seeing.

Elena Govor's chapter follows this up, examining a specific and enormously important set of representations from a single voyage encounter in detail. I noted earlier that a few famous images of Polynesian *tatau* had become decontextualized icons. It is not widely known that one of Parkinson's famous engravings is adapted from a sketch in which the half, not the full face, is shown with *ta moko*. The subject was probably a man encountered on 11 October 1769, one of a group who came off in canoes, not far south of the initial landfall in Turanganui (Poverty Bay). The 'incompleteness' of the *moko* was not in fact uncommon: it is present in slightly later Maori and Hawaiian portraits, and is fully consistent with the dynamic asymmetry that is generally a feature of Oceanic art. Nor is it appreciated that Parkinson's other canonical portrait is not in fact just any 'New Zealander', but a chief's son named Te Kuukuu, who was injured during a hostile encounter on 29 November 1769 at Motuarohia in the Bay of Islands in northern New Zealand.[25]

Govor provides similar but far richer stories behind very well-known engravings of tattooed Marquesans. While, for the Cook voyages and many other British and French expeditions, much work has been done since the 1950s tracing and editing original journals and original visual material, no sustained attempt has been made before now to locate or publish the comparable and very extensive records associated with the first Russian circumnavigation. Here, we publish an important series of original sketches, together with Elena Govor's analysis of the encounter, the individuals represented, and the issues that arise from these records of perhaps the most elaborate and astonishing of all Polynesian *tatau* traditions. To some extent the new richness of data does not help. Not only do visual images of the same person turn out to be somewhat inconsistent, the whole corpus, it transpires, depicts a closely associated group of people, the so-called royal family of Taiohae, the bay most visited by Europeans on the

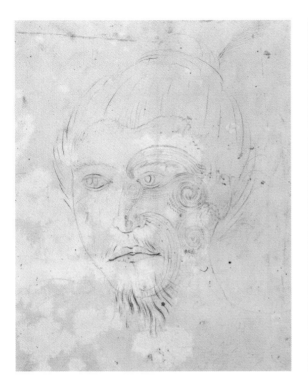

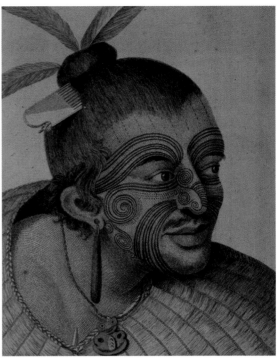

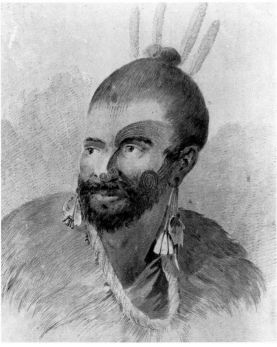

11 (*above left*) Sydney Parkinson, 'Sketch of a New Zeland Man', pencil. (For Parkinson's developed sketch, see illus. 20.)

12 (*above*) Thomas Chambers after Sydney Parkinson, 'The Head of a Chief of New Zealand, the face curiously tataowed, or mark'd, according to their Manner', engraving from Sydney Parkinson, *A Journal of a Voyage to the South Seas, in His Majesty's ship, the Endeavour* (London, 1773), plate 16.

13 (*left*) John Webber, *A Portrait of the Chief Kahura*, 1777, pen and wash.

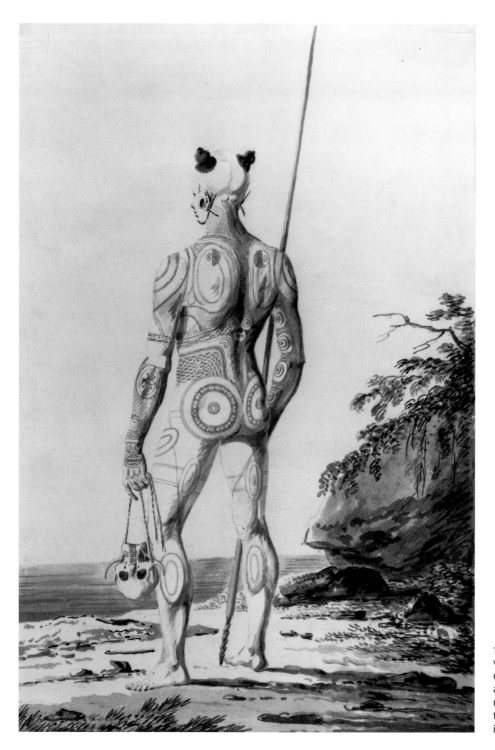

14 Georg Heinrich
von Langsdorff,
untitled drawing of
a young Nukahivan
not completely
tattooed, 1804,
ink and wash.

island of Nuku Hiva. Although Marquesans else-where were certainly tattooed in a broadly similar fashion, these canonical images need now to be considered as distinctively local rather than as representative as they have been. Govor's chapter is moreover important for reminding us that mariners, Russians as well as Britons, were apt to become infectiously keen to obtain tattoos on many voyages subsequent to Cook's.

Joanna White looks at what can be seen as the next stage of European tattooing in the Pacific. While sailors who visited Pacific islands and ports only transiently tended to adopt the technique or obtain what were in effect tattoo-souvenirs, a class of longer term, often involuntary visitors soon emerged. Those called 'beachcombers' in the Pacific literature were generally deserters or sur-vivors of shipwrecks, although they also included mutineers, renegade missionaries and convicts escaped from Australia. These Europeans, almost exclusively men, depended for their survival on indigenous communities; in some cases they remained peripheral to those communities, in others they integrated themselves more fully, marrying in, taking on local roles, using parti-cular skills with guns, metals or other imported goods, becoming crucial advisors, or sometimes only the ornaments, of high chiefs. Beachcombers in one sense or another went native, and this transition very often involved tattooing. White explores the ways in which undergoing tattooing was vital to the resident European's accommoda-tion to local culture, and how it could become an embarrassment to be explained away, or a curiosity to be exploited, for those beachcombers who returned to civilized society.

In Anne D'Alleva's chapter, our attention shifts from this impact of Pacific custom upon Euro-peans to the effects of European colonization on Pacific culture. The interventions of evangelical missionaries in the indigenous cultures of Oceania are notorious, and were certainly pervasive, yet nevertheless remain prone to being popularly misunderstood. It remains difficult to grasp precisely why some large indigenous populations made radical changes in religious and social prac-tices, indeed in many areas of work, ceremony, dress and subsistence, demanded by small groups of often fairly powerless and unimpressive mis-sionaries. Because locals themselves necessarily and actively played crucial roles in implementing missionary reforms, and because much the same programme had certain ramifications in one place and others that were very different else-where, the encounters between Christianity and indigenous culture – here, *tatau* specifically – must be seen not as uniform and predictable projects of suppression, but as singular trans-actions in themselves. Anything approaching a comprehensive study of missionary responses to tattooing across the Pacific would entail a very considerable amount of new research in both archives and island communities, but Anne D'Alleva broaches the comparative problem by examining the Tahitian case alongside that of Samoa. In Tahiti, tattooing was closely identified with other aspects of heathenism and was pro-scribed and repressed in the early legal codes designed and enforced by Christian chiefs and missionaries. In this context *tatau* assumed new forms, including forms specifically resistant to the new order; but nevertheless waned during the

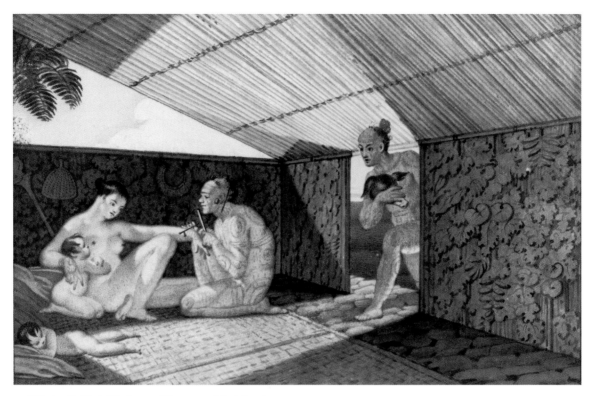

15 Wilhelm Gottlieb Tilesius von Tilenau, untitled drawing of tattooing, Nukuhiva, 1804, ink and wash.

first half of the nineteenth century. In Samoa the story is intriguingly different for a combination of reasons.

Anna Cole's chapter follows up this exploration of colonial intrusions and body arts. Her chapter moves out of the Pacific to Burma, where both local traditions of body modification and adornment, and colonial relationships were quite different from those characteristic of Polynesia. Yet the case – of a woman's forcible tattooing, at the behest of a colonial officer – importantly attests to the wider emergence of punitive tattooing in the British empire, and to an unexpectedly fertile, if disturbing and injurious confluence, between

the violence of the colonial state and indigenous tattooing practices. The main documentary source, an official inquiry into the officer's conduct, brought punitive tattooing suddenly and contentiously into view, via a warped, private abuse that nevertheless represents a further sort of tattoo transaction, an adaptation of local tradition to novel, here emphatically colonial, ends.

As the nineteenth century progressed, tattooing therefore assumed multiple lives in metropolitan and peripheral cultures. Tattoo continued to be an object of ethnological curiosity and inquiry, a practice whose appeal seems to have grown steadily among members of all branches of the

armed forces as well as sailors, a practice that was subject to various forms of missionary and colonial proscription, yet also one deployed in colonial policing and punishment. And even, well after Pacific tattoo practices had mostly been suppressed, a tattoo encounter continued, whereby local tattooists were enlisted – not always fully compliantly, as Cole demonstrates – in new deployments of indelible body marking.

Peter Brunt's chapter brings us forward to the recent antecedents of contemporary developments. In some ways it is odd that so singular a form of 'primitive' art as tattooing should not have attracted the attention of the early twentieth-century modernists who notoriously gained inspiration from African and Oceanic arts. Brunt's essay is in one sense a specific enquiry into a colonial settler modernist, a New Zealand painter who appropriated the Samoan tattoo not to his art but to his person. Tony Fomison has, since his death in 1990, become an increasingly mythic figure in Aotearoa-New Zealand, a figure who seemed to live and anticipate the post-colonial parity of Maori and European cultures that has only since become officially upheld. Yet, through a nuanced and revelatory reading of Fomison's paintings and biography, Brunt argues that the artist's vision was deeply melancholic, pervaded by notions of fatalism and entrapment that could only forestall or even preclude post-colonial possibilities. Although 'it is difficult in the end to get a straight read on Fomison's tattooing', this subjectivity may recall that of the colonial cast-away more than it prefigures a new bicultural or multicultural being. Yet this is no unknowing recapitulation, but a deliberate and awkward one

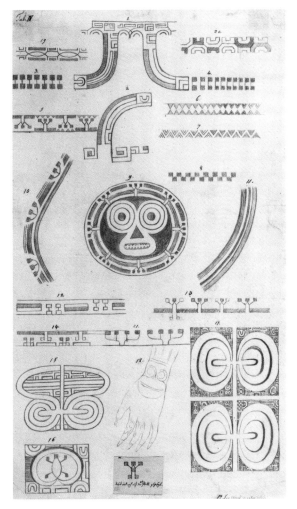

16 Georg Heinrich von Langsdorff, *Figures used in Tattooing*, Nuka Hiva, 1804, ink and wash.

that in a way offers its own implicit analysis of the connection and the gap between *tatau* and tattoo.

The three chapters that follow move forward to deal with contemporary Pacific practices, albeit in their historical contexts. Sean Mallon's essay complements Brunt's in surveying contemporary Samoan *tatau* practice. The milieu is notably flourishing and dynamic, and is marked by much

internal debate about whether non-Samoans such as Fomison should be tattooed. Mallon, in effect, writes against a concern to keep *tatau* within the Samoan community, pointing out that it has a much longer cross-cultural history of exchange with other Polynesians as well as with Europeans than is commonly appreciated. It is moreover a practice that has become, to an astonishing degree, globalized. Contemporary *tufuga ta tatau* (priests of tattooing) are now nothing if not frequent flyers, sustaining gruelling travel schedules to meet the needs of young men in Samoan diasporas, and Europeans and Americans wanting Pacific tattoos. The present extensions of the practice are certainly unprecedented, but on the other hand consistent with the longstanding adaptation of *tatau* in the pre-colonial and colonial periods.

With Sean Mallon's, Makiko Kuwahara's chapter enables us to update D'Alleva's Tahiti-Samoa contrast. While tattooing in Samoa was never abandoned, Tahitian tattooists and Tahitians interested in *tatau* are emphatically reviving a practice that had suffered extended discontinuity. Tahitian tattooing is therefore, unsurprisingly, entirely disembedded from its historic ritual and social context, but has re-emerged in the context of a recent cultural renaissance, and as part of contemporary urban Tahitian youth culture, which is beautifully evoked in this essay through a series of casual visits to tattooists and their friends and clients. Tahitian tattoo, like Samoan, is globalized, but its articulation is different. Although some Tahitian tattooists like the Samoans tattoo in Europe and elsewhere, the connection in this case is above all via tourism.

In part as a result, tattoos assume specific and divergent styles, including an 'ancient' style derived primarily from the powerful and distinctive Marquesan designs rather than those actually documented from early Tahiti, and more eclectic approaches that combine this with Westernized and global references.

Linda Waimarie Nikora, Mohi Rua and Ngahuia Te Awekotuku enable us to turn the tables on Parkinson's classic images through their discussion of contemporary *ta moko* from the wearer's perspective. Against the background of the ambivalent astonishment of early observers from Joseph Banks onward, the decline of men's *moko* and the survival of the women's tattoo into and through the twentieth century, this essay ranges over the varied meanings attached to *ta moko* in the present. Wearers find that the tattoo provokes curiosity, as it always has, nostalgia, expectations of deep traditional knowledge, and respect, but sometimes also more conventional prejudices and outright hostility. Yet its current evolution is marked by renewed confidence, and a deeper sense of the integrity and continuity of Maori knowledge, culture and practice.

The current tattoo renaissance has been marked, as I noted earlier, by a special interest in tribal tattoo traditions. A whole range of 'neo-tribal' tattoo styles have in fact emerged, and these are among those now most visible in tattoo magazines and in middle-class tattoo practices today. Both this widespread interest and an earlier, 1980s avant-garde body modification movement have been criticized for what is seen as their recapitulation of conventional Western primitivisms. The charge was more or less invited by one of the

most influential publications in this scene, the collection of 1989 entitled *Modern Primitives* – which represented both early and contemporary Polynesian tattoo practices extensively.[26] Fifteen years after the publication of that book, we raise the question again of the nature of 'modern' interest in 'tribal' practice. It is undoubtedly the case that many in America and Europe who acquire pseudo-Oceanic or for that matter pseudo-Celtic designs in tattoo studios are influenced by naïve and one-dimensional New Age romanticizations of indigenous culture and spirituality. It may be argued also that such people appropriate elements of living indigenous cultures, ignorant and indifferent to indigenous notions of cultural property. Just as tattoo transactions have in fact proceeded for a long time, debates about what should be transacted and who are appropriate recipients will inevitably carry on as contentiously as they do now. But Cyril Siorat's chapter argues that the body modification world is itself stereotyped by the critique of 'modern primitivism'. He considers whether tattoos really are commodities, whether tattooing in fact is embedded in consumer culture to the degree that has been asserted. He suggests that the 'modern primitive' label was, or at any rate can and should be, ironic –

as the colonial castaway role was, so painfully, for Fomison.

This book's epilogue takes up the question of what these transactions entail and amount to. I conclude this introduction on another note. Since the publication of Robert Goldwater's *Primitivism in Modern Painting* in 1938, the modernists' dealings with, or appropriations from, tribal traditions have become a canonical topic of critique and debate in art history and cultural theory.[27] The privileged status of now over-cited instances such as Picasso's *Demoiselles* has meant that many, many other exemplifications of European-African and European-Pacific (among other cross-cultural) histories of mutual representation, colonization, appropriation, reappropriation and exchange have been passed over. Yet those neglected histories may have as much or even a good deal more to tell us about art, culture and politics in the colonial and post-colonial epochs. It is our contention that the tantalizingly incomplete histories of *tatau* and tattooing are no less important than modernism, as paradigms of appropriation – if that is the right word. Between the blood on a sailor's backside and the hammering of a Samoan tattoo tool today lies a host of extraordinary stories and problems that we can only begin to explore here.

Histories and Encounters

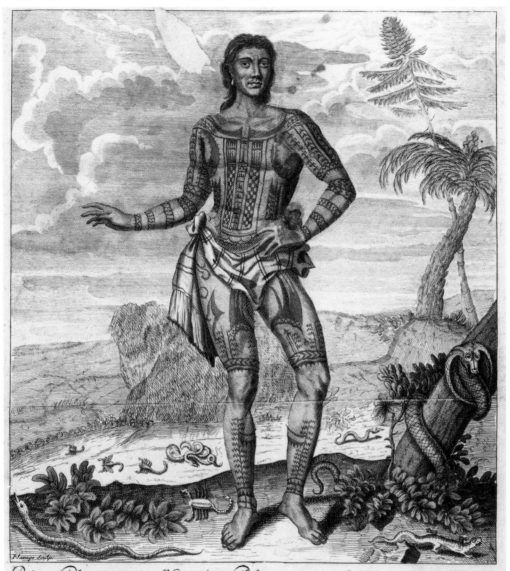

17 Anon, 'Prince Giolo . . . ', from the broadsheet
An Account of the Famous Prince Giolo (London, 1692).

'Cureous Figures': European Voyagers and *Tatau*/Tattoo in Polynesia, 1595–1800

Bronwen Douglas

'They all came naked, without any part covered; their faces and bodies in patterns of a blue colour, painted with fish and other patterns'.[1] The Portuguese-born Spanish navigator Pedro Fernández de Quirós thus depicted the men he saw in 1595 at Fatu Hiva in the Marquesas Islands. This is the earliest reference I have found to any Polynesian variety of the pan-Austronesian practice of indelible body marking called *te patu tiki*, 'wrap in images', in the Marquesan language; *tatau*, 'mark', 'strike', in Tahitian and Samoan; and *ta moko*, 'strike', 'tap', in Maori. Sydney Parkinson, the artist on James Cook's first voyage of 1768–71, recorded the Tahitian term: 'The natives are accustomed to mark themselves in a very singular manner, which they call tataowing'.[2]

'Tataow' denoted not only the stained designs that Polynesians and other Oceanic people painfully chiselled or punctured on their faces, limbs and bodies but, universalized as 'tattoo', quickly came to designate historical precedents elsewhere, as well as the foreign adaptations initiated by Parkinson and many of his shipmates. Whereas these and subsequent European voyagers in Polynesia exclaimed over the 'singular' practice

and gave it much ethnographic attention, their Spanish predecessors wrote little about the spectacular full body *patu tiki* they saw in the Marquesas, perhaps in part because it was no novelty to them. Indeed, in another account of his voyage published in Antonio de Morga's history of the Spanish colony in the Philippines, Quirós wrote that the Fatu Hivans were 'marked in the same manner' as the Visayans, the indigenous people of the islands south of Luzon.[3] Morga explained that they and their islands were also called *Pintados*, 'painted people' in Spanish, because 'the more prominent men' marked their whole bodies, 'pricking them according to a design, then throwing a black indelible powder over the bleeding'. Morga's modern English editor called the practice 'tattoo' and glossed *Pintados* as 'Picts', a historical allusion to the early inhabitants of northern Britain who were so called by the Romans because they were *picti*, 'painted'.[4] The universalization of the term tattoo is further evident in formal modern definitions of 'Pict': a late nineteenth-century Latin–English dictionary derived *Picti*, 'Picts or ancient Caledonians', from 'their practice of tattooing themselves', while the

Oxford English Dictionary linked the etymology of the word to Latin *picti*, 'painted or tattooed people'.[5]

The widely travelled Englishman William Dampier depicted the full body marking of one Visayan man in graphic terms that anticipated later accounts of *patu tiki*:

> He was painted all down the Breast, between his Shoulders behind; on his Thighs (mostly) before; and in the form of several broad Rings, or Bracelets, round his Arms and Legs. I cannot liken the Drawings to any Figure of Animals, or the like; but they were very curious, full of great variety of Lines, Flourishes, Chequered Work, &c. keeping a very graceful Proportion, and appearing very Artificial, even to wonder, especially that upon and between his Shoulder-blades.[6]

The man was 'Jeoly' or Giolo (illus. 17), the so-called Painted Prince from Miangis, a tiny isolated island due east of southern Mindanao, where he had been enslaved with members of his family when blown off course in a storm. In 1690 Dampier purchased a half-share in him and his equally 'painted' mother, who soon died. Notwithstanding Jeoly's objectification as a slave and Dampier's hopes to profit from him, he made a strong impression on the Englishman who claimed to have cared for him and his mother when they were sick, 'as if they had been my Brother and Sister'. Dampier, though, never met Jeoly on equal terms or in his indigenous setting. He remained a singular curiosity, detached from his own world and extolled as 'the just wonder of the Age' in England, where his 'painted' body was 'shown for a Sight' and where he ultimately died.[7]

These vignettes set the scene for a comparative ethno-historical investigation of representations of 'tattaowing'/'tatouement' in the artwork and writings of British and French voyagers in Polynesia during the classic era of scientific maritime exploration, spanning the four decades between the voyages of Samuel Wallis (1766–8) and Louis-Antoine de Bougainville (1766–9) and the voyage of the Russians Ivan Kruzenshtern and Iury Lisiansky (1803–6). During more or less fleeting visits to indigenous communities that had previously encountered few, if any Europeans, members of a dozen or so official naval expeditions produced the earliest systematic representations of Polynesians. The ethnographic legacy of scientific voyaging is limited but crucial, both for its priority and also, especially with respect to a visual medium like tattoo, because such voyages usually combined the trained empirical observation of naturalist-anthropologists with the expertise of artists whose job was to produce naturalistic images of the people, places and things they saw.[8]

During the late eighteenth century there was considerable flux in European ideas about and conventions for representing non-white people as new information poured into Europe from around the globe and the battle over slavery intensified. The modernist biological idea that race is phylogenetic and fundamentally differentiating began to challenge older, holistic beliefs about essential human similitude, while empirical naturalism supplanted long dominant neo-Classical values in art and aesthetics. Neo-Classicism had tied accuracy in depiction to an ideal of perfection, producing portraits that by more naturalistic standards are far from lifelike – for instance, in

works by Parkinson considered below. But, as Bernard Smith argued,[9] these conventions steadily gave way to insistence on greater realism, exemplified in the demand of the German philosopher Johann Gottfried von Herder that artists adopt 'the accurate and natural-historic manner of delineating the human species'.[10] More realistic depiction paralleled hardening attitudes to Polynesian 'savages', who had initially inspired excesses of primitivist idealization but whose notorious series of lethal assaults on European navigators during the 1770s and '80s provoked an increasingly racialized disgust.[11]

This chapter charts variations in indigenous tattoo motifs and tattooing techniques as recorded by European sailors, naturalists and artists in various Polynesian settings – mainly Tahiti, Aotearoa-New Zealand, the Marquesas and Hawaii. For the self-styled civilized in the late eighteenth century, tattoo was an emblem of the exotic, a 'curiosity', something worthy of discerning interest and collection as a specimen.[12] It is tempting, but inappropriate, to take this attitude at face value and regard European representations of indigenous body marking as merely the discursive appropriation of passive native bodies by a dominant imperial gaze, or the growing fashion for tattoo among European voyagers as just artistic colonization.[13] Yet first-hand drawings of tattoo were always produced in situations of performative interaction, as was indigenous tattooing of European bodies. Both processes hinted at ambiguous stories of cross-cultural agency and exchange.[14] I thus relate the representations of tattoo by outsiders not only to contemporary European artistic conventions and ethnocentric

or racialist ideas about non-Europeans, but to the actual circumstances of their generation in particular situations of cross-cultural interaction in Polynesia, which often left subtle countersigns of indigenous agency in what visiting Europeans wrote and drew.

George Robertson, master on HMS *Dolphin*, the first European vessel known to have visited Tahiti, described 'a very particular Custom' observed during a month-long stay on the island in 1767: 'at the age of Sixteen they paint all the men's thighs Black, and soon after paint cureous figures on their Legs and Arms', while girls 'go through that operation' somewhat earlier. Robertson took the 'Custom' for a kind of initiation rite, whereas his captain Samuel Wallis assumed it was a sign of 'superior rank and authority' in a few men 'whose legs were marked in chequers'.[15] The following year, members of Bougainville's French expedition wrote somewhat more about the body 'painting' they saw during less than a fortnight spent in Tahiti. Charles-Félix-Pierre Fesche, a young volunteer, included the term *tatau*, 'marks they have on the body', in his vocabulary of 184 Tahitian terms. The physician-botanist Philibert Commerson heard the word as *tata* and glossed it as 'blue stain'.[16] Bougainville himself drew ethnographic or historical parallels between these 'indelible marks' and those he had seen worn 'by the natives of Canada' or read about in Caesar's account of the ancient Britons. From these cases, he generalized a timeless association of body painting with 'peoples close to the state of nature'. In Tahiti, it seemed to him to be a 'mark of rank' – 'free men' were distinguished from 'slaves' by their 'painted buttocks' – and also 'a fashion like in

Paris'.[17] Fesche provided the earliest reasonably accurate ethnographic description of the process of tattooing:

> their buttocks [are] painted black and encircled with garlands; to do this, they use an instrument made from an extremely thin piece of shell, toothed at the end like a comb and fixed to the end of a small stick half a foot long; they dip the piece of toothed shell into the colour and apply it to the skin which they pierce by striking the handle with another stick held in the other hand; the colour thus applied seeps into the holes and stays there forever. This operation is painful, the skin swells at once and remains that way for several hours.[18]

During their relatively brief sojourns in Tahiti, Wallis and Bougainville were both preoccupied by the need to obtain fresh supplies and ensure the security of ships and crews. To this end, Wallis used extreme force to suppress Tahitian assaults on the ship. Neither voyage produced first-hand visual impressions of indigenous people, while the journals and narratives written by participants are of great historical value but ethnographically superficial. In general, the authors of these random catalogues of exotic practices were so mesmerized by the startling sexual complaisance of unmarried Tahitian girls that they referred only in passing to cultural practices like body marking. In contrast, Cook's three-month stay in 1769 provided extended opportunities for Europeans, including several naturalists and artists, to interact at length with Tahitians, learn something of their language, and write or draw detailed impressions of the local people, not least

of their *tatau*. Bernard Smith suggested that Joseph Banks, the gentleman naturalist on this voyage who commissioned its artists, had set himself to assemble 'a systematic, empirical, and faithful graphic account of all the principal kinds of rocks, plants, animals, and peoples in the world'.[19] Banks regarded pictures as superior to writing in conveying information, but with regard to people his aim was ethnography rather than portraiture – the accurate representation of typical figures, dress, artefacts and bodily adornment,

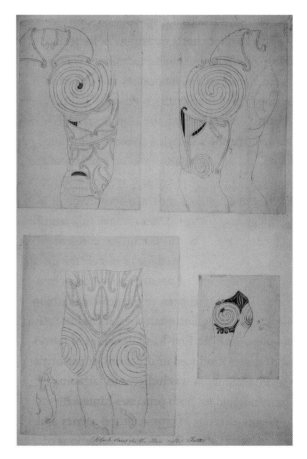

18 Sydney Parkinson, *Black Stains on the Skin Called Tattoo*, 1769, pen on paper.

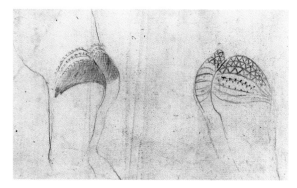

19 Sydney Parkinson, untitled drawing of tattooed buttocks, probably Raiatean, 1769, pencil on paper.

rather than the portrayal of particular individuals. In convention and technique, this ethnographic project paralleled natural history draughtsmanship, Parkinson's chief employment under Banks. Smith saw its adoption in the service of science overseas as the first stage in the triumph of empirical naturalism in European art.[20]

Accordingly, Parkinson and the assistant naturalist Herman Diedrich Spöring drew disembodied loins, legs and buttocks embellished with different tattoo motifs they had seen in Tahiti, Raiatea and Aotearoa.[21] One such pencil sketch done by Parkinson in Tahiti in mid-1769 is the earliest extant visual representation of a Polynesian tattoo (illus. 19). Others, probably executed in Raiatea, served him as studies for formal compositions of Leeward Islanders engaged in everyday tasks (illus. 24).[22] These compositions depict both women and men with tattooed buttocks, but the artist's concern was ethnographic rather than voyeuristic: he represented purposeful action by generalized indigenous subjects who typically undressed in order to swim, fish, wash or work canoes. Banks remarked – and Cook

echoed him – on the 'infinite diversity' of the figures tattooed on Tahitian bodies, apparently dependent 'upon the humour of each individual'. Both, however, stressed the ubiquity of blackened buttocks capped by arches over the loins, which appeared to be 'their great pride' and were shown 'with great pleasure'.[23] These observations were confirmed and extended 20 years later by James Morrison, a *Bounty* mutineer and Tahiti's earliest ethnographer, whose word picture of this characteristic tattooing mode laboriously complements the economy of Parkinson's pencil:

the Hips of Both sexes are Markd with four or five Arched lines on each side, the Upermost taking the whole sweep of the Hip from the Hip bone to the Middle of the Back where the two lines Meet on one, which is drawn right a Cross from one hip bone to the other and on this all the other lines begin and end; under this Center line are generally four or five more, sweeping downwards, but Most Weomen have that part blackd all over with the Tattowing – but evry one pleases their own fancy in the Number of lines or the Fashion of them, some making only one broad one while others have 5 or 6 small ones ornamented with stars & sprigs &c.

Morrison added that tattooing of the hips was 'at their own option', but that 'it is as bad to want these Marks as it would be among us not to be Christened or to go Naked'. Nonetheless, 'some want both'.[24] Indeed, a 'want' of *tatau* was reported in one of the highest-ranking *ari'i*, 'chief', on the island, the man known to the English as Pomare I or Tina. According to George Tobin, a lieutenant on William Bligh's second breadfruit voyage to

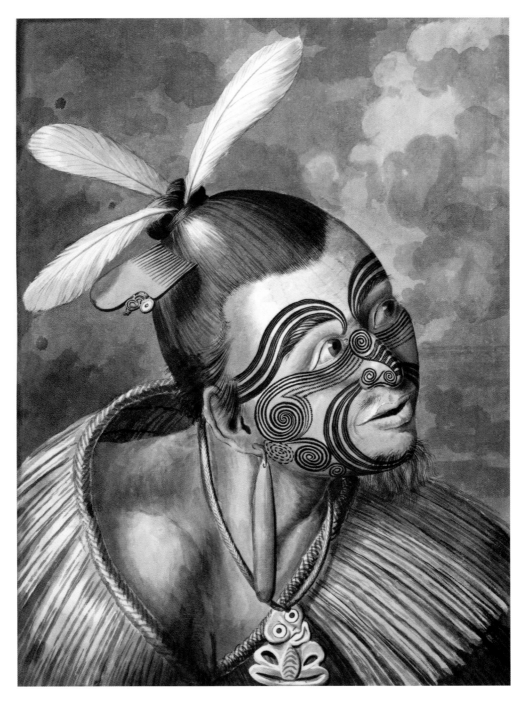

20 Sydney Parkinson, *Portrait of a New Zeland Man*, 1769,
pen and wash on paper.

Tahiti in 1792, Tina's skin was 'darker than that of most of the natives' and was not 'much tatowed'.[25]

Banks noticed only one instance of facial *tatau* in Tahiti, possibly on the man with 'curiously tataow'd' neck and chin whose portrait was engraved by R. B. Godfrey for Parkinson's posthumously published journal.[26] By contrast, tattooed faces feature significantly in written and visual representations of Maori encountered in Aotearoa late in 1769 by Cook's party and by the contemporaneous French commercial venture of Jean-François-Marie de Surville. Ethnography remained the object in Parkinson's celebrated finished drawings of Maori men (illus. 20 and 21). The faces are conventionally neo-Classical but are diagrammatic, as in botanical draughtsmanship, rather than idealized portraits.[27] The first was developed from a sketch probably made in Poverty Bay in October 1769. The second was named by Parkinson as a man wounded in an affray with the British in the Bay of Islands in December 1769. Notwithstanding this verbal identification, there is still no trace of personality in the drawing. Yet despite the lack of individual physiognomy, these faces are not racial types. Rather, they served as blank canvases for the replication of typical varieties of Maori dress, hairstyle, ornaments and the startling facial tattoo called *moko*.[28]

The anthropologist Alfred Gell categorized the tattoo designs in illus. 20 as 'classic' *moko* – chiselled spirals in imitation of wood-carving – whereas illus. 21 apparently replicated older, painted *puhoro*, 'rafter', motifs, applied not with a chisel but with the multi-toothed tattooing comb used elsewhere in Polynesia. Whereas *moko* designs comprised pigmented lines incised on a lighter ground, *puhoro* patterns were made by leaving clear skin on a darkened background.[29] Parkinson's drawings illustrated a marked difference in tattoo styles, patterns and techniques noted by several of the voyagers as Cook coasted northwards along the east coast of Aotearoa's North Island. In and around Poverty Bay, he wrote, 'their faces were tataowed . . . very curiously in spiral and other figures; and, in many places, indented into their skins, which looks like carving'. Yet as the ship approached the Bay of Islands, he observed that the people 'were more tataowed: . . . several had their legs, thighs, and part of their bellies, marked . . . The tataow upon their faces was not done in spirals, but in different figures' from those seen previously. These figures were scrolls, *puhoro* rather than *moko* motifs. Everywhere, thought Banks, it seemed to be 'Essential' that the lips of both sexes be 'staind with something put under the skin (as in the Otahite tattow)'. He differentiated this familiar technique from 'some art unknown to me' by which 'deeply engravd furrows . . . formd in regular spirals' were incised on male faces. He first saw this 'remarkable' method of tattooing at Poverty Bay, the expedition's earliest landfall in Aotearoa, where 'the oldest people had much the greatest quantity and deepest channeld'. William Monkhouse, the surgeon, saw no incised tattoo on bodies or limbs at Poverty Bay, while Cook thought that it was generally 'less common' for Maori men to tattoo parts of the body other than their faces. However, at the Bay of Islands he had seen few people 'mark'd in the face' but several with 'Backsides tattou'd' in similar fashion to Pacific

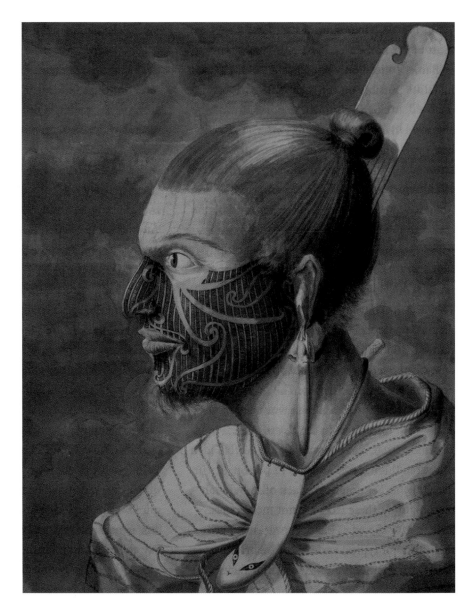

21 Sydney Parkinson, *Portrait of a New Zeland Man*, 1769, pen and wash on paper.

Islanders. Also in the far north, having learned and generalized the Maori term, Banks remarked the 'much larger quantity of *Amoco* or black stains upon their bodies and faces; almost universaly they had a broad spiral on each buttock and many had their thighs almost intirely black, small lines only being left untouchd so that they lookd like stripd breeches'.[30]

These English reports of characteristic punctured tattoo patterns in the extreme north of Aotearoa, worn on limbs and bodies as well as faces, were corroborated by the Frenchman

Surville and one of his officers, Jean Pottier de l'Horme, who anchored in Doubtless Bay only nine days after Cook had passed, named, but not entered the bay. Surville's 'Observations on the country' include the following ethnographic passage: 'their faces are more or less elaborately decorated; some have up to ¾ of it done. It is pricked and coloured lead black so that it can never be erased. Their buttocks and legs are similarly decorated with various designs.'[31] Pottier de l'Horme called it 'painting' and explained the term as a metaphor for marks 'inlaid in the skin in the same way that some people have crosses inlaid on their arms' – an allusion to an analogous contemporary European practice. His description of the tool used clearly denoted pricking rather than chiselling: it was a 'piece of wood bent at one end to a right angle and very sharp'.[32] Pottier also drew the portrait of a Maori man called Ranginui (illus. 21), who was abducted by Surville on the pretext of avenging a 'theft' but actually to serve as a source of information on the country. This rather clumsy figure might have been designed to illustrate Banks's and Parkinson's written descriptions of far northern *puhoro* patterns; or it might have been a companion piece to two items in the pictorial corpus of Cook's voyage – Spöring's schematic pencil sketch (illus. 23) of a profiled Maori head tattooed in very similar fashion to the Bay of Islands man depicted by Parkinson in illus. 21; and Parkinson's disembodied pen drawing of a tattooed thigh and buttock seen at the Bay of Islands (illus. 18). Within two decades, the fashion in the north for *puhoro* facial tattoo designs had waned in favour of chiselled spiral *moko* patterns, but the *puhoro* technique was retained for thighs:[33]

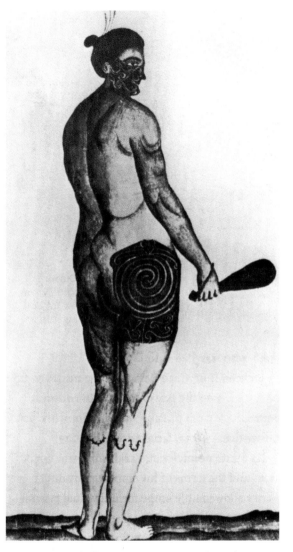

22 Jean Pottier de l'Horme, *Ranginui*, 1769, from the 'Journal du Sr Pottier de l'Horme, lieutenant du Vau. le St Jean-Baptiste'.

hence the remarkable correspondence between Banks's description of thighs marked 'so that they lookd like stripd breeches' and the depiction by the French artist, Louis-Auguste de Sainson, of disembodied *puhoro* thigh tattoos modelled for him early in 1827 by a minor *rangatira*, 'chief', named

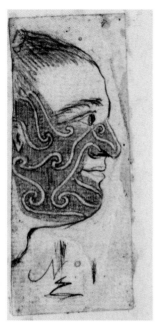

23 Herman Diedrich Spöring, *Black Stains on the Skin Called Tattoo*, 1769, pencil on paper.

Pako, who travelled with Dumont d'Urville's expedition from Cape Reinga, at the northern tip of Aotearoa, to the Bay of Islands. In contrast, Sainson's portrait of Pako showed him with *moko*, rather than *puhoro*, facial tattoo (illus. 25).

As Smith pointed out, Parkinson's training, skills and the terms of his employment under Banks allowed little scope for individual portraiture and his drawings of indigenous people retain a diagrammatic, ethnographic quality even when he sought to capture the expression of emotions.[34] Tattoo features in only four of his extant drawings and only two of the seven engravings of Maori men in his published journal. Presumably, these pictures were intended specifically to illustrate tattoo patterns, whereas the artist or his engravers omitted tattoo when typifying other ethnographic curiosities – arms, dress, facial expression, ornaments. Yet Parkinson's uneven representation of

tattoo was also an ethnographic register of the great personal, as well as local, variation remarked in several of the Cook voyage journals and also by Surville and Pottier. Most of these observers agreed that tattooed lips were near universal to both sexes, but elaborate incised facial *moko* was limited to 'the most elderly and those who appear as chiefs'. Banks commented that 'almost every different tribe seem to vary their customs' with respect to tattoo and Monkhouse saw 'no general rule'. Surville concluded his passage on tattooing at Doubtless Bay with this indefinite statement: 'I also saw some [men] who had none. Women have the calf decorated, but not all of them, and the lower lip, [but] not the rest of the face.' Pottier, however, claimed that not all women had their lower lip 'painted', while maintaining that both sexes indiscriminately 'painted' their buttocks. These early journalists mostly assumed a general association of tattoo with male rank and age: thus, for Pottier the limited incidence and the quantity and style of 'face painting' signified the relative 'distinction' of 'chiefs'.[35] Cook, ever pragmatic, speculated that the 'intolerable pain' of the operation 'may be the reason why so few

24 Sydney Parkinson, tattoo designs on loins and buttocks, 1769, pen, wash and pencil on paper.

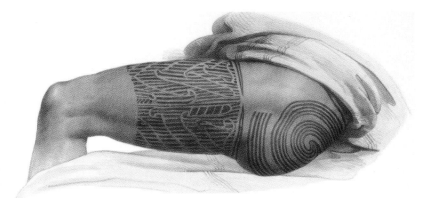

25 Antoine Maurin after Louis-Auguste de Sainson, detail from *Nouvelle-Zélande, Pako, Chef du Cap Reinga; Tatouage de la Cuisse de Pako*, lithograph from Jules-Sébastien-César Dumont d'Urville, *Voyage de la corvette l'Astrolabe exécuté pendant les années 1826–1827–1828– 1829 . . . Atlas historique* (Paris, 1833), plate 57 (3, 4).

are mark'd att all, at least I know no other'.[36]

Pictures and words convey different kinds of information in different ways. Broadly, pictorial symbolism is specific and holistic while verbal symbolism is general and linear, although the differences should not be exaggerated. Roland Barthes pointed out that 'a diagram lends itself to signification more than a drawing'.[37] Semantically, Parkinson's first-hand, diagrammatic pictures of Oceanian people approximate ethnography which is in principle among the most dispassionate of written modes and is expected to suppress the complex mix of emotions – fear, discomfort, liking, admiration, exhilaration, ambivalence, titillation, squeamishness, distaste, etc. – provoked in Euro-pean observers by encounters with indigenous people and confronting practices like tattoo. Accordingly, Cook and Parkinson confined their discussions of Tahitian and Maori tattooing to a succinct description of 'the operation', its imple-ments and its outcome. Both, however, remarked the high degree of pain involved, Parkinson in the course of a clinical, ultra-ethnographic commen-tary on a plate depicting 'Tataowing Instruments'.[38]

The theoretical ideal of impersonality ought in practice to leave limited space for the infiltration of indigenous countersigns into either visual or verbal ethnography. Yet Parkinson's ethnographic phrase 'a great deal of pain' also encodes an intense personal experience that he described as

an aside in a general ethnographic passage on 'the natives of this island [Tahiti]'. He 'and some others of our company' – apparently including Banks – 'underwent the operation, and had our arms marked: the stain left in the skin, which cannot be effaced without destroying it, is of a lively bluish purple, similar to that made upon the skin by gun-powder'.[39] They thereby inaugurated a famous nautical tradition that made a tattoo 'the badge of a voyage to Polynesia in the eighteenth century',[40] as illustrated in numerous journal anecdotes. Thus, a group of messmates on Cook's second voyage of 1772–5 did in fact devise an esoteric 'Badge', 'connecting us together, as well as to commemorate our having been at Otaheite', which each had tattooed on his breast.[41] In 1788 Arthur Bowes Smyth visited Tahiti as surgeon on board the convict transport *Lady Penrhyn* and 'was tattowed on both arms, as were the Capt. & most of the people on board'. Another surgeon, George Hamilton, who visited Bora Bora in 1791 on HMS *Pandora*, brought professional intimacy to his astonished commentary on the 'singular' practice whereby some men had 'the glans of the penis entirely tatooed': 'our men, from being tatooed in the legs, arms, and breast, places of much less sensation, were often lame for a week, from the excruciating torture of the operation'.[42]

These are fleeting textual traces of permanent indigenous imprints made literally on the bodies of many visitors (see the essay by Joanna White, pp. 72–89). Such stories hint at ambiguous inter-actions, exchanges and agency that have largely eluded historical inscription. The agency of indigenous people in the business of tattooing foreigners was, however, made explicit by the

well-connected *Bounty* midshipman, Peter Heywood, who was '"very much tattowed"' according to his captain, Bligh. Heywood justified his aberrant state in a letter to his mother by acknowledging (or shifting responsibility to) indigenous control:

> I was tattooed, not to gratify my own desire, but [the Tahitians'] . . . , for it was my constant endeavour to acquiesce in any little custom which I thought wou'd be agreeable to them, tho' painful in the process, provided I gained by it their friend-ship and esteem.[43]

Unlike the stolid professional Cook and the modest artisan Parkinson, Banks the gentleman naturalist on his global grand tour treated the subject of tattooing at some length and in more than one rhetorical mode: apart from eyewitness reportage and ethnographic generalization – the normal currency of voyage journals – he ranged from stories of personal engagements with the exotic to learned conjecture as to the origins and significance of the practice. These speculative passages are authoritative in voice, but both their tone and content were partly, if obscurely shaped by the actions and the demeanour of particular indigenous people. In 1768 and 1769, Tahitians proffered friendship to Bougainville's and Cook's expeditions as a strategy adopted in the wake of the extreme violence they had experienced during the visit of the *Dolphin*.[44] In general, however, the complacent French and British took Tahitian geniality literally, as their due, barely sensing its strategic dimensions. Accordingly, Banks's reflec-tions on tattooing in Tahiti are written in a tone

of amused detachment, qualified only by amazement that people would voluntarily bear the 'almost intolerable' pain it inflicted. As 'cause' or 'reason' for 'so apparently absurd a custom', he suggested 'proof of their perseverance and resolution', 'superstition', 'beauty' (like 'Our European ladies'), 'shame' ('so disgraceful is the want of it esteemd that every one submits to it') and habit ('their ancestors did the same').[45]

In Aotearoa, by contrast, where warriors clashed violently with the British on several occasions and numbers of them were killed by British fire – he was himself involved in a tense confrontation ashore at the Bay of Islands – Banks restricted his general explanation of tattooing to a conjecture that the deeply incised facial *moko* worn by many older Maori men was intended 'to make them look frightfull in war'; 'possibly', moreover, these 'spirals upon their faces' were meant as 'examples to encourage' the 'emulation of Bearing pain with fortitude' in the 'more populous' places, where he 'generaly observd . . . the greater quantity of this *Amoco*'. The ethnographic verdict of bellicose intent for 'this dy[e]ing in grain' was obvious enough, given the belligerent style of Maori political action and male demeanour, and was one often reached subsequently by other voyagers and cultural commentators.[46] Banks's assessment of the likely object of *ta moko*, however, is also an indigenous countersign – a texted residue of the impact of intimidating indigenous actions and demeanour towards Europeans on contemporary European aesthetics, understandings, reactions *and* representations. Torn between revulsion and admiration for Maori and their *moko*, Banks let slip his own mask of ethnographic detachment

and took refuge in aesthetic ambivalence. Unsettled by the inscrutability of Maori actions and the political implications of *moko*, Banks rhetorically disarmed tattooed men by dissociating them from their most intimate personal signatures, objectified as the artistic products of individual 'wild imaginations':

> it has the Effect of making them most enormously ugly, the old ones at least whose faces are intirely coverd with it. . . . Yet ugly as this certainly looks it is impossible to avoid admiring the immence Elegance and Justness of the figures in which it is form'd, which in the face is always different spirals, upon the body generaly different figures resembling something the foliages of old Chasing upon gold or silver; all these finishd with a masterly taste and execution, for of a hundred which at first sight you would judge to be exactly the same, on a close examination no two will prove alike.[47]

In keeping with the dispassionate ethos of the ethnographic convention, I have found few other aesthetic judgements on tattoo in the published accounts of Cook's first voyage. There was no such absence of sensibility expressed in the more mixed written and visual corpus emanating from the *Resolution* on Cook's second voyage. Smith saw 'the ethnographic convention humanised' in the 'Polynesian' portraiture of William Hodges by his evocation of individual personality, his 'search for feeling' and his displacement of the diagram by a sympathetic holism.[48] Juxtaposition of Hodges's and Parkinson's portraits of Maori men makes the point. There is far more individual presence in Hodges's naturalistic faces than in

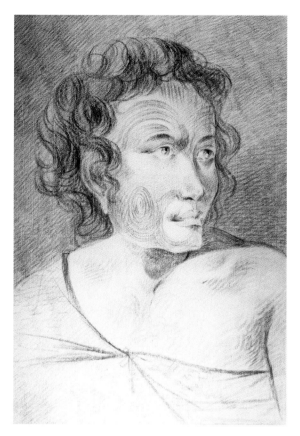

26 William Hodges, *New Zealand* (portrait of a Maori), June 1773, red chalk on paper.

him as 'strangely marked in the face with deeply excavated spiral lines . . . very regular on his chin, cheeks, forehead, and nose', so that his beard was reduced to 'a few straggling hairs'. However, if the sketch was of 'Tringho-Waya', Hodges's cursory rendition of his *moko* captured neither the substance nor the impact of Forster's words. Rather, the apparent youth of the drawing's subject, his completely unbearded chin and his untattooed nose all suggest that he was more likely one of a group of 'some old men . . . and some young men, with amazing bushy hair' whose 'characteristic faces' Hodges had sketched a couple of days previously.[49] The man portrayed in illus. 27 came briefly on board the *Resolution* from a canoe off the south-east coast of the North Island and was later identified in 'Maori tradition' as a 'chief' called Tuanui. Georg Forster described him as 'a tall middle-aged man', elegantly dressed and coiffed, with 'a piece of albatross-skin covered with its white down' in each ear and his face 'punctured in spirals and curve lines'. He confirmed that this man was the subject of Hodges's portrait.[50] Yet, while the drawing does successfully invoke something of the man's individuality and dignity, Hodges's rendition of his *moko* is no less schematic than Parkinson's diagrams. I read this reticence in representing *moko* as a countersign of the seemingly peaceful behaviour of Maori encountered by the *Resolution* on this voyage. Lacking exposure to the agonistic quality in Maori social and political life, Hodges all but ignored its symbolic manifestation in *moko*.

Anchored briefly at Tahuata in the Marquesas in April 1774, the crew of the *Resolution* were the first European observers of the spectacular full-

Parkinson's diagrammatic representations, but his red chalk was less exact than Parkinson's pen and the cost is a loss in ethnographic precision.

Some of the persons depicted by Hodges can be localized or even named by correlating his drawings with the written texts. The man in illus. 26 might have been 'Tringho-Waya', a man met at Queen Charlotte Sound in 1773, whom the young naturalist Georg Forster said was 'tall and strong, and nearly middle-aged', and who was 'drawn by Mr Hodges' according to Georg's father and fellow naturalist, Reinhold. Georg Forster described

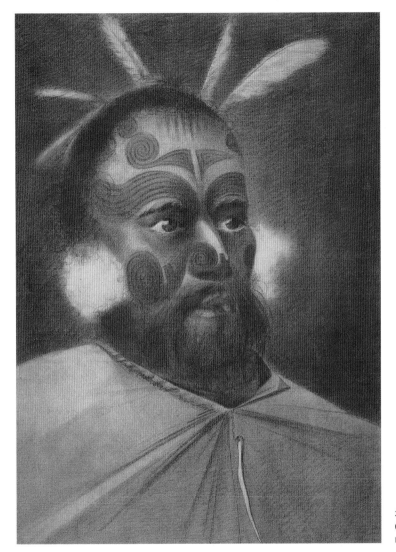

27 William Hodges, *New Zealand* (portrait of a Maori), June 1773, red chalk on paper.

body tattoo of mature Marquesan men since the Spanish visit of 1595. As with *ta moko*, Hodges's response to *te patu tiki* was blinkered, certainly by the brevity of the visit and presumably by unawareness of the 'competitive warrior ethos' that dominated Marquesan politics. Recently, anthropologists have argued that, in this fraught milieu, tattoo served to 'empower' and 'reinforce'

the bodies of Marquesan men by providing a kind of 'visual armour' that sealed them against physical and spiritual harm.[51] In the absence of such insight (although in a manuscript fragment, Cook likened Marquesan tattooing to 'a coat of Mail'[52]), the imprint of *patu tiki* on the visual output of Cook's voyage is disappointingly muted. The only extant portrait of a Marquesan man is a

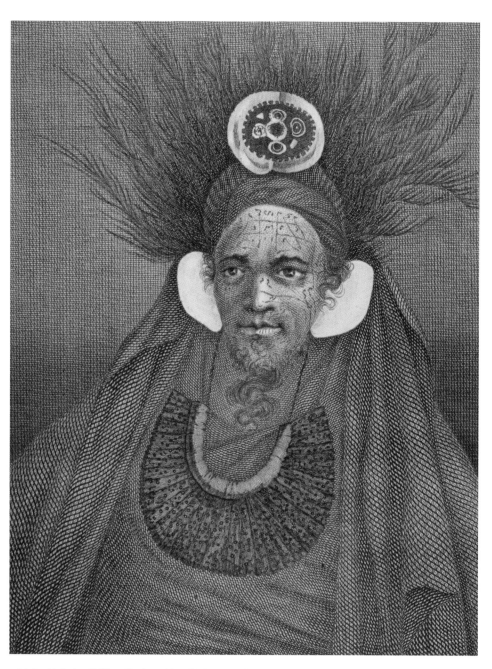

28 John Hall after William Hodges, *The Chief at Sta. Christina*,
engraving, from James Cook, *A Voyage Towards the South
Pole and Round the World Performed in His Majesty's Ships
the Resolution and Adventure in the Years 1772, 1773, 1774, and
1775 . . .* (London, 1777), vol. I, plate 36.

rather tentative drawing by Hodges, which depicts a gorgeously ornamented *haka' iki*, 'chief', and was engraved by John Hall for Cook's narrative (illus. 28). In both drawing and engraving, the face is only faintly marked and the body is swathed in cloth. However, the artist's talent for evoking personality was justly remarked by Georg Forster with respect to this man: 'his name was *Hònoo . . .* He seemed to be a very good-natured, intelligent man, a character so prevalent in his countenance, that Mr Hodges, who drew his picture, could not fail of expressing it'.[53]

Unlike Hodges, his shipmates expressed a range of aesthetic opinions on Marquesan tattooing, their reactions variously blending the sensibilities of individual authors with conventional ethnocentrism and at times betraying an ingrained aversion to the stereotyped figure of 'the Negro'. For example, the second lieutenant Charles Clerke, a cheerful optimist, described Marquesan men as tattooed 'from head to foot in the prettyest manner than can be conciev'd'.[54] Georg Forster, by contrast, was as ambivalent about *patu tiki* as Banks had been about *moko*. On the one hand, Forster's narrative supplies the most precise description:

> These punctures were disposed with the utmost regularity; so that the marks on each leg, arm, and cheek, and on the corresponding muscles, were exactly similar. They never assumed the determinate form of an animal or plant, but consisted of a variety of blotches, spirals, bars, chequers, and lines.[55]

On the other hand, Forster deplored the 'most motley appearance' produced by 'this unsightly ornament' with which the men 'disfigure themselves'.[56] This paradoxical mix of disinterested reportage and dogmatic aspersion probably coupled Forster's own youthful enthusiasm for the exotic with the strait-laced asceticism of his pastor father, whose influence permeates the narrative.[57] Furthermore, Cook and Georg Forster both betrayed a tacit racial aesthetic in evaluating *patu tiki*. Cook remarked that 'these punctuations makes [*sic*] them look dark', whereas women, young men and children, who were little or not tattooed, 'are as fair as some Europeans'. Forster reiterated that middle-aged men 'looked almost black, by being punctured over the whole body', which camouflaged their 'elegance of form', whereas the youths 'who were not yet marked' revealed 'beauties singularly striking, and often without a blemish', inviting comparison with 'the famous models of antiquity'. This coded distaste for blacks contrasts with the explicit verdict of Monkhouse, the surgeon on Cook's first voyage, that Maori men with full *moko* 'look as black as any Negroe whatever'.[58]

Unlike these decontextualized snippets, tattooing features prominently in an extended narrative segment of George Vancouver's journal of his surveying voyage to the Pacific in the years 1791–5.[59] He had gained wide experience in Polynesia during two voyages as a midshipman with Cook, including his final, fatal visit to Hawai'i in 1779, where Vancouver must have seen local versions of *mo'o*, 'tattoo'. His fellow voyager, the surgeon David Samwell, described the men of that island as:

> tattawed or marked in various parts; Some have an arm entirely tattawed, others more frequently the

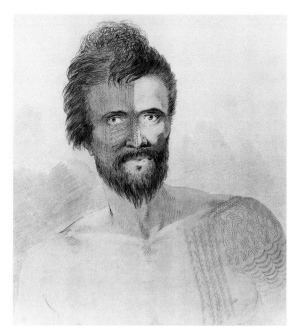

29 John Webber, untitled drawing of a man of the Sandwich Islands with half face tattooed, 1778, pen and wash.

they appeared to choose to be tattooed in 'figures agreeable to their own fancy & not so as to distinguish the bearer of them to be a Vassal or dependent on such or such a Chief'.[60] Fourteen years later, tattoo had perhaps acquired a different political significance on Oahu, where the ultimate overlord was Kahekili, an *ali'i*, 'chief', of the highest rank. He had 'elected' to have half his body 'tattooed black', like two of the incarnations of the god Kane, and was aped by his closest followers – 'a type of soldier new to Oahu called "Cut in two" (*pahupu'*), strange-looking men tattooed black from top to toe'.[61]

The story here outlined is thick with ambiguous indigenous countersigns. It tells how, in Oahu in March 1793, Vancouver colluded with several leading local *ali'i* in the arrest, sham 'trial' and execution of three men incriminated by those chiefs in the earlier killing of two of his colleagues. He described thus the man identified by the chiefs as 'the principal offender':

> One half of his body, from his forehead to his feet, was made jet black by punctuating; the other two men were marked after the same manner, but not with the same regularity. These appearances alone would not have been sufficient to have identified their persons, as we had seen many . . . disfigured after the same barbarous fashion; which I understood had been adopted in the late wars, for the purpose of increasing the ferocity of their appearance, and striking their enemies with terror.[62]

No portraits were produced from Vancouver's voyage, but John Webber's naturalistic depiction of a man he met in Kaua'i in 1778 approximates

Thighs and Legs, the Lines being continued from the upper part of the Thigh to the foot with various figures between them according to their fancy; their bodies are marked with figures of Men and other Animals; Some few among them had one side of their faces tattawed, & we saw 2 or 3 who had the whole of the face marked, differing something from the New Zealanders in being done in strait not in spiral Lines.

Samwell stressed that most 'Chiefs were entirely free from these marks on every part of them, tho' we saw a few who had them, but never any marked on the face'. He thought that Hawaiians used 'tattawing' as a 'Mortification or at least in remembrance of the dead', but that 'it is not imposed upon them as a necessary duty' because

the facial appearance of these men (illus. 29).

By his own account, Vancouver overrode his own criterion of 'sufficient' evidence when he convicted the first man on the basis of 'circumstantial' recognitions of his appearance and all three on hearsay confirmation of their guilt by the chief of the island.[63] This whole episode and its ramifications have long been attributed exemplary status by historians: the nineteenth-century Christian Hawaiian Samuel Manaiakalani Kamakau made it a parable of the post-contact perversion of indigenous chiefly politics – 'the pride and arrogance of the chiefs'; for Vancouver's modern editor, W. Kaye Lamb, it was a dubious incident of naval biography; recently, Greg Dening located it within the ambiguous theatrics of cross-cultural violence, imperial posturing and historical knowing.[64] Much that might be said about the episode exceeds the space available here and the limits of my present interest – tattoo and indigenous countersigns.

As with Banks's interpretations of Maori *moko*, Vancouver's terms 'ferocity', 'terror' and 'the late wars' encode distorted traces of strategic indigenous recourse to *mo'o* – a linguistic but not really a social cognate of Maori *moko*. Gell argued that 'Hawaiian tattoo does not seem ever to have amounted to very much', but that in the political disorder of the late eighteenth century it served on some islands as an insignia of allegiance to a particular chief and to 'conservative-legitimist' authority, such as was claimed by Kahekili.[65] Vancouver chose to believe Kahekili's assertion that the original 'murder' had been 'committed by a lawless set of ill-minded men'.[66] Yet according to Kamakau, Kahekili himself was 'tattooed a solid black . . . from head to foot on the right side'. Furthermore, 'his whole company of warrior chiefs . . . and household companions . . . were tattooed in the same way' – as were the executed men.[67] Kamakau's history was that these men were adventitious victims sacrificed by Oahu chiefs to protect their henchmen, the actual perpetrators of the killings.[68] But might they not equally have been *pahupu'* followers of Kahekili who agreed or were forced to be sacrificed in the public interest? Entangled in Vancouver's narrative are problematic countersigns of particular indigenous agency – the apparent manipulation by some Hawaiians, to now unfathomable ends, of Vancouver's portentous charade of the enforcement of universal justice. Other loaded terms in the passage cited, 'disfigured' and 'barbarous', attest alike to the observer's ethnocentric prejudice and the specifically disquieting impact of a confronting, tattooed indigenous demeanour, which served, perhaps, with fatal irony, to justify the outcome of the judicial charade.

This chapter selectively surveys Polynesian tattooing techniques and motifs as witnessed and experienced during cross-cultural encounters by early European visitors to the region. They recorded their impressions in words and pictures, speculated about the significance of body marking, and often had their own bodies tattooed by local interlocutors. Paying consistent attention to countersigns of local agency in cross-cultural exchanges, I identify a variety of strategies adopted by indigenous people in particular Polynesian settings to handle European voyagers: Tahitian friendliness following the bloody suppression of earlier aggression; Maori belligerence; Hawaiian

(chiefly) complicity with and defensive manipulation of the foreigners. I also outline two ethnographic sequences and an ethno-historical episode that hint at tattoo's wide range of meanings and uses in Polynesia: the interplay of personal choice, geographical diversity and historical change in Maori and Hawaiian tattoo designs or techniques; and Hawaiian collusion in Vancouver's travesty of universal justice in Oahu. The method used is comparative critique of the varied media and entangled genres in which tattoo was represented (written or drawn; anecdote, empirical observation, functionalist ethnographic interpretation, history), and of the several rhetorical modes evinced (Spanish indifference; British and French voyeurism; British ethnographic detachment and its subversion by emotion; racial stereotyping).

It is always problematic to ground ethnography or ethno-history primarily in the writings or drawings of transient foreign visitors, even naturalists and artists professedly committed to the empirical scrutiny and naturalistic representation of the exotic. Blinkered by ethnocentrism and racial complacency or arrogance, hamstrung by linguistic and cultural ignorance, torn by conflict-ing emotions, European voyagers could at best distantly caricature the people and cultures they encountered. Yet, at least to some extent, caricature is a condition of all ethnography. Despite their limitations, the reports and pictures of voyagers do inscribe fleeting early traces of dynamic, often ephemeral cultural practices such as indigenous Polynesian tattooing. In this chapter, moreover, I have argued that travellers' representations are not simple reflexes of metropolitan discourses and conventions but are also personal productions generated in the stress of cross-cultural encounters, where the agency of local people challenged visitors' predispositions and training and stamped ambiguous countersigns in what they wrote and drew. The ethno-historical utility of such a corpus of material thus derives from the complex interplay in its constitution between aesthetic or intellectual pre-programming, ethnocentrism, racial prejudice, precedence, experience and indigenous countersigns. Indigenous countersigns are always distorted and often deeply camouflaged, but can be cast in sharper relief by exploiting tensions among the different media, genres and rhetorics of representation – as this chapter exemplifies.

'Speckled Bodies': Russian Voyagers and Nuku Hivans, 1804

Elena Govor

He that increaseth knowledge
increaseth sorrow
Ecclesiastes 1:18

The world of *te patu tiki* – Marquesan tattoo –
has attracted scholars for more than two cen-
turies. After the detailed examination and inven-
tory published by Karl Steinen in the 1920s, the
modern ethnological study by Alfred Gell and the
most complete recent work by Pierre and Marie-
Noelle Ottino-Garanger,[1] it might be thought that
this theme had been explored in full. Nevertheless,
my attempt to look more closely at the inception
of the rich body of information on tattoo in a
particular part of the Marquesas – the island of
Nuku Hiva – brought to light unexpected discov-
eries that in some respects go beyond this limited
area and raise a number of more general questions.

The object of my study is the first Russian
round-the-world expedition on the sloops
Nadezhda and *Neva*, which spent twelve days at
Taiohae Bay at Nuku Hiva in May 1804. The
accounts by its principal members – the com-
mander and captain of the *Nadezhda*, Adam
Krusenstern (Ivan Kruzenshtern in Russian), the
captain of the *Neva*, Iury Lisiansky, and the natural-
ist Georg Langsdorff – translated into Western
languages and the visual imagery published in
their works belong to the corpus of so-called clas-
sical sources about Nuku Hiva.[2] But numerous
materials were not translated: being scattered in
Russian periodicals and locked in Soviet archives,
they remained almost inaccessible to Western
scholars. During a recent research trip to Russia, I
was able to copy little-known accounts by Langs-
dorff, the artist-naturalist Wilhelm Gottlieb
Tilesius von Tilenau (including his original
sketchbook), Makar Ratmanov, Fedor Romberg,
Fedor Shemelin, Nikolai Rezanov, Nikolai
Korobitsyn, Archpriest Gedeon and Vasily Berkh,
as well as a Russian translation of the diary of
four Japanese men who had been shipwrecked in
Russian waters in 1790 and who were being
returned to Japan on board the *Nadezhda*. The
German manuscript of the voluminous journal
of Lieutenant Herman Loewenstern (Ermolai
Levenshtern in Russian) has recently been pub-
lished in Russian translation, while many of his
drawings are held by the Estonian Historical
Archives.[3] Langsdorff's original drawings are

30 I. S. Klauber after Wilhelm Gottlieb Tilesius von Tilenau,
Depiction of the Faces of Nuku Hivans, coloured engraving,
from Ivan F. Kruzenshtern, *Atlas k puteshestviiu vokrug sveta
kapitana Kruzenshterna* (St Petersburg, 1813), plate 15.

extant, while Tilesius and Langsdorff also published accounts of the voyage in early nineteenth-century German periodicals. The written and pictorial accounts of over a dozen members of the expedition have been brought together here for the first time, including works by at least three artists – Tilesius, Langsdorff and Loewenstern.

None of the other early voyages to the Pacific, including Cook's, produced such numerous and diverse accounts. My research so far has not only brought to light new material but permits the juxtaposition of different genres, each of which enhances the others. My textual analysis of the

English versions of the classical accounts by Krusenstern, Langsdorff and Lisiansky in tandem with their Russian/German originals helped eliminate numerous misreadings in translations. The process raises the general problem of the contingency of the early texts that are used for ethno-historical reconstructions, but this chapter deals mainly with pictorial representations, including the portraits of several well-known personalities, most of whom are depicted with more or less elaborate tattoo.

Tilesius made the important remark that he 'had drawn portraits of . . . the members of the

king's family'.[4] Indeed, the selection of people whom the Russians drew and the way they were represented did not occur by chance. Plate xv in Kruzenshtern's *Atlas* entitled 'Depiction of the faces of Nuka Hivans' is an engraved collective portrait of 'King Ketenue's court', where each person occupies a corresponding position (illus. 30). This 'court' at the time of the Russian visit was not numerous. It included about a dozen close family members to whom the visitors constantly referred and who became the models for their drawings. In total, the three Russian artists produced detailed drawings of more than 20 individuals, whom I try here to identify with particular named persons.

The central figure in the Russians' interactions with the Nuku Hivans was 'king' Keatonui, called 'Ketenue' by the Russians. He was described by many voyagers, including the London Missionary Society missionary William Pascoe Crook, the beachcomber Edward Robarts, and the US Navy

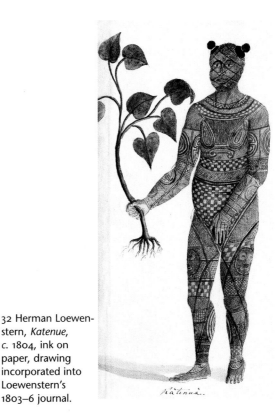

32 Herman Loewenstern, *Katenue*, c. 1804, ink on paper, drawing incorporated into Loewenstern's 1803–6 journal.

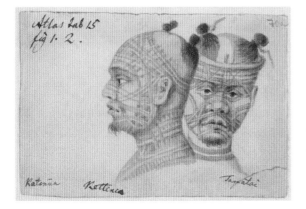

31 Wilhelm Gottlieb Tilesius von Tilenau, *Kettenue. Tamatoi*, 1804, gouache, ink and pencil on paper, from the 'Skizzenbuch des Hofrath Dr Tilesius v. Tilenau Naturforschers der Krusensternischer Reise um die Welt in den Jahren 1803–1806', fol. 70 verso.

captain David Porter, but no particular visual imagery has previously been associated with him. Russian visitors broke the ground in this respect. Tilesius' drawing of the 'king' in his sketchbook,[5] inscribed 'Kettenue', uses classical conventions to an anthropological end – to represent a typical member of a particular ethnic group rather than an individual personality (illus. 31). The drawing was engraved in Kruzenshtern's *Atlas* as the central figure in the upper row of plate xv (illus. 30). The engraver, I. S. Klauber, added tattoo designs to the shoulder that were lacking in Tilesius' drawing but which presumably were meant to contribute to the solemnity of the 'king'. The most interesting representation of Keatonui is the full-length portrait drawn by Loewenstern (illus. 32).

Not an artist by profession, he nevertheless managed to catch the individuality of this important man. The solemn, imposing, slightly corpulent, probably late middle-aged man depicted in the act of presenting a kava plant (*piper methysticum*) is certainly more than a curiously decorated savage. Although naked, he seems to be richly dressed – in tattoos. The picture refers to the particular moment when Keatonui visited the *Nadezhda* for the first time. Lieutenant Romberg briefly remarked in a letter to his friends: 'The naked king with a sapling in his hand made a visit to us'.[6] Tilesius provided further details:

> a big pirogue pulled up to our ship. There was an exceptionally corpulent and completely tattooed man with a thick neck standing at the front. His body was of dark-blue colour. This fat man was called the king of the valley . . . His name is Kettenue, Tapega. The latter is his title which means right hand. In the right hand he was carrying a pepper plant, from which an intoxicating drink is made, signifying by this peace and friendship.[7]

Shemelin, the supercargo on the voyage, wrote about Keatonui with respect, sympathy and some humour. Shemelin was not shocked by the naked tattooed body of 'the king', but the density of his tattoos so darkened his skin as to remind Shemelin of an African – a common analogy in the early literature on Polynesian tattoo (see Douglas, this volume):

> The king seemed to be over fifty already, he was stately and of a large stature. Unlike his retinue, bold and talkative, he was distinguished by modesty and reticence which imparted him a spirit of some dignity . . .
>
> His questions about the things around him were brief, his answers even briefer. . . . The things which he saw probably for the first time in his life had little effect on his curiosity. He preferred to all practical things he saw a big mirror in the Captain's cabin, to which he came up with a joyful air and looked at himself in it from top to bottom, outstretching hands, bending to all sides, turning to it with his sides and back and seemed to admire with delight his patterned skin which was all speckled with circles, ovals, wide and narrow strips and lattices so thickly that there was not even a nail sized spot clear of black dots left on his body, so that the King under his foppish dress seemed to be a true native of Angola.[8]

Loewenstern, who referred to Keatonui's tattooed skin as 'dark-blue, nearly black',[9] managed to convey this impression in his drawing, in which, however, the details of the tattoos on the face are indistinguishable and schematic. Tilesius, on the contrary, attempted to trace the pattern of the tattoo in his drawing of Keatonui's head.

There is tantalizing information about one more portrait of Keatonui done by the artist of the expedition Stepan Kurliandtsev, a Russian portraitist. It surfaced in the documents of the Academy of Fine Arts in St Petersburg at least twice. In 1818 Kurliandtsev applied for financial assistance, referring to his work on the portrait of 'Katenue, king of Taiogai'. In the following year he submitted the painting as a gift to the tsar, Alexander I. The officials considered that it was 'rather weak' and returned it to Kurliandtsev. Its

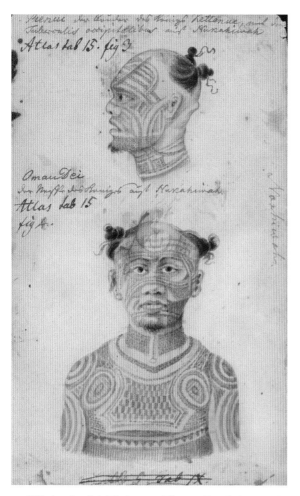

33 Wilhelm Gottlieb Tilesius von Tilenau, *Pienui. Omau Dei,* 1804, gouache, ink and pencil on paper, from the 'Skizzenbuch', fol. 72 verso.

further destiny, as well as that of his entire pictorial legacy, remains unknown.[10]

Tilesius made at least two portraits of Keatonui's 'brothers'. One drawing in his sketchbook is entitled 'Pienui der Bruder des Königes Kettenue' (illus. 33) and another simply 'Tamatoi' (illus. 31).[11] The engraver reworked head and neck drawings by Tilesius into upper bust engravings

and added chest shields. Aligned alongside Keatonui in plate xv of Kruzenshtern's *Atlas* (illus. 30), they resemble him somewhat in tattoo style and facial traits. 'Tamatoi' was most likely Keatonui's youngest brother recorded by the missionary Crook as 'Tamati'. Loewenstern recorded in his journal that 'Tamatai, his [the "king's"] brother, has the name of an enemy he killed'.[12] As for 'Pienui', it is hard to say with certainty which of Keatonui's nine brothers he might have been, but it is likely that the 'king's brother' mentioned by nearly all the Russian voyagers was he. Analysis of the Russian accounts suggests also that he ranked next to Keatonui in importance. 'The king's brother' (never '*a* brother') was the first visitor to the *Nadezhda* when it had just moored. He visited the ship soon afterwards in Keatonui's retinue but only he and Keatonui himself were singled out to be entertained with tea in the captain's cabin. Rezanov, the envoy extraordinary aboard the *Nadezhda*, commented that they were tattooed more than the others and, according to Rezanov and Shemelin, the gifts the brother received were nearly equal to those given to the 'king'.[13] 'The king's brother' accompanied Keatonui during their visit to the *Neva*, where he bartered a pig and a piglet for a duck and a drake. The priest Gedeon explained that they hoped that the duck would have offspring with red feathers.[14] Red feathers were prestigious items in the Marquesas, and probably the brothers made the association with the Brazilian red parrots that had fascinated them on the *Nadezhda*. Lisiansky remarked that on the way to Keatonui's residence they had a break to rest at his brother's house. Finally, he mentioned that 'the brother of the king of

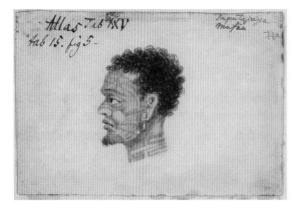

34 Wilhelm Gottlieb Tilesius von Tilenau, *Taputakaya Mufäu*, 1804, gouache, ink and pencil on paper, from the 'Skizzenbuch', fol. 71 verso.

Tayohaia married the daughter' of the neighbouring chief to the west and that this union had stopped warfare between the two districts.[15]

The upper row of plate xv in Kruzenshtern's *Atlas* depicts a profile portrait of a man who seemingly broke the mould of Keatonui's relatives by virtue of his curly hair without 'horns' (illus. 30). The inscription over this portrait in Tilesius's sketchbook reads 'Taputakaya Mufäu' (illus. 34). Langsdorff referred to him as 'Mau-ka-u, or Mufau Taputakava', others as 'Muhau', 'Maugau', 'Mugau'. All the participants in the expedition admired 'his extraordinary height, the vast strength of his body, and the admirable proportion of his limbs and muscles'. Tilesius measured every part of his body and sent the details to the great German comparative anatomist Johann Friedrich Blumenbach in Göttingen. Blumenbach 'compared these proportions with the Apollo of Belvedere, and found that those of that masterpiece of the finest ages of Grecian art, in which is combined every possible integer in the composition of manly beauty, corresponded exactly with our Mufau, an inhabitant of the island of Nukahiwa'.[16] Independently of the savants, who were mostly Germanic in origin, Shemelin, an ethnic Russian who went on an excursion around the island with 'Mugau', wrote: 'His limbs were so well proportioned that sculpture and art depicting human perfection would never find a better example than this Nuahivan Hercules'.[17]

Unsurprisingly, the voyagers' pictorial representations of 'Mufau' were not limited to Tilesius' drawing. I believe that the famous coloured engraving of the 'Man from Nuku Hiva Island' depicted with a club, *u'u*, on his right shoulder and a gourd in his left hand in Kruzenshtern's *Atlas* is also a portrait of Mufau (illus. 35). Krusenshtern wrote in the Russian edition of his *Voyage* that Mufau was the 'handsomest men that ever existed' and that 'The attached drawing would represent more clearly his gigantic, perfectly built body'.[18] Versions of this engraving illustrate both the German and English editions of Krusenshtern's *Voyage*, while it is the only full-length detailed portrait of a Nuku Hivan in the Russian *Atlas*. There is no original full-length drawing of Mufau in Tilesius' sketchbook, although there is a sketch of a man's head wearing a headdress made from pig's teeth similar to that in the engraving of Mufau. This face is depicted with no tattoo at all, probably because the artist was in this instance more concerned to show the man's ornamentation and facial expression.[19] A coloured drawing presumably of Mufau by Tilesius was preserved among Blumenbach's papers in Göttingen (illus. 36).[20] Here Mufau holds the same club in his right hand while his outstretched left hand grasps the outline

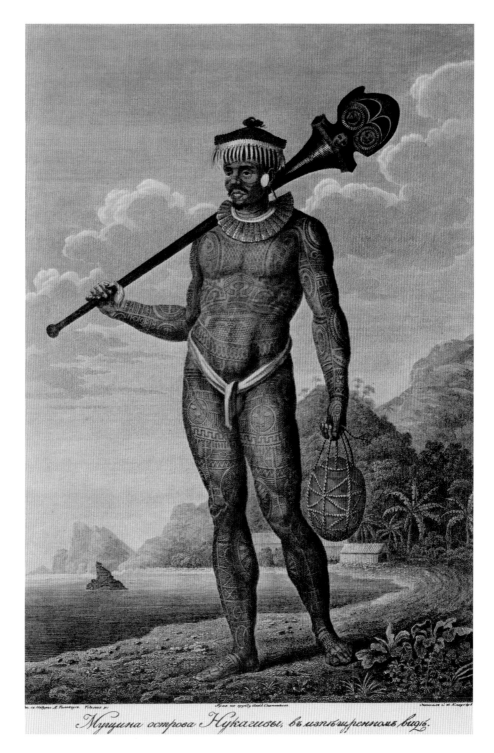

Муцина острова Нукагиеы, въ изпыщренномъ видѣ.

35 Egor Skotnikov
and I. S. Klauber
after Wilhelm
Gottlieb Tilesius von
Tilenau, *Man from
Nuku Hiva Island*,
coloured engraving,
from Kruzenshtern's
Atlas.

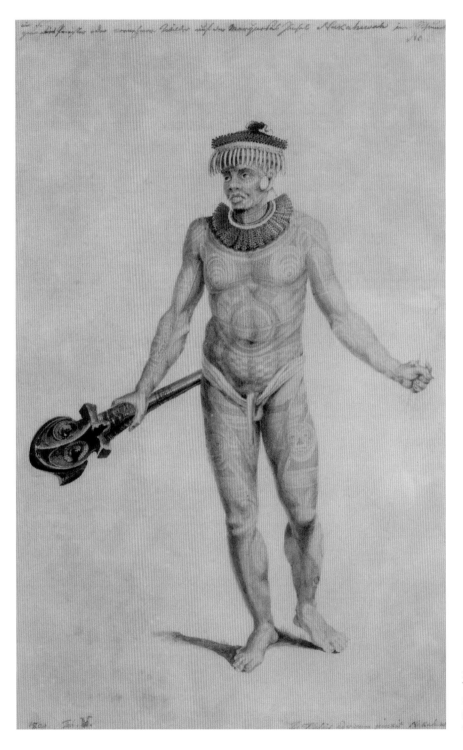

36 Wilhelm Gottlieb
Tilesius von Tilenau,
untitled sketch, 1804(?),
gouache, ink and pencil
on paper.

of a vertical spear. It is probable that Tilesius sent this drawing to Blumenbach in connection with his account of Mufau's figure. The meticulously prepared coloured engraving of Mufau in Kruzenshtern's *Atlas* by Egor Skotnikov and Klauber became canonical. The engraving by J. A. Atkinson in the English edition of Krusenshtern's *Voyage* is poorer and more schematic. It simplifies many details of the tattoo, especially on the torso. The differences between the Göttingen coloured drawing and the engraving in the *Atlas* are more important – the tattoos, though uniform in general, have numerous divergences, especially in the middle and lower part of the torso, which cannot be explained by simplification, as in Atkinson's variant, but most likely resulted from the engravers' exercise of artistic licence. Moreover, Tilesius' drawing of Mufau's head is quite different from the full-length representations. Thus, despite this rich iconography of a particular person, it is impossible to say which, if any, of the representations corresponded most closely to past actuality. In principle, however, greater verisimilitude is to be assumed in an artist's field sketches and then in his reworked drawings than in engravings.

It was not by chance that Mufau was depicted among the members of Keatonui's family. The visitors learned that he was the 'firemaker at the king's', that is, the queen's *pekio*, 'secondary husband'. At the same time Krusenshtern remarked several times on Mufau's glory as 'the strongest and most intrepid' warrior.[21] At the end of the eighteenth century, according to Crook, 'the chief's Pekkeyo' was 'Paienue' (Peueinui), a member of the *tapu*, 'restricted', 'forbidden', class who owned large properties; he was also *toa*, 'head warrior', in the Tei'i tribe. As Nicholas Thomas argued, however,

> Crook . . . noted that a *pekio* came to 'belong' as much to the husband, or the husband's part of the family, as to the wife and the wife's, and this perhaps explains why Peueinui was spoken of as Keatonui's *pekio*. The roles of chief and head warrior were sometimes shared by the same individual, which perhaps explains why the ornaments which Peueinui wore into battle actually belonged to Keatonui. . . . It was exceptional for a prominent man such as a head warrior to act as a *pekio*.[22]

It is therefore tempting to identify 'Mufau Taputakava' with Peueinui because Mufau, according to the Russians, combined the duties of *pekio* with a prominent position in Keatonui's household and was an outstanding warrior (the Russians did not record the word *toa*). The only contradictory detail is Langsdorff's impression that Mufau was 20 years old in 1804 – thus it is doubtful that he could have been *toa* in 1798 during Crook's visit – although Shemelin was less definite, referring to him as 'a young islander', and Loewenstern called him 'a big lad'.[23] Moreover, the fact that his intricate tattoo seems to have been complete at the time of the Russians' visit suggests that he must by then have been older than 20.

Finally, among the depictions of the important male members of Keatonui's family is a full-face head, shoulders and chest portrait – the sixth man in the upper row of plate xv in Kruzenshtern's *Atlas* (illus. 30). The original drawing by Tilesius in his sketchbook has the inscription

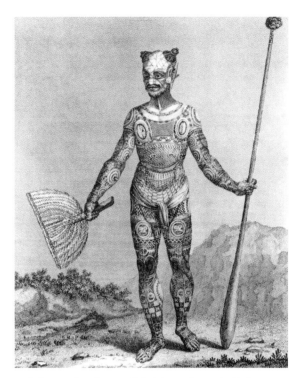

37 J. Storer after George Heinrich von Langsdorff, *An Inhabitant of the Island of Nukahiwa*, engraving, from Langsdorff, *Voyages and Travels in Various Parts of the World* . . . (London 1813), plate 6.

fortunate union has set the inhabitants of Tayo Hoae at peace with those of another valley in the interior, the king of which is called Mau-day ['Mau-Dei' in the Russian original], (signifying head of the warriors) . . . He married the daughter of Kettenowee, and as no naval war can be carried on between them, they live in a state of perfect peace. Mau-day was almost always in Tayo Hoae, and after Mau-ha-u and Bauting was the handsomest man we saw; he was likewise one of our daily guests.[25]

Fortunately, the iconography of Mouwateie is not limited to Tilesius' drawing and the engraving based on it. I believe that this 'handsome' man was the model for Langsdorff's full-length portrait published in his *Voyages* as 'An Inhabitant of the Island of Nukahiwa' – this is one of the most

'Omau Dei der Neffe des Königes aus Hikahiwa' (that is, the king's nephew) (illus. 33). I identify him as Mouwateie, the husband of Keatonui's daughter Tahatapu and the son of the chief of Hapa'a valley, rather than as a nephew of the 'king'. Tilesius said of him: 'the king's nephew, of whom, as well as of other members of the King's family, I have drawn a portrait, was always dressed in a bast mat instead of cloth'. Krusenshtern seems to have written about the same man: 'Mats are sometimes used among them, and the king's son-in-law, though he indeed was the only person, always came to the ship in one of a very coarse kind'.[24] He added:

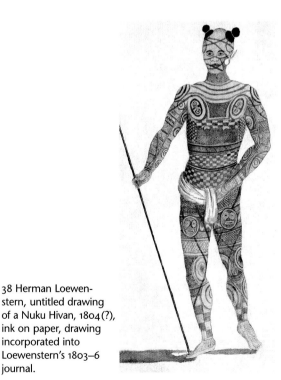

38 Herman Loewenstern, untitled drawing of a Nuku Hivan, 1804 (?), ink on paper, drawing incorporated into Loewenstern's 1803–6 journal.

celebrated of all portraits of tattooed Nuku Hivans (illus. 37). Langsdorff commented that it was:

> engraved from designs made upon the spot, that the most accurate idea possible might be given of so singular an art. The portrait here delineated is of a man about thirty years of age, a period at which the figures formed by the punctures appear the most distinctly. In later years, one figure is made over another, till the whole becomes confused, and the body assumes a Negro-like appearance, as may be observed in the stripe across the belly.[26]

Loewenstern also made two full-length drawings that I identify as Mouwateie. In one, he is holding a spear and in the other he is preparing to throw it (illus. 38 and 39). And finally Tilesius created a new drawing of a seated Mouwateie which was engraved for his publication in the *Allgemeine Musikalsche Zeitung* in 1805. The coloured engraving is at the National Library of Australia (illus. 40). Later Tilesius wrote that the Islander depicted was 'Omaudei, nephew of king Kettenue'.[27]

These five portraits of one man made by three artists who were simultaneously in the field depict a number of crucial elements of his tattoo in similar fashion: the shield on the chest with two ovals on the sides; similar ovals on the shoulders; the 'necklace'; the thickly tattooed 'neck-collar' with an opening at the front; and the line across the nose evolving into a darkened segment on the lower left part of the face. Langsdorff's and Loewenstern's drawings are also similar in the composition of the torso and leg decorations. But a precise look at the tattoo elements reveals numerous discrepancies. For instance, the shape and contents

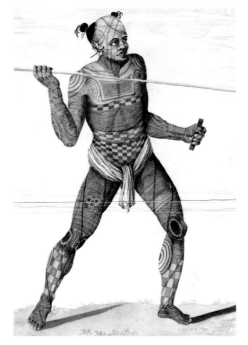

39 Herman Loewenstern, untitled drawing of a Nuku Hivan, 1804(?), ink on paper, drawing incorporated into Loewenstern's 1803–6 journal.

of the chest shield change from picture to picture; the content of the ovals also changes; one 'necklace' triples (even in different drawings by the same artist). The black eye that is present in four drawings is absent from the most detailed bust portrait by Tilesius. At the same time, only the latter portrait has an unusual sign resembling an anchor in a semicircle on the forehead. The engraving of 'Omaudei' illustrating Tilesius' German article is the most controversial. The text targeted a broad readership and was sprinkled with exotic tales, while the motifs depicted in the engraving are a concoction of fantasies, particularly the spirals and concentric circles on the torso. This engraving diverges dramatically from Tilesius' original sketch of 'Omau Dei'.

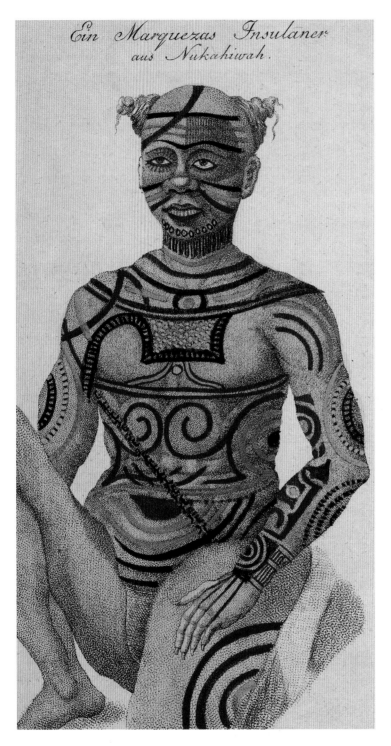

Ein Marquezas Insulaner aus Nukahiwah.

40 Anon, *Ein Marquezas Insulaner aus Nukahiwah*, coloured engraving after Wilhelm Gottlieb Tilesius von Tilenau.

This abundant and varied iconography of one man is a rare case in the history of early representations of Polynesian tattoo. Similar to the case of Mufau, each of these portraits taken in isolation seems reliable. But juxtaposition of different media and different artists' or engravers' impressions of the same person raises serious doubts about the precision of the tattoo motifs depicted. Later researchers have uncritically taken for granted the accuracy of tattoo elements reproduced in the best known of the engravings – Tilesius's 'Omaudei' and Langsdorff's 'An Inhabitant of the Island of Nukahiwa' (illus. 40 and 37) – and have painstakingly analysed them as exact images of 'traditional' tattoo.[28] At most, however, such representations can be taken as approximate variations on a theme and one can only surmise which, if any, is the most naturalistic. This is indeed an instance of the biblical maxim 'He that increaseth knowledge increaseth sorrow' – or at least uncertainty. It raises serious theoretical questions about the validity of overly literal interpretation of the detail depicted in representations of Polynesian tattoo produced in the pre-photographic era.

Finally, I consider portraits of Marquesan women made by the Russian artists and speculate on who might have been their prototypes. Tilesius' sketchbook contains four fine gouaches of women. The first is 'Ukea Wahini Nuku Hivan aristocrat', drawn with her head and breast draped in cloth (illus. 41). This portrait was later engraved with tattooed lips in plate xv of Kruzenshtern's *Atlas* (illus. 30). The second is 'Nuku Hivan with Palm Branch', depicted with the tattooed inner side of the wrist (illus. 42). The

41 Wilhelm Gottlieb Tilesius von Tilenau, *Ukea Wahini Nuku Hivan Aristocrat*, 1804, gouache, ink, pencil and watercolour on paper, from the 'Skizzenbuch', fol. 24 recto.

third is 'Titkia Wobusi Nuku Hivan girl in ball attire', shown without tattoo.[29] The final portrait is 'Woman in Yellow Cloth' drawn with tattooed hand and wrist (illus. 43). This watercolour became an engraving in Kruzenshtern's *Atlas* with tattoo added to the lips (illus. 44).

Tilesius's focus on depicting the principal members of Keatonui's family permits us to surmise that these drawings also represented close relatives of the 'king'. Keatonui's wife, Teheatioa,

can be excluded, since the elaborate tattoo on her hand elsewhere copied by Langsdorff did not coincide at all with the wrist tattoos shown in the four portraits.[30] Moreover, according to the anecdotal evidence of an anonymous man from the *Neva*, 'she was around forty, and all her attractive charms had deserted her already'.[31] Keatonui's daughter and daughter-in-law seem more likely models for these watercolours. Krusenstern said about them:

> The king's daughter, a young woman of about twenty-four years of age, and his daughter-in-law, who seemed a few years younger, were both of a remarkably good appearance, which even in Europe would not have been denied. . . . Their bodies . . . were neither coloured nor tatooed; but half of the arm and hand was tatooed black and yellow, which gave them the appearance of short gloves, such as our ladies used formerly to wear.[32]

The daughter was probably Tahatapu, the wife of Mouwateie, who lived at the time of the Russian visit in Keatonui's household and was the subject of drawings by Tilesius and others. More mysterious is the identity of the daughter-in-law, who was mentioned by several of the Russians. According to Krusenstern, Keatonui's son was 'married to the daughter of the king of the Tai-pihs' (Taipi) and she was brought to Taiohae by sea, thereby stopping sea warfare between the two tribes. Lisiansky added: 'The handsomest of my party was certainly the Goddess, whose name was Anataena. She was a daughter of the king of another bay in the island, called Houmé, and owed her title of divinity to her marriage'.[33]

According to the anonymous Russian, when visiting the *Neva* she and Keatonui's daughter 'were taken away by the officers to their cabins where they with special delight gave themselves to their will', while '"the Queen" was outraged that she was not given such a private audience being too old'.[34] Moreover, there are grounds to believe that 'the Goddess' was Lisiansky's choice. Lisiansky's 'Anataena' must have been Henateiane of Ho'oumi, the wife of Keatonui's eldest son, Duetowa. She was described by Crook as a middle-aged woman with numerous *pekios*. Either she was still very attractive in 1804, six years after Crook's visit, or Crook overestimated her age. I conclude that Tilesius' solemn-looking 'Nuka Hivan aristocrat' was Tahatapu, Keatonui's daughter, and that his 'Woman in yellow cloth' was inspired by Henateiane. In both the drawing and the engraving based on it, Henateiane is depicted as playful and attractive, though with a slight double chin, perhaps denoting that she was no longer young. Interestingly, the drawing and the engraving differ significantly in their depiction of her arm and hand tattoo. The less elaborate pattern shown in the drawing is presumably more naturalistic, while more intricate elements were probably added to the engraving as ethnographic information.

This novel capacity to identify the rich portrait iconography of the first Russian expedition to Nuku Hiva with historical personages who resided in the Taiohae, Hapa'a and Ho'oumi valleys and whose genealogies are well known is an important breakthrough in the ethno-historical exploration of Marquesan tattoo and society generally. It permits a more detailed and informed

examination of tattoo designs from particular family, social and territorial settings. At the same time, the analysis of discrepancies between different portraits of the same person in a variety of genres permits some discrimination between more and less naturalistic representations of tattoo patterns.

Shifting emphasis from visual to written representations of tattooed Marquesans, Russian textual accounts again suggest that different observers saw the same things differently. With respect to perceptions, the episode of the first encounter is telling. Entering Taiohae Bay, the *Nadezhda* sent two yawls forward. They were approached by a canoe apparently crewed by 'natives', one of whom came aboard the yawl and returned to the ship. That 'native' was Edward Robarts, an English beachcomber, who described himself at that moment:

> They took me out of the canoe into the boat. The officer gave me a bit of red cloth, a few fish hooks & some nails, he thinking I was a native. This diverted me, nor did I undeceive them untill after I got on board. My beard was very long; it coverd my breast, for I had not been shaved for about 3 years. My skin [was] tand with the sun. No one on board thought but that I was a native.[35]

It was his beard and the colour of his skin, he believed, that deceived the visitors. But other features struck the observers more forcefully. Shemelin wrote in his journal: 'The Lieutenant [Golovachev] reaching the ship introduced the savage to the Captain. We all looked at the newcomer, who was speckled over his body by brownish-blue geometrical figures, perpendicular and slanting lines and strips, triangles, quadrangles with different patterns inside, spots and lattices'.[36] Several others reported similar impressions: 'The boat came alongside the ship; all the natives were naked and speckled with patterns, and one of them, entering the ship, surprised us even more when he started to speak English' (Rezanov); 'We were very surprised when we saw among the natives a naked and tattooed Englishman' (Loewenstern); 'He was almost entirely naked, having only a narrow girdle tied round his middle, and was tatooed on the breast' (Espenberg).[37] Tilesius remembered another feature: Robarts kept his letter of introduction from an English captain 'tied with two knots in his hair as is customary among the natives'. In his earliest published account, Tilesius described him as 'a man of medium stature, not painted [i.e., not tattooed], though his hair was dressed the same as the natives, naked with a loincloth in front'.[38] What is remarkable in these accounts is the discrepancy concerning Robarts's tattoo. Moreover, in describing this encounter Krusenshtern, Langsdorff and Ratmanov did not mention his tattoo at all, while the Japanese on board the ship referred to Robarts and Cabri, a French beachcomber, as 'two fair-haired men completely different from the natives'.[39] These discrepancies exemplify the well-known phenomenon that eyewitness testimonies of the same event can vary wildly, especially when people confront the unusual in an agitated state of mind.

Even later, when the excitement of the first meeting had subsided and more dispassionate observation might have been expected, the two most reliable observers – Langsdorff and Tilesius – produced very different accounts of Robarts's

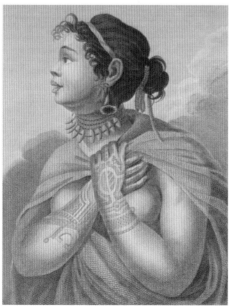

42 (*above left*) Wilhelm Gottlieb Tilesius von Tilenau, *Nuku Hivan with Palm Branch*, 1804, gouache, ink, pencil and watercolour on paper, from the 'Skizzenbuch', fol. 86 recto.

43 (*above*) Wilhelm Gottlieb Tilesius von Tilenau, *Woman in Yellow Cloth*, 1804, gouache, ink, pencil and watercolour on paper, from the 'Skizzenbuch', cover verso.

44 (*left*) Egor Skotnikov after Wilhelm Gottlieb Tilesius von Tilenau, *Portrait of a Woman from Nuku Hiva Island*, coloured engraving, from Kruzenshtern's *Atlas*.

tattoo. According to Langsdorff's well-known voyage narrative, Robarts 'had only a puncture on his breast, in the form of a long square, six inches one way and four the other', the sign of belonging to Keatonui's retinue.[40] In a much later work of natural history published in Russian, Tilesius described Robarts in terms sharply at odds both with Langsdorff's narrative and his own early published ethnography. By this account, Robarts had a fish tattooed on his body together with the 'figure of a heart pierced by an arrow, which he ordered to be done by the day of his marriage'. Otherwise, apart from the fish, he 'had no other usual Nukahivan decorations, which covered the whole body of the Frenchman [Cabri]'.[41] This example, as with that of the five different portraits of Mowateie discussed above, demonstrates the instability of voyagers' testimonies, both written and pictorial.

Surrounded by tattooed people, the Russians reflected widely on this custom in their accounts. A few well-educated members of the expedition, acquainted with earlier travellers' accounts, were prepared for the encounter with 'speckled bodies', but for many it was something new. Lisiansky admitted: 'This custom seemed strange to me at first, but finally familiarity overcame prejudice and the motley bodies of the islanders seemed very beautiful to me'.[42] Indeed, the word 'beautiful' recurs in Russian accounts. 'The natives have remarkably beautiful tattoo', Loewenstern recorded in his diary after the first encounter.[43] Russian textual accounts, which I do not discuss here in detail, supplement the iconography and indicate their general impressions as well as contributing valuable remarks on tattoo designs. They particu-larly commented on differences in tattoo depending on gender, age and social status and on the actual procedure of tattooing.

Finding themselves in a society where tattooing was one of the most important personal attributes, the Russian voyagers were tempted to try it themselves. Russian sailors, unlike British, French and American ones, had not yet been seduced by this relatively new fashion due to the general isolation of Russia. The word tattoo itself was still almost unknown in Russia. Reading their accounts, we can literally witness the inception of this novel practice among them.

On the third day after the Russian arrival, Loewenstern recorded in his journal: 'Today I had a tattoo done on my arm. The natives are very artful in this business.' Three days later he remarked: 'Tattooing becomes more and more popular on our ship. The native works from morning till night. Even Krusenshtern had a tattoo done.'[44] Krusenshtern, though not commenting directly about his own experience, wrote in his narrative: 'There are some great masters in this craft among Nuku Hivans. One of them, being aboard the ship during all our stay here, found a lot of employment for himself, as almost all the men invited him to have a pattern done in accordance with his art'.[45] Tilesius wrote in 1806: 'One of the artists often visited our ship and nearly all sailors and even some of our officers and travellers had different figures made on them'.[46] Langsdorff wrote that 'this new experience enthralled' nearly everyone on board.[47] Ratmanov's journal was especially detailed:

> Many of our officers and men had small figures tattooed on their hands and arms. The captain had

an inscription done on his arm: Jllie [Julie] – the name of his wife whom he adores. I had the inscription done in a semicircle over the left breast above the heart: 'Je suis à vous' – 'I am yours'. All officers felt pain. But I, having given my heart to you, my angel, was so excited making this sacrifice to you in this remote and savage part of the world, my darling, that I did not feel pain and felt that underneath the trembling heart says: 'Yes, I really belong to her'.[48]

Such conventional inscriptions comprised a significant proportion of the designs. Tilesius added that the tattooist would copy words written for him in Russian and Roman characters.[49] Obviously, the use of textual inscriptions to express emotional attachments was a usual procedure for the Russians, although presumably not in the form of tattooing.

At the same time, there is evidence that the variety of tattooed designs was not limited to such inscriptions. Ratmanov wrote about 'small figures', Krusenshtern about 'patterns done in accordance with' natives' art.[50] Tilesius, observing the tattooists' work aboard the ship, recorded: 'I even saw often that he, without any pattern, just out of his head, would punctuate figures known to him'.[51] Langsdorff mentioned that the visitors 'would have tattooed a bracelet, a name or a figure as a memento'. He himself, according to Tilesius, had tattooed on his arm a figure called 'Te ioe hinenau' (te a'ahinea'o), a love symbol, which Langsdorff described ethnographically as a 'sign of wishing to be loved'.[52] These remarks suggest that indigenous Nuku Hivan patterns were also favoured.

Especially interesting in this respect is the story of Count Fedor Ivanovich Tolstoy, a first cousin once removed of the great novelist Leo Tolstoy, who characterized him as 'an extraordinary personality, immoral and attractive'. Fedor Tolstoy was well known among the Russian aristocracy, being a hero, sometimes a negative hero, of numerous works by Russian poets and writers including Pushkin, Griboedov and Leo Tolstoy himself. While serving in the army, he was famous for his 'wild existence of drinking, gambling, womanising and extravagant exploits of every sort'.[53] Being one of the most celebrated Russian duellists, he used the opportunity to join Krusenshtern's expedition to flee troubles stemming from a duel with his commanding officer. Incidentally, he was taken aboard instead of another Tolstoy – Fedor Petrovich – who later became a famous painter. Nevertheless, Tolstoy also brought an art work back from the expedition – his own body tattooed all over, for reasons about which one can only speculate. Leo Tolstoy, who knew the count and even wanted to write a book about him, wrote in 1865 of 'that Tolstoyan wildness that's common to us all. Not for nothing did Fedor Ivanovich have himself tattooed'.[54]

Having been left at Kamchatka because of a confrontation with Krusenshtern, Tolstoy had many adventures in the north Pacific region. According to numerous anecdotes, he was for some time a 'king' of the Tlingits of south-eastern Alaska, but finally he chose to return to Russia via Siberia. The Tolstoy family history records that 'In the province of Kazan his arrival was recorded by an eyewitness, who recalled his amazement at encountering the wild figure, tattooed from head to foot and dressed in the weather-stained uniform of the Preobrazhensky Guards, in which

apparently he had led the Tlinkits on their walrus-hunts'.[55] Tolstoy's tales about his northern experience earned him the title 'Tolstoy the American', but, since I have found no documentary evidence of his actual stay with native Americans, I speculate that part at least of his intricate tattoo might well have been done by a Nuku Hivan artist.

On reaching St Petersburg, he was apt to display his newly decorated body, which presumably had a significant impact in awakening public interest to tattooing. His niece, Maria Kamenskaia, remembered one such exhibition:

> He undid his shirt-studs, and bared and swelled out his chest. Everyone at the table stood up in their places and gazed attentively at it: it was completely covered in tattoos. In the very middle sat in a ring some sort of big multi-coloured bird, rather like a parrot, in a red and blue hoop . . . both arms were likewise completely tattooed, with snakes and other wild designs entwined around them. The ladies sighed and gasped without ceasing, and asked solicitously: 'Wasn't it very painful, Count, when those savages tattooed you? How did they pick out the designs? Oh, what suffering!'[56]

This account is interesting because Kamenskaia might have misinterpreted the actual images tattooed on Tolstoy's body. It is unfair to expect an accurate account of an extensive body tattoo from a person overwhelmed by the sensory experience of seeing it for the first time. We have already seen this in the case of Robarts's tattoo.

But tattooing did indeed start to capture public imagination. Another 'promoter' of tattoo in Russia was the French beachcomber Jean-Baptiste Cabri, who left Nuku Hiva with Krusenshtern's expedition; he had indigenous Marquesan tattoos all over his body. According to Langsdorff,

> The extraordinary fate of this man, and the novel appearance of his tattooed body, attracted the attention of every one. Both at Moscow and at St Petersburg he exhibited upon the stage the dances of the savages, and was considered by all the great people of the country as a real curiosity.

Finally, 'his dexterity in swimming, in which he is scarcely excelled by the natives of Nuka Hiwa themselves, has procured him the appointment of teacher of swimming to the corps of marine cadets at Cronstadt'.[57] Presumably his tattoos stirred the imagination of aristocrats and young cadets alike. Furthermore, during the nineteenth century tattoo also became an almost universal fashion among Russian seamen, in spite of their relative isolation from the Western open markets for seamen's labour.

This study enables the attribution of celebrated images of Nuku Hivans to particular artists and brings to light a number of unknown portraits. The juxtaposition of different images with each other and with textual accounts helps to establish genealogies of the visual representations and to identify some of their subjects with known historical personages, thus opening a field for further ethno-historical explorations. Comparative analysis of the textual material contributes complementary information: on tattooing itself, on the ways in which it was perceived by the Russian visitors, and on the tattoo mania that seized them in Nuku Hiva, together with its metropolitan aftermath.

Marks of Transgression: The Tattooing of Europeans in the Pacific Islands

Joanna White

During James Cook's third and final voyage to the Pacific, John Ledyard, corporal of the marines on board the *Resolution*, described in his journal a relationship that was struck up between a sailor and a Maori woman during the ships' sojourn in New Zealand. According to Ledyard's version of events, the visiting seaman elected to become tattooed in full conformity with indigenous tradition:

> though our sailor appeared amiable in her eyes in the habit of a stranger he was conscious that to ornament his person in the fashion of New Zealand would still recommend him more to his mistress and the country he was in; he therefore submitted himself to be tatowed from head to foot.[1]

Although Ledyard might have slightly romanticized the scenario,[2] this account is striking since it demonstrates how elaborate, indigenous forms of tattooing were readily adopted by Europeans at such an early point in the history of their contact with Pacific peoples. Such engagement with the local practice is closely identified with gaining acceptance among Islanders (in this particular

case the sailor's adoption of Maori tattooing formed part of a wider strategy for incorporation within the local community, since he later attempted to desert from his ship and take up local residence). Furthermore, this account illustrates how tattooing can be understood as not merely an individual enterprise, but a mutual constitution of human agency and social environment.[3] The practice can be understood as a product of many factors, including personal and collective relationships, events, obligations and the prevailing social context.[4]

This chapter will examine the various processes that resulted in some of the Europeans (and later, Americans) who visited the Pacific in the late eighteenth and early nineteenth centuries electing to become tattooed as a result of their contact with indigenous peoples. By exploring the diverse motivations that led to individuals irreversibly transforming their bodies, the motifs they chose to have inscribed, and the meaning(s) that this process and its outcome held for them, new insight can be gained into the role of tattooing in both shaping and communicating personal and social identities. The ways in which tattooing was

perceived in different cultural contexts and the impact of Pacific encounters on European tattooing traditions during this period will also be discussed.

Although encounters between explorers, sailors and Pacific Islanders in the late eighteenth century are still popularly understood to have made a significant contribution to modern Western tattooing, recent studies have suggested that exposure to Pacific body modification conventions may have resulted in the reinvigoration of a long-standing, though historically inconsistent, tradition rather than constituting the origins of the practice in Europe.[5] It is now broadly accepted that British sailors were already engaging in voluntary[6] tattooing in the second half of the eighteenth century, although evidence of this practice remains sparse. Records from the Marine Society and 'description books' used to identify employees in London shipyards just after the middle of the eighteenth century, for example, reported occasional cases of boys and men 'mark'd' with their initials or names on their hand, wrist or arm.[7] The relative scarcity of such references – among copious records – indicates that this practice was not widespread, and was likely to have been customary only among a minority of sailors and those with associations with the sea-faring world, rather than belonging to a linear tradition.

The excitement stimulated among Europeans when they first encountered Pacific tattooing is apparent from the elaborate descriptions of the aesthetic content, visual effects and the technical methods of tattooing reported in contemporary accounts, as well as Sydney Parkinson's striking drawings of this practice, which were produced during Cook's first voyage. The publication of these works ensured that knowledge of Pacific tattooing spread swiftly among the literate classes of Europe.[8] Yet the place of tattooing within indigenous cosmologies and its importance as a socializing and empowering process, expressive of adulthood, status and group membership (in ways that differed across location), was grasped only partially during this early stage of contact. What travellers were unwittingly exposed to during their voyages to the Pacific was not merely a prolific and sophisticated form of body modification, but tattooing as an *institution*, a prescribed practice that performed a specific, historical function in the maintenance and reproduction of local social systems.

Despite their limited understanding of the local significance of tattooing, however, European interest in Oceanic body modification practices extended beyond mere observation; practical engagement was almost immediate. From Cook's first voyage onwards, there is evidence that visitors to the Pacific Islands became tattooed as a direct result of their contact with indigenous peoples, although, as will be elaborated below, early voyagers, sailors and those who were resident in Pacific societies for prolonged periods engaged with local tattooing traditions in quite distinct ways. Indeed, the various forms in which Europeans adopted the body modification methods they observed in the Pacific expose the heterogeneous nature of the cross-cultural exchange that took place during the late eighteenth and early nineteenth centuries, as well as the varying appeal that tattooing held for different individuals.

Journals from the period revealed how, for the

gentlemen professionals and some of the sailors who travelled on board ships to the Pacific, the experience of being tattooed was a novel activity, engaged in out of curiosity. The indigenous tattooing motifs that were chosen to be marked on the skin served both as permanent, ornamental souvenirs of voyaging and evidence of encounters with Pacific peoples.[9] Frederick Bennett, a surgeon on board a whaling ship in the 1830s, for example, described visiting Raiatea, one of the Society Islands,

> while at this island, I gratified a wish to observe the process and effects of the tatoo by having a figure thus impressed upon myself. The artist I engaged was a Tahitian; and from the numerous patterns displayed on his person we selected a circular figure, named *pote*; the spot I preferred devoting to the impression was the upper arm.[10]

Early encounters in Tahiti in the second half of the eighteenth century appear to have had a different impact on many sailors, however. Seamen often employed local tattooists not only to inscribe their skin with local motifs, but to mark initials, names and dates on the hand or the arm.[11] Hence, encounters with Pacific tattooing did not necessarily result in the desire to replicate indigenous styles; instead local expertise was rapidly applied to the reproduction of an existing practice, which, as described earlier, would have been familiar to some sailors, that of marking familiar personal references on one's body. Such forms of tattooing became a convention among sailors that persisted well into the nineteenth century. Indeed, the tattooing of initials during this period has

been described as the equivalent of dog tags, providing a means of identification and thereby offering insurance against an anonymous burial, a particular risk for mobile populations such as sailors, who might be lost in a shipwreck or die in a foreign country.[12]

There is also evidence, however, that exposure to tattooing practices in the Pacific Islands contributed to sailors' understanding of the potential for tattoos to express collective relationships, which led to their imitation of this practice. This is revealed in the account of John Elliott, a midshipman on the *Resolution* during Cook's second voyage. Elliott reported in his journal how observation of the elite group *arioi* in Borabora in the Society Islands inspired him and his messmates to adopt the same motif, which distinguished *arioi* from other Islanders:[13]

> all our Mess conceived the idea of having some mark put on ourselves, as connecting us together, as well as to commemorate our having been at Otaheite. For which purpose we determined on having a compleat Star drawn and then tattowed with black, the same way as the Natives are tattowed, upon our left Breast, and painful as this operation was, we all underwent it, and have each a very handsome Black Star on our left Breast, the size of a Crown Piece.[14]

Here the design adopted was multi-referential, serving as a souvenir of the sailors' voyage, as well as a permanent symbol of an exclusive relationship between the men, in this case identification with one's mess – often sailors would be messmates for many years.[15] The dual expressive potential of

tattooing, to mark both personal experiences and social ties, clearly appealed, resulting in an indigenous collective practice being appropriated and transformed through its adoption within a new social milieu.

Later in his account Elliott revealed how, as a result of the tattooed messmates being observed bathing by other members of the crew, the trend 'spread halfway through the ship'. The original intention behind Elliot and his companions' particular adoption of the local practice was thereby destabilized, since the motif was hijacked and became the marker of a wider group among the crew.[16] Such ready commandeering and rapid diffusion of a Pacific motif is striking, and confirms the particular appeal that tattooing held for sailors and the potential speed at which this practice could spread among them. Alfred Gell proposed that mariners' interest in tattooing stemmed from its potential to express their class position, lifestyle or their unique *habitus*, that is, world views that were products of their social location and manifest in their personal habits and preferences. Therefore, on encountering tattooing in the Pacific, sailors rapidly 'made it their own'.[17] Greg Dening described how

> The essence of a sailor's existence was to be utterly
> without space he could call his own, to have all
> his possessions calculated narrowly, to be a totally
> public man to his peers and to be totally public to
> superiors who could muster him twice daily at his
> quarters.[18]

Living under such constrained circumstances, in a confined and unpredictable social world and isolated from friends and family, sailors found in tattooing a unique means of reaffirming both their individual identities and their personal relationships. In contrast with their controlled, shipboard life, the marking of the body offered them an unrestrained and autonomous space for both private and public expression. Since seamen lived in close proximity to one other and shared experiences at close quarters, such innovative means of self-expression are likely to have diffused exponentially throughout the seafaring world. Similarly, the practice is understood to have attracted and diffused among another marginalized group that came into contact with mariners: transported convicts.[19]

Descriptions of the *Bounty* mutineers recorded by William Bligh in 1789 indicate how, two decades after Cook's first voyage, the adoption of tattooing was already a growing phenomenon among sailors. Indeed, in his inclusion of tattoos for crew identification purposes, Bligh unknowingly pre-empted a trend that emerged in the navy over the coming decades and became formalized practice by the 1830s. That tattooing was common among everyday seamen who had travelled to the Pacific, and visible within their own particular social world, but might have been less known among their superiors, is evidenced by the fact that Bligh depended on the mutineers' peers for descriptions of the various motifs on the bodies of the individual 'pirates'.[20]

Twenty-two of the 25 mutineers described by Bligh were tattooed. In some cases details are vague, with individuals referred to as being 'very much tattooed',[21] but in others more intriguing descriptions are provided. Peter Heywood, for

Description List of the Pirates remaining on board
His Majesty's Armed Vessel Bounty on the 28th April 1789.

Fletcher Christian Mas.te Mate — Aged 24 Years 5.9 high. Very dark
complexion — Dark brown Hair — strong made — A Star tatowed on his
left breast — Backside tatowed — A little bow legged — He is subject to a
violent perspiration in his hands so that he soils any thing he handles.

George Stewart Mid. — Aged 23 Years 5.7 high — good complexion —
dark Hair — slender made — narrow chested & long neck — On his left breast
is tatowed a Star & also one on the left arm, on which likewise is tatowed
a heart with Darts. Tatowed on the backside — Very small features.

Peter Haywood Mid — Aged 17 Years 5.7 high — Fair complexion
light brown Hair — Well proportioned. — Very much tatowed, and on
the right leg is tatowed the Legs of Man as the impression of that
coin is. — At this time he had not done growing. — He speaks with the
Isle of Man accent. —

Edward Young Mid — Aged 22 Years 5.8 high — Dark complexion, and rather
a bad look. — Dark brown Hair strong made — has lost several of his fore teeth
& those that remain are all rotten — A small Mole on the left side of the
throat, and on the right arm is tatowed a Heart & Dart through it, with
E.Y. underneath, and the date of the Year 1788 or 1789 we are not sure.

Charles Churchill Ship's Corporal — Aged 30 Years 5.10 high — Fair complex-
ion — short light brown Hair — Bald headed — strong made — The fore finger
of his left hand crooked, and the hand shows the mark of a severe scald
Tatowed in several parts of the body.

James Morrison — Boatsn. Mate. — Aged 28 Years 5.8 high — sallow com-
plexion — long black Hair — slender made — lost the use of the 1st joint
of the fore finger of his right hand. — Tatowed with star under his left
Breast, and a Garter round his left leg with the Motto Honi soit qui mal
y pense. — Has been wounded in one of his arms w.th a musquet Ball. —

John Mills Gunner Mate. — Aged 40 Years 5.10 High — Fair complexion.
light brown hair — a strong raw boned Man — a scar in his right armpit
occasioned by an abcess.

John Millward Ab. Aged 22 Years 5.5 High, brown complexion — Dark Hair
strong made — Tatowed under the pit of the stomach with a Taomy of Otaheite

45 William Bligh, hand-
written description of
Bounty mutineers,
dispatched to the
Admiralty in 1789.

example, was marked with the 'three legs of the Isle of Man', a clear assertion of his Manx nationality. Thomas Ellison was tattooed on his right arm with his name and also with the date, 25 October 1788, the day the *Bounty* first arrived in Tahiti. He had thereby apparently elected to mark a critical moment in his personal history.[22] Other mutineers were also marked with their initials, dates or motifs, such as hearts. In common with many of their predecessors, the mutineers therefore appear to have largely employed indigenous expertise to create European motifs, using familiar symbolic and literal references. Innovation also took place. One of the mutineers, Adam Smith, for example, extended the convention of marking initials and dates to the body of his Tahitian lover: his initials and a significant date were tattooed on her arm.[23] A number of the *Bounty* mutineers had, however, adopted Tahitian motifs on parts of the body consistent with local convention, including the chest, legs, body, backside and feet. The Tahitian star that had such an impact on Elliott and his messmates, for example, re-emerged on the body of Fletcher Christian. Further innovation can be discerned with regard to the appropriation of Pacific motifs. One of the mutineers was described as being tattooed under the pit of his stomach with the ornamental design of the *taumi*, or Tahitian breastplate.[24] In this case, similar to Heywood's use of the Manx emblem, a familiar schematic or ornamental design had been transferred from material objects to the body through tattooing, a practice that already existed in Western Polynesian tattooing – although, as far as is known, the *taumi* was not in fact part of the lexicon of indigenous Tahitian tattoo motifs

during the period in question. This process, defined by Gell as 'scheme transfer',[25] had become an identifiable convention in European tattooing by the following century.[26]

The striking combination of both European and Tahitian markings on the bodies of the mutineers can be understood as a physical registration of a multitude of factors. Indigenous tattooing expertise had been used to assert the sailors' identities, commemorate particular life events, mark personal relationships and express new cultural influences. In sum, the mutineers' engagement in tattooing was a unique reflection of their hybrid associations, both European and Tahitian.[27]

Naval records held at the Public Record Office in the United Kingdom have documented how permanent body markings had become a significant indicator of a professional seafarer by the 1830s, by which time a growing range of popular motifs had emerged. The tattooing of names, initials and dates and designs such as man, woman and child – a striking symbol of domesticity for those away from home for prolonged periods – were all common. Other motifs that have since become more stereotypical mariners' markings, such as mermaids, anchors, hearts, stars and crucifixes, are also common. Early encounters with Pacific Islanders therefore appear to have made a lasting contribution to Western maritime culture in terms of the adoption of tattooing as popular practice, if not in terms of motif content.

Europeans (and later Americans) who found themselves resident in Pacific communities for an extended period of time in the late eighteenth and early nineteenth centuries, both voluntarily or involuntarily, also adopted tattooing as a result of

contact with local populations, but in forms more closely related to indigenous convention. The term 'beachcomber' was coined to describe individuals who spent long periods living on Pacific islands. These included deserters, discharged crew, castaways, captives of ambitious local leaders and runaway convicts. A number of beachcombers published accounts of their experiences on their return home. Although problematic in many ways as historical records, these diverse accounts nonetheless shed new light on the nature of cross-cultural encounters during the early period of contact, including the interactions and social relationships that resulted in a number of beach-combers becoming tattooed.

From the moment of their arrival, beach-combers found themselves in an ambiguous situation and had little control over their standing or status within the communities among which they found themselves. In Ian Campbell's words, they could be 'used, discarded or destroyed' by Island inhabitants.[28] James O'Connell, shipwrecked in the Caroline Islands in the 1820s, for example, betrayed his uncertainty at his position when he described being 'adopted' by a local chief soon after his arrival, referring to his patron as 'my new friend, or master, or owner, – I do not know exactly how he considered himself'.[29] A common experience depicted in both beachcomber narratives (and, indeed, in many voyage accounts of the same period) is the immediate removal by the local population of all the possessions of the new arrivals, including the clothes they were wearing. These prized articles were often appropriated for local use, including exchange purposes. Horace Holden, who was shipwrecked on one of the

Palau Islands, described one of the first interactions he and his crewmates had with a local man, 'After pretty thoroughly convincing us that in this case our only course was submission, he began to strip us of our clothing.'[30] This removal of clothing by local people may be interpreted as an immediate attempt by Islander hosts to force new arrivals to conform to local codes of conduct. In their introduction to the journal of William Lockerby, a sandalwood trader who was resident in the Fiji Islands, for example, Everard ImThurn and Leonard Wharton proposed that the practice of relieving shipwrecked sailors of their clothing meant 'no more than that the islanders reduced the clothes of their visitors to that which they thought proper for themselves'.[31] Whatever motivations prompted such treatment, this literal stripping of the trappings of European civilization exposed the physical vulnerability of beach-combers within their new cultural setting.

Given their uncertain position, establishing useful allegiances and a recognizable role for themselves was vital for beachcombers' comfortable existence, and even their survival.[32] While new arrivals were often accorded similar status among local communities as they were perceived to hold in their own, based on indicators such as dress and apparent position in the ship hierarchy,[33] conversely, those with no immediately recognizable status often found themselves at a disadvantage, open to ridicule and abuse and even living with restricted access to food.[34] Those who held skills in areas that were prized by Pacific communities, such as the employment and maintenance of firearms, the production of iron, the use of razors, or even the playing of musical instruments or

dancing, found themselves able to exploit these talents and use them to establish firmer reciprocal relationships with Islanders.[35] Indeed, Vanessa Smith even argues that the treatment of beach-combers with aptitude in certain practical skills often constituted an inversion of the prevailing system of class and status in Europe, due to the consequent prestige and authority awarded to visitors who were manually gifted.[36] As John Twyning, shipwrecked on Vatoa, one of the Lau Islands of Fiji, in 1829 described, he and his crew-mates provided valued services to their chiefly host:

> If we staid at home we were employed in furbishing his firearms and keeping them in repair. The service of one or other of us was sure to be required when-ever his highness wished to be shaved, because he conceived a white man could perform this opera-tion more dexterously than a native.[37]

In some cases, the novel skills that beach-combers offered provided such individuals with one of their few sources of leverage among their adopted communities. William Diapea, who was resident in Fiji towards the middle of the nine-teenth century, for example, related how he resisted the treatment he received as he was paraded as a novelty, the *manu manu* (pet bird), of a chief in the Islands, by refusing to repair muskets, a task usually assigned to him.[38] Several narratives detailed beachcombers' attempts to hoard their practical skills and prevent native people from learning them, a phenomenon that underlines how often the foreign visitors were highly aware of the tenuousness of their position.[39]

During this early contact period, the balance of power with respect to lone individuals or small groups of men isolated from the security of their ships lay firmly with the indigenous population. New arrivals were admitted into communities conditionally by people convinced of the correct-ness of their own social codes.[40] As a consequence, local norms of behaviour were frequently imposed upon beachcombers. Dening claimed that the participation of officers and sailors who were merely transient visitors in indigenous rituals such as name-exchange could be considered a fic-tion, a game to be played with mock solemnity. However, beachcombers who were resident for longer periods were faced with the social conse-quences and obligations of their incorporation within local communities.[41] This is exemplified in accounts of the pressure that was exerted on new residents to conform to local norms governing the treatment of the body. In addition to the removal of clothing, many narratives detailed how newcomers were pressurized to remove their facial and body hair in conformity with indigenous aesthetic values concerning physical appearance. In a number of cases, their bodies became sites of enforced transformation, as their facial hair was extracted using pearl-shells.[42]

Similarly, tattooing was presented in a number of the narratives as a process that beachcombers were pressurized to undergo. A common theme emerges of both coercion and encouragement from native people, which resulted in conformity on the part of beachcombers. Holden, for example, described the experiences of being tattooed that he shared with his crewmates during their stay at the Palau Islands:

To our sorrow, we were . . . compelled to conform to the custom . . . and shall carry with us to the grave the marks of the well-meant, though cruel operations upon our bodies.[43]

Holden's reference to the practice being 'well-meant' conveys his understanding of the importance placed on such conformity to local people. Indeed, given the significance of tattooing in many Pacific societies, the pressure placed on beachcombers by Islanders to have their bodies similarly marked is likely to have been considerable. Such indigenous agency in the tattooing of foreign visitors needs to be understood in both cosmological and social terms. For many of the communities among which the beachcombers resided, tattooing was a fundamental cultural practice, vital to social reproduction. Those who did not conform to this process were either pre-adolescent, of very low class or, on rare occasions in locations such as Tonga, those of the highest rank, closest to the deities. In his comprehensive analysis of tattooing in Polynesia, Gell emphasized the importance of tattooing in making a person 'whole' in many Pacific societies. Being tattooed at adolescence was a process of desancti-fication, rendering individuals 'safe' to engage in adult activities such as sexual and exchange relations (although particular modes of tattooing, when and to whom they applied and their social meaning varied from location to location).[44] It could therefore be argued that beachcombers who were not tattooed, and yet resided in Pacific communities and sought to engage in social relationships, did not 'fit' into any clear category. Their socially *un*integrated bodies were an overt and

constant transgression of cultural norms. In contrast, by becoming tattooed through accepted ritualistic processes, a cosmologically 'safer' and more coherent position could be established for them.

The pressure placed on beachcombers to become tattooed was therefore a consequence of their residence, a process they were required to undergo not only to become more viable members of their host societies but to mark the status assigned to them or the status to which they aspired through their attempts to forge meaningful relationships. Several narratives explicitly detailed the role that becoming tattooed played in the assimilation of foreign visitors. Joseph Kabris, a Frenchman who resided in the Marquesas Islands from 1796 to 1804 as a result of being ship-wrecked along with other crewmates, described their early experiences as follows:

> For about four months we were treated with great deference and care by the islanders. At this time the *quaitenouiy*[45] urged us to be tattooed all over, which these people regard as a mark of manhood . . . After the ceremony, which made us belong to the tribe, we each chose a wife and were married according to the islanders' custom.[46]

For Kabris and his crewmates, becoming tattooed was clearly a significant rite of passage that established their membership of the group. Similarly, O'Connell related how he and his crewmate were pressurized to be tattooed and were removed from public society for a number of days in order for the process to be completed. As a result of his pragmatic submission, O'Connell described how

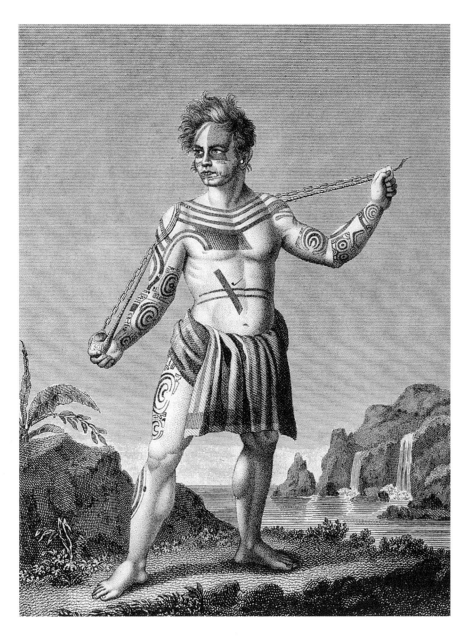

46 R. Cooper after Alexander Orlovsky, 'Portrait of Jean-Baptiste Cabris', engraving from Georg Heinrich von Langsdorff, *Voyages and Travels in Various Parts of the World, during the years* 1803, 1804, 1805, 1806, *and* 1807 (London, 1813).

he emerged 'a bird of much more diversified plumage than when I entered, being tattooed on my left hand, on both arms, legs, thighs, back and abdomen'.[47] As in the case of Kabris, immediately on the completion of this process the two men were married to local women. In fact, the extent to which they willingly acceded to being tattooed appears to have defined their future status among their hosts, since O'Connell went on to explain how in the case of his crewmate 'his unwillingness

to submit to the process of tattooing wedded him to a woman of no rank'.[48] Hence, whether they were aware of it or not, by consenting to be tattooed beachcombers were providing themselves with important symbolic capital.[49]

Tattooing was simultaneously a product and an expression of the beachcombers' social relationships within Pacific communities. In the case of Kabris, for example, many of the tattoos depicted in Alexander Orlovsky's celebrated drawing of him, engraved by R. Cooper for the English edition of Georg von Langsdorff's narrative of the Russian voyage to the Marquesas Islands in 1804 (illus. 46), evidently related to his status in the Islands: the partial facial mask indicated his title as a son-in-law;[50] a breastplate on the right breast signified his standing as a warrior;[51] and the tattooed eye marked his membership of a specific feasting society.[52]

A crucial feature of the beachcomber's experience was his ability to resist engaging in practices that he found morally abhorrent, such as cannibalism and infanticide, and his frequent transgression of other local codes of behaviour – whether knowingly or otherwise – with relatively little redress. Indeed, in some cases beachcombers even found themselves immune to or able to resist the sanctions associated with *tapu*.[53] Some voyage accounts and a number of beachcomber narratives emphasized European resistance to indigenous codes concerning the treatment of the body, for example, particularly concerning the baring of the individual's head and shoulders in the presence of those of chiefly status, a demonstration of deference that was standard practice in many Pacific societies, and heavily punished

if not adhered to. Such resistance reflects the importance that many European visitors placed on their own customary norms relating to the body. However, the attempted infringement of such normally non-negotiable codes of behaviour by beachcombers was not always blithely accepted by Islanders. When Morrison and several other *Bounty* mutineers expressed their desire to meet a young chief in one of the Society Islands, for example, they were told they would not be authorized to see him unless they stripped their clothing from their heads and shoulders. When they refused to do this because they asserted it to be 'not customary' in their native society, they were apparently forced to compromise by placing a cloth over their bare shoulders.[54]

The extent to which beachcombers were able to resist customary norms of behaviour appears to have depended on the relationship that they were able to cultivate with their chiefly patron(s). Hence William Mariner, who was shipwrecked in Tonga in 1806 and protected by the Vava'u chief Finau, did not conform to the convention of baring his head in the chief's presence. Yet he was regularly reminded of to whom he owed this privilege. As described in the published account,

> the king used frequently to tell Mr Mariner, that if he ever met any common fellow with his head covered, he should immediately knock him down. He was, however, like other foreigners, to wear a head-dress without any restriction, as being supposed to be governed by different gods, and accustomed to different manners.[55]

Given such attempts by some Europeans to cling

tenaciously to aspects of their own cultural codes of dress and behaviour, it is likely that the pressure to become tattooed resulted in resistance among some Europeans. As O'Connell's earlier account of his crewmate suggests, a process of negotiation and resistance regarding the process of tattooing is likely to have characterized some encounters. Edward Robarts, an Englishman who was shipwrecked and lived in the Marquesas Islands from late 1797 to 1806, overlapping with Kabris, appears to have demonstrated a much more selective engagement in local practices than his French counterpart. Indeed, European visitors to the Marquesas who met both men were struck with Robarts's limited acquaintance with local language and customs compared with the Frenchman's.[56] The Englishman's engagement with tattooing was perhaps, therefore, consistent with his more distanced, selective participation in indigenous cultural practices. Most contemporary accounts indicated that he only submitted to being marked on the chest with a motif indicating his membership of a feasting society.[57] He justified this engagement in tattooing to other visiting Europeans as induced by his need to survive. Joining a feasting group, he claimed, made his life considerably easier.

In contrast, however, many beachcombers engaged willingly – albeit selectively – with indigenous tattooing traditions. This is particularly evident in the case of beachcombers who voluntarily resided among communities in the Pacific Islands over the long-term. Such individuals are remarkable not only because of their enthusiastic participation in local practices but the levels of identification with indigenous

culture that ensued. Indeed, it appears that some beachcombers not only deliberately conformed to local manners and customs as a practical strategy but took on local symbolic and cultural references as their own. Joseph Kabris is a striking case in point. Kabris willingly engaged in local networks, forged a recognized place for himself within the chiefly class, married a chief's daughter, successfully engaged in local warfare, and, as described above, bore the tattoos that indicated his status. Essentially 'he became all but Marquesan'.[58] By the time of his departure on one of the ships from the first Russian voyage to the Pacific, he had virtually forgotten his native French. His identification with Marquesan values was so complete that, when offered a good new shirt, he desired to exchange it for a shabby red jacket, which he prized for its colour in a similar way to other Islanders, among whom red had significant symbolic value. There is every indication that he was removed from the Marquesas Islands by mistake and did not willingly return to Europe.

The fact that it was frequently possible for beachcombers to negotiate non- or partial compliance with certain practices serves to highlight how some individuals deliberately and pragmatically chose to become assimilated, due to the understood benefits that this could bring in terms of their relationships with local people. Tattooing may have been one of the means most available to them to express their commitment to conform. This is evident from the case of the crew member of the *Discovery*, described at the opening of this chapter, who, according to Ledyard, deliberately became tattooed in order to win favour with his New Zealand 'mistress' and her countrymen.

Similarly, Heywood, a *Bounty* mutineer resident in Tahiti, explained his reasons for being tattooed: 'it was my constant endeavour to acquiesce in any little custom which I thought would be agreeable to them, though painful in the process, provided I gained by it their friendship and esteem'.[59] While the explanation provided by Heywood is not as straightforward as it might appear (Bligh's description of him, cited earlier, revealed that he had been tattooed with European motifs during his first visit to Tahiti and therefore was clearly engaging in this practice on several levels), it nonetheless reveals how beachcombers conformed to certain behaviour that they knew would facilitate social relationships. Given the often precarious status of beachcombers in their adoptive communities, such means of assimilation would bring definite advantages.

The process whereby beachcombers became tattooed can, therefore, be usefully understood as a convergence of both indigenous and European agency. While some visitors might have deliberately adopted this practice for perceived benefits, such behaviour always took place within a context of indigenous articulation of the significance of tattooing, and, conversely, the negative status of the 'non'-tattooed' within indigenous culture. Many of the narratives of those who became tattooed provided accounts of indigenous attitudes towards those who had not undergone this process, perceptions that presumably had been communicated to the Europeans who fell into this category. Hence Heywood described how in Tahiti a person without tattoos was considered to be 'bearing a most indignant badge of disgrace, and considered as a "mere outcast of society"'.[60]

Similarly, other beachcombers referred to the 'disgrace' and 'shame' associated with not being tattooed. Holden, for example, elaborated on the perceptions of their Palau Islander hosts towards their foreign visitors: 'to go at large without being tattooed, was to carry with us the palpable proofs of our vulgarity'.[61] For these individuals, the sense of existing physically against the indigenous scheme of things had clearly been conveyed to them.[62] Therefore, as Gell argued, beachcombers' choice to adopt tattooing cannot be accounted for in purely European terms. The significance of the practice among indigenous peoples had been transmitted, at least in part, to the resident visitors.[63] The transformation of beachcombers' bodies was therefore a product not only of their new social relationships, but their sense of themselves within a new cultural setting.

The experiences of George Vason, who was landed on Tongatapu in April 1797 as part of the first missionary enterprise in the region, provide an illustrative example. Soon after his arrival, Vason began to adopt Tongan norms of dress and behaviour, thereby estranging himself from his Christian brethren, who could only hope for his 'recovery'.[64] The renegade missionary married into a family of chiefly status, became a landowner and participated in the civil wars that burgeoned towards the end of the eighteenth century and eventually forced him to return to Europe. Vason became tattooed relatively late in his residence and represented this process as submission to sustained pressure from the young men with whom he associated, who mocked him for lacking the body markings that all Tongan men were not only expected to bear to demonstrate their manhood

but took great pride in displaying.[65] He finally elected voluntarily to become tattooed after successful engagement in war and the celebration of battle victories, when male pride and exhibitionism was likely to be at its peak and hence the social significance of tattooing among Tongan men at its most explicit. Vason's description of himself once the permanent marking of his body was completed is a uniquely celebratory account; his thrill at his new appearance is palpable, revealing some level of identification with his adopted hosts:

> I was very much admired by the natives, as the European skin displays the blue colour, and the ornaments of the tattooing to very great advantage: I looked indeed very gay in this new fancy covering.[66]

Dening argued that beachcombers existed on the boundaries of two worlds, transgressing social codes in both and belonging to neither.[67] The precariousness and vulnerability of their status in both worlds often becomes most apparent in their narratives on the arrival of ships bearing representatives of their own native societies. Although many beachcombers forged a role for themselves as mediators between Pacific communities and European and American ships, their position among their compatriots was rarely comfortable. The physical appearance of many of these individuals had often been so transformed through their adoption of local dress and tattoos that it was not uncommon for those on visiting ships to mistake them for Islanders on first encounter.[68] As Heywood recalled on first meeting European sailors who arrived during his residence on Tahiti, 'being dressed in the country manner, tanned as brown as themselves, and I tattooed like them in the most curious manner, I do not wonder at their taking us for natives'.[69]

When such cases of mistaken identity were resolved, a negative association was often made between beachcombers' unconventional physical appearance and their moral integrity. Hence, for example, the German naturalist Langsdorff referred to Kabris, whom he encountered during the Russian voyage to the Marquesas Islands early in the nineteenth century, as 'both morally and physically transformed into a savage'.[70] Such conflation of physical appearance and morality was common in the representation and understanding of indigenous people during the early contact period. Due to the transformation of their bodies, beachcombers were considered 'worse' than natives since they were perceived as having consciously rejected the supposedly civilized values of their home societies. On meeting the beachcomber James Coleman in one of the Sandwich Islands, for example, George Vancouver commented,

> He had in most respects adopted the customs of the natives, particularly in dress, or rather in nakedness; for, excepting the *maro*, which he wore with much less decency than the generality of the inhabitants, he was perfectly naked . . . and seemed greatly to exult in having degenerated into a savage way of life.[71]

Evidently the forms of physical transformation, including tattooing, that had provided markers of inclusion for beachcombers within

their adopted Pacific communities, cementing social relationships and enabling them to be more readily assimilated, created a palpable cultural distance between these individuals and their own compatriots. Hence Vason's description of the vulnerability and apprehension he experienced when on board the ship returning him to Europe,

> my mind was not at ease . . . and ashamed of my own exposed appearance among those who were more decently clothed (for I was still in want of many articles of dress), I began to reflect on my past strange life and conduct, and look forward with shame and anxiety to a return to my native country.[72]

The feelings described here by Vason are in striking contrast with his unrestrained *in situ* enthusiasm for Tongan practices, detailed earlier in his narrative. This account, written after Vason's return to the Church, can partly be understood as an attempt on his part to communicate the shame and remorse he felt his intended readership in 'civilized' society expected from him, due to his from 'fall from grace'. Yet whatever the primary intent behind his narrative, clearly the displacement of his transformed body into a new setting resulted in Vason's sudden awareness of his physical and cultural estrangement from his compatriots, and the implications of this for his return to Europe.

Clothing could be replaced, but tattoos were a permanent marker of beachcombers' residence in the Pacific Islands. They were interpreted by other Europeans as physical symbols of their transgression from and rejection of the values of their native culture. The more visible and irreversible the transformation, the more problematic the individual's reincorporation into his own native society. As one traveller observed in his account of a beachcomber in the Marquesas Islands, which was published in 1838, 'he is tattooed across the face, and will therefore probably never return to England'.[73] For those who did return home, such as George Bruce, who spent many years living among the Maori at the turn of the eighteenth century, life did not prove easy. In Bruce's appeal to the Treasury of the Royal Navy, he lamented his existence back in England and requested to be allowed to return to the Pacific. The former beachcomber made an explicit link between the treatment he received from 'the lower classes' and the visibility of his tattoos:

> Life is a burden to him in this Kingdom. some calls him a Man Eater, another says his is the Devil & others calls him a Traitor To his Country. & this is because he don't sattisfie Them all, with the marks in his face.[74]

Herman Melville's semi-fictional account of a sailor's experiences in the Marquesas Islands, *Typee*, first published in London in 1847, encapsulated many of the preoccupations of earlier beachcomber narratives.[75] The protagonist of the novel, Tommo, who deserted his ship in order to live among a Marquesan community, was simultaneously attracted and repelled by the exotic world he saw around him and lived in fear of being destroyed by his adoption of the 'savage' way of life. This dominant theme was captured by Melville in Tommo's descriptions of tattooing

that is variably depicted as both elegant, artful and grotesque. Late in his stay, Tommo was pressurized by the local people to have his body marked in what he understood to be a bid to 'convert' him to the indigenous 'religion' of tattooing. He strenuously resisted this pressure.[76] Tommo's almost hysterical fear of being tattooed on his face and therefore never being able to return and live among his own countrymen is telling, and may betray Melville's knowledge of the experiences of Western men who had adopted indigenous Pacific tattooing and then attempted to reintegrate within their native societies.

Tattooed beachcombers who returned home dealt with their anomalous status in various ways. It could well be argued that the depiction in a number of beachcomber narratives of the adoption of tattoos as an outcome of pressure from indigenous communities was an attempt by returning 'transgressors' to play down their own personal volition in an attempt to avoid alienating their readership. This is likely to be true in the case of John Rutherford, who asserted that the markings on his face and body were a result of his being forcibly tattooed over a period of four hours while being held down by several members of the Maori community among whom he lived for ten years.[77] Since the varied motifs are indigenous to several different island groups in the Pacific, and the *moko*, or Maori tattooing, borne by Rutherford on his face is usually carried out over a much longer period, his claims have been largely discredited.

The contemporary account of Rutherford's return to England described how he occasionally showed his tattoos in public and recounted his

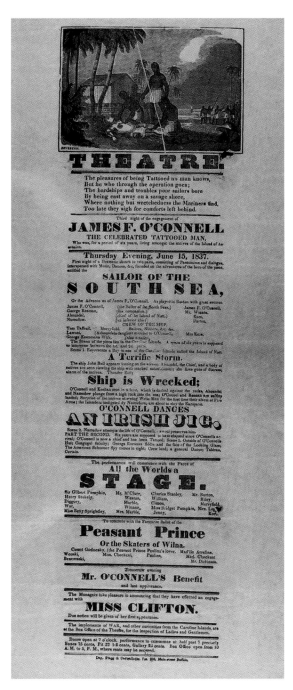

47 Theatre handbill advertising the performance of James O'Connell, the 'celebrated tattooed man', in the United States of America, 1837.

adventures, although he was averse to displaying his body for money.[78] Other individuals, including Kabris and O'Connell, opportunistically exhibited their tattooed bodies on their return to the metropoles. Indeed, O'Connell might have been the first tattooed man to be exhibited in an American circus. For nineteen years, until his death in 1854, he is known to have earned his livelihood through displaying his marked body and performing the Irish jig that had so enthralled his Pacific hosts.[79] It appears that some former beachcombers, therefore, deliberately exploited the 'otherness' that they represented in their home communities. Through performative displays, the tattoos that had been customary marks of belonging in the Pacific context were deliberately transformed into spectacular symbols of exotic ornamentation within a new social context.

The problematic position of those who had become tattooed in the Pacific Islands was not consigned solely to beachcombers. John Ledyard, who accompanied Cook on his third voyage in the 1770s and was tattooed in Tahiti, described the differing receptions he received during his travels subsequent to his trip to the Pacific, exposing the shifting and unanchored meaning of tattooing in different metropolitan cultural contexts during a period when the practice was still relatively unfamiliar to most Europeans. While visiting France, where round-the-world voyaging was well known, Ledyard described how when 'The Otaheite marks on my hand were discovered; the mistress and the maid asked our servants the history of so strange a sight? They were answered that I was a gentleman who had been round the world. It was

enough.'[80] On this occasion, Ledyard's presentation of himself as a man of status bearing souvenirs of his travels was accepted. His later reception in Russia, where such voyages were still unfamiliar, was somewhat different, however: 'I am a curiosity here . . . Unfortunately, the marks on my hands procure me and my countrymen the appellation of wildmen.'[81] Here, Ledyard was no longer in control of the 'reading' of his body and status, since observers in a different cultural context perceived his tattoo marks as synonymous with barbarism. Ledyard's experiences reveal how the tattooing process was not only intrinsically linked to the social environment in which an individual became tattooed but that what was accomplished could only be understood in relation to the social environment in which such body modification was perceived. In contexts where tattooing was not a recognized, conventional practice, its meanings were unstable and were transformed as the body moved through time and space.[82]

The differing engagement of Europeans with the indigenous tattooing practices they encountered in the Pacific reflect both the variety of cross-cultural exchanges that took place during the classic period of voyaging and the different legacies of encounters in the Pacific. For many beachcombers, becoming tattooed in indigenous fashion was a fundamental outcome of their residence in Pacific communities, a product of the social relationships that were established, or which individuals attempted to forge in order to become assimilated. The permanent markers that ensued from these relationships became a source of spectacle in non-Pacific contexts. In the case of more transient, visiting sailors, cross-cultural

encounters in the Pacific exposed them to the potential for tattooing to express their own individual and collective relationships and new expertise to facilitate this expression. Seafarers rapidly established ownership over this practice, which became a symbol of their trade. These varied outcomes of exposure to Pacific tattooing are both likely to have contributed to modern understanding of and engagement in the practice in Western societies.

Christian Skins: *Tatau* and the Evangelization of the Society Islands and Samoa

Anne D'Alleva

Ye shall not make any cutting in your flesh for the dead, nor print any marks upon you: I *am* the LORD.
Leviticus 19:28

Chapters 17–26 of Leviticus comprise what is commonly known as the Holiness Code, regulating the lives of the Israelites as a holy people. Chapter 19 addresses both cultic and cultural requirements – it speaks of the ritual of sacrifice and the treatment of strangers, the breeding of cattle and the sin of idolatry. The prohibition against marking the skin – the Hebrew term *k'thoveth qa'aqa* used in Leviticus 19:28 literally means 'writing that is stuck in' and refers to cutting or piercing the skin and filling the wounds with pigment – appears at the end of a list of prohibitions against eating flesh with blood in it, augury, witchcraft and cutting the hair on the temples or the beard.[1] Although a seemingly random set of concerns, these were all practices that distinguished the Israelites from neighbouring peoples.

This vision of a people set apart by both religion and culture was at the heart of the evangelical enterprise in the Pacific. In 1797 the London

Missionary Society (LMS) established its first Pacific mission in the Society Islands to both Christianize and civilize the Islanders. The painter Robert Smirke's depiction of the LMS's arrival at Tahiti captures the spirit of the missionaries, if not the facts of the encounter: the missionary men look grave but stalwart, while one missionary wife clings to her husband and another pulls her child to her breast, shrinking from the kneeling Tahitian before her. That figure gratefully acknowledges the new arrivals and offers them – in the missionary imagination only – a gift of land. In order that the noble generosity of this figure would not misleadingly suggest that the missionary presence was perhaps unnecessary, Smirke endowed the group of Tahitian witnesses with multiple signs of their heathen state: a pair of young title-holders rides on the shoulders of their attendants; a bare-breasted woman wears pretty ornaments that set off her all-too-visible charms; and several figures display *tatau* on arms and legs. Indeed, the London Missionary Society chose Tahiti as the primary focus of its first Pacific mission precisely because, in the wake of the eighteenth-century voyages of exploration, the

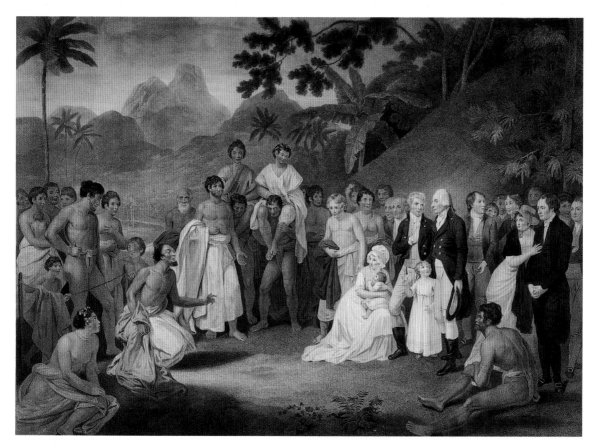

48 Francesco Bartolozzi after Robert Smirke, *The Cession of the District of Matavai in the Island of Otaheite to Captain James Wilson for the Use of the Missionaries*, c. 1797, hand-coloured aquatint.

island had been so widely – and, to their minds, wrongly – celebrated as an ideal land where people lived, like the ancient Greeks, in innocent and natural splendour.[2] Not surprisingly, then, the Levitical prohibition against marking the skin found its echo in missionary attitudes and policies toward *tatau*. Unlike the explorers, many of whom submitted themselves enthusiastically to the instruments of the *tahu'a tatau*, LMS missionaries in the Society Islands attacked *tatau* as a heathen and savage practice.

And yet, despite the zeal of the missionaries, the history of *tatau* – indeed, the history of evangelization in the Society Islands and in Polynesia – is not a simple story. Islanders variously met the efforts of missionaries with curiosity, hostility, indifference, amusement and enthusiasm. These responses varied geographically and temporally, and were inflected by the social status, gender, sexuality, age – even personality – of the people involved, both missionaries and Islanders. In relation to *tatau*, not only did missionary ideologies,

policies and actions change over time and in response to local conditions, but so did those of its practitioners and recipients. The history of *tatau* has profound implications for culture and politics today, for, as the Samoan writer Albert Wendt notes, *tatau* is not an art form, but a way of life.[3] So, then, in telling the complex history of *tatau* during the evangelization of Polynesia, I start from a question premised in the present: Why does *tatau* exist today as a continuous tradition in certain island groups, while in others it has either disappeared or returned as a revival after a long period of severely diminished presence, if not complete disappearance? What happened during the introduction of Christianity to the islands to shape these different historical trajectories?

In looking back to the events of the first half of the nineteenth century, I do not want to propose a search for the origins of any particular current state of *tatau* practice in any particular island – whether that be the continuous presence of *tatau* or the absence and revival of it. Instead, the project is akin to Michel Foucault's 'genealogical' history – a history that neither looks for unitary or clear origins nor seeks to establish an inevitable path to the present. This is a history that traces the multiple possibilities of interaction, cultivating the 'details and accidents that accompany every beginning' in considering the first years of evangelization in Polynesia and their impact on *tatau* practice.[4] Of course, the idea of a genealogical history has special resonance used in relation to the history of Polynesia: for the people of these islands, genealogy was and is a foundational practice in culture, politics and spirituality. And the practice of genealogy in these cultures reminds us

that genealogy is not just a matter of descent, as Foucault would have it, but of ascent: the living trace their kinship back to ancestors who give them claim to particular titles, rights of access to certain *marae* or other privileges. Genealogy, as ascent and as history, is a process of creative interpretation, of recognizing significant connections and crucial moments.

Unfortunately, the historical record does not provide an easy path to the past. The archival resources can sometimes prove to be fragmentary and inadequate: missionaries themselves too rarely discussed *tatau* practice and significance beyond a general condemnation; explorers sometimes made brief visits and did not delve into

49 R. H. Pease after A. T. Agate, 'Tattooing', engraving, from Charles Wilkes, *Narrative of the United States Exploring Expedition* (Philadelphia, 1845). The first published image of Samoan *tatau*.

local culture in any depth; and the historical record often lacks Islander voices. The visual record can be problematic – either through the scarcity of early images, as in Samoa, or because many images were made by amateur artists and the accuracy of their depictions of *tatau* must be evaluated with extra care. Moreover, investigating this question fully would require looking at events in Samoa, Tonga, Fiji, Hawaii, Aotearoa-New Zealand, the Austral and Marquesas Islands, Tahiti and the Society Islands, the Cook Islands and other Polynesian islands – as well as islands of Micronesia and Melanesia – not only because there are links among the *tatau* practices of these places, but also because the same missionary societies and often even the same missionaries were active in multiple places. The celebrated LMS missionary John Williams, for example, was active in the Society Islands, Austral Islands, Cook Islands, Tonga and Samoa before meeting his death in Vanuatu.

Since the full scope of the question is necessarily beyond the boundaries of this essay, I will focus here on the introduction of Christianity and the history of *tatau* in the Society Islands and Samoa, comparing what happened during this period of the 1810s and '20s for the Society Islands and the 1830s and '40s for Samoa.[5] In Tahiti and the Society Islands, *tatau* was severely suppressed and had apparently entirely disappeared by the mid-nineteenth century (although I certainly would not rule out its secret practice, or survival in more remote places in the archipelago) and re-emerged only as a revival in the past 20 years or so, as explored by Makiko Kuwahara in this book. The Samoan *tatau* tradition was a major inspira-

tion for this revival in Tahiti, for *tatau*, in the form of the *pe'a* for men and the *malu* for women, has been practised continuously and has even flourished in Samoa, despite missionary opposition. In fact, the Samoan *tufuga ta tatau* Su'a Suluape Paulo, whose work is discussed by Sean Mallon in this volume, was a crucial figure in inspiring the *tatau* renaissance in the Pacific, including Tahiti and the Society Islands. These divergent situations are the more striking because the evangelical histories of these two island groups are directly and closely linked through the presence of LMS missionaries – and even some of the same individuals – in both places.

Although they might have expected to make rapid progress in evangelizing the islanders, the LMS missionaries who arrived at Tahiti in 1797 met with little success; Society Islanders were generally uninterested in the Christian message, except insofar as it led to economic or political advantage.[6] Just a year after their arrival, in 1798, more than half the missionaries left Tahiti for Australia because of attacks on their persons and property. In 1808 most of the remaining missionaries were forced to abandon their posts, when inter-district wars threatened the pre-eminence of their protector, Pomare II. It was only in 1812, with the conversion of Pomare II and his subsequent military victory and consolidation of his titular supremacy, that the LMS mission began to obtain a secure foothold in the archipelago. From that point, conversions were rapid if not, perhaps, always sincere; 'Oro, Ta'aroa and the other gods were cast away and chapels were built in many settlements. Over the next 25 years, the LMS missionaries were a major religious, cultural,

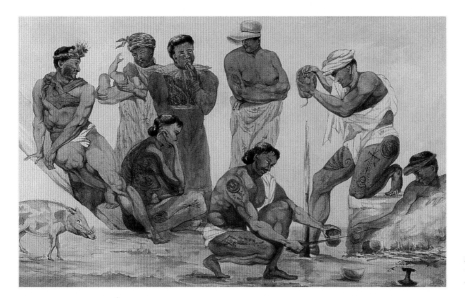

50 Jules Lejeune,
Costumes de l'île Taiti,
1823, watercolour.

economic and political presence in the Society Islands, despite continuing resistance to their teachings and policies in some quarters.

With their secure establishment, the missionaries sought to eradicate *tatau*, just as they did native forms of dress, housing, dance, sexual relationships, etc. In reality, missionary perspectives varied on *tatau* and the question of its relationship to religion – a question that was not purely academic, for it was a determining factor in the priority given to the effort to eradicate *tatau*. Some missionaries strongly believed that *tatau* was closely linked to religion – as the missionary William Ellis observed, religion 'not only disclosed the origin, but sanctioned the practice' of *tatau*, which, as he explained, had its origins among the gods and was undertaken in imitation of them.[7] Ellis further noted that although the simple act of *tatau* in itself was no breach of the peace, it was 'connected with their former idolatry and always attended with the practice of abomin-

able vices'.[8] Although a missionary like William Crook believed that *tatau* had no immediate relationship to Tahitian religion, he still worried that its practice indicated a *tacit* preference for heathenism.[9] Similarly, Tyerman and Bennet noted that *tatau* 'though harmless in itself' was 'associated with obsolete abominations'.[10]

In 1819, in response to such concerns, the missionaries, Pomare II and some of the Christian title-holders of Tahiti established a penal code, based on both the Ten Commandments and English law. In addition to laws concerning murder, theft, adultery and the Sabbath, this code outlawed *tatau* and it set up a court system to try offenders. The title-holders of Ra'iatea, Huahine and Borabora followed in 1820, with a law code that also prohibited *tatau*. The title-holders of Huahine revised that code in 1822, but kept the prohibition against *tatau*: 'No person shall mark with tattoo, it shall be intirely discontinued. It belongs to ancient evil customs. The man or

 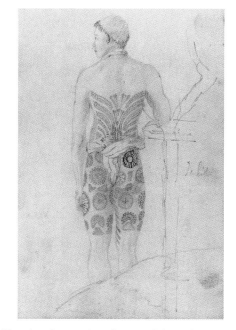

51 William Smyth, front view of man with buttocks and torso tatau, pencil. Sketchbook from the *Blossom* voyage, 1826.

52 William Smyth, rear view of man with buttocks and torso tatau, pencil. Sketchbook from the *Blossom* voyage, 1826.

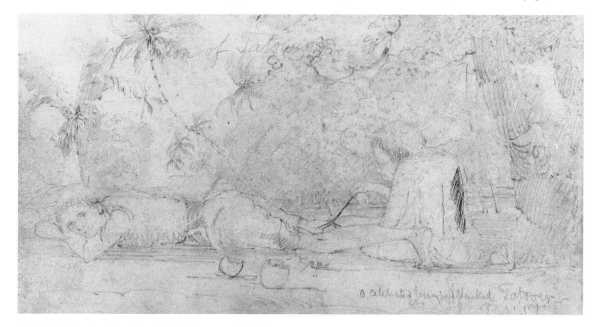

53 William Smyth, *Operation of Tatooing – a celebrated humped backed Tatooer – Tahiti*, pencil. Sketchbook from the *Blossom* voyage, 1826.

woman that shall mark with tattoo, if it be clearly proved, shall be tried and punished'.[11] Such laws resulted from close cooperation between missionaries and the local title-holders who sat in court as judges and administered the law. In their public writings the missionaries were often careful to distance themselves from both the creation of the legal codes and their application in the courts – Ellis, for example, wrote approvingly that 'On account of the immoral practices invariably connected with the process of tattooing, *the chiefs* [my emphasis] prohibited it altogether'.[12] The mission overseers Tyerman and Bennet emphasized in their account of the drafting of the first legal code that the missionaries steadfastly refused to be involved, until they were requested to help so often that they finally gave in.[13] In reality, whatever the instructions from the home board about political neutrality, missionaries were extensively and proactively involved in civic affairs. During court sessions, they typically sat with the judges, who were drawn from the ranks of the elite male converts, and they exercised, informally, special rights of appeal. The writings of the missionaries themselves often reveal their political involvement: Williams readily acknowledged that he and Lancelot Threlkeld 'assisted' in preparing the Ra'iatean law code.[14] Some critics accused the missionaries themselves of introducing some of the harsher punishments and more stringent laws.[15]

In all three codes, the punishment prescribed for people who broke the law against *tatau* was hard labour; the Huahine code states:

> The punishment of the man shall be this – he shall make a piece of road ten fathoms long for the first marking, [twenty] fathoms for the second . . . This shall be the woman's punishment – she shall make two large mats, one for the king, and one for the governor; or four small mats . . . If not this, native cloth, twenty fathoms long, and two wide.[16]

Those who persisted in *tatau* had these images blotched and disfigured: 'The man and woman that persist in tattooing themselves successively for four or five times, the figures marked shall be destroyed by blacking them over, and the individuals shall be punished as above written.'[17] The goal, of course, was to destroy the signifying properties of these *tatau* – to render them illegible as expressions of cultural practice, religious belief or political resistance. This use of *tatau* as a punishment emerged as a local adaptation of the European use of corporal punishment, including branding, for criminal acts – a set of practices that persisted in England until the 1830s.[18] Disfiguring *tatau* was also used to punish women who committed adultery. The merchant J. A. Moerenhout, no friend of the missionaries, was outraged by this practice:

> If a woman was suspected of some error of conduct, a running noose of a big rope was placed around her loins, which was pulled by the two ends and tightened until the unfortunate woman confessed her fault and denounced her accomplice . . . And the worst is that, when she was overcome, she was tattooed with certain marks on her face. You could see a great number of girls and women in that state, a horrible thing for the inhabitants of the Society

Islands! Also the marks, which they carried to their grave, perpetuated their hatred, and they only waited for the moment of vengeance.[19]

René-Primevère Lesson, surgeon and naturalist on board the French exploring ship *Coquille*, which visited Tahiti in 1823, noted that in Borabora women convicted of prostitution had marks tatooed on their foreheads, and he accused J. M. Orsmond of inventing this brutal punishment.[20]

Despite the severity of the laws punishing *tatau*, both individuals and groups persisted in practising it. In 1821 Orsmond noted one such episode in his journal, recorded in the metaphoric language of the elite:

> At daylight this morning the kings informed me that the Canoe had almost sunk, I asked what is the wind then. They replied – It is the tatooing but we have [righted] her again & she might perhaps swim yet. The Canoe is the Island almost sunk, almost all the people have been marking themselves. They were all judged 14 in number & sentenced to [get] a hole through a hill for a Road as a reward.[21]

A year later Orsmond reported a outbreak of *tatau* on Borabora, noting that there were several baptised members of his church among the offenders.[22] On Huahine, the son of a title-holder got *tatau* to protest against his father's conduct.[23] *Tatau* became an important component of religious resistance, especially among the *tutae auri*, or Rust of Iron, a youthful rebel movement that practised Society Islands religion and deliberately desecrated Christian institutions.[24] The missionary William Crook noted that in Tahiti's Taiarapu

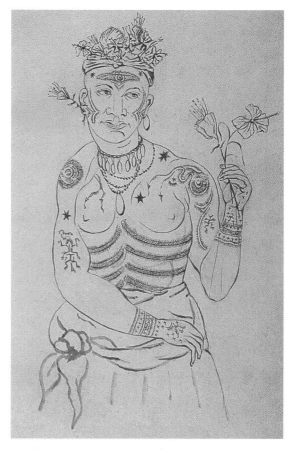

54 Jules Lejeune, *Taitienne tatouée*, 1823, pen and ink.

district the *tutae auri* were 'very wild' and included 'all of the young men with very few exceptions and many of the young women'. In a passage marked with outrage, he recorded that 'they mark their bodies out of bravado and most of them are guilty of fornication or adultery'.[25] Crook also noted that in a neighbouring district almost everyone had joined what he called 'the heathen party', even the judges; he writes that 'In a way of contempt [they] choose the Sabbath as their favourite day to mark themselves'.[26]

The laws against *tatau* lasted only a few years

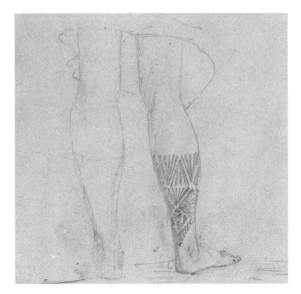

55 William Smyth, drawing of leg tattoos, pencil. Sketchbook from the *Blossom* voyage, 1826.

before they were repealed. In 1824, for example, J. M. Orsmond noted, with some frustration, 'Many have been mark [sic] themselves with the tatoo [sic] but that is now no crime. The law takes no notice of it.'[27] Despite the change in the law, *tatau* seems to have been diminishing, although the evidence is contradictory, with some accounts emphasizing the prevalence of *tatau* and others noting its disappearance. When the missionary overseers Daniel Tyerman and George Bennet visited the Society Islands mission in the early 1820s, they asserted that the practice of *tatau* was 'very rare indeed'.[28] Similarly, when the explorer Otto von Kotzebue visited Papeete in 1824, he noted, despite his generally harsh criticism of the evangelical enterprise, that 'The Missionaries have abolished the custom of tattooing, and so far at least spared the Tahaitians some useless torment. These marks are now only to be seen on

people of the middle age and upwards – never on the young'.[29] Kotzebue did not anchor long in the Society Islands and he stayed primarily in Papeete, the place perhaps most under the influence of the missionaries and the Pomare allies, so *tatau* might have been less prevalent there than elsewhere in the islands. And of course Tyerman and Bennet would have wanted to stress, for their home supporters, that the mission was making significant progress, which the disappearance of *tatau* would have strongly signalled. But then there is Charles Darwin, who remarked, upon visiting Tahiti in 1835, 'Most of the men are tattooed, and the ornaments follow the curvature of the body so gracefully, that they have a very elegant effect' and 'The women are tattooed in the same manner as the men, and very commonly on their fingers.'[30] He specifically noted *tatau* on the bodies of his mountain guides, men who were probably not even middle-aged, an observation that contradicts both Kotzebue's and Tyerman's and Bennet's accounts. Nonetheless, some eleven years after Darwin's visit, when the French Marist missionary Louis Padel visited Papeete in 1846 on route to his mission in Samoa, he remarked: 'Les Tahitiens ne se tatouent plus, on ne voit quelque restes de tatouage que sur les plus âgés' ('The Tahitians no longer tattoo themselves, one sees but few traces of tattoo on the most elderly').[31] Through the mid-nineteenth century, visitors remark less and less frequently on *tatau*, suggesting that by this time it was a seriously diminished practice.

When Father Padel arrived in Samoa, he found that *tatau* was still a vibrant practice there, despite the arrival of LMS missionaries in the 1830s. John Williams had first visited the islands

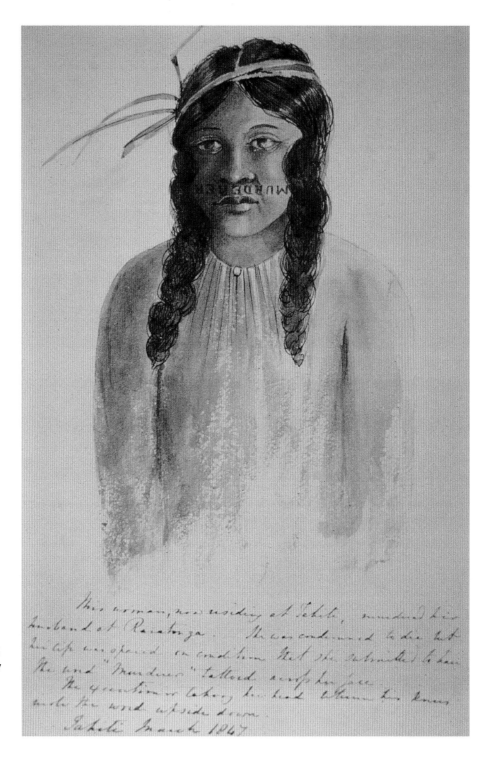

56 Henry Byam
Martin, 'Native
Woman with letters
"Murderer" tattooed
on her face – penalty
for murdering her
husband – Tahiti',
watercolour, March
1847, from Martin's
Polynesian journal.

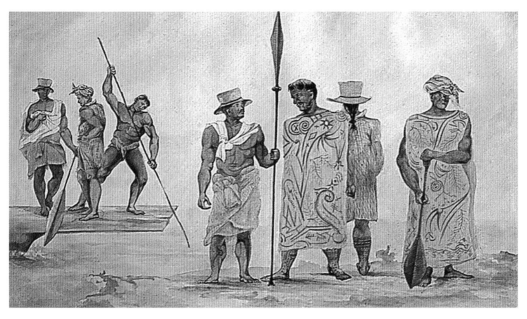

57 Jules Lejeune, *Costumes des chefs Taïtiens*, 1823, watercolour.

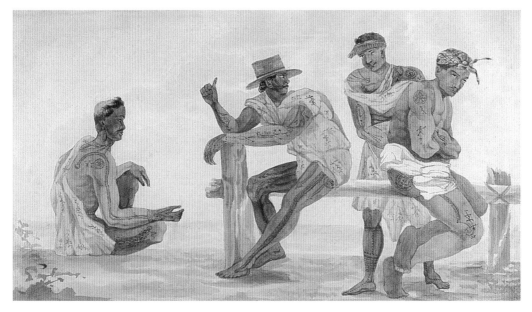

58 Jules Lejeune, *Costumes des habitants de l'île Taïti*, 1823, watercolour.

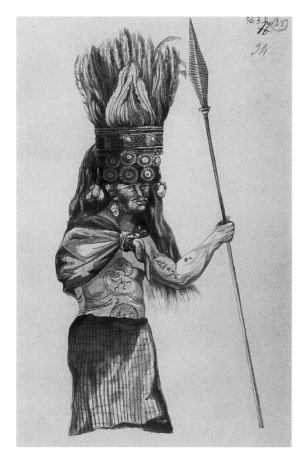

59 Jules Lejeune, *Guerrier taïtien*, 1823, pen and ink.

to be following a policy of 'discountenancing' it: they spoke out against *tatau* and the 'abominable customs' that accompanied it but did not take organized action against it.[32] Perhaps they had seen that the kind of pitched battle waged against *tatau* by William Crook, J. M. Orsmond and others in the Society Islands was misguided, draining the resources of the mission and creating unnecessary conflict that did nothing to bolster Christianity. The missionary George Turner, who took charge of the LMS seminary at Malua, 'Upolu, in 1844, explained the policy of the Samoan mission:

> The waste of time, revelling, and immorality connected with the custom [of *tatau*] have led us to discountenance it, and it is, to a considerable extent, given up. But the gay youth still thinks it manly and respectable to be tatooed, parental

in 1830 and 1832, leaving behind native converts who had been trained as teachers. In 1835, after missionaries who had served in the Society Islands had prepared the field, six members of the LMS arrived in Samoa from England to establish a large-scale and permanent mission. By 1840 LMS missionaries had established a network of stations on the three main islands, 'Upolu, Savai'i and Tutuila. The LMS missionaries had modified their practices to some extent by the time they arrived in Samoa, especially when it came to *tatau*. Rather than outlawing *tatau*, they seemed

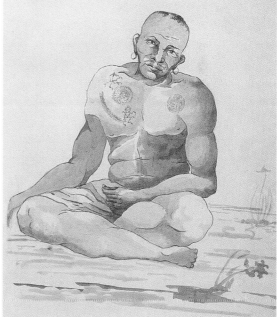

60 Jules Lejeune, *Taïtien*, 1823, wash drawing.

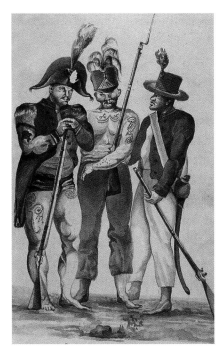

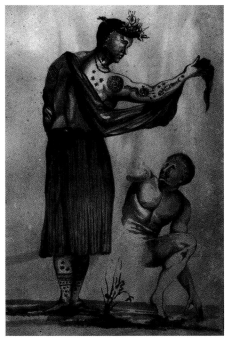

61 Jules Lejeune, *Le mot d'ordre – garde royale*, 1823, wash drawing.

62 Jules Lejeune, *Costumes des habitants de Taïti*, 1823, wash drawing.

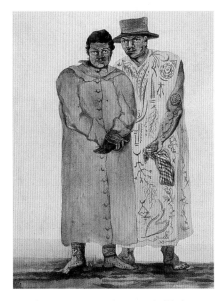

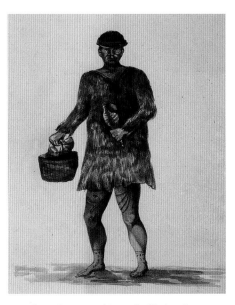

63 Jules Lejeune, *Les deux rois de l'île bora-bora*, 1823, watercolour.

64 Jules Lejeune, *Habitant de l'île borabora*, 1823, watercolour.

pride says the same thing, and so the custom still obtains. It is not likely, however, to stand long before advancing civilization. European clothing, and a sense of propriety they are daily acquiring, lead them to cover the tatooed part of the body entirely; and, when its display is considered a shame rather than a boast, it will probably be given up, as painful, expensive, and useless; and then, too, instead of the tatooing, age, experience, common sense, and education will determine whether or not the young man is entitled to the respect and privileges of mature years.[33]

In a letter dated 1842, the missionary A. W. Murray expressed a similar view:

In reference to general improvement – we find that that follows easily and naturally in the track of Xtianity. Let but the heart be brought under the influence of the purifying & exalting principles of the gospel and all else is comparatively easy, while, without this, all efforts to produce any improvement, wh. will be to any considerable extent salutary & permanent, will be utterly unavailing.[34]

This attitude contrasts strongly with that of the LMS missionaries in the Society Islands, for there was certainly nothing 'easy' or 'natural' about Crook's and Orsmond's practices regarding *tatau* or anything else.

In the end, a crucial difference might well have been the personalities and philosophies of the individual missionaries themselves – the LMS historian Lovett himself seemed to point to this as a determining factor for the Samoan mission, remarking, 'Samoa has exhibited few of those sensational episodes or outstanding personalities which impress the imagination and captivate the general reader'.[35] The approach of Murray and Turner was very much in the spirit of an exhortation delivered by John Williams to Tahitian teachers going to the Cook Islands:

All their lesser evil customs you will endeavour to cast down, going in a State of Nudity or nearly so, cutting and scratching themselves in seasons of grief – tatooing their bodies. Eating raw fish, their lewd dances etc. but the greater evils will require your first attacks and then the smaller.[36]

Of course, in Ra'iatea Williams himself had participated in the writing of a law code that included a prohibition against *tatau*, but it seems that in the Cook Islands and Samoa his approach was to attack it if an opportunity presented itself but not to make that a primary preoccupation. Unlike the LMS missionaries in the Society Islands, who had to answer charges that they were too involved in civic affairs, those in Samoa had to answer charges that they were too narrowly focused on religion.[37] Perhaps as a lesson learned from the organization's experiences in the Society Islands, the LMS missionaries stationed in Samoa also tried to make Christian culture a source of pleasures as well as prohibitions. Several missionaries wrote enthusiastically of the magazine that they were planning to publish in Samoan as soon as a press arrived. According to the missionary William Miles, it was to contain 'light and interesting matter' that would help converts learn how to read (Heath's idea of 'light and interesting matter' was Bunyan's

Pilgrim's Progress, which he translated into Samoan for the magazine).[38]

In addition to their own changes in policy and attitude, the presence of the Wesleyan Methodist Missionary Society (WMMS) in Samoa certainly complicated the cultural and evangelical work of the LMS. The six English missionaries who arrived in 1835 were surprised – and dismayed – to find Peter Turner of the WMMS already resident in Samoa, along with a large cohort of Tongan missionary teachers. The LMS view was that foreign peoples should be evangelized without getting into differences of doctrine and practice: the organization saw itself as promulgating a basic, Gospel- and prayer-centred Christian message that most Protestants could support. The LMS was, at this time, non-denominational; there were Wesleyan Methodists who supported it, along with Presbyterians, Congregationalists and even some Anglicans. In a joint letter protesting against the WMMS presence in Samoa, the LMS missionaries noted that 'The great object is the same, but the agents of the two proceed in a somewhat different manner'.[39] George Platt, an LMS missionary who was particularly hostile to the Wesleyan Methodist presence in Samoa, asserted that 'Indeed their system does not seem well calculated for the heathen. It is better calculated to revive drooping churches, or to follow up what others have done . . . '.[40] Not only did the Wesleyans continue to work in Samoa for several years at the same time as the LMS missionaries, but even after the WMMS missionaries were compelled to leave Samoa in 1839 through an agreement made between the missions' home offices, the Tongan teachers remained and did, in

the LMS view, 'incalculable mischief'.[41] Many Samoans continued to adhere to Wesleyan Methodist beliefs and refused to join LMS congregations, perhaps reflecting not only religious beliefs but the strong political connections between Samoa and Tonga – King George Tupou Taufa'ahau I visited Samoa in 1842 and 1847. After all, the connection between Samoans and Wesleyan Methodist Tongans pre-dated the arrival of English missionaries of either denomination in Samoa: it was the title-holder Saiva'aia of Savai'i who had brought the Lotu Toga to Samoa in 1828.[42]

Thus the situation that existed in Tahiti and the Society Islands, where the LMS were the sole Christian missionaries at work for nearly forty years until the arrival of the French Roman Catholic missionaries in 1836, was not to be repeated in Samoa. The presence of this other Christian church undercut the LMS authority, for the missionary message was no longer monolithic. If the WMMS and the LMS could disagree with each other, then this opened a space for Samoans to disagree with both – or either – of these Christian views. Like the LMS, the WMMS strongly disapproved of *tatau*. Indeed, in Tonga, where the WMMS were strongly established, the missionaries cooperated with King George Tupou Taufa'ahau I and his elite allies to outlawed *tatau* in the first law code of 1839: 'It is not lawful to *tatatau* or to *kaukau* or to perform any other idolatrous ceremonies, if any one does so, he will be judged and punished and fined for doing so'.[43] But Peter Turner himself, in Samoa, was relatively lax when it came to the requirements for church membership and he did not seem to make the rejection of *tatau* or other local customs a condi-

tion for membership.[44] He baptized new converts quickly, and did not expect them to undergo the period of testing that the LMS demanded. This might have been his personal approach to evangelization, or a position he was forced into because of the competition from LMS; also, he did listen carefully to the advice of his Tongan teachers, and they might well have counselled him not to be too severe on *tatau* in Samoa, even though such policies were developing in Tonga.[45] So even though there was the same policy, the practical reality might have dictated a modification of positions and Samoans could have taken advantage of this to keep on practising *tatau*. Moreover, the scene was further complicated by the evangelizing of Sio Vili, a Samoan sailor who had learned of Christianity in travelling to Tonga and Tahiti, as well as beachcombers who functioned as ersatz missionaries.

The situation was further complicated by the arrival of Roman Catholic priests of the Marist order in 1845. The LMS had anticipated the arrival of Roman Catholic missionaries, who had already established themselves in Western Polynesia; in fact, one of the first publications produced by the Samoan missionary press, in 1839, was *O le Tala i Lohi Eseese* (*A Talk about Different Religions*), which warned against the evils of the Roman Catholic religion.[46] The presence of the Roman Catholics in Samoa did not drive the LMS and WMMS any closer, but further fragmented the religious and cultural scene. In fact, the Marists took a radically different view of *tatau*, which they did not expressly prohibit, and so directly opened up the possibility of an alternative Christian religion for Samoans who wanted to practise *tatau*. In a long letter describing missionary work and life, written to the superior of the seminary where he had studied, Father Leon Gavet noted that the LMS prohibition against *tatau* actually brought converts to his Church: 'I have entire families who attend [church] because one of them who was not tattooed submitted to the process, which, among them, passes for a great crime (theology of the ministers who have, time and time again, distorted the thinking of these poor people).'[47] Which is not to say that the Marists were unconcerned with cultural life in the islands outside the realm of religion; Gavet, for example, spoke out strongly against the public penetration of the bride before marriage, an important custom among elite Samoan families and encouraged the members of his Church to avoid participating in such rituals.[48] So theirs was a deliberate choice not to oppose *tatau* and to see it as marginally important to the Roman Catholic mission.

Although I am delving deeply into missionary history here, I do not want to imply that the practice of *tatau* in either the Society Islands or Samoa rested solely on missionary practices and policies during the first years of evangelization. There were significant local factors, independent of the missionary presence, that affected *tatau* practice and its survival in Samoa and the Society Islands. One was the nature of the power of title-holding families, which, in the early nineteenth century, was less centralized in Samoa than in the Society Islands. Although Malietoa had managed to consolidate four titles and gain supremacy in Samoa, in the 1830s and '40s title-holders nonetheless guarded their village- and district-

based power. When Malietoa attempted to monopolize the missionaries and missionary teachers, other title-holders actively sought them out, due to concerns for prestige and political advantage if not spirituality, at least initially. As Father Louis Violette noted in a letter, 'There are perhaps a hundred chiefs each wishing to have a missionary . . . it is enough that a chief have a missionary for the other to no longer wish to ally with him, because that would be debasing himself before an equal.'[49]

In the Society Islands, on the other hand, the Pomare dynasty had consolidated titular supremacy through a series of wars in the late eighteenth and early nineteenth centuries as well as through strategic alliances with the premier title-holders of the Leeward Islands. Partly through the support of the British, the Pomares were able to link this titular supremacy to certain forms of political and economic power.[50] Although there were certainly challenges to, and checks on, Pomare's authority, which was not truly monarchical at this time, the LMS missionaries in the Society Islands had powerful allies in both Pomare I and Pomare II. In contrast, the LMS missionaries in Samoa feared that title-holders would act out their rivalries via the multiple Christian sects present there; in a letter to Peter Turner, Thomas Heath warned, 'I am told that there is also danger that the people will make the question a political one, a result which we must all endeavour to avert'.[51] This, of course, could not happen in the Society Islands, where the LMS missionaries worked alone for almost 40 years and leading title-holders, like Pomare, did not have other options if they wanted access to Christianity.

These different configurations of title-holding power facilitated the passing of the law codes, with their prohibitions against *tatau*, in the Society Islands, and hindered that process in Samoa. Close missionary relationships with the powerful Pomare dynasty in Tahiti and Tamatoa title-holders in Ra'iatea made far-reaching law codes possible on these two islands. Although LMS missionaries did encourage Samoan title-holders to establish a law code to address problems like adultery, theft and fighting, they resisted; given the independence of the Samoan title-holders, it would have been particularly hard to establish a rule of law that provided them with jurisdiction in each other's districts.[52] Only in Manu'a was a ban against *tatau* written into law, and that occurred relatively late, in the 1860s. The Manu'an law code prohibited the practice of *tatau*, and if people went elsewhere to acquire *tatau* they were forbidden to return (in the 1890s this banishment was eliminated and the offender paid a fine to the church instead).[53] Thus a primary tool used by the missionaries in the Society Islands to suppress *tatau* was unavailable in Samoa. Even though the laws against *tatau* were enforced for a very short time, they must have had a continuing impact, since women with disfigured faces and religious resisters with blotched arms and legs continued to live and work in their communities. The spectacle of *tatau* as punishment, long after it had ceased to be applied in this way, might have done as much as anything else to turn people away from its practice.

This question of visibility, in terms of the staging of *tatau* and the nature of its motifs, might also have been a factor in its survival, for the Society Islands and Samoan practices were quite distinct.

In the Society Islands, almost everyone had the buttocks *tatau*, with its arching bands reaching up to the lower ribs – a design clearly linked to the Samoan *pe'a*, and yet, unlike the *pe'a*, worn by both men and women. By the 1820s some buttocks *tatau* had become quite elaborate, with multiple large 'sunburst motifs' replacing the arched geometric bands depicted by Parkinson. In addition to the buttocks *tatau*, people wore various designs on arms and legs – most often geometric, but sometimes also incorporating figures of human beings, animals or plants.[54] According to Ellis, a person might start receiving *tatau* at the age of eight or ten, and the process continued at intervals and might not be finished until the person's twenties.[55] All of this meant that *tatau* must have been a fairly constant and visible practice in the Society Islands, especially because it was done on an individual basis – there are no reports of collective *tatau*, as in Samoa.[56] When young Samoan men received the *pe'a*, which was also a coming-of-age *tatau*, they had it done in groups; as the son of a title-holder was preparing to get his *pe'a*, other young men would join him and undergo the procedure at the same time, bearing his pain with him – apparently a young woman might also have others join her in undertaking the *malu*.[57] While the elements of the *pe'a* and *malu* varied, the design structure was quite consistent and did not undergo the same degree of post-contact experimentation that occurred in the Society Islands. In this way, the much more frequent, if small-scale, practice of *tatau* in the Society Islands, combined with the varied motifs, kept it more constantly in missionary view and perhaps made it more of an irritant. At the same

time, the group practice of the *pe'a* meant that it had political implications – the groups of young men who had undergone the process together were often tightly bonded and often, as they matured and began to take on roles in public life, they supported the young title-holder they had accompanied through *tatau*; Samoan title-holders might well have been very reluctant to abandon such an effective political tool.

The direct connection of *tatau* with religion in the Society Islands also might have made it more of a target there – the missionary John Davies observed:

> the case of the Tahitians was such that without the overthrow of their *religious system* they could not change their customs, or in other words adopt the modes and manners of civilized life, because their Religion was so blended with everything they did, all their employments, customs, diversions and affairs of Government.[58]

The *arioi* society, which was connected with the worship of the god 'Oro, used *tatau* to distinguish between the various grades of membership. The best description of this comes from texts collected by J. M. Orsmond and later amplified by his granddaughter Teuira Henry, although the sources are not entirely clear on the subject. Henry noted, for example, that the highest grade of *arioi* was the *avae parai*, 'blotted or black legs', whose legs were completely covered with *tatau*, while other *arioi* had no *tatau* at all.[59] In this context, giving up the religion weakened *tatau*, and the connection between religion and *tatau* made it more of a target for missionaries.

In Samoa, *tatau* was not directly connected to religion and religion was less institutionalized than in the Society Islands; the displacement of Samoan religion by Christianity did not cause a crisis in social institutions as it did in the Society Islands and elsewhere in Polynesia.[60] The meaning of *marae* or *malae* makes clear the difference: in the Society Islands a *marae* is a sacred place of worship, while in Samoan a *malae* is the village green where important political debates take place.[61] In Samoa, there was not a strong priestly class to be dislodged, nor were there elaborate practices involving god figures or other paraphernalia. This was in some sense an advantage for the missionaries, for it was easier to replace such religious practices with Christianity, but it also meant that *tatau* could not be as clearly linked to religion and therefore prohibitions against it carried less force. The LMS missionaries in Samoa did not view *tatau* as linked with religion, as Ellis and others did in the Society Islands. A. W. Murray explained that his objection to *tatau* was not so much for the practice itself or its religious associations, but the immorality of the practices that accompanied it:

> As practised among the heathen, besides being barbarous and useless in itself, it was always accompanied by a variety of abominable customs. A whole train of evils generally accompanied such practices. Hence, on *relative* grounds, it is often of great importance to get practices discontinued, which, in themselves, are comparatively harmless.[62]

Tatau, in the end, might have been comparatively harmless, perhaps, but it was not consistent with the missionary vision of a people so thoroughly Christian in religion and culture that they became an example not for their godlessness but their godliness, the Polynesian Israelites. In the Society Islands, partly because of the distinctive *tatau* practised there and its connection with religion, and partly because of the nature of the missionary presence, *tatau* did not survive evangelization. In Samoa, perhaps because the missionaries had modulated their policies, and because there were several denominations present, and because of the distinctive nature of *tatau*, which was closely tied to politics but not religion, people found ways for the practice of *tatau* and the practice of Christianity to coexist, even if this was not always to the missionary liking. Above all in tracing the history of these early years of evangelization, a genealogical sensibility puts the focus on persons, on human agents: the missionaries, the title-holders, the outside observers, the religious resisters, the enthusiastic converts, and their multiple and complex practices and conceptions of *tatau*. This is somewhat different from Foucault, for whom the body is 'the inscribed surface of events', and for whom the power structures enacted on and through bodies are the primary concern. Can history maintain its focus on both simultaneously, the persons and the power structures? It would not be a Levitical vision, perhaps, nor Foucauldian, but it might well accord with the genealogy as history – *ihotatau*, *gafa* – of Society Islanders and Samoans.

Governing Tattoo: Reflections on a Colonial Trial

Anna Cole

But hope tugs: Could skin be the site where difference becomes intense, where it sucks both ways and rearranges the present?[1]

Alfred Gell, in his study of Polynesian tattooing, *Wrapping in Images*, argued that in pre-colonial Polynesian societies tattooing played an integral part in the organization and functioning of major institutions (politics, warfare, religion and so on). It was so central that the description of tattooing practices becomes, inevitably, he argued, a description of the wider institutional forms within which tattooing is embedded.[2] Gell distinguished between the deeply embedded tattooing practices of Polynesia and what he called the 'unanchored' and historically contingent Western tattoo, which, by contrast, he argued played no role in the mechanisms of social reproduction.[3] Drawing on Gell's work, Jane Caplan and others have argued that in Western culture in comparison to Polynesia tattooing has occupied an ambiguous and uneasy status within a dominant culture in which body-marking was usually treated as punitive and stigmatic rather than honourable or decorative. Partly because of this, argued Caplan, there is a

deficit of knowledge about the European tattoo compared with societies where its 'status has been more secure, or its aesthetics more complex'.[4]

Despite what has been described as the 'nomadic' status of European tattooing traditions, and precisely *because* of the pervasive British use of tattoo as punishment, in some contexts an analysis of European colonial tattooing practices becomes inevitably also a description of the wider institutional forms in which tattooing is embedded. Tattooing, in contexts outside the Pacific, also played a part in the mechanisms of governance and social and political reproduction. A comparative case of an official British government inquiry into the enforced tattooing of a local Burmese woman by order of a British police superintendent in that late nineteenth-century colony explores these ideas. This case presents a comparative context from which to reflect on the debates about the historical and contemporary representations of tattooing in the Pacific discussed in this collection.

Little-known evidence of the widespread use of tattoo as punishment by the British East India Company (which I will outline briefly in the course of this chapter) suggests that tattooing

played a role in British colonial culture in a way that has not previously been widely recognized. This lack of recognition of British colonial tattooing practices reflects an ongoing reluctance to think through the dialectic between the 'mother' country and the colony that was both mutually transformative and destabilizing. In this case neglecting this two-way process makes it harder to see both the historical and contemporary interaction between British colonial tattoo culture and indigenous tattoo traditions. More generally, the interaction between European tattooing traditions and those of the Pacific or South-East Asia for example, are not well understood.

TATTOO IN PRE-COLONIAL BURMA

Upper Burma where this story unfolds was colonized late in the nineteenth century, creating a frontier zone between British forces and Burmese society some decades after British colonization in South-East Asia, and many decades after the first missionary and trade contacts in the Pacific. The official Government Inquiry into the case of the tattooed woman discussed here is exceptional in this sense because of the written records surrounding the case and the contemporaneous written documentation about local Burmese tattooing traditions.

Despite much longer informal contact from British India, the occupation of Burma took place relatively quickly. In India the colonizing process took place over hundreds of years, stretching from the time the East India Company started exercising administrative powers over the settlements that grew up around their factories until 1858, when Victoria was proclaimed Queen Empress.[5] British annexation of Burma, on the other hand, was accomplished in three wars spread out over a half-century. The third Anglo-Burmese war of 1885 led to British occupation and an end to the Burmese monarchy.

Like Oceania, Burma had a long pre-colonial tradition of tattooing and the persistent fascination with tattooing in South-East Asia is reflected in the richness of sources on the subject from the fifteenth century to the twentieth.[6] By the late nineteenth and early twentieth centuries, travellers, anthropologists, district commissioners and other colonial officials were documenting and interpreting the significance of tattoo in Asia.[7] The first eyewitness account by a European was written by the Venetian traveller Nicolo de' Conti, who observed tattooing in and around the city of Ava in Burma in 1435. He noted in his journal 'the inhabitants, men as well as women, puncture their flesh with pins of iron, and rub into these punctures pigments which cannot be obliterated and so they remain painted forever'.[8] He gave an explanation of tattooing that has since been dismissed as a figment of his rather fevered imagination, but it is interesting as a clue to the role that tattooing was perceived to play in sexual and gendered relationships. Tattooing was, wrote de Conti,

> the invention of a certain queen, who observing that the men were deserting their wives and giving themselves up to abominable vices, persuaded her husband to establish by royal decree this custom of tattooing the loins, thus disfiguring the men, and setting off the beauty of the women.

This account of the origin of tattooing is apocryphal, not least because other accounts of the practice of male loin tattooing emphasize the added attractiveness it contributed.

An account of tattoo practices written 40 years after the British occupation by John Nisbet, an amateur but detailed ethnographer living in Burma for more than 25 years during the late nineteenth and early twentieth centuries, records the technique of loin tattoo:

> The tattooer (*Togwin Saya*) also termed the 'artist in ink' (*Hmingyaung Saya*) begins operations by first sketching the figure in pencil before proceeding to render it indelible by the use of the tattooing instrument (*Sut*) made of brass. It consists of a thin solid lower portion divided into four or eight prickers, often weighted in order to enable the skin to be lightly punctured. The ink used is lampblack obtained from the smoke of sessamum oil and diluted water. On being introduced below the skin it turns the same blue colour as gunpowder when similarly used among soldiers, sailors and schoolboys. With an eight-pronged tattooing instrument work proceeds so rapidly that a person's whole body might be covered with elaborate designs in a day . . . A Burmese lad whose thighs I have just examined, tells me that in his case the operation was performed when he was fifteen years of age, that it was done on three consecutive days and that he was a cripple for about twenty days after. The design all round the thighs consisted of tigers, and fabulous flying animals like winged lions, and demons, dragons . . . [o]ne or two peacocks and fish above his hip joints, one or two demons and quails around his knees, cats and flying animals. The artist's charge

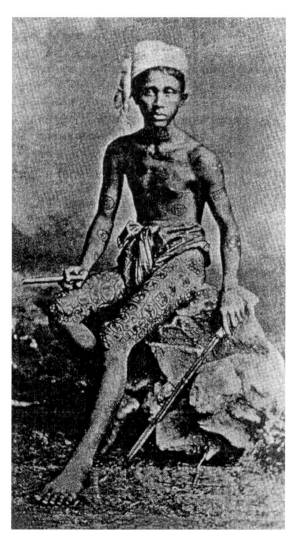

65 Gambier Bolton, *Mr Biato from Mandalay*, 1897, photograph from 'Pictures on the Human Skin', *The Strand Magazine* (vol. 13, no. 54, 1897).

> for operating on him was two rupees, which does not seem an exorbitant price to pay for an indestructible pair of skin-tight breeches of beautiful figuring and indelible colouring.[9]

Nisbet drew parallels between European and Burmese traditions, noting: 'In the kingdom of

66 Gambier Bolton, *British Burma Regimental Crest*, 1897, photograph from 'Pictures on the Human Skin', *The Strand Magazine* (vol. 13, no. 54, 1897).

symbols of the sun and moon.[11] Michael Symes, sent on an embassy by the British to the court of Ava in 1795, recorded that the Burmese 'tattooed their thighs and arms into various fantastic shapes and figures'. Symes understood this to operate as a charm against the weapons of their enemies.[12] He also noted the use of circles tattooed on the cheeks of men to identify them as persistent criminals and assumed that the circles were tattooed with the use of gunpowder, a custom, he noted, prevalent among sailors in the British Navy.

Similarly Ananthakrishna Iyer described how offenders had a circle tattooed on the cheek or a description of their offence inscribed on their chest:

> The Burmese Kings used to apply this art to incorrigible offenders who were tattooed with a circle on their cheeks or the title of their offence was described on their breast. Some rulers used to order the offender to have the names of crimes tattooed in blue upon his forehead.[13]

Robert Fletcher's 1883 account of tattooing among 'civilised people' has a description of criminals in Burmah being tattooed across the breast with a sentence declaring their offence.[14] A more recent study states that prior to British occupation it was customary to tattoo the words 'do no evil' and 'beware' on the left and right wrists of criminals.[15] Myint documented the use of tattooing in anti-colonial movements in the 1930s to signal their resistance to colonial rule and to protect against the British.

Three coloured pigments were commonly used for Burmese tattoo: red, greenish-black and dark

Ava a black spot used to be tattooed on the side of men who belonged to the King, this "palace mark" being the Burmese equivalent of our broad arrow.'[10] Citing an eighteenth-century Burmese military manual, Noel Singer noted that soldiers divided into different companies were tattooed on the nape of the neck. Musketeers who were either of Portuguese or Indian descent were marked with a figure especially created for their regiment. These symbols were commonly based on powerful Burmese supernatural beings. Figures were shown standing on charmed or cabbalistic circles or on

indigo blue.[16] The red pigment, used for tattooing the face and upper body, was designed to fade with age. Patterns in red often represented Buddhist cabalistic squares, symbols and incantations. These designs were intended to bring protection and to act as charms. The use of tiny vermilion spots pricked between the eyes, on the lips and parts of the head were seen to act as a love charm. This type of tattooing called the *Ah Nu Say* or 'tender medicine' was meant to ensure the love-lorn person the return of their affections.[17] Other tattoos in deep blue were tattooed on the ears, jaws, throats, shoulders and back, hips of both men and women and, most commonly by the late nineteenth century, on women's forearms, hands and sometimes feet.

Gambier Bolton's popular survey of tattooing published in 1897 suggests that by the late nine-teenth century Burmese tattooing was considered some of the most artistic and well-entrenched practices of the time:

> [T]oday we find tattooing practiced in such widely different places as Great Britain, Japan, Palestine, Central and South America, Burmah, Borneo, New Zealand and over the whole of Oceania whilst many of the natives of Africa and the wild red men of North America are decorated . . . and in very ancient times we find it also a common practice amongst Germans, Gauls and Romans. . . . But to come down to more modern times, we find England, America, Burmah and Japan the centres of really artistic tattooing . . . the artist sitting on some portion of his victim's anatomy steadies the hollow point of the weapon with his toes and then with both hands proceeds to prod the point into the skin

67 Ananthakrishna Iyer, 'Women's tattoo on arms and feet', line drawing, 1899, from *The Mysore Tribes and Castes* (Mysore, 1935).

> dot by dot . . . This is an extremely unpleasant oper-ation, as the writer can testify from his own experi-ence, and when added to this it is borne in mind that the work is generally performed in public and with a crowd of laughing girls and boys anxiously waiting to hear the victim cry out or use more or less violent language as the operator touches on a tender spot it will be seen that the tattooed in Burmah have to pass through a very disagreeable ordeal. Although since the occupation of that country by the British the practice has become almost obsolete, it is quite common to see men of twenty-five and upwards tattooed, as shown in the photo-graph taken of a native, a Mr Biato of Mandalay, and the artists still manage to earn a precarious livelihood by operating on travellers and soldiers who are stationed there.[18]

Bolton also recorded that some military officers and men who had been quartered in Burma bore the regimental crest or badge on their arms 'roughly forced into the skin with the weapon already mentioned'.[19]

A COLONIAL INQUIRY

In this context of continued tattooing practice for both protection and punishment, shortly after the violent occupation of the Burmese highlands by the British military police in 1886, a case of enforced tattooing on the forehead of a local Burmese woman by order of a British police superintendent came to the attention of the highest levels of colonial officialdom. Burma's Chief Commissioner, Sir Charles Croswaithe, was drawn to a paragraph in the *Rangoon Gazette* of 28 May 1889, charging an Assistant Superintendent of Police with having the words 'Bazaar prostitute' tattooed on the forehead of a Burmese woman who, the paper claimed, had been his mistress.[20] At the time there was considerable parliamentary debate and public concern back in Britain about the conduct of the Burmese military police and, unable to obtain further information from the editor of the newspaper in which the article appeared, the Inspector-General of Police ordered the District Superintendents of the Mandalay, Myingyan and Meiktila districts to enquire into the case. The Chief Commissioner directed that every police officer in Upper Burma should be ordered to state distinctly if he knew anything about the matter.

As a result of these initial police enquiries, the District Superintendent of Police, Mandalay, who had been making independent enquiries, reported to the Inspector-General that he had had the 'branded woman before him'. Ma Nge claimed she was procured by local Burmese men who took her to the bungalow of a European officer who went by the name of *Wundauk* (District Superintendent of Police). The Wundauk 'had connection with her during the night' and then allowed her to return home. About three days later two Burmans came and took her to the police guard outside the village, and while there a tattooer by the name of Maung Lun tattooed on her forehead the word prostitute. She claimed that about eight men were present when it happened and that she was held down by two of them. Maung Lun, the professional tattooer, corroborated Ma Nge's statement and claimed that he was ordered to tattoo the word on her forehead by the Superintendent of Police, Mr Chisholm. The report concluded by noting that the words 'bazaar prostitute' were hardly visible on her forehead but in fact only a couple of faint red letters could be made out.[21] This was later substantiated by a medical doctor who, in the course of the inquiry and in the interests of scientific accuracy, shaved the hair from Ma Nge's forehead and confirmed only red spots of pigment on her hairline and forehead were discernible.

On the strength of the initial report, however, the Chief Commissioner, with the interest and backing of the high-ranking Under-Secretary of State for India, demanded a full inquiry into the matter. This inquiry continued over three months and caused a furore at the time in the Anglo-Indian, Burmese and British Press.[22] Mr Chisholm, the police superintendent in question, was asked

to leave his post in Upper Burma and proceed to an official inquiry in Mandalay. In the event he was permitted to cross-examine all the witnesses, including Ma Nge, the woman in question.

Perhaps predictably the inquiry came to be a trial of the Burmese woman's character rather than the police officer's conduct, and in the end the conclusion of the inquiry was that 'Ma Nge', married to a Burmese police officer, was in fact 'a woman of loose character, if not wholly a public prostitute'.[23] It was alleged by Chisholm that she had been paid by disaffected Burmese police officers to make up the story against him and she was asked to explain why the tattoos on her wrists, done a long time previously, were evident while the much more recent tattooing had substantially disappeared. Chisholm, it was concluded, was in no way party to the ill-treatment of the woman. Instead, local Burmese police constables were reported responsible for any violence against her. Maung Sin, a local Burmese man, a clerk in the Deputy Commissioner's Court, was accused of stirring up the rumour and the case, of acting in cahoots with local lawyers and the proprietor of the *Mandalay Herald*, and of paying Ma Nge to come before the inquiry.

Despite the high level of official interest in the case, curiously, in the course of the trial, the tattooing on the woman's forehead became one of the least interesting aspects of the inquiry from the British point of view. To highlight this lack of surprise at Ma Nge's tattoo, three other local women were produced before the court, a Ma Byan, Ma Daw and Ma E Dyu, each testifying that they had been tattooed in red on the forehead voluntarily some years ago and no longer had vis-

ible tattoos, or only very faint lettering. From an official point of view, it was Police Superintendent Chisholm's use of a Burmese police constable under his orders as a procurer or at the least a go-between to establish relations with a local woman that needed further investigation. 'Immorality' was considered a 'serious offence' in an officer of the Government. But the immorality in question, when all was said and done, was not that of sleeping with the Burmese woman, or of ordering her to be tattooed across the forehead. In an off-the-record letter calling for further investigation into Chisholm's actions a few weeks after the official inquiry had found in his favour, Chisholm's offence was to use his police subordinate as a procurer: 'one of the worst official offences' the Chief Secretary to the Chief Commissioner of Burma wrote to the Inspector General of Police.[24]

> It makes discipline altogether impossible and causes service in the police to be dishonourable to the men employed and the Force to be looked down upon and detested by people. It leads to disgraceful scandals . . . the fault of which, unfortunately can not be restricted to the reputation of the individual at fault.

The lack of evident surprise about the tattooing on the woman's forehead tells us both about continuing Burmese tattoo and the colonial context of British tattoo. In Burma, as this case illuminates, as in other colonial contexts where tattooing traditions were important before colonization, there was an interaction between local Burmese uses of tattoos for branding criminals and also for protection, and Europe's own traditions of tattoo for stigmatization and identification. To

From R. Martin, Esq., District Superintendent of Police, Mandalay, to the Personal Assistant to the Inspector-General of Police, Burma,—No. 814-12A., dated the 3rd July 1889.

I have the honour to acknowledge the receipt of your letter No. 33C., dated the 13th June 1889, and in reply to inform you that enquiries have been made as requested in your letter and the following report submitted for your information.

The scandal regarding the branding of a Burmese woman by a Police Officer originated in the Civil Judge's Court, Mandalay, amongst the following lawyers, Messrs. Hirjee, Pillay, Swinhoe, Dawson, and D'Silva. It appears Messrs. Hirjee and Pillay were heard mentioning to Mr. D'Silva that a certain Burmese woman in the district bears on her forehead tattooed the words ဈေးဆိုး (bazaar prostitute), and that this was done by the orders of a Police Officer belonging to the Myingyan or Kyauksè district, and that it was suggested by those present that the matter should be advertised. Some few days after this an advertisement appeared in the *Mandalay Herald*, the proprietor of which is Mr. D'Silva, who is already mentioned amongst those who were present in the Civil Court when this conversation took place.

I sent Messrs. Hirjee and Pillay subpœnas, and the former admitted that he did speak of this scandal to Mr. D'Silva, but regretted that he could throw no light as to who the culprits were, but had an idea that he first heard of the report whilst at Myingyan. I have since had this branded woman before me and find that she at present resides at Kyauksè. She makes the following statement and says that some two years ago she resided at Natogyi village (Myingyan district); that a Burman named San Kado and a Native servant came to her house and took her to the bungalow of a European officer who went by the name of *Thanmigyi* (သင်္ကြီး), *Wundauk*,* alias *Shwe Kodaw* (ရွှေကိုတော်), that the *Wundauk* had connection with her during the night and then allowed her to return home. Some three days after this two Burmans (names not known) came to her house and said that the Thanmigyi wanted her, and took her to a police guard outside the village, and whilst there a tattooer by name Maung Lun tattooed on her forehead the word ဈေးဆိုး (prostitute). The following persons were present when Ma Ngè was tattooed,—Nga Pè Thi, Nga San Po, Maung Kyauk Lun (Saya Lun), U Po Sin, and Ma Shwe Gun. No reasons can be given by Ma Ngè for being tattooed. The European called her when in the house on the night she had connection a *meinmashwin* (prostitute), but he was not present when she was tattooed, and [she] was merely told by those present that it was the order of the *Thanmigyi Wundauk*. She then had to fly from Natogyi village to Pyinzi village as a Burman police constable named Nga Pè Thi tore off her clothes and left her in a state of nudity. She remained at Pyinzi for 10 months, then returned for three days to Natogyi on hearing that her enemies had left the place. She has since joined her husband at Kyauksè, who is a head constable. Some seven days ago Inspector Maung Myat Tha and U Aung Gyi, of the Myingyan police, came to her house at Kyauksè and asked her to return to Natogyi, and that they would give her Rs. 15 or Rs. 20 a month. When this offer was made the following persons were present,—Ma Myin, wife of U Pè, Ma Thet Su, and Ma Shwe U Maung Lun (professional tattooer) corroborates Ma Ngè's statement and says that he was ordered to tattoo the above word on her forehead by the present Superintendent of Police, Myingyan, Mr. Chisholm.

68 Extract from *Proceedings in the matter of the alleged branding of a Burmese woman on her forehead by order of a Police Officer*, 1889.

understand the significance of the case, and the lack of surprise at the tattooed forehead, it needs to be contextualized within a wider nineteenth-century history of convict tattooing in Europe and its colonies. This context in turn forms part of a much longer history of the use of tattooing by Greeks, Romans and Celts for penal and property purposes to mark criminals and slaves.[25] It was the nineteenth century, however, as Jane Caplan has argued, that captured the tattoo in the full glare of official publicity and regulation.[26] In other histories of European tattooing, the usual theoretical procedure is to trace the ways that the penal use of tattooing was inverted when tattooing was appropriated, say by Christians in Roman territories or by other sub-cultural groups within dominant cultures.[27] This case of forcible tattooing of a local Burmese woman by a British colonial police officer reverses that usual paradigm and highlights a history of interaction between

South-East Asian and British colonial use of tattoo.

In some regions in eighteenth-century India, for example, tattooing on the forehead had become an established part of penal culture under British rule. Under British East India Company control, as Clare Anderson has shown, bodily markings were integrated into colonial penal codes in areas of South Asia.[28] In the Bengal presidency, for example, life convicts, perjurers and forgers had their name, crime, date of sentence and court by which convicted tattooed, in the vernacular, on the forehead. Similarly, when areas around Madras were ceded to the East India Company life convicts were tattooed on the Bengal model, that is, on the forehead from 1803. In William Sleeman's infamous campaigns against thuggee (anti-colonial guerrilla fighters were classed as a criminal caste by the British administration) concentrated in central India in 1830, men who were arrested had the words 'convicted thugs' on the forehead or back in the vernacular. Marks in the vernacular provided a warning of their crime to potential future victims and were an irrevocable prescription of criminal identity.

What is unusual in this case, then, is not the forcible tattooing on the forehead, for this had for many years played a part in the fabric of British colonial rule in East Asia, but the extra-judicial nature of it, the widespread public interest in the case, and the fact that it had become the object of a public inquiry. That it did indicates a shift in official British attitudes towards tattooing as a penal tradition. The inquiry into the tattooed Burmese woman can be seen in a broader context

of a new public interest in and moral outrage at acts perpetrated against the body as a form of punishment in the late nineteenth century. The official interest in the case and the surrounding publicity are symptomatic of changing colonial attitudes and can be more broadly related to that axiom of Enlightenment philosophy, that the treatment of women is an index of civility. The later nineteenth century was a period in which the British women's movement at home and evangelicism in the colonies was reaching a new peak.[29] It was a philosophy that would be echoed by Engels: for these reformist women the status of 'native' women provided an exemplar of the status of the whole society. In the context of British interaction in South-East Asia, where tattooing was an established part of colonial control and punishment, this Government inquiry into the case of a woman tattooed on her forehead reflects contestations and the re-definition of British masculine colonial identity in the later nineteenth century.

COLONIAL VOICES

Ma Nge, the 30-year-old Buddhist woman at the centre of the case, gave her own evidence before the inquiry. She claimed that the police superintendent had been to her house on three or four occasions and that they had 'had connection on two occasions'. Shortly afterwards police constables came for her saying ' . . . you have given the Wundauk a sickness and he has got sores, so you are to be tattooed on your forehead'. They wished it done in black, Ma Nge recalled,

but the tattooer and Sergeant [a Burmese police officer] took pity on me and did it in red. . . . From fear of the Wundauk I at once left the village. As I was leaving the guard-house a police constable . . . snatched off my tamien [dress] . . . the tattoo marks were quite visible when it was first done but the marks have worn away.[30]

Evidence given by a later witness claimed that, in addition, Ma Nge had raw chillies rubbed into her genitals as further punishment for her 'crime' of allegedly passing on a venereal disease to the British officer.[31] Maung Nyo Lun, the tattooist, was also called to give evidence:

> I was told . . . that it was the order of the Thanmigya Thakin (Superintendent of Police) that the words 'Meinma Shwin' [Bazaar Prostitute] were to be tattooed on her forehead. They said 'do it in black pigment', I replied 'No'. I refused to do it in black 'go again and speak to the Thanmigy Thakin and ask him to let me do it in red, she might as well dies as have it done in black' . . . I wrote the words with red on her forehead and then used the needle. The places where the skin was not punctured were more numerous than those where it is punctured.[32]

In this detail of the inquiry it can be seen that the tattooist exercised agency, in a context that appears from the outset to be one of official violence, through the technique and practice of tattooing. As we have seen earlier, the presence of red dots on the forehead, or between the eyebrows, had the significance of a love charm in pre-colonial Burma – a tradition that continued after British occupation and was recorded in the late nineteenth century. To inflict his punishment, the British Superintendent of Police was dependent on the Burmese tattooist and in this dependency came an opportunity to change a punishment into a charm. It was the act of tattooing itself that gave him scope to subvert the punishment. Significantly, in the broader context of colonial rule, Maung Nyo Lun's actions in this case were not exceptional. Anderson has noted in her work on British colonial tattooing that in regions where the tattooing of criminals was part of regulations under the East India Company, there were often difficulties in finding appropriate local tattooists. From fear that local professional Indian tattooists would not perform the task effectively, some convicts were marked on arrival at jail rather than at the place of their trial.[33]

'Could skin be the site', as Elspeth Probyn suggested, where 'difference becomes intense, sucks both ways and rearranges the present?' The point of the tattoo needle in the Burmese case, and more broadly in the Indian context, was a site of power and subversion in a time of frontier colonialism. Tattooing was a particular kind of practice whose technology could subvert dominant, colonial meanings, and it continues to be so in contemporary contexts. The tattoo, as Gell argues, is a practice that occupies a kind of boundary status on the skin. Cultural meaning is derived from or attached to the tattoo's visible and indelible physical status on the body and this is paralleled by its cultural use as a marker of difference, an index of inclusion and exclusion. Yet, despite the fact that the tattoo is visible and indelible in a physical sense, the structures of exclusion and inclusion that it appears to support

are undermined by its conceptual instability.

The tattoos 'unfixity' seems to be at its most blatant in Western society, argues Gell, because it has not been fully integrated into Western culture, unlike the Polynesian societies that Gell discusses.[34] But as the case described here shows, the tattoo's unfixity may not always be at its most intense in metropolitan Europe. We need also to ask what happens to the technology and practice of tattoo in the process of occupation, policing and sustained interaction under colonialism with indigenous local practice? In both pre- and post-colonial Burma, the tattoo meant a number of different things and served different purposes. The vermilion tattoo, designed to fade over time, speaks in particular of a physical and conceptual unfixity.

I began by using sources from Burma that change and complicate our understanding of British colonial tattoo culture. In conclusion, I return to my earlier questions about the broader implications for representations of tattooing in the Pacific when seen in comparative perspective. Encounters with Polynesia, as other writers have established, were a critical event in the eighteenth- and early nineteenth-century European imagination, helping to establish its cultural identity and boundaries. The Pacific encounter acted, for example, as a way to define British gender and class categories and played a part in refining and categorizing ideas about sexuality. In particular, as Harriet Guest has argued, the way tattooed bodies were perceived in the Pacific by European voyagers was important to differing notions of modern masculinity at 'home'.[35]

A comparative perspective shows that this was not a process confined only to these Pacific encounters but was played out in different ways in various contexts and times. The punitive use of tattooing by the British in nineteenth-century Asia is revealing of a wider set of ideologies about the body and reflects contestations over gendered identities, in particular British colonial masculinities. In its own way an exploration of British colonial tattoo and its interaction with indigenous practice is revealing of a wider set of power relations, of colonial institutions such as the military police, and more generally of the mechanisms of colonial social and political reproduction. One conclusion, then, is that tattooing in the Pacific was and remains of a particular intensity but a conceptual divide between an 'unanchored' European world of tattooing, where it was and is only a marginal occurrence, ignores a history of tattooing by the British in colonial contexts. A continuing sense that tattooing historically belongs to 'other' cultures than Europe is one result of this conceptual divide.

Contemporary Exchanges

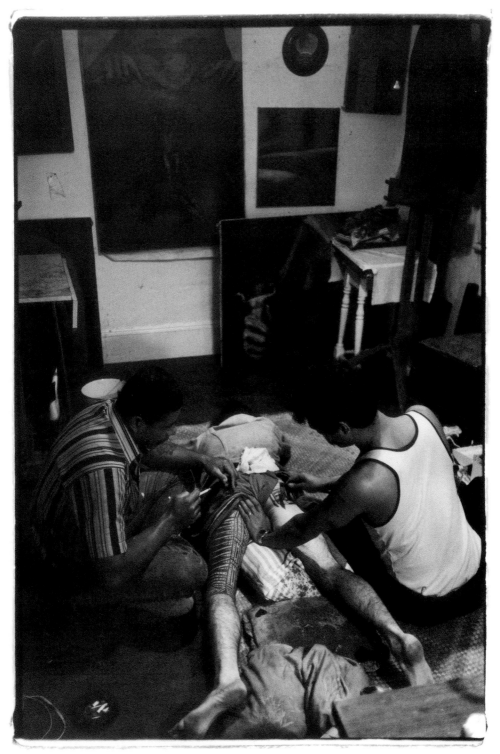

69 Mark Adams, *Gunson Street, Freemans Bay, Auckland.*
Tony Fomison in the studio upstairs with Paulo Sulu'ape and
Pio Taofinu'u, 1979, goldtone silver bromide print.

CHAPTER SIX

The Temptation of Brother Anthony: Decolonization and the Tattooing of Tony Fomison

Peter Brunt

Between 1979 and 1980, the New Zealand artist Tony Fomison was tattooed by the *tufuga tatatau* (tattoo expert) Sulu'ape Paulo II with a traditional Samoan *pe'a*, an intricate body tattoo extending from the waist to the bottom of the knees. Paulo was a recent Samoan immigrant living in South Auckland, working as a *tufuga tatatau* in the evenings and weekends among mainly fellow migrants like himself. Fomison was a nationally renowned painter of European descent, famous for his dark, Goya-esque allegories of the self and the nation and his combative, adventuresome lifestyle, often featured in newspapers and magazine articles. His tattooing occurred over several sessions at various locations around the city: the artist's studio in Ponsonby, an inner-city, multi-ethnic suburb; the *tufuga*'s home in Mangere in South Auckland; the family home in Onehunga of another participant in this affair, a young Samoan law student, Norman Tuiasau, the artist's friend and 'tattoo brother', who underwent the ordeal at the same time.

Fomison's tattooing was a complex event, significant on several levels. On one, it was an episode in the artist's personal life, emerging from the contingencies and chance encounters of everyday life in the city. Tuiasau happened to be Fomison's neighbour in Ponsonby, living across the road in Gunson Street. The artist's friendship with Sulu'ape grew out of a sequence of fortuitous meetings and seized opportunities: the chance discovery of Samoan tattooing in the city and a decision one day on the part of Fomison and Mark Adams, a friend and photographer, to seek out the *tufuga*, whom they'd heard about through friends. The ordinariness of this milieu is not unimportant to the nature of the event. Fomison's tattooing occurred in the 'life-world' of the city. It was not a formal, public ceremony; it came about through the negotiation of personal friendships and transpired in the casual privacy of people's homes and daily lives.

On the other hand, his tattooing was indeed a public event, significant on a national scale. It was recounted in newspaper articles, magazine features, television documentaries, photo essays and personal anecdotes as the defining episode of Fomison's highly visible and carefully constructed public persona. Moreover, his tattooing seemed to reflect, or personally embody, profound historical

changes taking place in Aotearoa-New Zealand. For from the late 1950s to the end of the 1980s, the span of Fomison's adult career as an artist, the country went (to put it crudely) from a largely monocultural, Eurocentric, protectionist welfare state, dependent on British markets and British cultural ideals (the historian James Belich sums up the national super-ego of the period in the phrase 'Better Britons')[1] to a post-colonial, bi-cultural and multicultural nation dominated by neo-liberal economics and the global market-place, and eager to redefine its culture and identity as uniquely Pacific and Polynesian. Fomison's personal metamorphosis from a Pakeha New Zealander to a *soga'imiti*, a tattooed 'Samoan' man, seemed to mirror or allegorize this national transformation. One might almost say its 'text' was written into his flesh.

Thus, in an interview in 1981, Fomison described his move from Christchurch, where he was born in 1939, to Ponsonby in Auckland in 1974 as a deliberate attempt to engage with Polynesian people and simultaneously as a rejection of the British colonial 'imago' in which the nation had been historically fashioned.

I like Auckland because it is not bloody English everything. It's the biggest Polynesian city in the world . . . I was looking for a freer place, not tied down to mother England. I felt at home in Ponsonby, so I did everything I could to live there.

Getting tattooed, he went on to say, was both a gesture of respect for the art of the *tufuga* and an affirmation of the values of Polynesian culture. It was a statement *to* the dominant culture – the

primary audience for his ordeal – of an impera-tive to redefine its identity in Pacific terms.

I go to extremes about this sometimes, but I really do think we need to develop the Polynesian aspects of our life down here at the bottom of the Pacific. Getting tattooed was, for me, my vote of confidence in the important values of Polynesian culture.[2]

It was also Fomison's answer to the vexed ques-tion of settler identity in the 1960 and '70s, faced with the gathering forces of political and cultural decolonization in New Zealand and the Pacific in general. As Simon During put it:

The sixties drive for utopian alternatives both came from, and continually struck against, another set of questions: what is it to be a New Zealander today? How to live *here*? Or more accurately: how to affirm one's New Zealandness . . . [when] older stereotypes for, and ideologies of, white New Zealandness seemed to have lost their persuasiveness[?].[3]

By the early 1990s, in the wake of the artist's death in 1990 and more especially in the aftermath of revolutionary governmental reforms in the late 1980s, Fomison, with his tattooed body, came increasingly to exemplify a kind of new ideal of the national subject:

He seems to have lived multiculturalism to the end.[4]

[Fomison was] a shaman to this multifarious South Pacific culture that he was never afraid to front up to.[5]

He had such an amazing connection with Maori-

tanga and Polynesia and he would be the only *palagi* artist I admire because of his intelligence to talk about these things in a genuine way.[6]

Rigorously to live biculturally is to re-invent oneself, to identify across cultures, to undergo a certain 'conversion' – as Fomison, born into a Pakeha working class, Christchurch family became, at least in part, self-identified as a Samoan.[7]

While Fomison in many ways certainly deserved this admiration, significant aspects of his life and work undercut any attempt to view him as simply a hero of historical change or a new ideal of post-colonial subjectivity. His paintings, for one thing, are deeply melancholic. They are replete with images of confinement, paralysis and death, as if he were exploring the *underside* of historical metamorphosis, its apprehension of discontinuity and loss. Then there is the contradictory – or at least ambiguous – relationship between the utopian vision of social change that animated his life and art in the 1960s and '70s and the neo-liberal / bicultural state that came to power in the 1980s. There were hardly congruous. In those early decades Fomison's paintings – populated with images of Vietnamese war victims, Black American civil rights heroes, South African martyrs of apartheid, human rights activists and so on – are steeped in the political passions of the period. These figures are joined in turn by images of social outcasts of every description: beggars, vagrants, lunatics, freaks, weirdos, the diseased; a veritable catalogue of 'the wretched of the earth' whose iconic presence in his paintings embodied the dialectical, redemptive ambitions that fired

Fomison's imagination and drove his personal brand of political activism. For Fomison also threw himself into the fray of his times, joining anti-Vietnam war demonstrations, the Gay Liberation Front, anti-apartheid protests, Maori land marches, anti-nuclear protests and pretty much whatever else was going down at the time. These activities had their specific occasions; but they were also directed against a more abstract enemy: 'the state' or 'the capitalist system'.[8]

Now it is just this dream of liberation and social redemption that is also *encrypted* in Fomison's paintings. They represent the idealism of a post-war generation of young New Zealanders, battling the teetering edifice of the welfare state, that is, as Simon During puts it, '*lost in the public memories of* [that era]'. Recalling his own experience of the 1960s and '70s in 1994 through a re-encounter with Fomison's paintings of that period, During concedes: 'All this was, in Proust's sense, time lost'.[9]

In other words, Fomison's project exposes deep *discontinuities* between the decolonizing imaginary of the various protest movements and activist politics of the 1960s, '70s and early '70s, and the radical, government-driven reforms of the late 1980s and early '90s, which systematically dismantled the welfare state, privatized the economy, institutionalized biculturalism, and otherwise 'restructured' the state and the nation to survive in a recently globalized 'free-market' economy. Only in partial and compromised ways was the neo-liberal/post-colonial state inaugurated by these reforms continuous with the utopian political imagining, much of it anti-capitalist, of the previous two decades.[10] Indeed, the state's

reforms largely brought that era to an end, dissipating its idealism in the new status quo or co-opting its energies into the new structures of power. While there were, to be sure, important victories for the colonized in the late 1980s – such as the empowerment of the Waitangi Land Claims Tribunal in 1985; the establishment of biculturalism as official state policy in 1986 and 1987; and the revivification of the Treaty of Waitangi as a foundational national document – the economic and geo-political arrangements set in place in the 1990s none the less represented a massive defeat for the kind of leftist ideologies that inspired Fomison and his allies. The 1980s marked the final collapse of a global colonial system unravelling politically and ideologically since at least the end of the Second World War. At the same time, many argue that 'neo-colonial' and 'new-imperial' power formations have only displaced old colonial structures and ideologies, utterly transforming colonialism while continuing it by other means. Indeed, as Robert Young puts it, the paradox of liberation struggles worldwide was to have 'helped the new imperialist system to break up the old one'.[11]

So Fomison's apotheosis at the turn of the 1990s was an ambiguous one, a Pyrrhic victory. In a posthumous exhibition of his work that toured New Zealand's major cities in 1994 and 1995, the tension was recognized. Entitled *Fomison: What Shall We Tell Them?*, and curated by Ian Wedde, the exhibition was both a tribute to the artist and a farewell. What had passed away, however, was not just Fomison but also an entire historical era for the country, along with many of the mythologies that had defined and sustained it. As Wedde wrote:

We have to recognize that [Fomison's] art was made at a time when these stories were beginning to break open and their audience to disperse. Fomison took his art just past that moment where we sense history sheer away from the redemptive myths towards which he drove himself and his audience. His art offers us, the audience he needed but also hectored and could never trust, the chance to measure ourselves against his bravery. It also offers us the chance to reroute ourselves from an old history of longing whose disintegration overwhelmed him.[12]

'Rerouting ourselves' was a historical necessity by the 1990s, if not a *fait accompli*. But the 'chance' to do so is exactly what Fomison's art *doesn't* offer us. The paradox of Fomison's painting is that 'redemption' was always imagined menaced by blockage or failure. As Garth Cartwright put it, 'Fomison doesn't lack conviction – he confronts his monsters, exposes his nightmares – yet his failing is that *he never overcomes them*, he seems destined to live in purgatory'.[13] His *inability* to 'reroute' himself from 'an old history of longing' – his *failing*, as Cartwright calls it – is the persistent theme of his paintings. That is what they 'tell us'. The irony of Wedde's suggestion is that it proposes a narrative of national passage from welfarism to neo-liberal post-colonialism on the melancholic *impasse* of his paintings. History takes its exit from the late colonial state past the no-exit signs he relentlessly painted. For the real obsession of Fomison's art is not redemption but the failure of redemption – a theme that must be linked to the dilemma of settler culture, its desire (but inability) to construct its existence in enabling ways against the ethical quandary underlying its

occupation of the country on dubious terms. There was to be no 'rerouting' from that particular historical burden.

This brings us to a question that deserves to be asked about Fomison's project, which is: what is the relationship between his painting and his tattooing? Fomison never painted his tattooed body, or the body tattooed, despite numerous self-portraits and portraits of alter-egos. There is, however, a striking imagery of the body in his painting, and particularly – if we may risk the comparison – of the body tortured and subjected. There is also a significant correspondence between tattooing as a 'technology' of the body for 'the creation of political subjects', which Alfred Gell argues was once its function in Polynesia,[14] and the predominant theme of Fomison's painting, which was also, I would argue, the formation of political subjectivity. In Fomison's case, however, the context is the New Zealand welfare state in the throes of structural, ideological and historical transition. Subjectivity in this context was also, as far as Fomison's paintings were concerned, an affair of the body.

In 1979 the artist was photographed by Mark Adams during a tattooing session in his Auckland studio. In one image from that session, Fomison can be seen lying face-down on the floor while Sulu'ape Paulo marks out the night's work on the back of the artist's shaved thigh, his left hand steadying his mark by brazenly taking hold of the artist's backside. Meanwhile, an assistant (who wipes the blood) smokes a cigarette, waiting for the tattooing to begin. What is intriguing in this photograph is the similarity between the drama acted out on the studio floor and the strange scenes visible in the paintings near the artist's head. Resting on the floor to Fomison's right is a small canvas entitled *Hand of Fate* (illus. 70), painted in 1979, the year his tattooing commenced. In it, a 'little man' (a recurring character in the artist's *œuvre* and one of those alter-egos for himself) is held from behind in the grip of a giant, hooded figure personifying Fate, just as Fomison, prone on the studio floor, is held from behind in the 'grip' of the tattooist. The 'little man' flexes his muscles and puffs out his chest in defiance at the world – but he advertises a power that is ultimately impotent given his real situation, where Fate controls his every move. Adjacent to that painting, directly above the artist's head, is another canvas entitled *Up Up and Away* (illus. 71), also presumably painted in 1979. In this painting, a naked, blindfolded man, his body unmarked (in stark contrast to Fomison below), rises from the mouth of a giant corpse whose death shroud has been pulled back by a ghoulish-looking figure, who presumably allows the man's escape. Fomison painted more than one version of this subject. In another, called *Open Window* (illus. 72), a small sky-blue rectangle is visible at the top-right corner of the canvas, suggesting the goals of light and escape, which impel the man's ascent. Beyond this nightmarish ordeal is the world of the living and normal social intercourse. What is the relationship between these enigmatic scenes and the ritual the artist is about to undergo on the studio floor in Adams's photograph?

Both paintings may be read as allegories of resurrection or rebirth. In Polynesia, tattooing was also a ritual that, in a variety of ways, imitated or alluded to processes of childbirth and separation

from the mother. This was certainly the case with male tattooing in Samoa, where young men were traditionally tattooed with the *pe'a* as a rite of passage into the status and privileges of early manhood. Tattooing Samoan males was seen as the ritual counterpart to the female experience of giving birth: women grow up and give birth; men grow up and get tattooed, as a famous couplet from a Samoan tattooing song puts it. In his brilliant exegesis of Samoan tattooing, Gell refines this gendered complementarity, arguing that the male tattooing ritual imitates not the bearing of children, but the very experience 'of being born (or reborn)'.[15] From the first cut of the skin, which releases the flow of blood, to the final tattooing of the *pute* motif over the navel, which completes the ordeal by sealing off that part of the body as evidence of maternal birth, Samoan tattooing recalls the processes of parturition and separation from the mother. Its purpose is to secure male personhood as independent of maternal birth, to make a creature who is a fully social and cultural person, rather than a natural, or dangerously other-worldly, one.

Many of Fomison's paintings are also about birth or rebirth. But in contrast to the ritual described above, as well as the one Fomison is about to undergo in Adams's photograph, they are about *the failure to be born or reborn*. They picture rebirth from the far side of the event as if it promised nothing but its opposite: annihilation and death. Or they picture it as some catastrophe: born freakish, as in Fomison's numerous paintings of monsters and mutants; or badly, as in his series of 'dead baby' paintings: malformed foetuses strung upside down from hooks. These paintings, unlike tattooing in Polynesia, represent the failure to attain satisfactory personhood, the inability to accede to the social or cultural contract implicit in the metaphor of rebirth. In *Up Up and Away* and *Open Window*, escape or rebirth are represented as a desperate wish, a forlorn dream, menaced or threatened by defeat. In *Up Up and Away*, the ghoulish 'woman' holds the death shroud in her hands – *and* mouth (for ghouls feed on the dead). She confronts the viewer with staring blue-red eyes, as if the man's fate lay in some obscure collusion between them. Will they – will we – allow him to pass from this nightmare into the world of the living or will the 'woman' envelop him again with the shroud of death and darkness? His fate is in her hands. But the painting keeps the question in endless, purgatorial suspense.

In *Not Just a Picnic* (illus. 74), also painted around the same time in the years 1980–82, a family is depicted at a beach, viewed from the interior of a deep cave. The beach is an iconic site in New Zealand of the country as a utopian social paradise, a good place to bring up the kids. But in Fomison's painting, relationships within the family – the first model of political societies, according to Rousseau[16] – are clearly strained. The 'father' refuses his role in this society, isolating himself in the depths of the cave, almost as if he would be absorbed by it, while the 'son' sits alone between the darkness of the cave and the sunlight and sociability of the mother and child beyond. How to pass beyond this threshold? This painting too elaborates the theme of rebirth as an aborted social ritual. The cave in the painting is an anthropomorphic presence, its forms transmogrifying into the muscular 'sinews' of a giant body,

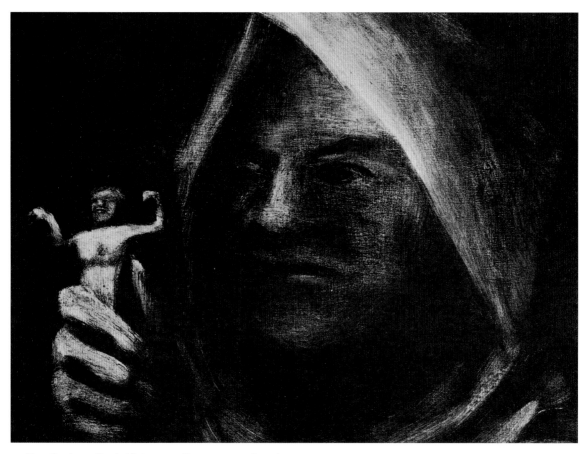

70 Tony Fomison, *Hand of Fate*, 1979, oil on canvas on board.

like the giant corpse in *Up Up and Away*. Could this be a view from inside the corpse's mouth? Caves are one of a series of interchangeable motifs in Fomison's painting comprising crypts, crevices, canals, boxes, mouths, mazes, wombs, vaginas and enveloping landscapes that may be interpreted as so many metaphorical variations of the maternal body. Indeed, recalling Gell's characterization of tattooing imitating the very experience of being born, the point of view in *Not Just a Picnic* is arguably that of the emerging foetus, looking anxiously through its birth canal at a

social ideal of the bourgeois, nuclear family it cannot, or will not, join.

In two further paintings based on the well-known children's nursery rhyme 'Humpty Dumpty', the narrative turns masochistic. In *'Naughty boy!' Humpty Dumpty gets a telling off* (illus. 75), Humpty Dumpty – an egg (this is another painting about birth) – is depicted perched on a wall smoking a cigar, cheekily defying the wagging finger of authority, who no doubt warns him of his fate; namely, the irreparable shattering of himself and his bodily envelope,

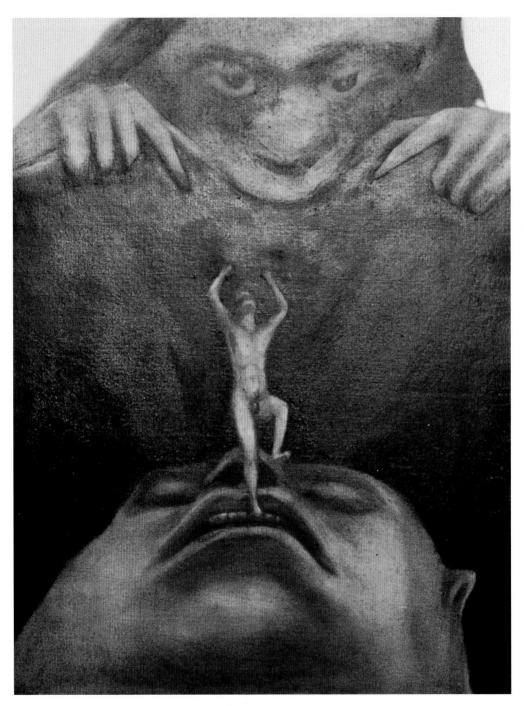

71 Tony Fomison, *Up Up and Away*, c. 1978–9, oil on canvas
on board.

72 Tony Fomison, *Open Window*, c. 1977, oil on hessian on board.

which, as the rhyme has it, all the king's men and horses could not put together again. The same theme appears with a similarly comic touch in *Humpty Dumpty toasting himself in the mailbox: he's just got a birthday parcel* (illus. 76). In this painting the imminent tearing open of the parcel's wrapping serves to allegorize the fate that awaits the birthday boy himself. These paintings recall Freud's characterization of the masochist as someone who 'wants to be treated . . . like a naughty child', who finds some obscure pleasure in being beaten, maltreated, or debased.[17] Humpty Dumpty is naughty because he *wants* to be punished. The paintings clarify an important aspect

of Fomison's painting: that the body is always depicted in implicit or explicit relationship to a stronger power, to some figure or metaphor of authority or the social order.

The introduction of a masochistic theme, however, further complicates the relationship between Fomison's painting and his tattooing. Not because tattooing is masochistic – it isn't – but because masochism implicitly subverts one of the central functions of tattooing as a technology for the creation of political and social subjects. Gell's book, *Wrapping in Images: Tattooing in Polynesia*, is premised on Foucault's influential proposition that 'the body is directly involved in the political

73 Tony Fomison, *Untitled no. 126*, c. 1976, oil on hessian on plywood.

74 Tony Fomison, *Not Just a Picnic*, 1980–82, oil and epoxy on hessian on board.

field'; 'power relations', Foucault writes, 'have an immediate hold over it; they invest it, mark it, train it, torture it, force it to carry out tasks, to perform ceremonies, to emit signs'.[18] Polynesian tattooing is a case study of that intimate relationship between the embodied person and the political order. Following Foucault, Gell stresses that this person-making function was not simply a matter of imposing tattooing with its social meanings on the body from without, like a slave branded by his master. Tattooing ideally entailed a subjective, consensual, properly hegemonic aspect, as something paradoxically desired and desirable. It was not just a means of subjection, but of subjectification. As Gell writes, 'In Polynesia the physical subjection involved in tattooing expressed hierarchy and domination, yet it was most ardently sought where, in effect, it was most obligatory.'[19]

Interestingly, while Gell's book concentrates on Polynesia, it begins with a comparative glance at tattooing in the modern, industrializing West, where, from the eighteenth century until perhaps very recently, it was largely associated with marginalized subcultures and the lower classes: sailors, soldiers, prostitutes, criminals, prisoners

and the like. Even in this context, Gell shows, tattooing continued to function as a technology for the making of persons in ways that reflected the ideological content of society's dominant discourses. In the West, however, tattooing contrasts with Polynesia by the deeply hostile and prejudicial meanings attached to it, derived from discourses of Western 'knowledge' at the time – scientific criminology, evolutionary theory, psychology, aesthetics – and directed against the class 'other' in ways designed to exclude them from social privileges, rather than include them. (Similar ideas, of course, of psychological underdevelopment and irrational propensities were directed towards the racial or 'primitive' 'other'.) Yet in the practice of Western tattooing there is the same paradox. For these very meanings were often appropriated and internalized by their victims in a voluntary inscription on their bodies. Gell gives the example of typical texts like 'BORN CRIMINAL' or 'Born to be hanged' tattooed across the chest. Despite the negative value of such markings, they none the less served a kind of protective function that still defined the self through a set of meanings derived from the social order.

One of the core ideas Gell develops in his book is derived from a psychoanalytic study by Didier Anzieu called *The Skin Ego*, which argues that 'the psyche is grounded in bodily existence and bodily structures at every point',[20] and that the skin, in particular, is a fundamental locus for the sense of selfhood. Further, the skin's peculiar character as a boundary zone, a border with surfaces facing both inside and outside, extends psychoanalytic concepts of the self in ways that crucially include the body. Thus the skin is posited as an ego for-

mation positioned between an 'inside' – or the libidinous, pre-social energies Freud called the id – and an 'outside', or that complex of meanings, norms, ideals and traditions drawn from society he called the super-ego.

> The inside-facing and outside-facing skins are, meanwhile, one indivisible structure, and hence the skin continually communicates the external world to the internal one, and the internal world to the external one. This traffic, mediated by the skin, is the formative principle of the ego's basic sense of selfhood in the world.[21]

For Gell, tattooing is a social practice, a 'technology', that augments the skin as a locus of personhood, reinforcing it with a 'second skin' of images and texts replete with metaphorical meanings and associations to do with submission, protection, support, armouring, defence and so on that derive from the social order and constitute the social self.

Here we may return to Fomison's Humpty Dumpty paintings and the particular twist the masochist makes of the relationship between the embodied self and the social order. For with the masochist, Freud argues, the function of the ego has broken down; it fails to reconcile the self to the social order, to make, as Gell puts it, 'one indivisible structure' out of the 'external world' and the 'internal one'. Society turns hostile and sadistic; a perception reflected in Fomison's case in the extraordinarily oppressive representation of society in his paintings: it bears down on the body in relentless, punishing ways. The body is pursued, denuded, bitten, confined, disfigured, diseased,

75 (*above*) Tony Fomison, *'Naughty boy!' Humpty Dumpty gets a telling off*, 1984, oil on hessian on wooden tea-tray.

76 (*left*) Tony Fomison, *Humpty Dumpty toasting himself in the mail box: he's just got a birthday parcel*, 1987, oil on hessian on board.

broken, isolated, menaced, hung upside-down from hooks. Meanwhile, the ego masochistically exaggerates its submission, wanting to be punished, cowering in abject submission, or deliberately acting up in order to invite a telling off – as in 'Naughty boy!' This perverse behaviour does not aim to internalize the norms and rules of society; on the contrary. As Freud argues, it pitches the internal world *against* the external one; subverts the normative rituals of subject formation on which society is based. In contrast to the protective and socially reinforcing functions of tattooing in Polynesia (where its meanings are positively valenced), or for that matter the industrializing West (where they are negatively valenced), the body-ego in Fomison's painting is a body-ego *without* social protection, *in need of tattooing.* Consider the naked man running through the landscape in *The Fugitive*, the companion piece to *Not Just a Picnic*. This is an image of a body-ego without protection, exposed and vulnerable.

A revealing painting in Fomison's *œuvre* is *The Temptation of Brother Anthony (ki One roa a tohe)*, painted in 1983. Its title alludes to the third-century Christian ascetic who gave up his worldly possessions and the company of family and community to live a life of solitude and self-denial. Ensconced in a tomb near his native village, Anthony was famously tormented by demons in the shape of wild beasts, who inflicted blows upon him, and sometimes left him for dead. In the twelfth century, sects of flagellants who beat themselves incessantly with sticks and leather thongs invoked him as their patron saint.[22] In modern interpretations of the subject (such as Flaubert's novel *The Tempta-*

tion of St Anthony), Anthony appears as a prototype of the romantic artist, the social outcast and visionary burdened with the discord and moral complexities of his time. In Fomison's version the scene of 'temptation' is relocated to a New Zealand coastal landscape, where a storm gathers ominously on the horizon, casting a triangular black shadow across the ocean. Brother Anthony's 'temptation' is depicted in the form of two therianthropes – serpents with human heads – twisted around each other, facing in opposite directions. Meanwhile, this tormented image of the self divided is observed from the shore by a second figure, whose features and compositional position recall that of the man in 'Naughty boy!' Both are witnesses to the ordeal of suffering taking place or about to take place before them.

Fomison's quasi-autobiographical identification with Brother Anthony suggests a further explanatory key to his painterly themes and tattooing. Developing Freud's ideas on 'moral masochism', Theodore Reik elaborated a specifically Christian version of the syndrome, which contains three distinctive characteristics. Each is prominent in Fomison's art and life. As summarized by Kaja Silverman, they are, first of all, the structural necessity of an external audience, 'although it may be either earthly or heavenly'.[23] That idea is aptly illustrated in *The Temptation of Brother Anthony* by the figure of the watcher on the shore who witnesses the saint's torment, just as Humpty Dumpty's coy brinkmanship with the fate of his body depends on the presence of an audience. The role of the audience or witness occurs in other paintings as well: as a direct address to the viewer, as in *Up Up and Away* and

77 Tony Fomison, *The Fugitive*, 1980–82, oil on hessian on board.

Humpty Dumpty toasting himself in the mailbox, where we, as viewers, are made complicit in the narrative. Of course, the entire *œuvre* exists to be exhibited. The retrospective exhibition of Fomison's work in 1994 was tellingly subtitled *What Shall We Tell Them?* (after a painting by the same name), a phrase that captures perfectly the sense of Fomison's art as self-consciously addressed to, and painted for, a particular national audience, ever present in his imagination. Moreover, as Wedde observed in his catalogue essay, that audience was not only the recipient of his exhibitionism; it colluded with the artist in his

imaginings, complemented and completed the narratives they wove and needed together.[24]

Second, Silverman continues, 'the body is centrally on display, whether it is being consumed by ants or roasting over a fire'.[25] Again, Fomison's life and entire *oeuvre* could be summed up in these terms. In the numerous public accounts of the artist's life, it is primarily his body that is 'on display': Fomison drugged out of his brain in the Christchurch 'gear' scene in the 1960s; Fomison scrapping on the streets as a member of a French street gang; Fomison imprisoned in France; Fomison sick and hospitalized in a sanatorium in

78 Tony Fomison, *The Temptation of Brother Anthony*
(ki One roa a tohe), 1983, oil on hessian on board.

London; Fomison turning orange from eating too many carrots; Fomison decked out in 'Biko squad' during the Springbok Tour demonstrations of 1981 with a shield and armour cut from plastic buckets; Fomison collapsing on the grounds of Waitangi on 5 February 1990, the day before he died.[26] One could go on. And, of course, the iconography of his painting may be summed up as various depictions of the body: diseased, punished, tormented and so on. 'Finally', Silverman writes,

> behind all these 'scenes' or 'exhibits' is the master tableau or group fantasy – Christ nailed to the cross, head wreathed in thorns and blood dripping from his impaled sides. What is being beaten here is not so much the body as the 'flesh', and beyond that sin itself, and the whole fallen world.

Silverman comments:

> This last target pits the Christian masochist against the society in which he or she lives, makes of that figure a rebel, or even a revolutionary of sorts. In this particular subspecies of moral masochism there would thus seem to be a strong heterocosmic impulse – the desire to remake the world in another image altogether, to forge a different cultural order.[27]

Interestingly, Gell makes the same point about the tattooed criminal or prisoner who, with nothing to gain from society, fatalistically has 'BORN CRIMINAL' (or something like that) tattooed on his body.

The prisoner who does this accepts once and for all that he is a criminal *and seeks to reconstruct the world on that basis*; either by challenging the forces of order or, more typically, by *representing* passive acceptance of destiny as the symbolic equivalent of exercising mastery over it.[28]

Here, I think, we have the two distinct dimensions of Fomison's project: on the one hand, there is a body of paintings that depict fatalistic variations of alienation and social exclusion, in which, however, the painting itself, like tattooing, functions as a form of symbolic mastery over fate by representing it. For Fomison, painting was a slow, painstaking, obsessively crafted pursuit; its procedures meticulously documented in turn in numerous notebooks in which he recorded colours used, binders, brand of canvas, source of image and so on, in effect honing his mastery of a representational practice used to depict the abject and wretched. On the other hand, that very theme in both his art and life is the basis of a utopian ambition radically to remake the world altogether.

Fomison painted Christ many times, usually as a man of sorrows (though never, as it happens, on the cross – the exception that proves the rule perhaps?). The 'master tableau' of Christ crucified can be seen to lie behind the artist's numerous portrayals of (and identifications with) 'the wretched of the earth', symbols of redemption, despite their abject state. His tattooing was also imagined through a narrative trope of Christian suffering and atonement. Hence Fomison's story to a group of Samoan elders while he was being tattooed that 'he was shedding blood to compen-

79 Tony Fomison, *Study of head of Christ by Morales*, 1969, oil on canvas.

sate for the blood of Tupua Tamasese Lealofi [the leader of the Samoan passive resistance movement when Samoa was under New Zealand colonial administration], who was shot by New Zealand soldiers in 1929'.[29] The artist also made transfer prints on bits of cloth of the bloody pattern from his freshly tattooed wounds and sent them to friends like relics of a martyred saint. And speaking of martyrdom, he even died on 6 February 1990, the precise sesquicentennial anniversary of the birth of the nation at Waitangi on 6 February 1840, after collapsing on the Treaty grounds the day before – a martyr to the new 'post-colonial' nation.

It is difficult in the end to get a straightforward reading of the relationship between Fomison's painting and his tattooing. In many ways his tattooing is a striking contrast to his painting. His tattooing entangled him in social relations with Samoans; with Sulu'ape Paulo and Fuimaono Tuiasau and their networks of extended family and friends. It signified his commitment to other cultural values in a monocultural state and to social obligations, which he took seriously. It proclaimed a different cultural order in the postcolonial Pacific. Indeed, there could be nothing more dissimilar to the loneliness and alienation portrayed in paintings like *Not Just a Picnic* and *The Fugitive* than the photograph taken by Mark Adams in 1980 – the year these paintings were painted – of a family gathering, including Fomison, at Tuiasau's parent's home to celebrate the completion of their son's tattooing (illus. 81). Here Fomison is incorporated – with some reluctance, apparently[30] – into a group portrait of Tuiasau's family and friends. Has he at last found a place in the world, or is he, with his tattoo and *lavalava*, more strange and out of place than ever? In a tribute to Fomison written in 1994, Tuiasau described his friend's acceptance by his family and friends as a direct consequence of his having been tattooed. 'But the key to it, in terms of him being accepted by my friends, was the tattoo. It was like a key to a big door'. And yet, in almost the same breath, Fomison slips through the net of Tuiasau's attempt to properly describe him: 'Once my friends and family saw that he had the tattoo, it was like they considered him . . . not quite Samoan, it is very hard to describe. It was almost like part of the community – our community'.[31] '*Not quite* Samoan . . . *almost* part of the commu-

80 Mark Adams, *17.8.1979. Chalfont Crescent, Mangere, South Auckland. Su'a Sulu'ape Paulo, Tony Fomison and unidentified man*, cibachrome print.

nity . . . very hard to describe'. Fomison's real place here is the ellipsis, a non-place, where identity fails.

Adams's photograph may be contrasted with another photograph of the artist taken in his studio in September 1989, by a fellow artist, Shirley Grace, five months before his death (illus. 82). The session produced the remarkable *Double Portrait of Tony Fomison* in which the artist, in two guises, is pictured as the object of his own act of representation. He is 'the artist' in the big leather coat, his arm thrust aggressively forward, brush in hand,

81 Mark Adams, *10.5.1980. Grotto Rd, Onehunga, Auckland.*
The evening of the umusaga for Fuimaono Norman Tuiasau.
Colour print.

towards the tattooed man in the skirt, a 'white savage' (to use a term coined by Rod Edmond to describe castaways, mutineers, beachcombers, adventurers and the like, 'gone native'),[32] who is also himself. The photograph recalls familiar binary identities – the artist and his model, the 'civilized' man and the 'native', the aggressor and the victim – rendered here as two aspects of the same uncanny person.

For most of the photo shoot Fomison had worn a large leather coat, posing in various ways for the camera. The coat inflated his otherwise slight and, by that point in his life, physically frail person. In her diary that day Grace recorded him quipping that he wore the coat '[to] shut up the crummies at openings', a reference to the social class that generally attended exhibition openings in the local New Zealand art scene. It was 'camou-

82 Shirley Grace, *Double Portrait of Tony Fomison*, 1989, photograph.

flage', he said, used to conceal 'any clothes he had neglected to change or were dirty. Renée [his friend] had made it for him, shaped to counteract the hollow chest and humpy look he described himself as having'.[33] The coat then was a kind of personal prosthesis; a device to mimic and intimidate his social enemies, but also, like tattoo, to protect an otherwise exposed and vulnerable interior.

Towards the end of the session, with a couple of shots left in the camera, Grace asked Fomison if she could photograph his tattoo. After thinking about it, Fomison left the room, shaved, changed, and re-emerged wearing beads and a *lavalava*. Shedding one disguise for another, one 'prosthesis' for another, he then presented himself to the camera as an old colonial castaway 'gone native'. Seated before the viewer, he wears a Western jacket, open to reveal his naked torso. There are

Samoan beads and a Maori bone carving around his neck. In his left hand he holds a matai stick, a sign of his ceremonial rights in the Samoan culture as a *soga'imiti*, a tattooed 'Samoan' man (of sorts). His legs are spread seductively and his *lavalava* parted to expose his tattooed knees and thighs, the design of his *pe'a* receding towards his crotch. Around him is the paraphernalia of the artist's studio: an easel, various canvases, a carved 'Gauguinish'-looking paint-stand with some brushes and paint tubes on it, and a bottle marked x for poison.

The figure of the castaway (and his ilk) 'gone native' was indeed a poisonous one in the colonial literature of the Pacific. The photograph captures something of their disreputable and ambiguous status in the eyes of the dominant culture of the West. From the viewpoint of the upholders of the norms and ideals of 'civilization', they were

degenerates, backsliders and mongrels who, by abandoning 'civilization' and living like 'natives', perverted the proper order of history, law and morality. In 1838 the Reverend William Ellis of the London Missionary Society warned departing missionaries of 'wicked men' and 'unprincipled seamen' in the Pacific 'who, for the purpose of gratifying a depraved propensity, have left their vessels, settled among the natives, and created vast mischief . . .'[34] On the other hand, the same figures held an irrepressible fascination for the metropole, where they sent a continuous stream of letters, books, drawings, paintings and yarns to fascinate an audience avid for vicarious tales of the strange and exotic. But these tales too only confounded the boundaries between truth and fiction, prompting accusations that the men who told or wrote them were nothing but fantasists and liars.

In his second persona that day Fomison aligned himself with these 'wicked' and 'unprincipled' men. In this persona he inhabits the class identity of the tattooed sailor, castaway, beachcomber or criminal gone over to the other side. In contrast to Adams's family portrait, this image harks back to a colonial paradigm in which the tattooed castaway, in common with the 'native', was an object of denigration and oppression in the dominant discourse of the modern West. Fomison here is not the precursor of a post-colonial ideal of the bicultural or multicultural subject but a marginal figure, a threat and a menace. In his first persona that day, the artist mimicked his oppressors, those with whom the powers of representation lie, who are masters of all the symbolic codes (like those well-camouflaged men in Holbein's famous painting *The Ambassadors*). But they too are part of him. Remarkably, Grace's photograph combines these two personas in a single image, thus dramatizing their dual and constitutive relationship, like the entangled therianthropes in *The Temptation of Brother Anthony*, to the artist's 'self'. Moreover, the masquerade ensnares *us* in that relationship, its viewers, *for whom* the 'self' is here performed. In his guise as tattooed colonial castaway, Fomison stares us down, invites us to deal with him; implicates us in the same effort of his double to dominate him, read him, take his measure.

Samoan *Tatau* as Global Practice

Sean Mallon

Contemporary accounts of Samoan tattooing often privilege continuity over change and transformation. Today in Samoan society many people uphold *tatau* as ancient and unchanging, a practice essentially Samoan in its location and practice. Across the Samoan diaspora images of *tatau* are a distinctive and visible symbol of Samoan cultural pride or identity. In an era where global 'cultural flows' bring seemingly disparate peoples closer together, blurring the boundaries between cultures, they also seemingly make people cling more tightly to some of the cultural products, like *tatau*, that make them distinctive. Yet in historical perspective Samoan *tatau* has long comprised a less stable and fixed set of cultural ideas than popularly believed. Circulation of the images of *tatau* has given them relevance in diverse locations outside Samoa and beyond Samoan communities. In this survey, I review a somewhat fragmented history to argue that *tatau* has long been a contested and changing practice. I also analyse some recent events that demonstrate how one family of *tatau* practitioners continues to reach out to the world beyond Samoa, at once attempting to stabilize but also renegotiate the

boundaries of their work. A history of Samoan tattooing practices contributes to our understanding of the process of globalization and what *tatau* can and has meant to people in various times and places. It reminds us about the traffic in ideas and culture, and how Samoan *tatau* and Samoan culture are implicated in these processes historically and in the present day.

SAMOAN *TATAU* (TATTOO)

In Samoa, the process of tattooing is known as *tatatau*. In relation to tattooing the word *ta* means 'to strike' and the word *tatau* refers to lines and motifs that are tattooed onto the body. Today, Samoan men tattooed in the Samoan style wear markings that extend from the waist down to the knee. This distinctive form of *tatau* is called *pe'a*, and is made up of areas of dense shading and fine parallel line-work, interspersed with a wide range of motifs and geometric patterns. The overall structure of the *pe'a* varies little from person to person, but in terms of the finer motifs that fill this structure each tattooist interprets and composes the imagery differently. The Samoan word *pe'a* refers

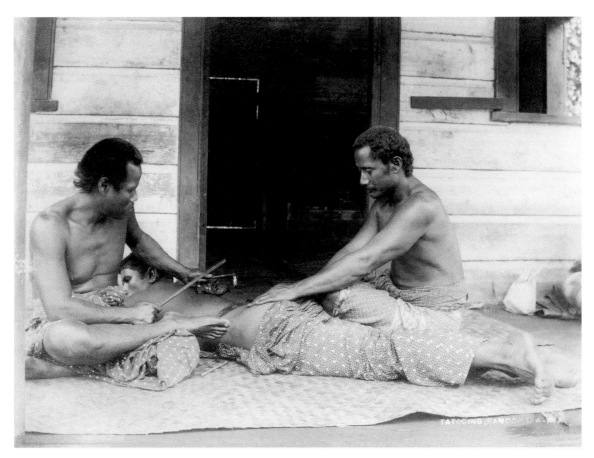

83 'Abbildung des Tätowirzprozesses', photograph attributed to Thomas Andrew, published in Carl Marquardt, *Die Tätowirung beider Geschlechter in Samoa* (Berlin, 1899).

both to the male *tatau* and to the fruit-eating bat known as the flying fox. Young Samoan men who are tattooed are called *soga'imiti* and as such they are responsible for performing duties for *matai* (village chiefs) at formal meetings and other events.

The name given to the main form of *tatau* worn by women is *malu*. It appears on the legs, starting at the knees and finishing at the top of the thighs. Some nineteenth-century accounts indicate that the lower abdomen and right hand of women were sometimes tattooed,[1] and there are a few individuals who have had *tatau* rendered on these parts of the body today, although it is uncommon. Overall, the *malu* is less elaborate and not as densely patterned as the *pe'a*. The *malu* takes its name from a particular motif of the same name, usually worn behind the knee, and is one of the key motifs not seen on men. In Samoan tattooing '*malu*' refers to notions of sheltering and protection.[2]

In Samoan society, the tattooing specialist is known as a *tufuga tatatau*. In the nineteenth century *tufuga tatatau* were associated with two family branches, Su‘a and Tulou‘ena. The Sa Su‘a worked mainly on Upolu and the Sa Tulou‘ena mainly in Savai‘i. The organization of these families is comparable to artisan guilds in other societies. Tattooing 'families' shared continuity over time as a group and were organized in a hierarchical master craftsman-apprentice fashion, each with particular rules, standards and distinctive trade marks.[3] This type of arrangement has meant that contemporary descendants of these families still work as *tufuga tatatau* and the skills of *tatatau* continue to be transferred from generation to generation. This is not to suggest an overwhelming vein of continuity in *tatatau* practice, over time or within the families themselves. There is a growing number of Samoan and non-Samoan tattooing practitioners who do not belong to either of these families, but use Samoan motifs. Most render the work primarily with electric tattooing machines.

The hand-made tools used most often by *tufuga tatatau* of the Sa Su‘a and Sa Tulou‘ena comprise a set of tattooing combs, and a short wooden rod or tattooing mallet. The hand tools are especially valued and are finely crafted. These *'au*, or tattooing combs, are made of three components: a small bone comb, a shell plate and a wooden handle to which they are attached. The tattooing combs are made to different widths, each designed to render a different quality of line. Some are used for filling in large dark areas, while others are used to make very fine lines and dots. The comb perforates the skin delivering the pig-ment into it, and is usually made from small sections of boar's tusk with a row of very small sharp teeth cut into it.[4] In the nineteenth century the tattooing combs were said to have been made from human bone, with one missionary saying that if possible the bone was 'procured from the body of a strong & daring chief'.[5] The combs were fixed with strands of coconut fibre to a turtle-shell plate, which in turn was fastened to a thin stick to form a handle. Today, turtle shell is still used, but is sometimes replaced with a piece of Perspex or metal. The coconut fibre is usually substituted with nylon fishing line. Restrictions on turtle fishing in the islands have made it difficult (but not impossible) for *tufuga* to acquire turtle shell. The use of nylon fishing line perhaps allows the tools to be cleaned more easily between uses. Increasingly, familiarity with equipment such as ultrasonic cleaners and cleansing chemicals are required for *tufuga* to work outside Samoa.

The *sausau* is a wooden rod used to strike the *'au* so that pigment is deposited from the comb into the skin. Internationally, commercial inks are used, although in Samoa, kerosene soot mixed with *bluo* or candlenut soot and water have sufficed.[6] Often the pigment is mixed in a half coconut shell before it is spread on a palette made from a freshly picked leaf stretched across the top of an empty tin can or half coconut shell. The *tufuga* draws the pigment from this palette before it is applied to the skin. I mention the material culture associated with *tatau* because it is in various forms of material culture that we find clues relating to *tatau* and its origins.

Archaeologists who study the material culture of humans in the Pacific have unearthed evidence that suggests that the origins of Samoan tattooing motifs lie with the early seafaring ancestors of Polynesian peoples. Around 1500 BC the ancestors of Polynesian people were making a form of distinctive decorated pottery that archaeologists call Lapita ware. It has been argued by some archaeologists that the motifs found on ancient Lapita pottery relate directly to those present in contemporary tattoo and bark-cloth decoration.[7] There is other convincing evidence for the connection between tattoo and the decorative elements found on Lapita pottery. As well as the stylistic similarities of the motifs, archaeological excavations of Lapita pottery-bearing sites in Tongatapu in Tonga have unearthed examples of tattooing chisels in the same context. In the Reef Islands in the Santa Cruz group, a Lapita site has produced what appears to be the buttocks of a small baked clay figurine, bearing images that may represent tattoo, and a small clay-modelled head with a facial tattoo has been reported from a Lapita site in Papua New Guinea.[8] Furthermore, linguistic reconstruction of the word *tatau* and the word *uhi* – the eastern Polynesian term for tattooing implement – also point toward an origin for *tatau* early in the settlement of the Pacific.[9]

The inter-island influence and connections made through tattooing are also evident in origin accounts from Samoan folklore. According to stories and songs recorded in the nineteenth century, two sisters, Taema and Tilafaiga, who were Siamese twins, brought the first tattooing tools to Samoa. They acquired the tools and the instructions on how to use them from the tattooists Filelei and Tufou in Fiji. They were told to 'tattoo the women and not the men', and they sang this instruction over and over as they paddled their canoe to Samoa. On the way, as the story goes, they saw a large and beautiful shell glistening in the waters below and they stopped singing their song to swim down and fetch it. On returning to the surface they tried to remember what they were singing and got the song mixed up. 'Tattoo the men and not the women' they sang, and this was the message they took on to Samoa.[10] This reference to the origins of *tatau* being located outside Samoa is a curious one, because it points to the non-indigenous origin of Samoan *tatau* – a cultural practice 'essentially Samoan'.

Other contemporary explanations currently circulating among Samoans suggest a site called Fiti-uta in Samoa's eastern islands of Manu'a as an origin site, one possibly confused in the past with Fiji (Fiti). Beliefs among some contemporary *tufuga* and Samoan *matai* suggest Mesopotamia and the ancient Near East as origin sites (based largely on similarities between markings and motifs), with some saying that Fijians have no tradition of tattooing, despite evidence to the contrary.[11] But could Fiti, Viti or Fiji have been a reference to another location in the Samoan archipelago? and what or where was Fiti, Viti or Fiji in the context of this origin story? These questions are probably beyond any definitive answer, but what is clear is that the origins of *tatau* are, as we shall see, as contested as its practice.

Accounts of tattooing in Samoa made at different times over the last 200 years describe customs,

stories and songs, and transformations in style and meaning. They also highlight relationships in Samoan society and changing attitudes and responses to the increasing influence of the outside world. The historical sources provide valuable insight into the nature of cultural exchange, however, and if their specific details are difficult to verify, the more general points they make relating to the interaction and exchange mediated by *tatau* are significant for the inter-archipelago connections they suggest.

FRAGMENTED HISTORY AND CONTESTED PRACTICES

In 1721–2 a Dutch seafarer named Jacob Roggeveen made a long voyage from Cape Horn to New Ireland (near Papua New Guinea). On 14 June 1722 he sailed close to the islands of Olosega and Ofu, two of the easternmost islands of the Samoan archipelago. As Roggeveen's three ships passed by the islands he wrote about the inhabitants he sighted there:

> The Indians of this first island are like the Paaschlanders in sturdiness and robustness of body, also in painting themselves, but not so much and abundantly, as their colouring commences from the thighs downward to the legs. Furthermore we did not see anything as covering for their nakedness, except a girdle round the waist to which a lot of long broad leaves or rushes, or of another plant, was fastened.[12]

This glimpse of 'colouring . . . from the thighs downward to the legs' is probably the first written description of Samoan *tatau*. It is one of many accounts of tattooing to emerge as European exploration progressed across the Pacific and encounters with local peoples became more common. Later, cultural encounters between British seaman and Tahitians would eventually see tattooing gain popularity in Europe, especially among the under classes (see White, this volume).[13] However, it is easy to forget that these types of cultural exchanges had also taken place among Pacific peoples for generations. For example, in the 1700s and possibly when Roggeveen was in the region, certain classes of Tongan nobles were tattooed by Samoans, some of them travelling to Samoa especially for this purpose. In Tonga, Samoans known as *matapule* were part of an intermediate class of ceremonial attendants who played important roles in the Tongan social system. Tongan commoners were forbidden to touch the Tongan elite, so Samoans acting in this role 'could tattoo Tongan chiefs with immunity, cut their hair (the head of a Tongan chief is extremely *tapu*) and prepare their bodies for burial'.[14] In the 1800s Tongans were still travelling to Samoa to get tattooed, since King George Tupou I had forbidden the practice.[15]

Another early but more detailed account of the tattooing process comes from the missionary John Stair, who lived in Samoa from 1838 to 1845. He stated that all males from the ages of 12 to 15 and upward were tattooed and described the tattooing of a young chief. According to the custom of the time, sons of the *tulafale* (orators/talking chiefs) of the district were expected to receive their tattoo simultaneously and share in the sufferings of their chief. Great interest was shown in the occasion and a large shed was usually erected

in the *malae* (village open space) where the tattooing would be performed. The young chief's family and people from all over the district would come to observe the proceedings and help to support the young men. The time taken to tattoo the young chief and his supporters could be anything from four to six weeks. During this period, friends, family and well-wishers staged evening entertainment in the form of dancing, sham fights and wrestling matches. When all the tattoos were complete, the *tufuga* would receive the last of several payments for his work, consisting of hundreds of mats and large quantities of bark-cloth.[16]

This account from the late 1830s to mid-1840s is a snapshot of Samoan *tatau* in a period when the Christian missionary presence in Samoa was only just becoming established. Over the course of almost a century (from the 1830s to the 1920s), the customs associated with *tatau* would come under unprecedented pressure to be abandoned. The nineteenth and early twentieth centuries were a period when colonial powers became established in Samoa, and trade and communication increased with countries both within and beyond the Pacific. Reading and writing, new technology and ideology transformed Samoa in many ways and Samoan people were to prove creative agents in the ways they dealt with new ideas and cultural products.

In nineteenth-century Samoa, the missionaries of the London Missionary Society (LMS) were particularly keen to ban tattooing, but the Catholic Marists were more tolerant. It seems that the LMS were not keen on the revelry and celebrations that took place in relation to the tattooing, rather than the act itself, and succeeded in abolishing tattooing in Tutuila before 1850, before it emerged again in the village of Leone in 1851.[17] Later in the 1860s the *matai* of Manu'a banned tattooing for religious reasons. However, despite this ban, many of the young men of Manu'a took the opportunity to travel to Savai'i to get their *tatau*, although they were forbidden to return home.[18] By the 1890s this ruling had been revoked and young men were allowed to return to Manu'a on condition that they paid a fine to the church.[19] In other cases there was a clear reluctance to give up tattooing. A *matai* in one account held out on the local missionaries and deferred 'making a profession of his new opinions till his son was tattooed, and thus admitted to manhood, according to heathen custom'.[20] What is clear is that Samoan men persisted in seeking opportunities to acquire *tatau* in spite of local and foreign-imposed prohibitions, so it was not actually abolished across the archipelago as a whole at any one time. As I have mentioned, young Tongan men are said to have travelled to Savai'i to receive tattoo, the missionary prohibitions against tattooing being just as strong in the Tongan islands and having the support of the Tongan king.[21] Sunderland's remarks in September 1851 highlight how conflict on Upolu offered opportunities for young men on Tutuila to get tattooed.

There is a great desire manifested amongst many of the young men of the district to get tattooed. The custom seemed to be passing away on Tutuila, but the war on Upolu has revived it again and has induced many persons expert in the art of tattooing to resume their profession and a considerable number of young persons have secretly gone off

to Upolu to get marked, as no person, at present, is allowed to tattoo on Tutuila.[22]

These mid-nineteenth-century episodes saw *tatau* survive in different parts of the archipelago through to the turn of the century. It is difficult to trace stylistic developments and innovations in Samoan *tatau* during this period, although an account from the 1920s clearly suggests that some design innovations were emerging from the *tufuga* of the time. The homogeneity of *tatau* practice in Samoa can be questioned when anthropologist Te Rangi Hiroa makes reference to a younger school of *tufuga tatatau* and a move towards a breaking up of the dark areas of the *pe'a* with the introduction of more ornamentation. This took the form of *fa'aila*, window-like design elements that framed motifs and isolated skin imperfections such as birthmarks. This was in contrast to the work of an older school, which preferred a greater proportion of plain bands and dark areas.[23]

This development suggests that the practice of *tatau* was not uniform across the archipelago, and that there were different schools of thought within the families of *tufuga tatatau*. Individuals employed in tattooing were acting on creative impulse and possibly competing for business and status. They were also undoubtedly responding to new influences from the changing social environment around them, as well as new demands from their clientele. These developments remind us that an archipelago such as Samoa was not culturally homogeneous in the past.[24] It is true that the people of nineteenth-century Samoa were internally connected by shared ideas and concepts. However, villages and districts were often distinguished not only by their geographical location, but also by their diverse versions of origin stories, myths, local customs and specialized trades, or access to certain commodities. In relation to *tatau*, one nineteenth-century commentator remarked that certain districts had 'what may be called coats of arms in addition, – some animal usually, which serves to distinguish a man slain in battle'.[25]

The tattooing operation itself, as described by Te Rangi Hiroa, seems to have retained strong continuity in its practice, but the ritual that accompanies *tatau* had become less elaborate and formalized. Some time in the nineteenth and early twentieth centuries, the sham fights and wrestling that once accompanied the tattooing ritual were replaced by young men with modern musical instruments. The musicians would sit around their friend being tattooed singing to distract him from his pain in 'melodies . . . diffused from foreign music halls'.[26]

Few accounts of Samoan tattooing from the 1930s and '40s exist, but a remarkable series of 52 drawings made in the 1950s by J. W. Groves offer some insight into the cross-cultural entanglements of *tatau* practices. As part of a manuscript in the British Museum Groves wrote:

> There is a strong tendency nowadays to display the American Eagle in a tattoo design actually as the whole or part of the punialo. This would seem to be the result of occupation of the American troops during the war. There seems to be nothing incongruous to the Samoan mind in the spread eagle appearing in what is entirely a fa'asamoa [*sic*] decoration and it is quite impossible to convince them of it.[27]

PUNIALO

84 J. Groves, *Punialo* (Apia Samoa), April 1951, pencil drawing.

Although there is a lack of contextual information about Groves's drawings, their very existence raises several questions. The types of images that appear suggest that American troops stationed in Samoa during the Second World War were an influence, but it is not established who made them, who wore them, why they were made and what the reaction was to them. The incorporation of the American eagle as part of the *punialo* (a tattoo element situated above the groin), and Groves's report that there seemed to be 'nothing incongruous to the Samoan mind' as to whether it was a *fa'asamoa* (Samoan customary) decoration or not, suggests that Samoan tattooists were open to new ideas and readily incorporating them into their cultural products. It seems Samoans not only appropriated foreign cultural forms into *tatau*, they also modified *tatau* to suit non-Samoan demand. For example, a decade later, in the late 1960s, American Peace Corps volunteers in Samoa were behind the emergence of tattoos known locally as 'Peace Corps tatts' or *pe'a pisikoa*.

These *taulima* (armbands and wristlets) and *tauvae* (anklets) are to this day popular souvenirs of Samoa for the tourists who can get them, and have become a significant form of *tatau* for people of Samoan descent living overseas. Although many people and practitioners claim that this form of *tatau* is recent, the *taulima* form of tattooing appears to have existed from at least the 1890s. A group of 30 Samoan women visiting Berlin at this time were seen by Felix von Luschan to be tattooed on the arms with rings and armlets, highlighting a variation in tattooing practice not remarked upon in most ethnographic accounts.[28]

Despite these innovations for much of the early to mid-twentieth century, there is one account that questions the widespread popularity or relevance of *tatau* in Samoan social life. When the anthropologist Tim O'Meara was in Samoa in the 1980s, he recalled seeing only one woman and no men over the age of 40 with a tattoo. He suggested that the resurgence of tattooing among young men probably began around the time of Samoan Independence in 1962. There could be some truth in this since Su'apa'ia writing in 1962 noted that people were refused admittance into chiefly assemblies unless they were tattooed.[29] He is not more specific but it is likely that his statement may refer only to a particular village or district, since there were and still are many Samoan *matai* who are not tattooed. By 1990, however, one village on Savai'i had made it compulsory for all men to have the *pe'a*.[30] Whatever the case may be, a sustained local interest in *pe'a* from the early 1960s onward is evident, and became especially so overseas.

This interest in *tatau* has intensified not only in Samoa but also in Samoan populations abroad.

As Samoans have migrated to cities such as Honolulu, Los Angeles, Sydney and Auckland, so too have aspects of their culture and customs. Today, among migrant Samoan communities, *tatau* is widely considered a statement of Samoan heritage and identity. Within the Samoan cultural milieu some of the values recorded in the nineteenth century still resonate in ritual aspects of *tatau* practice. But increasingly the *tatau* has acquired a broader range of meanings and forms that are often specific to certain contexts. The *taulima* or armband is probably the most popular form of *tatau* among young Samoans in Auckland,

New Zealand. (In the late 1990s the cost of a *taulima* started at approximately New Zealand $50 ranging to around $100). Many young Samoan men and women wear it, since it is both affordable and quickly rendered. Generally speaking, for many young Samoans it has become an ethnic marker, a means of signifying Samoan heritage and an important link to what can sometimes seem like a distant heritage and way of life. The *tatau* is such a strong image of Samoan heritage that its motifs are also appearing on clothing and apparel and have been reinterpreted by artists in new media and art forms.

85 J. Groves, *A Unique Tattoo* (Apia Samoa), January 1952, pen and ink.

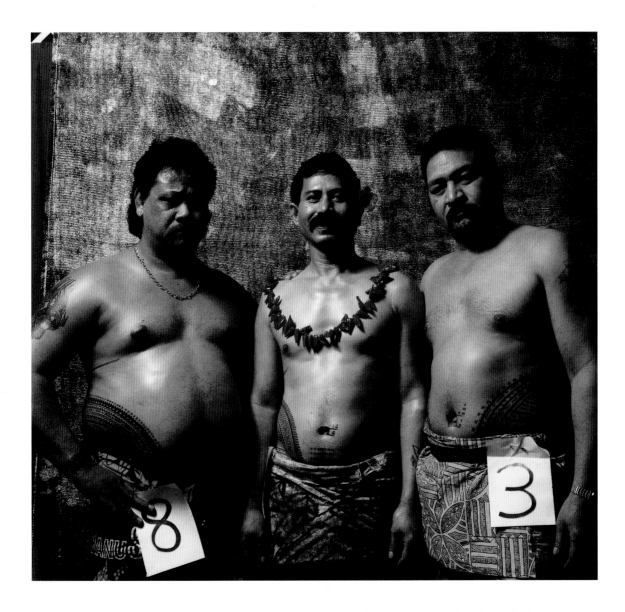

86, 87 (*above and opposite*) Greg Semu, *Contestants, tatau competition, Apia Way, Mangere, Auckland, 1998. Tufuga ta tatau: Paulo Sulu'ape II, 1998*, photograph.

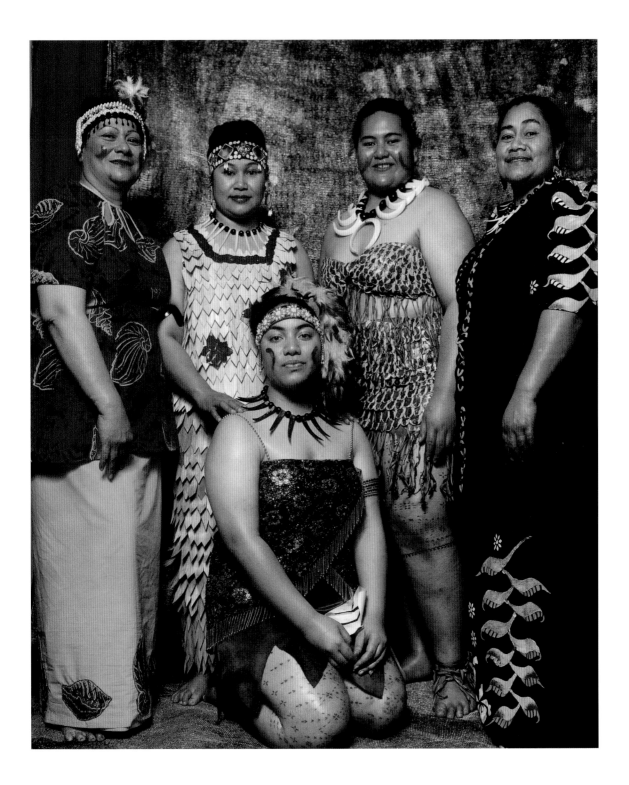

The tattooing of non-Samoans with Samoan *tatau* is not uncommon, although it has been a point of controversy among leaders in Samoan communities in recent times. We know that historically Samoan *tufuga* tattooed Tongans, but there are also records that indicate that *tufuga tatatau* were tattooing Europeans from the earliest encounters. The missionary John Williams, who visited Samoa in 1832, described a tattooed English sailor named Jerry memorable for his accounts of his efforts to convert Samoans, but also for his tattooed belly and navel.[31] Another early account is from E. J. Wakefield, who, in recounting his adventures travelling through New Zealand in the early 1840s, described two characters he met in the countryside who had both escaped from a local jail:

> One of them, an American named McLeod, had assumed the name of Mickey Knight . . . He spoke the native language very well, had with him a native wife from Thames, and had been tataued from the knees to the hips at the Navigator Islands [Samoa].[32]

The missionary Murray, working in Samoa in the nineteenth century, mentioned that in 1844, soon after returning from Upolu, he had a visit from a British man-of-war, the *Hazard*. Captain Bell, the commander, 'wished to take home in his own person a specimen of Samoan tatooing'. The locals at Pagopago were initially not keen to tattoo Bell, so Murray acted as a negotiator, explaining that 'What Captain Bell wished them to do for him was a very different thing to tattooing as they had

been accustomed to practice it in their heathen state'. However, Murray also made clear in his account that he took care to guard against the incident being regarded as giving sanction to heathenism. Other foreigners living in Samoa said to have received the *pe'a* include 'Old Tom Franklin', also known by the chiefly title Vavasa, who was still wandering around Samoa in the 1860s, having been there at least 20 years.[33] Later, during the German Administration, it is recorded that the German Governor of Samoa in 1912, Dr Erich E. Schultz, and a number of his officials, including Rudolph Berking, the Collector of Customs, also wore the *pe'a*.[34]

Other documented cases of tattooed non-Samoans include that of an American Peace Corps volunteer working in Samoa in the 1960s, a woman named Elsie Bach. She became friends with the Sulu'ape family, was tattooed with a *malu* and bestowed with the Sulu'ape title.[35] We can only speculate on the benefits that wearing the *tatau* had for these people at the time, but it must have offered some kind of benefit of incorporation, demonstrating perhaps a commitment or respect for the Samoan people and their culture, and an opportunity for the tattooed individual to enhance their own status. In Captain Bell's case, perhaps his *tatau* was merely a memento of his visit. It is significant in the Peace Corps Volunteers' case that *tatau* can be likewise considered a souvenir but also a mark of incorporation, with Americans making over their bodies into Samoan ones, in much the same way as Peace Corps Volunteers in Niger use Tuareg jewellery and hair braiding to achieve the same result.[36] It is also notable that in the 1970s a well-known American

tattooist, Lyle Tuttle, visited Samoa and left having acquired a sample of Samoan *tatau* and a *matai* title.[37] Non-Samoans were visiting Samoa not just for the sun. They were actively seeking the *tatau*.

In the same way that, in the past, *tufuga tatatau* travelled to the villages of Samoa and the courts of the Tongan elite, today the *tufuga* has an international clientele and it is not unusual for *tufuga tatatau* to fly to clients and tattoo conventions in cities such as Madrid, Miami and Amsterdam. Overseas clients also come to visit *tufuga* both in New Zealand and Samoa, and not just for the *pe'a*. In 1981 Lesa Li'o, a *tufuga tatatau* from Siumu, tattooed Ioteve Tuhipuha Puhetini from Rurutu of the Austral Islands.[38] After studying drawings of old Marquesan tattoo designs, the *tufuga* took six weeks to reconstruct a Marquesan tattoo design on Ioteve that started at the neck and shoulders and extended the length of the body down to the ankles. Later, in 1982, three Samoan tattooists demonstrated *tatau* at the annual Bastille Day celebrations in Tahiti, and by 1983–5 the Samoans had three Tahitians working with them, contributing to the renewed interest in tattoo in Tahiti and partly inspiring the current generation to begin tattooing again (see Kuwahara, this volume).[39]

Samoan tattooists have been travelling to New Zealand, where there is now a large Samoan and Polynesian population, from at least the early 1970s. The first Samoan *tufuga tatatau* to begin tattooing in New Zealand was Tavu'i Pasina Sefo Ah Ken, who arrived in New Zealand in 1972. Later he was followed and joined by his cousin Su'a Sulu'ape Paulo II (1950–1999), who for a long time maintained the most visible presence and ongoing practice in New Zealand. He is survived by his brothers who continue to *tatau* in Samoa, New Zealand, the United States and Europe. Other members of the Sa Su'a and Sa Tulou'ena work in New Zealand and include Su'a Vitale Fa'alavelave, who is currently based in Wellington.

The contemporary interest in Samoan *tatau* and its changing relevance across the Samoan diaspora and among non-Samoan tattooing enthusiasts has meant that that *tufuga tatatau* have had to alter their practice to suit new locations and client demands. The interaction of *tufuga* with clients in Europe began with Su'a Sulu'ape Petelo's invitation to a tattooing convention in Rome in 1985. His brother Su'a Sulu'ape Paulo followed in the 1990s, with both of them winning prizes and recognition for their work. Their travel to the United States and Europe was the catalyst for new friendships and participation in a global community of tattooists.

In New Zealand Su'a Sulu'ape Paulo became particularly well established, and later a controversial figure. He worked tirelessly among Samoans living in Auckland, but was often criticized by them. At one stage, his acceptance of cash instead of the customary Samoan exchange goods such as *'ie toga* (fine mats) caused him to be accused of commercializing Samoan *tatau*. This is despite cash being used in many other forms of Samoan ceremonial exchange. Paulo was also criticized for his tattooing of non-Samoans, particularly later in his career. Significantly, in 1979–80 Paulo tattooed a well-known New Zealand painter Tony Fomison, with his close Samoan friend Fuimaono Tuiasau (see Brunt, this volume).[40] But it was

when his connections to other tattooists in the international tattooing community increased that his tattooing of non-Samoans became a concern to Samoan community leaders and commentators.

Sulu'ape Paulo was a controversial figure because aspects of his practice (particularly the tattooing of non-Samoans) were seen by Samoan community leaders and *matai* as devaluing an ancient and important custom. Among some Samoans in New Zealand there is a strong sense that a distinctive part of Samoan society and culture will be lost to them. In an interview in 1999 Su'a Sulu'ape Paulo explained to me that he did

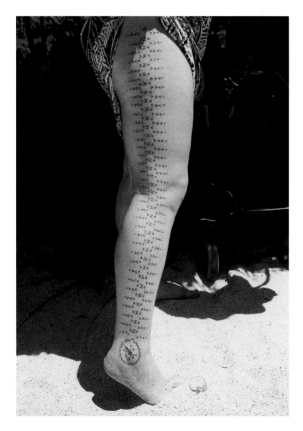

88 Su'a Sulu'ape Paulo II, malu inspired pattern worn by Carina Persoons, 2001.

not share this concern. He considered the *tatau* something the wearer could not exchange or sell, something that is with the wearer for life. He assumed that, to receive the *pe'a*, the recipient must have some respect for its history, values and aesthetic. He therefore had no problem taking *tatau* to the world and sharing it with other tattooing enthusiasts.

Despite Paulo's position and sentiment, a nationalist and traditionalist view exists in Samoan society relating to who has authority over Samoan tattooing. Among some Samoan *matai* in New Zealand and Samoa, there is a deep sense of ownership over *tatau* and in particular the *pe'a*. When non-Samoans are tattooed, a custom Samoans feel they have some authority over slips beyond their influence and control. Even within the Sa Su'a there are conflicting views relating to whether or not non-Samoans should be tattooed with the *pe'a*. Su'a Sulu'ape Paulo was very much involved in these debates and he was defiant in the face of extreme pressure. Despite the debates, however, the directions that *tatau* practices have taken, and the many global manifestations of Samoan *tatau* on non-Samoan skins, the *pe'a* retains a special significance among New Zealand-based Samoans. While it retains some continuity with past practices in its communal role, it also has a role in shaping the individual. The service and skills of the *soga'imiti* (tattooed male) remain crucial to completing formal Samoan meetings and ceremonials. But how and why individuals 'wear' their *pe'a* and the personal meanings they attach to the tattooing process and its resulting imagery is also important.

Similarly the significance of the *malu* – the female form of Samoan *tatau* – is being renegotiated. This is in contrast to earlier ethnographic accounts, in which it hardly rated a mention, was not categorized as *tatau*[41] and was seen almost solely as a learning opportunity for apprentices.[42] Times have changed, so have attitudes, and the role of women in Samoan society. Partsch's study of 1993 of *malu* among Samoan women in New Zealand highlighted a range of attitudes to the wearing of the *malu* and its acceptance by the church and the wider community. Her research indicates that the church still exerts some pressure on young Samoans not to be tattooed, because it is seen as 'a spilling of blood' and a means to achieve 'self-glory'. Even so, there is strong resistance to this rule, despite fines and the threat of temporary disassociation. The *malu* was seen by some to be 'a personal sacrifice and an outward symbol and acknowledgement of how they feel about their fa'asamoa and cultural identity'.[43] This study also highlighted a trend for older Samoan women in their late forties and fifties to acquire the *malu*, raising questions about the relevance of *malu* to this generation in their youth, and supporting O'Meara's earlier observations.

Non-Samoan women also receive the *malu* and I have met one European woman with a full *malu* and several with only elements of it. This 'sampling' of *tatau* motifs is common. During the South Pacific Arts Festival in Samoa in 1996, I witnessed a Peace Corps Volunteer being tattooed with the *malu* motif on the rear of her leg just behind the knee. The various ways that parts of the *malu* can be isolated as interesting elements in themselves make them attractive to people who

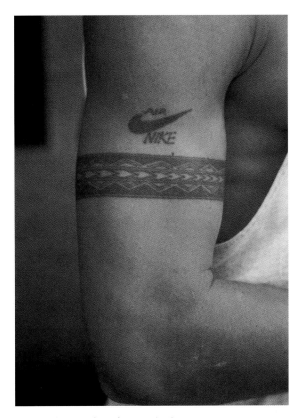

89 Nike logo with taulima, Apia, Samoa, 2000.

collect tattoos and want something quickly.

Today *tatau* is rendered in tattooing conventions, art galleries and festivals, as well as in private homes. In the global context there are many ways to negotiate and pay for the *tatau*. The customs involved and methods vary, as do the income and access to resources possessed by the customer. For example, young New Zealand-born Samoans do not often have access to customary Samoan exchange items such as *'ie toga* (fine mats). In many cases cash is the most practical currency and a readily acceptable substitute. The cost of a *pe'a* in New Zealand starts at around $1,800–$2,000. As with most commercial

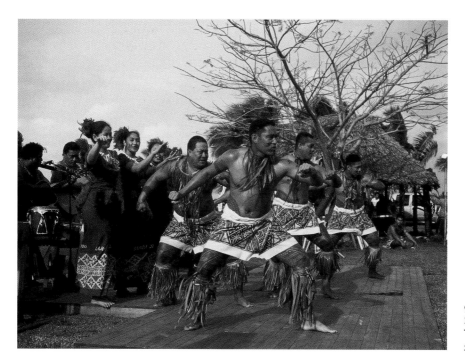

90 Performance of the Samoa National Dance Troupe, Apia, Samoa, 2001.

transactions, one can expect to get what one pays for. In theory, the more one pays, the better the quality of the work. In some situations, *fa'asamoa* (Samoan custom) prevails when negotiating and paying for the *pe'a*. Cash payments, the gifting of pigs, *'ie toga* and *siapo* (bark-cloth) become part of the transaction and are divided and distributed by the *tufuga* among his helpers.

Outside the usual Samoan social contexts, information about *tatau* is most widely disseminated through literature, film and photographic representations. Increasingly the Internet has become an effective tool for documenting and distributing information about tattooing.[44] In published sources such as books and magazines, *tufuga* have (mainly through interviews) given various accounts of what the *pe'a* and *tatau* mean. Two important historical sources on Samoan tat-

tooing are Augustin Kramer's *The Samoan Islands* and Carl Marquardt's *The Tattooing of both Sexes in Samoa*.[45] Both books from Germany, originally published at the turn of the nineteenth and twentieth centuries, are based on or include first-hand accounts from *tufuga* and tattooed Samoans Their popularity has seen them translated into English and republished. Today they circulate as the standard references on Samoan tattooing. Nineteenth-century ethnographic sources such as these are often the only way that tattooing enthusiasts in Europe, for example, can access Samoan *tatau* imagery and accounts. I have interviewed tattooed Europeans who mention the importance of these sources time and time again. Increasingly, other sources for information on Samoan tattooing include magazine articles and generalist books on body art and the art of the Pacific.

Tattooing magazines that have featured Samoan *tatau* include the United States-based *TattooTime* and *Skin and Ink* and recent articles include submissions from Pacific tattooing practitioners reporting on current events. The main market for tattooing magazines is the Western tattooing milieu, and while individual magazines do not have a wide circulation, their combined total readership is considered to be quite significant. Today, popular tattooing literature as well as older historic and ethnographic accounts keeps images and stories of Samoan *tatau* circulating globally. As published interviews with, and articles about, *tufuga* circulate, they shape wider understandings about *tatau* history, meaning and significance.

As the popularity of *tatau* has grown, its presence has increased in other forms of media such as television, film and literature. For example, the Samoan authors Albert Wendt and Sia Figiel have used the imagery of *tatau* to speak to wider issues of cultural change,[46] and filmmakers have focused their lenses on the lines and lives of tattooed Samoans.[47] In contemporary media representations *tatau* has become emblematic of the Samoan nation and culture; for example, in 2002 a series of phone cards from Samoa featured images of *tatau*, and tourist brochures and calendars from Samoa often feature tattooed Samoan men and women. An American tattooist who wears the *peʻa* describes his first glimpse of the *tatau* on a travel brochure as a major discovery:

> It was an epiphany, I mean it led directly to the path for me to get my own peʻa and to my own title and to my own path of traditional [tattooing]. The first time I saw a Samoan peʻa, was on a travel brochure,

literally. I saw this obscure image that was peaking out from under something and a guy in the background, it wasn't even the featured picture, there was something in there . . . what is that . . . what? Look at that tattoo, look at that pattern! . . . it was just a little bit of the inner thigh that was showing.

Apart from the promotional materials and agendas of tourist markets and marketers, Samoan *tufuga* themselves are proactive users of technology and media to publicize and disseminate information about their work. An Australian-based *tufuga* often uses the Internet to educate and generate discussion about Samoan *tatau*. Suluʻape Uili Tasi runs two websites to support the work of Suʻa Suluʻape Petelo. An example was the registration for the Second International *Tatau* Convention in Samoa in 2001, which was distributed via the Internet. He is also a regular correspondent (under pseudonym) on the *Samoa Sensation* website, where there is an e-mail posting section where visitors to the site post questions relating to Samoan history and culture. A topic that frequently comes up is *tatau*. Suluʻape Uili Tasi uses the site to answer questions, explain the meanings of *tatau*, and direct people to specific events and the location of other *tufuga*. As well as the sites that Suluʻape Uili Tasi administers, there are many other Internet sites that feature Samoan tattooing histories; most notably the *Tattoo History Source Book* (http://tattoos.com/jane/steve/index.htm). These sources for information on Samoan *tatau* have the potential to distribute a range of meanings on *tatau* and multiply the diversity of those meanings. They are crucial parts of the mediascape that *tatau* circulates within.

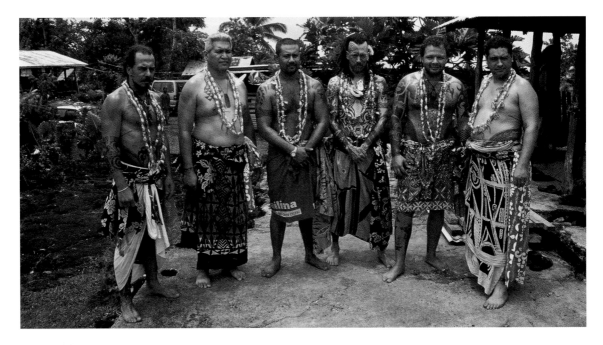

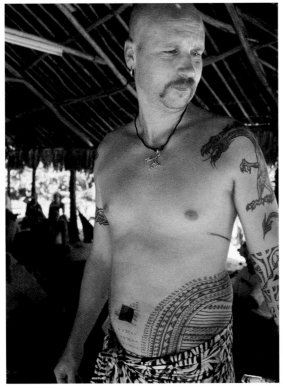

91 (*above*) Participants before the Sulu'ape Title bestowal at the village of Lefaga, Samoa 2001. left to right: Mo'o, Keone Nunes, Uili Tasi, Freewind, Michel Thieme, Inia Taylor.

92 (*left*) Rene Persoons with newly completed pe'a, Saleapaga village, 2001, tattooed by Su'a Sulu'ape Paulo II and Sulu'ape Michel Thieme, 2001.

The use of the Internet is an example of how *tufuga* are able to distribute information about Samoan *tatau* to the world, but also how they attempt to fix and control its dissemination.

THE INSTALLATION OF SULU'APE FAMILY TITLES AT LEFAGA, SAMOA, 2001

If there is one event that ruptures the stereotype of *tatau* as unchanging, and Samoa as its single locus of production, it is a *saofa'i* (title bestowal) that took place during the Second International *Tatau* Convention in Samoa in 2001. The title bestowal was held at this time to take advantage of the title-holders' attendance at the convention. I was invited to attend by one of the Maori participants in the tattooing convention that was taking place simultaneously at another village. He would receive the Sulu'ape tattooing title from the Sulu'ape family in the village of Lefaga, and was one of several non-Samoan tattooists to receive the title that day.

On the morning of the *saofa'i*, we drove to the family property in Lefaga, where we awaited the arrival of the village *matai*. The title recipients were ushered to a small nearby *fale* and dressed by people from the *'aiga* in long pieces of *'ie palagi* (printed cloth) and rubbed down with oil. Stripped to the waist, with flower garlands draped around their necks, the recipients of the title were a Frenchman, a Dutchman, a Samoan, an American, a Hawaiian and a New Zealand Maori (illus. 91). Others present were to receive the Pasina title that is closely related to the Su'a tattooing clan. What the new title-holders all had in common was their profession as tattooists and a shared connection

to Su'a Sulu'ape Paulo and Su'a Sulu'ape Petelo. Most had met the brothers during their international travels and had received instruction from them in the use of Samoan tattooing tools.

Once they were dressed, the prospective *tufuga* moved into the *faletele*, the main house on the property. Waiting there for them were the *matai* of the village of Lefaga. The prospects were made to sit in the centre of the *fale* and formalities were begun that would incorporate them into the Sulu'ape family. The symbolic handing over of the titles came at a price. The recipients made substantial cash gifts to the title owners. The family in return presented *to'oto'o* (ceremonial staffs) and *fue* (ceremonial flywhisks), the status symbols of *tulafale* (orator chiefs). After speeches, the bestowal took place, in front of an audience that included locals as well as friends and family of the new *matai*.

As I have already mentioned, historical accounts of the apprentice/guild arrangement indicate that the specialist arts and trades of Samoa are long established; therefore a social structure is already in place in Samoan society that enables new apprentices or agents to be incorporated into the Sulu'ape family of the *'aiga* Sa Su'a.[48] The bestowal was an initiative conceived by Paulo several years prior to his sudden death in 1999. Despite some opposition within the family and village, his brother Su'a Sulu'ape Petelo decided to see the initiative through to completion. With the exception of one participant, all were students of Paulo. The remainder was a student of Petelo. According to Sulu'ape Petelo, the bestowal of the Sulu'ape title gave the recipients the right to tattoo others using the Samoan tattooing tools,

but in their own specific cultural styles. It was not a licence to tattoo *pe'a*. It appears, however, that this intention has never been communicated widely and has resulted in various responses from the new Sulu'ape title-holders.

Regardless of the original intentions, there are several reasons why this particular bestowal of Sulu'ape titles to foreigners might be beneficial not only to the newly installed *tufuga* and the Sulu'ape family but the Sa Su'a as a whole. First, the bestowal of the titles creates agents or apprentices for the Sa Su'a in a range of communities overseas. This assures access to different markets and clients for *tatau*. Second, an international distribution of members of the Sa Su'a keeps *tatau* prominent in the conventions and tattoo shows in the areas in which they are located. This develops and helps to service an existing client base, one that is not only interested in the markings but in having images created with the tools themselves. Third, while the scatter of *tufuga* around the globe makes the *tatau* more prominent, it also provides the Sa Su'a (intentionally or unintentionally) with a sense of control over who appropriates, uses and renders Samoan designs overseas. Prospective clients are probably more likely to approach an authorized tattoo artist to produce Samoan designs than not, especially if an 'authentic' motif and the experience of tattooing under the *'au* is sought after. Fourth, these *tatau* agents also serve potentially to reduce the demands on the Samoan based *tufuga*. The newly installed California based *tufuga* Sulu'ape Freewind has said that when Su'a Sulu'ape Petelo visited there for the Long Beach Tattoo Convention in the 1990s he was swamped by the number of people

who wanted some tattooing work from him. Having a member of the Sa Su'a in California may ensure that to some extent client demand is met. Now operating under the Sulu'ape title, Freewind believes he may eventually have permission to produce Samoan *tatau* in a region where there is a substantial Samoan community. As he explained, Petelo wanted him to have the title eventually enabling him to,

> tattoo the hundred and thirty thousand Samoans that live in California alone . . . there is going to be so many people that won't be able to wait, or be able to travel to Samoa or be able to wait for him to come . . . and even if they did, he is only one man that can't do them all, . . . he wants me to help take on the responsibility of learning the pe'a and giving the pe'a to the Samoan population that is there . . .[49]

In Europe, this type of arrangement does not seem to be in place – or at least there is a different kind of understanding – with the responsibility and privileges of the title considered differently. The newly installed *tufuga* Sulu'ape Michel, who also works as a tribal art dealer in the Netherlands, is not actively seeking opportunities to do work in the Samoan style. He has completed one *pe'a* on a European that was started by Su'a Sulu'ape Paulo, but he does not plan to pursue Samoan *tatau* work further. I interviewed him six months after receiving the title. At that point he was of the view that the family title was not necessarily a licence to practise *tatau* abroad or claim some kind of authority over Samoan *tatau*. He said:

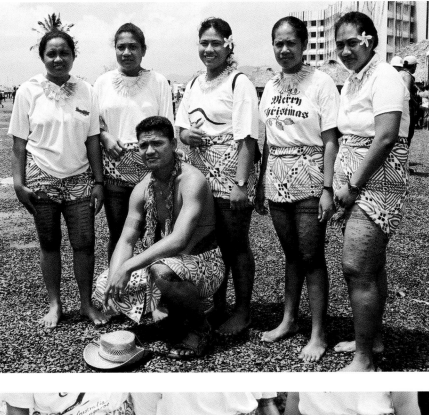

93 Samoans with newly
completed malu and
pe'a, Seventh Festival
of Pacific Arts, Samoa,
1996.

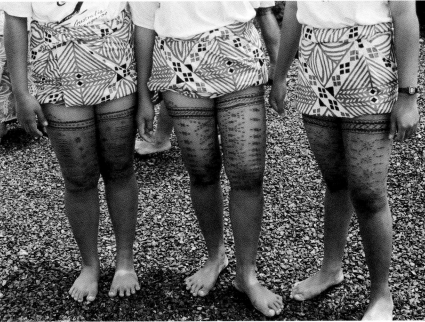

94 Students from Samoa
College with newly
completed malu,
Seventh Festival of
Pacific Arts, Samoa 1996.

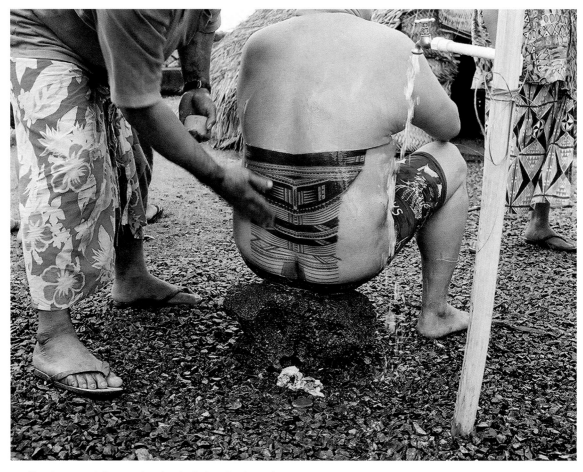

95 Cleaning a partially completed pe'a during the Seventh Festival of Pacific Arts, Samoa 1996.

To me it seemed it was an honorary thing. Each one of us had done something for Samoan *tatau* or traditional tattoo . . . there are persons [title-holders in the group] who hardly have anything Samoan on them who carry the title . . . If I go to Samoa I will never introduce myself as Sulu'ape Michel. Because I might be shaking hands with Malietoa so and so. By introducing myself as Sulu'ape I bring relations to such a high level of protocol that I would make a fool of myself because I don't know this level. So I think it is something that people can only say of me to other people, and then I can be the clown and say that it is an honorary thing, its not the same as you and your title. So I think that there is really a misunderstanding of what happened [at the bestowal].[50]

What long-term implications the recent introduction of these non-Samoans to the Sulu'ape family and Sa Su'a tattooing fraternity will have is difficult

to predict. The main point I want to make is that some Samoan *tufuga* who claim authority or sovereignty over the arts of *tatau* are seeking to share it with the wider world. They are active agents in its dissemination and dispersal. This suggests a certain amount of confidence in the understanding of the people they are entrusting with their family title and knowledge. It also indicates that some *tufuga* sense that the skills and knowledge of *tatau* may be lost if not shared. What will be interesting to observe in future is the extent to which the Samoan communities accept some of these non-Samoan members of the Sa Su'a that some are claiming they are permitted to serve, as well as how they are viewed by the other families in the Sa Su'a. The same is true in regard to the acceptance and recognition of the *tufuga* among the Western tattoo community. Will these non-Samoan *tufuga* be seen as experts and authorities in Samoan *tatau*? Will they meet clients' expectations and perceptions of what a *tufuga tatatau* is and can be? On a day-to-day basis the new title-holders will not move in the Samoan social circles where the Sulu'ape title will have most relevance. But they will find relevance for the title wherever they choose to put it to work, whether this is in the European tattooing convention circuit or in a tattoo shop in a Los Angeles suburb. And in this respect the titles not only serve the cause of the Sa Su'a or Sulu'ape family, but potentially the ambitions or desires of the individual title-holders in their own communities and social contexts.

Within the Sa Su'a extended family some members who are *tufuga tatatau* do not approve of the bestowal of Sulu'ape title to non-Samoans, or the gifting of tools and what may seem like a licence for non-Samoans to tattoo *pe'a* and *malu*. It is, however, significant that the only challenge made in relation to this history-making bestowal related to one of Samoan recipients and his right to receive the Sulu'ape title and not to the rights of the non-Samoan titleholders. This title dispute went before the Samoan courts in 2003 and was granted in favour of the recipient.[51] And this raises an interesting point, and that is that the granting of these privileges to non-Samoans is probably no more threat to traditionalist views of Samoan tattooing and culture than granting them to Samoan people only. Remember that Samoan *tufuga* themselves have historically been and still are significant transgressors of 'tradition' or *fa'asamoa*. The most strenuously contested innovations or changes in contemporary Samoan tattooing practice have been instigated by Samoans. And as they continue to travel globally they will continue to adapt their practice to new environments, situations and client demands.

In terms of the title bestowal alone, there are several, co-existing and in some aspects conflicting perspectives of what the event was about. It was not universally accepted by the family, or by other families in the tattooing clan, and was criticized by *matai* in Samoa and New Zealand.[52] What is not widely known is the original intention behind the bestowal and the efforts to inform and share tattooing technology, ensuring its survival and perhaps developing some sense of fellowship. And this is the paradox. Just when circumstances are set up to take hold of *tatau*, fix its meaning and stabilize or control its dissemination and relevance, it somehow slips away and moves in a new direction.

CONCLUSION

In November 2002 I was talking on the telephone
to Sulu'ape Uili Tasi who was working with Su'a
Sulu'ape Petelo in Hawaii. I had spent a great deal
of time trying to track the *tufuga* down. I found
out that they had already been to Hawaii in July
and August when they completed nine *pe'a* in six
weeks. They were currently back in Hawaii doing
three more and in a nice throwback to their
ancestors they were working on a Tongan, tattoo-
ing and reconstructing on him a Tongan version
of a *pe'a* based on a rare drawing from the
nineteenth century. They were then booked to
travel to the United States for a week, up to
Sweden for a few days, then to Berlin for a con-
vention, then another in Malmö and finally back
to Samoa. All in less than five weeks. I could
hardly keep up with what the *tufuga* was telling
me. So how do we keep up with what they are
doing and the way *tatau* is changing as it circu-
lates and is inscribed on bodies oceans apart?

The Samoan tattooing history I have outlined
is fragmented but cohesive enough to allow some
general conclusions to be made. From the first
settlers of Samoa and their shared 'Lapita' culture,
to the tattooing of non-Samoans and Samoans
internationally, Samoan tattooing can be consid-
ered a contested practice. Samoan *tatau* was con-
tested within the islands of Samoa and reinter-
preted to suit the circumstances of the skins it
was on. Historically, local and trans-local forces of
change have shaped Samoan *tatau*. I have argued
that inter-island connections, processes of colo-
nization and new and conflicting ideologies locate
Samoa at the convergence of forces of change

from beyond its shores. However, the changes and
contestations were not always externally imposed:
Samoans were active agents in response to these
outside influences. In the nineteenth century their
persistence ensured the survival of *tatau* in the
face of a conflicting and powerful ideology. While
external forces were an impetus for change, the
internal politics among *tufuga* of older and
younger generations and the banning of *tatau* in
some villages and not others, demonstrates that
tatau and its associated practices, like the society
in which it is embedded, was not homogenous. The
meaning and social relevance of *tatau* were locally
and diversely negotiated in response to local and
non-local influences. What these accounts present
us with is a more complicated history of *tatau*
and an insight into how a single cultural produc-
tion can be variously interpreted, even within one
archipelago.

Today the circumstances of history and the
stories from folklore may lead the tattooing fami-
lies to assume that they alone have ownership and
authority over *tatau*. But the reality is that the
visible and distinctive profile of *tatau* makes it an
attractive and important cultural icon in the status
politics of Samoan *matai* and the social elite.
Moreover, outside Samoan social and cultural sit-
uations, *tatau* is important to non-Samoans, who
also play an influential role in its dissemination
and reproduction. Today, the circulation of *tatau*
outside the Samoan social contexts is more obvious
in an era where visual culture is more accessible
and moves quickly on global cultural flows via the
Internet, television and other mass media. Social
actors with access to these sources appropriate
and create ideas around symbols to suit their own

desires and realities. What is not so new about these processes is that they have been taking place for centuries. Anthropologists have recognized this for some time, but what is new is the intensity of these processes in the present day, and the importance of understanding how these processes converge and create diversity.

The present-day tensions over the ownership of *tatau* and its practice are a result of a heightened awareness of global 'cultural flows'. There is anxiety among some Samoans of *tatau* becoming devalued or losing significance in a seemingly overwhelming tide of westernization. What this history of Samoan *tatau* illuminates is how, despite its increasingly global practice, *tatau* still persists in expressing a very local (albeit transnational/diasporic) set of identities and experiences for Samoan people.

96 Drawing of Marquesan warrior by Efraima, Papeete, 2000.

Multiple Skins: Space, Time and Tattooing in Tahiti

Makiko Kuwahara

Historical discontinuity is one of the significant features of Tahitian tattooing that differentiates it from other Polynesian practices, such as Samoan. Tahitian tattooing was abandoned due mostly to suppression by missionaries in the 1830s, and revived in the 1980s as part of a cultural revitalization movement, but tattooing of the pre- and early contact period was lost after a long absence and displaced by a newer practice, extensively implicated in youth culture, gender relationships, cultural revitalization, modernity and prison culture.

An important feature of Tahitian tattooing is its location in global tattooing networks. Today, Tahitian tattooists travel anywhere, participate in international tattoo conventions and serve apprenticeships at European and American tattooists' salons. Tourists, gendarmes and military personnel are tattooed in Tahiti. Both Tahitian and international journalists working for tattoo magazines, museum magazines, newspapers and television document Tahitian tattooing and tattooists. While non-Tahitians are interested in Tahitian tattooing, Tahitians introduce Euro-American, tribal, Japanese, Celtic, and other Polynesian styles, techniques and technology into their tattooing.

Tattooing is an act of sharing time and space among tattooists, tattooed people and observers. These people experience, compare and observe their bodies and others. Through objectifying the body, they mark similarities and differences, and include and exclude each other according to the representation, experience and social contexts of the tattooed body. Tattooing, as body inscription, is thus the embodiment and representation of identities and relationships resulting from the objectification of one's own body, and others', in a shared time and space.

In this chapter, I examine the spatiality and temporality of tattooing and aspects of identity formation and social relationships. Tattooing is often considered to belong to a place. Different practices are often distinguished one from another by the name of the place or ethnic group, such as 'Tahitian tattooing' or 'Japanese tattooing'. This conception results from the idea that a group of people who live in a place that is geographically separated develop and distinguish culture differently from their neighbours because of this isolation. Tahitian tattooing is, however, not confined to Tahiti, and my approach to the spatiality of

tattooing focuses on the tension between movement and confinement. In other words, it makes an enquiry into the complex and dynamic relationship between place and the cultural/ethnic collective that has been emerging from the movement and confinement of people (tattooists, tattooed people and the other people) and knowledge (tattoo design, style, motif and practice).

Temporality is also approached in a similar way. As the history of Tahitian tattooing is discontinuous and today tattooing in non-Tahitian or a mixture of different styles is popularly practised among young people, the concept of 'past' or 'history' seems to be less relevant in the context of contemporary Tahitian tattooing. I argue, however, that ancestral history is still significant in contemporary practice, since young Tahitians have established and developed their tattooing through manipulating the practice and meanings of tattooing in the past. Young Tahitians' process of adaptation of modernity and globalization comprise their understanding and articulation of their ancestral history. My aim in this chapter is thus to examine how young Tahitians deal with this discontinuous cultural history and with globalization, and how they form their gender and ethnic identities and develop their social relationships, through tattooing.

GENDER, ETHNIC AND AGE DIFFERENCES IN TAHITI

The Tahitian tattoo world is male-dominated, where establishing and expressing masculinity is significant.[1] Masculinity is embodied throughout a Tahitian man's life, but it is founded mostly during their adolescence, taure'are'a. Both female and male Tahitians have taure'are'a from the late teens and the early twenties, although some have a longer period of taure'are'a. Taure'are'a is the period to enjoy liberty from domestic and social obligations, which will be imposed upon them as they become older. During this period, adolescents establish solidarity based on same-sex relations. Girls share time with girls and boys with boys. Yet, it is also the time for taure'are'a to explore sexual experience with different partners.[2]

Many taure'are'a travel to different districts and islands to visit their friends or relatives. Even if taure'are'a reside in one place, they move around to see friends or do some business within the district or island. Although they move whimsically, Tahitians know how to find their friends. They know the spot where the friends are likely to appear, so they hang around there or leave a word for the people who are there, and the message is passed on to the person being sought after.

Large numbers of taure'are'a, especially males, leave school early. Female taure'are'a who have left school generally become involved in the household structure by helping out with domestic work, such as cleaning, cooking, taking care of younger siblings and making tifaifai (patchwork). Male taure'are'a work with their fathers or relatives either full- or part-time. They feel more comfortable spending their time with other male friends of the same age, playing soccer, surfing, drinking beer, smoking pakalolo (marijuana), playing guitar or ukulele, and singing. Fiu is a common term often expressed by taure'are'a (not only by taure'are'a but also Tahitians of any generation), which means 'to be fed up with'. Taure'are'a often

become *fiu* with study, work, weather, traffic, any kinds of relationships and even doing nothing. They exorcise the feeling of *fiu* by playing sports and music, having *bringue* (party) and tattooing.

The main reason that male *taure'are'a* avoid spending time at home is the nature of the Tahitian household, which is female-dominated. Mama, literally mother, has authority over household maintenance and decision-making. The elder male members are also respected, but often remain as quiet figures in the family. While female *taure'are'a* are involved in domestic work and maintain close relationships with mama, the work of male *taure'are'a* is usually outdoors, such as fishing, hunting, constructing houses, cutting and clearing bush off the property. Through having the *taure'are'a* period, Tahitians shift the basis of activities from house to outside for men and strengthen domesticity for women. After exploring different jobs, partners and places, Tahitians end *taure'are'a* by marrying or having a stable relationship, finding full-time employment and settling down in one place. Many Tahitians, however, prefer to share time with the same-sex friends even after marriage.

Gender identities are constructed and enforced both through assimilation and differentiation, often articulated in the conversation among people of the same gender. In the presence of their male friends, Tahitian men often talk about and to women with sexist language, although their actual relationships with women are not necessary sexist. In their conversation among men, they stress an interest in the physical features of women rather than personality. By making little of women, Tahitian men make implicit the significance, respect and affinity with their male friends and relatives. They enforce male solidarity by articulating and exaggerating female otherness.

For the male artisans including tattooists, female dominance occurs not only in the household, but also in the artisan associations to which they belong. In general, male artisans carve stone, bone, wood or shell, and plait coconut fibre, while female artisans plait fibres, make *tifaifai*, shell necklaces, bracelets and anklets. Although male artisans participate in the artisan associations, the associations are mostly organized and run by female artisans.[3] Women artists in the artisan associations are often called 'mama' or 'mummy' with respect and intimacy. They are 'mothers' in the artisan associations, which are formed as a fictive household. They order male or young female artisans to set and clean up the stand, transport their crafts and run errands. Young male artisans listen to the senior artisans who are, in many cases, their mother (either biological or foster), aunt, elder sister or cousin.

Ethnic complexity is also entangled with the age and gender relationships of *taure'are'a*. For instance, the unemployment of young Tahitians, especially males, is one of the most significant problems in French Polynesia. Many Tahitian men complain, 'There is no job for us because the French came and took them all.' *Taure'are'a* who do not adapt themselves to the French educational system and drop out of school face another French authority over employment. The antagonism of Tahitian men towards French people is generally implicit. They often mock them by emphasizing physical differences. Tahitian men

call French people *taioro*. *Taioro* means 'fermented grated coconut', but when addressed to French men, it signifies 'uncircumcised penis'.[4]

Some Tahitian men themselves embody '*sauvage*-ness' – wildness as a feature of their masculinity that has been also perceived by French people. Wildness is essential for Tahitian men to form their identity as *taata ma'ohi* and relate themselves to warrior ancestors. Through demonstrating wildness or actually embodying the wildness of nature, Tahitian men assert that the nature of the islands is inaccessible to 'the civilized' French people or *popa'a* (white foreigners). Tahitian men are emancipated from female dominant households, artisan associations and the French-controlled state (although they inevitably remain within them), and consolidate Tahitian identity and descent from male *tupuna* (ancestors) by embodying 'warrior' masculinity. Therefore, identities as male (gender) and as Tahitian (ethnic) are constructed through interrelation with different gender and ethnic groups.

Opposed to their masculinity that emphasizes physical strength directed towards women and French people, Tahitian men establish fraternal bonds with their male relatives and friends. Tension generated through emphasizing physical strength is restrained. In the male-exclusive relationships, Tahitian men become moderate and cooperative. They also consider easy goingness an ideal character. It is juxtaposed with the complexity of French people generalized by Tahitians. Tahitians often state that French people do 'too much talking' and are 'too uptight'. This is not considered proper behaviour among Tahitian men.

Juxtaposing the hierarchical structure of household and state, male relationships tend to be egalitarian and inclusive. Tahitian men call each other *brad* or *frère*. *Brad* derives from the English word 'brother', although it does not necessarily imply a biological or legal relationship. Tahitian men use *brad* not only with their close friends, but also to acquaintances or even to those whom they have not met before. *Brad* is a useful term to address a man whom you do not know, or whose name you have forgotten. Tahitian men rarely address male friends, cousins or even brothers by name. I argue that the use of the term *brad* does not necessarily express male friendships, but establishes as well as consolidates relationships by including themselves and other men within their fictive family apart from household.

I argue that within this inclusive structure and fraternal bonds, male Tahitian relationships are competitive. It is important for Tahitian men to be proud of themselves, but it is also considered inappropriate to make their pride too explicit. Tahitian masculinity is apparently demonstrated towards people of a different gender and ethnicity, but in fact it is implicitly directed towards those who are the same gender and ethnicity – Tahitian men. Women and French people are mediators to avoid Tahitian masculinity from impacting too directly and severely on other male Tahitians.

Gender, ethnic and age differences affect the network of tattooists, which has been formed mostly among those who work full-time and have many tourists and military personnel as their main clients. Most tattooists are interested in the designs and styles, the method and tools with which the other tattooists are working. Exchange

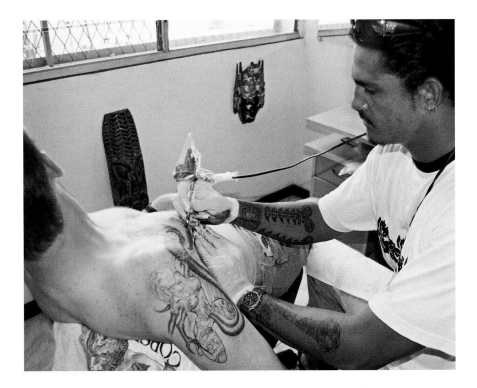

97 Aroma, Papeete, 1999.

and diffusion of knowledge about style and technique are manipulated by their cooperative and competitive attitudes towards the other tattooists. In the following section, I introduce tattooists who have been transforming as well as consolidating the practice and form of Tahitian tattooing in their networks.

AROMA, MANO AND MICHEL AT THE SALON

The sound of the death-metal band Cannibal Corpse is shaking the bleak room. This is a tattoo salon, called 'Polynesian Tattoo', located above the Bar Taina in the quarter of Papeete, which by night is frequented by sailors and military personnel. Aroma is tattooing a devil on the shoulder of a French military man, shaking his head and mumbling the lines of a song,[5] Devil is bleeding black blood. Music is, Aroma explains, necessary for his creativity. Aroma believes that all his clients share his musical tastes. Jimmy, Jérémie and a guy whom I have not met before are watching the tattooing and drinking Heineken. Aroma sees me and calls out 'How are you, Maki? What did you do this weekend? Did you eat Tahitian *kokoro*?'. 'No. Not *kokoro*. I want *mafatu*!'.[6] 'That's not good. You should try Tahitian *kokoro* before you go back to Japan.' The other men all laugh and keep on joking. Every time I see Aroma and his friends, there is a lot of joking, especially about sex.

Aroma, aged 26, started working at Polynesian Tattoo in 1993 when Bruno Kea, a French tattooist and the previous owner of the salon, decided to

return to France. Bruno handed over the salon to Aroma who was working at the Beachcomber Hotel and tattooing only at weekends. Aroma was from Fakarava, Tuamotu, but spent most of his childhood in New Zealand. These dislocations have made him fluent in English, French, Tahitian and Paumotu (the language spoken in Tuamotu), and have also given him a frank and friendly character. The guy that I do not know leaves the room. I ask Aroma who he is. 'He is my cousin.' 'How many cousins do you have?' I have already met many of his cousins at the salon. 'Many. You see, Maki. All the boys are my cousins and all the girls are my girlfriends.'[7]

The French military man has already had many sessions with Aroma. After each session, Aroma and this man have beer at Bar Taina. They have become friends. Aroma explains in front of him that he is *taioro*, but a good guy. In the room behind a big reception and waiting room where flashes of North American Indians, *Samurai*, *Geisha*, Satan, dragon and tribal designs decorate the wall, Mano, aged 23, Aroma's younger brother, is drawing a big Polynesian-style manta ray on the tracing paper for a local French boy. 'Hi, Maki, how is your pussy today?' 'I am fine. Thanks. How was your weekend?' 'Great. Fucked many girls'.

Mano stepped into Aroma's shoes when he moved from Fakarava to Tahiti at the age of 18. Aroma and Mano are very intimate brothers. They have been playing death-metal music in a band with two other friends. They also canoe in the same team. Before Hawaiki Nui, they were training after lunch or late in the afternoon.[8] Aroma once explained that Mano and he had been doing many things together, and understand each other. When one is down, having problems with his wife or drinking too much, the other supports him. Mano tattoos only black works, Polynesian and tribal styles; he explains that he cultivated and developed the designs and his style of tattooing by himself and learned techniques such as handling and tuning machines and making needles from Aroma.

I enter the last room of the salon. Michel is tattooing a small lizard in *le style local* on the back of a French tourist. 'Bonjour, Michel'. Michel raises his fist towards me and I rap my fist against it. He does not say anything. He often ignores me at the beginning and starts murmuring jokes, but today his silence is longer than usual. That means he is a little grumpy. Michel normally becomes passionate when he tattoos a large free-hand dragon, for example, because he is *fiu* to tattoo the small local style of turtle and dolphin. 'I saw young people tattooing in Mahina.' 'I have to modify them. They have to stop tattooing with razor.'[9] 'Oh . . . but it would be good for you. You can have more clients then.'

Michel, 32 years old, is from Raiatea. He learned tattooing with his friends on the street in Pamatai where he lives. Michel worked at a furniture shop for eight years and tattooed at weekends and after work. He started working with Aroma at Polynesian Tattoo in 1996. Michel is strongly conscious of being a working 'professional' and constantly distinguishes himself from the artisan-based tattooists. Not only Michel, but also Aroma and Mano distinguish themselves as 'professional' from artisan tattooists who tattoo mostly Polynesian designs by using a razor with a single needle and China ink. The artisan-based tattooists, how-

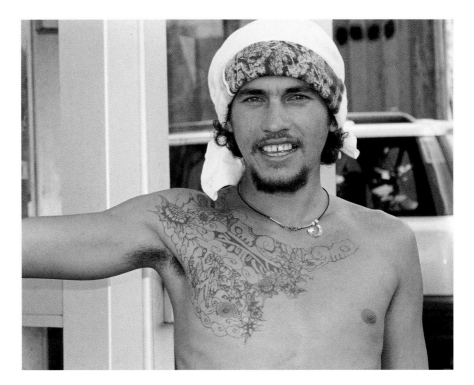

98 Saté, Outumaoro, 1999.

ever, do not assert that 'we are artisan', but that 'we are tattooists'.

Michel is neither a death-metal musician nor a canoe racer. He does not drink much, because he believes that drinking spoils his tattooing. The relationship between Aroma and Michel, however, is more than that of work colleagues. They criticize each other's work, but consider that they are both good tattooists and work well together. Tattooing at the salon is distinguished by the fact that they tattoo in all the styles: Polynesian, tribal, European and Japanese. They use a *machine complet* – tattoo machine, a wide rage of needles, professional tattoo ink with many colours, flash, carbon papers, *ultrason* (a needle and tube cleaner) and sterilizer.

Aroma, Mano and Michel have modernized

and developed their local styles. Their *tiki* often incorporate facial expressions such as *tiki faché* (angry *tiki*), *tiki souri* (smiling *tiki*), *tiki dormi* (sleepy *tiki*) and so forth. Some *tiki* show teeth. Aroma has tattooed *tiki* whose eyes are open, but recently started tattooing *tiki* whose eyes are closed. He said that he wants to change his style once in a while. Aroma tattooed *tiki Spiderman* by cross-hatching the head of *tiki*. Mano tattooed several female *tiki* that have long eyelashes.

ERIC – IN OUTUMAORO

Getting off *le truck*, most people cross the street and go to the Continent, the biggest supermarket in Papeete, but I walk in the opposite direction, cross over a filthy ditch and step into a spot where

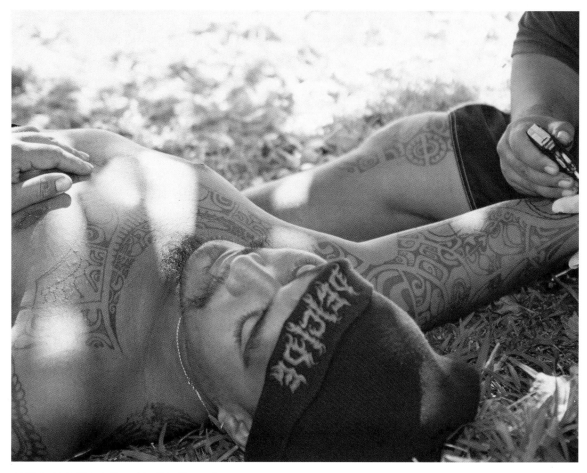

99 Tupuna getting tattooed by Eric, Puunauia, 1999.

all the rubbish is scattered.[10] Four young men are sitting on a fallen trunk and listening to Bob Marley. 'Ia ora na, how are you?' I shake hands with these men. Some of them raise red eyes and nod, smiling. 'E maitai roa, Are you looking for Eric?' 'Is he going to tattoo this morning?' 'No. He is over there, the other side. Talking with his friends.'

Saté, one of the men, was born and grew up in Outumaro. He is one of a few men hanging around in the district who is not vague and always gives me a quick and clear response. He is tattooed on the chest in a mixture of European and Tahitian styles by Eric. His tattoo is not yet finished and Saté wants to have it finished someday. Saté said to me the other day that he is happy to have Eric's tattoo because he is an artist. This tattoo is Eric's painting (le tableau d'Eric) and he always carries it on his body.

Another man has many matchboxes in his cotton knapsacks. When he sees a car or a French person approaching, he silently disappears from my sight and comes back after a while.[11]

Erita, another man, spits and says: 'Bring your friends from Foyer here. There are many girls over there, right? Here there is no girl, only men . . .'.[12] Erita is the younger brother of Eric and has many tattoos by him. 'But, the girls do not like mess like this. You've got to clean it all first. As you spend the day without doing anything, you can clean here. You should work!' I mean 'work' for cleaning, but Erita takes my words differently. 'We cannot work. No work. Farani have taken all the work, and there is no more for us', Erita says.

I leave them to look for Eric. He is talking with his friends at the other end. I do *bisous* and ask him: 'Clément told me that you will tattoo somebody today.' 'No, I stopped tattooing. *Fiu*. I started doing the sand painting. A bit of change.'

Eric, aged 28, is a big man who always smiles showing the holes of missing teeth in his mouth. Eric worked at a black pearl farm in Tuamotu for three years and travelled around the different islands and stayed with his relatives there. Now he stays in Outumaoro most of the time. Eric is heavily tattooed himself. He explains that he has the same tattoo as the ancient warrior of Papeeno. Eric once explained to me that while tattoo is decoration for most people, for him it is the representation of *aito* (warrior) and *tupuna* (ancestor). Together with Pipipe, who is now living in Arue, Eric has tattooed many of his colleagues in this district.[13] Eric's tattoo consists of a wide range of the traditional Marquesan motifs. His *tiki* figure is elegant and similar to those of artisan carving. Eric has always liked drawing since

100 Clément tattooing at the fire station of Papeete, 1999.

101 Pipipe tattooing at his home, Arue, 1999.

he was young. He always moves slowly and shows an overt and friendly smile, but our relationship changed when he found out that I had been working with the other tattooists in Tahiti. Since then Eric has been keeping his distance and trying to hide from me that he is still tattooing.[14]

A couple of months ago I was on the *motu* (small island) beside the Soffitel Maeva Beach Hotel, watching Eric tattooing his friend, Tupuna.[15] Tupuna had already got tattooed in the Euro-American style, a dragon on the left shoulder when he was a 'hippie' (as he explained). He decided to cover his right shoulder and arm in *le style local*. Then, he can be a real *tupuna*.

'That's better', Tupuna lays his body in a comfortable position and says, 'Why did you stop being hippie and become *tupuna*?' 'It was bad. Stole and caught, stole and caught.' 'Tupuna is better now because he doesn't do such nasty things'. Eric smiles.

From out of his cotton hibiscus print bag Eric takes out a razor, sewing needles, Rotring ink and

starts attaching needles to the head of the razor with a thread. After he has finished preparing the razor, Eric roughly divides the surface of Tupuna's arm by marking it with a pen and starts tattooing the motifs of *tiki bras* (*tiki* arm), *tiki mata* (*tiki* eye) and so on. The subtle sound of the razor is accompanied by the sound of waves and wind. Tupuna closes his eyes and seems to be sleeping. 'It is good to tattoo outside', I say, and Eric smiles, showing his missing teeth, 'Yes. This is tattooing.'

102 Big, thick and black tattoo, 1999.

Fare artisanat is located next to the Continent in Outumaoro. In the round-shaped neo-traditional building, several mamas are plaiting coconut fibre and making shell necklaces while minding the stand. I always say *bonjour* to Mama Tehea and Mama Carmen and have a chat with them before seeing Thierry and Clément.

Thierry, 31 years old and born in Tahiti, has his work place at the end of the *fare*. He has been a member of the artisan association for seven years, and has been plaiting coconut fibre. He started tattooing two years ago. Thierry learned tattooing by watching the tattooing of Eric and Pipipe, who were hanging out in the district, but he no longer spends much time with them. Since he has a wife and children, tattooing has become a way of earning a living. Thierry wants to be more 'professional' in hygienic and technical senses than is possible in street tattooing. Like other tattooists in the artisan association, Thierry has been working at *Heiva* (annual festival), *l'exposition d'Artisanat* and *la foire commerciale*. He was tattooed on his shoulder by Eric when he was spending more time with his friends in Outumaoro, and wants to get tattooed more on the back and probably on his legs by a Marquesan tattooist of another artisan association.

Thierry started tattooing tribal style in 1999, but most of his tattooing is in a modernized local style, a mixture of Marquesan, Maori, Tahitian and Hawaiian motifs. With his friendly nature, Thierry is getting along relatively well with other tattooists. He calls the other tattooists *chef* (boss) and seeks their advice. Not only does he collect

103 Small, thin, greenish black tattoo, 1999.

knowledge, Thierry is also a hard worker. He is always drawing designs when he does not have any clients.

'*Aha te huru, brad!*' William comes in. William is a friend of Clément and has been tattooed by him little by little. '*E, brad! Ça va, toi,* Maki?' Thierry stops tattooing and greets us. 'Isn't Clément working today?' '*Aita.* he is at home.' 'Ok. *Alors.* I will drop in here tomorrow.' 'Ok, *brad*'. Thierry goes back to tattooing.

Clément, a brother-in-law of Thierry, works at Thierry's stand. Clément has been working in construction and tattooing only at weekends at his own or his clients' residences. During my research, Clément is tattooing numbers of fire-fighters at the fire station of Papeete because Hugue, his brother-in-law, is working there.

Although Thierry and Clément work at the same place, their ways of tattooing and their clients are different. Clément has tattooed many local Tahitians, most of whom are his friends, while Thierry has many French tourists and military personnel as clients. Thierry sometimes said to me that he did not want the friends of Clément hanging around in their stand because the other clients, particularly French tourists and military personnel, would be afraid of them. While Thierry has extensively learned from salon-based tattooists and another artisan-based tattooist and his tattooing has transformed in the mixture of these styles, Clément prefers to tattoo with a fine, detailed motif style, but he has started gradually mixing Maori, Marquesan and Hawaiian motifs into his tattooing.

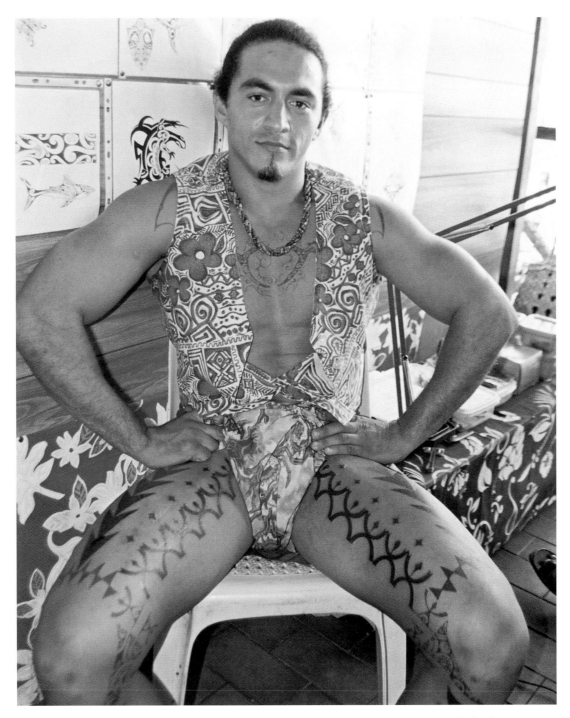

104 Tavita, Papeete, 1999.

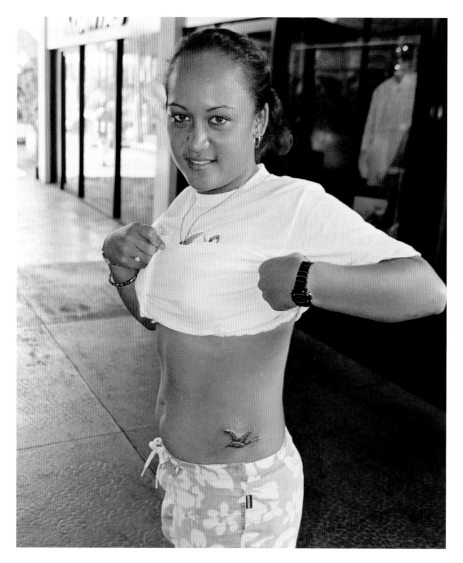

105 Girl's tattoo. 2000.

THE TAHITIAN TATTOO WORLD

The first question to ask in this section is whether tattoo-related people organize any kinds of solidarity. In other words, the question is whether I examine 'Tahitian tattoo culture' as a collective or individual activity. The tattooists rarely assembled for drinks or other social activities with the other tattooists who were not working partners, although they often met with their brothers, cousins and friends. They did not have regular meetings or gatherings to talk about their work. They often have their own working place and their own way of tattooing. They do not need to work in a group, as would be necessary for canoeing or playing band music.

The Tahitian tattoo world is not hierarchical and apprenticeships are not common among tattooists. Most tattooists state that they have learned tattooing by themselves, by watching what the other tattooists are drawing and tattooing, and trying it out themselves at home. Yet, tattooists give advice to each other on handling machines and drawing designs, more often with those who work together. Full-time tattooists often work in a group of two or three in the same place to share the rent of the workplace. They are often brothers, cousins, friends and relatives. The co-workers share a sterilizer, flash and sample photo files, and exchange knowledge of design and technique. They often arrange their clients to suit the convenience of the others. Many tattooists like Eric, however, who tattoo outside or at home work by themselves.

A network of tattooists has been established and developed with the increasing popularity of tattooing among local Tahitians and tourists, as well as with the increase of occasions when tattooists meet each other such as *Heiva*, the exposition of artisans, *la foire commercial* and a Tattoo Festival. Tattooists who are accustomed to tattooing their family and friends in their own districts have started tattooing tourists and people outside their community. Consequently, they are required to do a more 'professional' level of work in both technique and form. The exchange of designs and knowledge of techniques between tattooists has been promoted by the demands of clients and has made enormous changes in Tahitian tattooing.[16]

I propose that 'Tahitian tattoo culture' is located in three arenas of Tahitian society. First, it is located in *taure'are'a* culture. Tattooing is a pastime for male *taure'are'a* and assists bond-making among them. Eric, for instance, has tattooed many young men and women in the district of Outumaoro. Most of them are proud of being tattooed by Eric and have become conscious of being a member of the district. The fact that Clément tattoos many fire-fighters of the Papeete Fire Station derives from the same *taure'are'a* solidarity, although these men are older than those in Outumaoro and, in a strict sense, have completed the *taure'are'a* phase.

The mobility of *taure'are'a* is reflected in that of tattooists. As I have shown above, Tahitians move from one district to another, from one island to another, but their family and friends do not usually have problems in finding them. They simply hang around at the place where the person is likely to appear or pass a word in the network of people. The same tactic can be applied to find a Tahitian tattooist who moves from one place to another. However, non-Tahitian customers, tourists, military personnel, or those from the other archipelagos (although they might be likely to have a relative or friend in the area), do not have such a network, so they need the tattooist to be at one specific place so that they can find him easily. The mobile tattooists are embedded in more local networks, while the full-time tattooists who work at a fixed place tend to have more tourists and military personnel as clients.

Secondly, Tahitian tattoo culture is partly located in artisan associations. The tattooists based in the artisan associations, such as Thierry, mainly tattoo *le style polynésien*, although most of them can tattoo in the non-Polynesian style. They often have other craft-making skills, and Thierry

plaits coconut fibre. They often wear *pareu*, a necklace of carved wild pig's tusk, and head and leg dresses made with *ti'i* leaves. Tattooing is, in this context, one of the Tahitian 'traditional' cultures that express ethnic identity and lifestyle different from French people.

Masculinity expressed in this context is 'warrior' masculinity in physical terms, but is embedded in the gender relationships of Tahitian domestic structure. As I have illustrated above, the artisan organization has the same structure as the household, which is controlled and managed by senior female members.

Thirdly, Tahitian tattoo culture is also located in the global context. Polynesian tattooing has already been situated in the global tattooing scene and has been developed in both technique and form in a particular way. The tattooists such as Aroma, Michel and Mano consider themselves a part of the tattoo world outside French Polynesia and differentiate themselves from the tattooists based in the artisan associations.

Tattooists often state the difference between artisan-based tattooists and salon-based tattooists. In fact, the activities of artisans have been globalized through their trips and exhibitions abroad. Globalized Tahitian tattooing has partially encompassed the characteristics of artisan or 'traditional culture' that it is expected non-Tahitian tattooists and tattooed people will observe. These tattooists have more opportunity to meet and become friends with tourists, French military personnel and non-Polynesian tattooists. However, tattooists such as Aroma also keep on teasing French people calling them *taioro* and joking about them among their Tahitian friends.

Their ethnic identity is formed and articulated in an ongoing relationship with non-Tahitian people and their culture.

THE CREATION AND TRANSFORMATION OF TATTOOING

In the last section, I discussed how the form and practice of tattooing are assessed, particularly by tattooists, and how they have been transformed through these assessments and the interactions of tattooists. In doing so, I also showed how the tattooists construct, affirm or negotiate their identities. Choice of tool, for example, has a different significance in each context. In the context of cultural revitalization, the significance of *ma'o-hi* tattooing is not only in the representation of 'traditional motifs', but also in the practice of tattooing. The 'authentic' *ma'ohi* tattooing is, in this sense, realized by using the traditional tools. The more prolonged pain that people suffer while being tattooed with traditional tools is important in terms of warrior masculinity. Enduring the pain is a way to make a warrior body and to demonstrate both physical and mental strength. Many tattooists are interested in tattooing with the traditional tools, and Tahitian tattooists are also expected to tattoo in the traditional Polynesian way by a global tattoo audience.[17]

Tattooing with a remodelled razor is differently conceived according to the tattooists. Clément and Eric insist that tattooing with the remodelled razor is less painful and makes fine and detailed expression possible. Aroma, Mano and Michel consider that the tattoo machine is better than the remodelled razor because it is faster, more hygienic

(easier to clean) and more powerful. They state that both machine and razor tattooing are painful because both prick the skin with needles. The remodelled razor has been accommodated with male *taure'are'a*'s lifestyle and relationships. First, it has been adapted to their mobility because the remodelled razor does not work with electricity, but with batteries, so that tattooists can tattoo everywhere, even on the streets or on *motu*, as Eric tattooed Tupuna. Tattooing is a good way of killing time for male *taure'are'a* while on the streets or travelling. Secondly, the remodelled razor has been accommodated to the way of embodiment of *taure'are'a* masculinity. In the tattooing male-exclusive gathering, *taure'are'a* masculinity is embodied as moderate, expressed in the easygoing *aita e peapea* (no problem) way. Unlike tourists or the French military personnel, *taure'are'a* take possibly as much time as they want and stop if they are *fiu* and sometimes continue later. Some Tahitian women prefer to be tattooed with the remodelled razor because they consider it less painful, judging by its subtle sound.

Ways of transferring the tattoo design onto the skin are also differently conceived. Some tattooists such as Eric and Pipipe assert that good tattooists do not use carbon paper and tattoo directly on the skin (even without drawing the design with pen). Other tattooists such as Aroma and Michel, however, claim that it is better to draw the designs on the carbon paper before tattooing, because the tattoo is then more accurate and 'professional'. They also tattoo freehand, but often use carbon paper to trace designs that are symmetrical, such as the turtle and ray. Freehand has been popularly used by the artisan-based tattooists.

The motifs of the other crafts such as stone, wood, bone and mother-of-pearl carving are directly carved into the material without tracing on the carbon paper or drawing by pen. Some artisans mark the form of designs by pencil. When I asked these artisans and tattooists whether they did not need to look at the models for the motifs, they usually pointed to their head and said 'All in the head.' For these artisans and tattooists, freehand proves that they are 'Tahitian', 'Ma'ohi' or 'Polynesian', and naturally possess the knowledge of their tradition.

Ways of transforming the design vary according to the types of clients. Non-Tahitian, non-local and female clients demand more accuracy. Straightness is also one of the elements of good tattooing for Tahitians. However, Tahitians, particularly men, do not complain even if a line is not straight and a symmetrical design is tattooed as asymmetrical. This is also owed to the easygoing nature of Tahitian men among peers.

Many Tahitians just choose a tattooist whom they would like to tattoo them and let him tattoo whatever he likes or tell him only the basic characteristic such as 'something local/*haka*' or 'dolphin' or *tiki*. They are often brothers, cousins or friends of the tattooist, and know his work well, and trust in him. Furthermore, this is another embodiment of masculinity based on fraternal bonds.

Observing that world-famous tattooists tattoo not only the design from flash but also their own design by freehand, some Tahitian tattooists consider that freehand tattooing distinguishes artist tattooists from flash-only tattooists. Tattoo artists are required to have drawing skills as well being

creative. Freehand tattooing rejects reproduction of the same design and seeks originality and uniqueness, which is in contrast to the practice of Tahitian tattooing in the early European contact period. Freehand is, however, supported by contemporary artisan tattooists. The notion of 'artist' current in the global tattoo world has been introduced into the Tahitian context. Freehand tattooing is, in this sense, located between the local and global tattoo worlds. This is made explicit when Michel says that he is an artisan and he defines 'artisan' as an *artiste local* (local artist).

Tattooists are also differentiated by their tattooing expression derived from the different use of tools. Aroma, Michel and Mano prefer thick lines, big motif and black tattoo ink, using a tattoo machine with three to eleven needles. These tattooists are familiar with the Euro-American 'black works' such as tribal, Celtic and Euro-Polynesian. They explain that thick lines would not be smudged much even after ten years and remain black and sharp. Eric, Pipipe and Clément prefer the thin, fine, detailed style tattooed by a remodelled razor with a single sewing needle. These tattooists consider that the thick lines, big motif and black ink style is too modernized. Both groups consider that their style is *le style local*, but while the former means that it is comparing itself with non-Polynesian tattooing, the latter means that it is more similar to the old Polynesian tattooing. The dichotomy such as thin line equals local and thick lines equals less local is too simplistic, so requires further consideration.

The thickness of line, colour of ink and size of motif mark the distinction of man and woman, Tahitian and Farani, and locals and visitors.

Thick, black and bigger motifs of tattoo are associated with Tahitian masculinity. Many young Tahitians in the forefront of contemporary Tahitian culture through dancing and artisan activities are heavily tattooed and often in thick, black and bigger motifs because they stand out better from a long distance when they dance. As for motifs, the 'spear' – triangles vertically aligned – is popular as a representation of 'warrior' masculinity. Christian, a dancer of Les Grands Ballets de Tahiti, for example, was tattooed with *tiki* representing his family – himself, his wife and his children – on the loins by Aroma and Mano. These *tiki* were tattooed in thick, black, bigger motifs and modernized so they had facial expression.

Non-dancers and non-artisan Tahitians also apply this style. William, for instance, had detailed, fine, small motifs tattooed on his legs by Clément, but later he asked Clément to fill some of the motifs in black to make them bigger and more solid. For these tattooists and tattooed people, masculinity expressed in thick lines, black ink, and big motif tattooing is associated with *tupuna* (ancestor) and 'the ancient warrior', although this style of tattooing is modernized and features the tattooists' creativity, and is mixed with other Polynesian motifs.

While the block tattoo is popular among male Polynesians, the one-design tattoo is popular among women and non-Polynesian residents and tourists. In terms of women's tattooing, there is no difference between Tahitian and non-Tahitian women. Women prefer to tattoo with a small one-design, often figurative tattoo, such as a turtle, dolphin, hibiscus or lizard, on the upper back, near the navel, on the feet or on the ankle. A thin

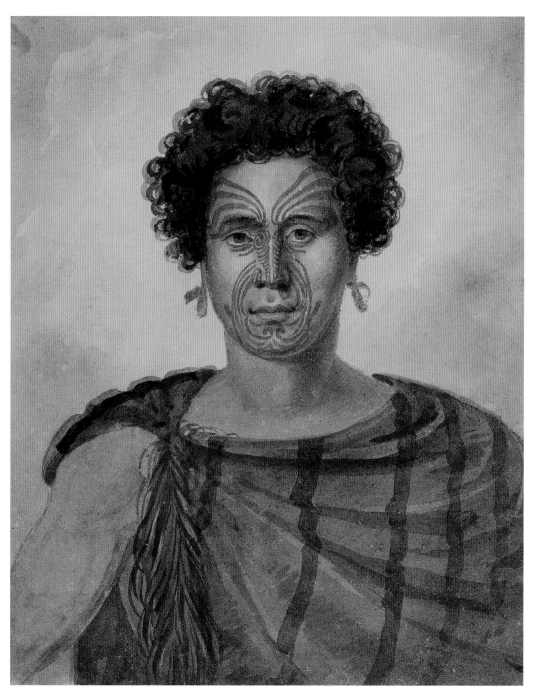

106 Augustus Earle, *A New Zealand Chief from Terra
Nacky* (i.e. Taranaki), *c.* 1827, watercolour.

band around the wrist and ankle is also popular. A design that stretches both sides and forms a bikini string shape above the hip is also often tattooed on women. In this sense, women's tattoos are considered a substitute for decorative accessories such as bracelets, anklets and bikini strings. Some women are tattooed inside the ear. Women's tattoo are often fine, black, Polynesian or tribal style, although hibiscus and dolphin, for example, are also tattooed in a realistic style.

CONCLUSION

Tahitian tattooists had a loose solidarity among them, but have developed it into more firm affiliation over recent years through networking and collaboration. Tahitian tattoo culture is located in three arenas of Tahitian society: *taure'are'a* lifestyle, *ma'ohi* identity-making, particularly in artisan activities, and global tattooing. The contexts, however, overlap with one another and tattooists explore the possibility of their style and practice through interactions with other tattooists, who are cooperative at some times and competitive at other times. The practice and form of tattooing are parts of Tahitian culture, and are used as a way of forming gender, ethnic and age differences and identities more broadly.

The space of Tahitian tattooing is determined by both the mobility and stability of tattooists, since *taure'are'a* tattooists are usually based in a district, but often travel from one district to another, or from one island to another, and tattoo in each place. Full-time tattooists usually have a salon or stand and work at the same place. Yet,

they also tattoo in different places at festivals, exhibitions and conventions, and they have started tattooing more on these kinds of occasions and travel to different places. With the mobility of the tattooists, tattooing and friendship bonds are extended in different districts and islands, and recently outside Tahiti.

The temporality of Tahitian tattooing is distinguished as modern or ancient by the technical, technological and formal aspects of tattooing. Modern tattooing is a contemporary invention and introduced into Tahiti with Western techniques and technology. 'Ancient' or 'traditional' motifs and the style of being heavily tattooed are significant ways to embody masculinity for Tahitian men and to consolidate *taure'are'a* relationships and for dancers and artisans to represent cultural identity. 'Modern Polynesian style' has been developed with tourism by responding to the demand for smaller designs and sophistication of the style. Yet, Tahitians are also tattooed in *le style modern* on their body, in small sizes for women and big for men.

Tattooing is a process of establishing cultural, gender, occupational and age identities for young Tahitian tattooists and tattooed people. This is a different process from that which occurs when the knowledge of tattooing is 'heritage', passed from the elder people to the younger. Because of a discontinuous Tahitian history of tattoo, young tattooists and tattooed people have been exploring and cultivating tattoo forms and technique both in and outside Tahiti. The notion of 'tradition' is, however, still significant since it boosts the social value of tattooing.

Wearing Moko: Maori Facial Marking in Today's World

Linda Waimarie Nikora, Mohi Rua and Ngahuia Te Awekotuku

I tiaria mai to mata whakarewa
Kia whakatauria te uhi a Wharawhara

They have adorned your radiant face,
To enhance the fine chiselling of Wharawhara[1]

The Europeans who made landfall on the shores of Aotearoa-New Zealand nearly 250 years ago encountered the tattooed face for the first time. Joseph Banks, having met and looked closely at Maori men with engraved skin, records his early impressions in his *Endeavour* journal:

> There faces are the most remarkable, on them they by some art unknown to me dig furrows in their faces a line deep at least and as broad, the edges of which are often indented and most perfectly black. This may be done to make them look frightfull in war; indeed it has the Effect of making them most enormously ugly, the old ones at least whose faces are intirely covered with it . . . Yet ugly as this certainly looks it is impossible to avoid admiring the immence Elegance and Justness of the figures . . . which in the face is always different spirals, . . . all these finishd with a masterly taste and execution.[2]

These words reflect a fascination, curiosity and repulsion. Confronted by such faces, Banks's focus engages the aesthetic much more than the grotesque. The face is the site of all of our senses. It is where we receive the world, where we taste it, smell it, touch it and see it. It is where we express or display our emotions and more subtly, where we show signs of age, stress and gains or losses in weight; it is where we reveal who we are.[3] We read faces and the messages they express, and make assumptions about what we are seeing. Comparisons are made, judgements reached. In some instances, a face may be utterly foreign, a new experience for the viewer to consider, manipulate, avoid or meet head on.

Bank's comments on the unique Maori technique were extended by the missionary Yate a few years later:

> There is a remarkable difference in the tattoo of the New Zealanders, and that of the Navigators', Fiigee or Friendly Islands. In the latter, the skin is just perforated with a small pointed instrument, and the staining matter introduced; so that, in passing the hand over the part that has been tattooed the skin is

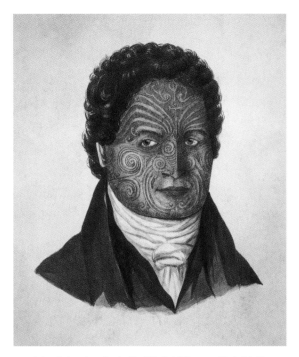

107 John Sylvester, *Portrait of Te Pehi Kupe, with full tattoo on face and wearing European clothes, c.* 1826, watercolour.

emerged the following rather breathless account:

> The art of tattooing has been brought to such perfection here, that whenever we have seen a New Zealander whose skin is thus ornamented, we have admired him. . . . I was astonished to see with what boldness and precision Aranghie drew his designs upon the skin, and what beautiful ornaments he produced; no rule and compasses could be more exact than the lines and circles he formed.[6]

Ambivalence, a mix of horror and admiration, pervades this early writing. As the colony was established, a more condemning, sanctimonious attitude prevailed, when the *moko* of the Maori face, however chiefly, became a metaphor for what must be confronted and removed. Or, if at all possible, reconfigured to suit the colonizing norm.

smooth, and the surface is fair; whilst in the former, the incision is very deep, and leaves furrows and ridges so uneven, that in some places, when long enough, it would be possible to lay a pin, which would be nearly buried in them.[4]

Another early admirer was the wandering artist Augustus Earle, whose response was similar to Banks, describing one encounter with a frisson of horror:

> their faces rendered hideous by being tattooed all over, showing by the fire light quite a bright blue.[5]

He later befriended a *ta moko* artist, whom he considered a great natural genius, and thus

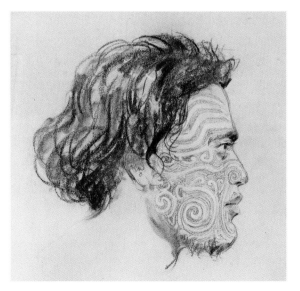

108 Charles Rodius, *Chief of Otargo, New Zeeland,* 1834, pencil and charcoal.

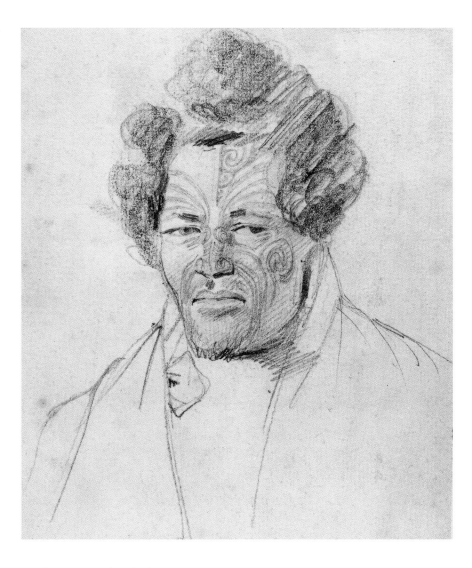

109 Charles Rodius, *Edanghe from Long Island*, 1834, pencil.

One of the first to pass judgement and actively condemn the practice of *ta moko* was Samuel Marsden of the Church Missionary Society. He arrived in 1814, and recorded in his journal:

> Tooi informed us that his brother Korro Korro wished him to be tattoed. We told him that it was a very foolish and ridiculous custom, and as he had seen so much of civil life he should now lay aside the barbarous customs of his country and adopt those of civilized nations.[7]

To adapt successfully to 'civilized life', the Maori male had literally to change face – or at least refuse to modify or mark the one he was born with. Another pioneer missionary, John Leddiard Nicholas, observed that it merely served:

The absurd and preposterous notion of its being a most elegant embellishment, while on the contrary it makes them appear truly hideous . . . It is hoped that this barbarous practice will be abolished in time among the New Zealanders, and that the missionaries will exert all the influence they are possessed of to dissuade them from it.[8]

By the mid-nineteenth century, in those trading and missionary centres where Maori and Pakeha engaged with each other, their efforts seemed to be gaining ground.

Tattooing is going out of fashion, partly from the influence of the missionaries, who described it as the Devil's art, but chiefly from the example of the settlers.[9]

MOVING INTO THE TWENTIETH CENTURY

During the period of the Land Wars in the 1860s, there was an active resurgence. The charismatic Tawhiao Matutaera Te Wherowhero, paramount chief and second Maori king, personified resistance to Pakeha invasion; his face was exquisitely adorned, and he encouraged the art's revival.[10] But towards the close of the nineteenth century, the *pukanohi*, the fully marked face, was seen less and less. This prompted a series of souvenir cartes visites by various photographers, and powerfully crafted portraits by artists like Goldie[11] and Lindauer.[12] Maori storytelling also offers this complex *whakatauki*, or saying:

Kei muri i te awe kapara, he tangata ke
Mana e noho te ao nei, he ma.

After the tattooed face, someone with
 unmarked skin
May claim this world.[13]

For at least two generations into the twentieth century, the *pukanohi* was rarely seen, although there are still aged Maori who recall their childhood and teenage years looking in awe at the faded markings on a venerable old man's face.

For women, the situation was different; their tradition continued, uninterrupted, though the technology witnessed a subtle shift from the scarification of chisels to the flatter technique of needle clusters bound to a punching stick. Over the first four decades of the twentieth century, many women were thus marked, as Michael King observed:

A full *moko* was more obtrusively Maori and less easily reconciled with the pervasive process of Europeanization and newly acquired aesthetic tastes. Women, however, were less vulnerable to these pressures, and female tattooing continued for another century. There was no association of their *moko* with fighting. Female *moko* had connotations of beauty, sex appeal and marriageability, and they became very much an assertion of minority group identity.[14]

This celebration of identity, of *whakapapa* – kinship, belonging – remains with Maori today, treasured in the photographs of those beloved *kuia*, and resonant in the contemporary practice and revival of the *pukanohi*, the *mataora* – the fully tattooed face of the contemporary Maori male.

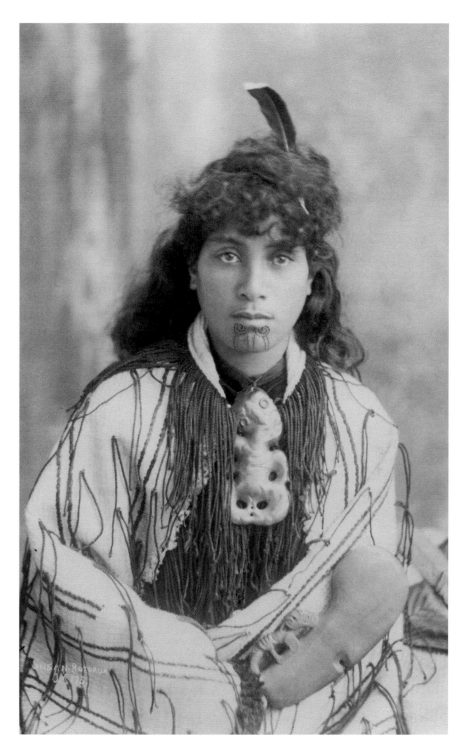

110 Josiah Martin, *Susan. Rotorua c. 1885*, black and white, albumen paper print. Half-length portrait of a young Maori woman with a tattooed chin and wearing a *korowai* (cloak decorated with tags). She is wearing a large *hei tiki* (figure) neck ornament and a *huia* feather in her hair, and she is holding a *wahaika* (curved short club) carved with a figure. Her *moko* has been recoloured by the photographer.

111 Gottfried Lindauer, *Ana Rupene and her Daughter*, 1878,
oil on canvas.

THE PRESENT DAY

Our traditions did not die, nor did they disappear. *Mataora* – the living face continues with vigour, force and pride. Electric machines have replaced the bone chisels of earlier times, marking the face with the metal needles of a contemporary artist. As a team of researchers, we are interested in the face that is marked, the face that is seen, that is challenged and feared and admired and demonized. And, more vitally, we are interested in recording the experiences of those that have chosen to carry *moko* upon their faces, to live this commitment.

When the face is patterned, and, in this case, permanently patterned with traditional marks of Aotearoa, the wearer and their newly acquired 'face' is transformed from one identity to another. The transition is instantaneous. They are a new person. The wearer must find a way to integrate their 'new look', their new being in the world, along with the assumptions, expectations and reactions they receive from others.

As part of his graduate research, Mohi Rua[15] gathered the opinions, experiences and views of contemporary wearers as they transformed from being unmarked to marked – the process of becoming a wearer of *moko* and living with *moko*.[16] In his work, Rua noted a series of phases in the transformation process. They were: the desire for *moko*; the process of preparing to be and then becoming a wearer; the reactions of others, and the effective coping strategies worked out by the wearer. In the remainder of this chapter, we focus on the reactions from Maori and Pakeha encountered by seven wearers.

These seven included three women with *moko kauae* – inscribed chins – and four men with *pukanohi* – full facial tattoo. It is also notable that the women were all mature – more than 40 years of age and active in the tribal community – and the men were comparatively young, between 25 and 35 at the time of interviewing. Two of the men had tertiary training, and two were between jobs. Six of the seven participants were residing in the rural eastern Bay of Plenty during the study. The thoughts and experiences of these wearers are presented below under pseudonyms to protect their privacy, a position chosen by them.

THE EXPERIENCES OF *MOKO* WEARERS TODAY

Physical difference and modification such as the facial *moko* can invite blatant and piercing stares. Those being viewed can be considered objects of curiosity; to be admired, respected and, for some people, abhorred. Whatever the reason, curiosity abounds as wearers are confronted with the reality of looking different. Hotewa and Korere are both middle-aged Maori women, now used to the probing attentions of the public in response to their *moko kauae*. In a shopping centre, Hotewa was stopped by an elderly Pakeha – European – woman, who commented, after a good long look,

> Oh. Sorry I didn't mean to [stare]. I just had to have a good look. Is it real? How long have you had it?

Hotewa was startled by the woman's abruptness and surprised at the number of probing questions. Many wearers believe, however, that Pakeha viewers are genuinely curious about the stories

112 Benjamin, Janice and family, Brisbane, 2003. Benjamin is Samoan, but wears Maori *ta moko* to affirm his links with his wife's family. Tattoo artist: Tangaroatuane.

made the situation awkward for Hotewa, yet she reflects upon it as a vivid and fond memory. Although the elderly man had seen, recalled and remembered, she had forgotten the potential impact of her *moko* as she negotiated the usually effortless task of buying café food. Similarly, Korere remarked, 'you get a lot of curiosity stares . . . I forget sometimes until they stare'. It is the forgetting that is important here; for both Korere and Hotewa, their living as *moko* wearers is an ordinary everyday experience; for others, it is not. Wearers admit that people are apologetic about their intrusiveness and genuinely interested in the *moko*. But they become a novelty, to be stared at; as Putaringa remarks: 'some people look at me, European people; they look at me like I'm an alien!' Putaringa feels people's ignorance and comforts himself in knowing that his *puka-nohi* is a reminder of past days. He claims: 'what they don't realize [is] that this *moko* was here before them or before their forefathers'. In an attempt to deal with curious stares, Putaringa is receptive to dialogue, discussion and the education of his viewers. He has come to internalize this behaviour for personal reassurance and in response to the reactions, curiosity and expectations of others.

Expectations reflect those historical experiences and impressions that people have formed, correctly or incorrectly. For wearers, their primary motivation for becoming so may have been a rite of passage or to mark a significant event or simply a premier fashion statement.[17] However, it is fair to say that irrespective of motivation, having become wearers, most have also become familiar with the diversity of expectations that viewers hold of them.

behind *moko* and the fascination it presents, an attitude that often alleviates unintended offence.

For some viewers, *moko* wearers have sparked a sense of nostalgia, with elderly viewers remembering back to earlier events and people in their lives. Hotewa, like many wearers, is humbled by such occasions and embarrassed too. None more so when an elderly Pakeha man quite spontaneous and forthrightly approached Hotewa in a café as she lined up to pay for her food. He said 'Oh, you've brought back a lot of beautiful memories for me and I went home last night and dreamed about you'. The statement, the environment and the many shoppers overhearing the comment

113 Waiteahoaho Te Ruki, of Te Kawa, Aotearoa / New Zealand, aged in her 50s; tattoo artist, Rangi Skipper.

When Ngarahu took her *moko kauae*, she was suddenly elevated to *kaikaranga* – the female ritual chanting role performed during a formal welcome of visitors to her *marae*. On the occasion of being handed this role, she looked about her and noticed a much older Maori woman, not marked, but who was just as capable. Ngarahu approached her and asked her why she hadn't been considered, to which she replied 'No! Because Koro [male grand-parent] said I haven't got the number plate!'

The number plate obviously being her *moko kauae*. Ngarahu saw the humour in the comment and came to understand the significance of her *moko* and the expectation to be a cultural leader. Many wearers are expected to be fluent in the Maori language and to have a high degree of cultural competence – an expectation all too familiar for Tiwhana and Putaringa: 'They sort of relate to me as a Kaumatua [Maori elder], just by my facial' [Tiwhana],

for me being young and I wear the *moko*, people have expectations of me . . . they expect me to know everything. [Putaringa]

Rewha, a university graduate with a *pukanohi*, has had similar experiences:

> People . . . assume you know heaps. Can sing 500 *waiata* and *Whaikorero*. Lucky some of us can or we'll be blowing the bubble on us if we couldn't.

The transition from being unmarked, to marked is one that takes place relatively rapidly. Some wearers may have obtained their *moko* over a period of hours, while others may have received the work progressively over a period of weeks or months. In contrast, though, becoming culturally and linguistically competent is an age and experience-related process. For young men like Rewha, Putaringa and Tiwhana, the expectations that their cultural communities hold of them are significant, at times burdensome, and often unrealistic. Yet these are the abilities by which their merit, their standing, their worthiness to have *moko*, is judged. Indeed, most Maori elders are doing well to know just 20 *waiata*, let alone 500!

Having felt the weight of expectation, most wearers believe that it is important to have a degree of cultural competency and to demonstrate a commitment towards this end. For the wearer, this commitment serves to counter, or at least hold off, concerns or challenges about merit that viewers may express. Rewha, in a warning to other wearers, succinctly summarizes this when he says: 'You best be on to it!'.

In contemporary Aotearoa-New Zealand, Maori continue to encounter unfavourable opinions and hostile attitudes based on preformed and unsubstantiated judgements.[18] Prejudice towards Maori and the tattooed face is not a new phenomenon and it continues today. Rewha's encounter with a clothing retailer quick to assume his economic status was revealing. He observed:

> I think they must think I'm unemployed or something. They'll always suggest cheaper things for you . . . Appearance is everything [Rewha].

Wearers who live in small rural communities and townships are usually known to others. Viewers see wearers not simply in terms of their changed physical appearance, but as people embedded in family and friendship networks. Although a wearer's physical appearance may have changed, their history has not. Poniania's comments about living in Whakatane, a small seaside town, therefore are not surprising.

> Around Whakatane they're used to us. But going to places like Hamilton [a large city] and that . . . They freak all right!

'Freaking' may take all manner of form. It may be an expression of surprise, of astonishment, fear, joy or of curiosity, as Putaringa comments:

> I get a lot of good response from Pakeha. A lot of them go to me, 'gee that's beautiful. Well balanced and there's not too much.' That's what they're saying . . . Some *moko* . . . you can't see the person. You can't see the face . . . But with mine you can see my face. You can see who I am.

114 Shane Te Ruki of Waitomo, Aotearoa/New Zealand, aged 34; tattoo artist, Rangi Skipper.

This seeing is about difference as well, and how it allures and attracts others. Another male participant, Tiwhana, observes:

> Pakeha people think it's too much. They want to come up to me and meet me and some of them are . . . just shy. Whakama. Yeah, but some Pakeha people they come up to me and talk to me. Ask questions.

But what exactly are they being attracted to? Is it the exotic, the erotic, the mystery, the threat, the transgressive, the savage? Not the modern primitive, but the primitive who is actually modern, alive, today?

The tattooing and modification of the face, rather than any other part of the body, can engender for the viewer strong feelings of intimidation, and this was certainly the experience recorded in the historical narrative cited earlier in this chapter. Putaringa recounts his experience on meeting a Black Power gang affiliate and reports the gang affiliate saying to him: 'Gee you're intimidating with your *moko*!'. For Putaringa, this was a rather ironic statement, considering that the gang affiliate carried symbols of gang association that were just as intimidating, if not more so, than Putaringa's *pukanohi*. When he highlighted this to the gang affiliate, he thought nothing of it in contrast to what he read as 'a face from the past'.

The reactions and feelings of children in seeing their parent, in this case their father with a *pukanohi*, is something that was not spoken about much at all by those wearers we spoke with. Tiwhana was the only person who commented on the reactions of his children, highlighting their need to make adjustments and his desire to help them.

> The only thing that really changes in my life is . . . I've got kids. They have to look at me, wake every

115 Tangaroatuane, the Ngapuhi (Maori) tattoo artist, 2003.

morning and eat with me, sleep with me, bath with me, in a different face. . . . But it's just getting them back to know that their father is still the same person.

There is preliminary evidence to suggest that children are far more accepting and encouraging of the transformations that their parents and grandparents are choosing than other family members. In this regard, Rewha, a young man, comments:

Their reaction was one of just complete, straight away not even go near it. It was not even, Wow! It was, Oh, how's it going? Turn away and talk to

you. They just won't look at you in the face anymore.

The level of acknowledgement or the lack of it could also suggest non-acceptance as well. A notion supported by Rewha and other wearers is that some viewers found it difficult to voice their disapproval.

Not all responses are negative; and this appears to be less prevalent as the number of people reclaiming and wearing *moko* with pride increases. There is now a growing sense of celebration, renewal and increasing strength within communities. Putaringa reflects upon the acceptance shown by his elders and the comfort he feels. 'A lot of *kaumatua* that I don't know, they will say, *pai ki ahau*! [That's fine with me]'. Tiwhana reports that others have said to him: 'Far . . . too much! Can't wait to get my one!'. Both Putaringa and Tiwhana are encouraged by these words as the art form continues to revitalize itself. For wearers in general, such comments reflect the ultimate accolade, a genuine and enthusiastic affirmation.

CONCLUSION

What do we face? We face everything. We face our own [people]. We face the Pakeha and attitudes. You can just look at them and you know what they're thinking in their mind. We've adjusted to it [Poniania].

The early voyagers, missionaries, settlers all reacted to the *pukanohi*, to the marked faces of the Maori people, during the period of first contact, and the century following it. Their accounts are vivid, judgemental, revealing, telling us as much about them as they do about the people they described. Curiosity and horror are mixed with a genuine fascination; where sternly evangelizing words failed, armed confrontation occurred; and we now live with the results, *te ao hou*, a new world.

In this world, today, *wahine mau kauae, tangata mau moko, pukanohi* – wearers – are speaking for themselves, about themselves, and commenting on how others view them. Unanimously, they insist that the decision to take the marking is about continuity, affirmation, identity and commitment. It is also about wearing those ancestors, carrying them into the future; as their *moko* becomes a companion, a salient being with its own life force, its own integrity and power, beyond the face.

Taia o moko, hai hoa matenga mou. You may lose your most valuable property through misfortune in various ways. You may lose your house, your *patu-pounamu*, your wife, and other treasures – you may be robbed of all your most prized possessions, but of your *moko* you cannot be deprived. Except by death. It will be your ornament and your companion until your last day.[19]

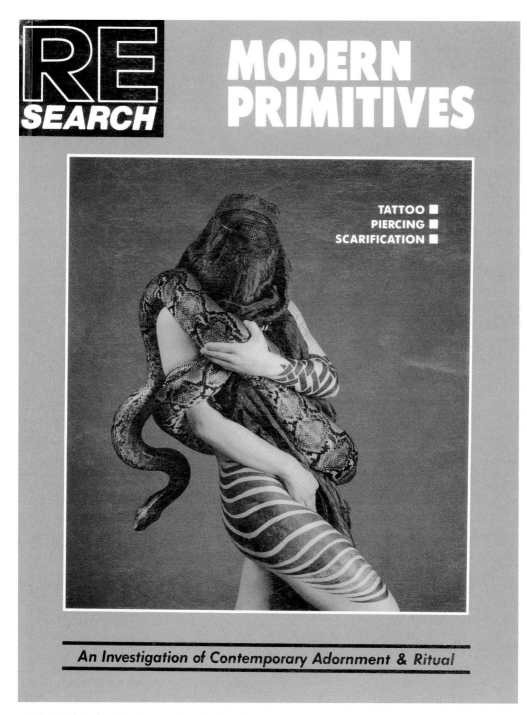

116 Cover of *Modern Primitives. An Investigation of Contemporary Adornment and Ritual*, edited by V. Vale and Andrea Juno (San Francisco, 1989).

Beyond Modern Primitivism

Cyril Siorat

Ever since the needles have entered my skin and the ink has settled, the existential dimension of tattooing has been clear to me. Born in France, I moved to Moorea, in French Polynesia, aged 20. There I became a friend of Chime, a Marquesan tattoo artist. During my first year-long stay, Chime gave me three tattoos of Marquesan design. It was thirteen years, and several tattoos, later that I started to study the practice officially as an anthropologist. It was then that I became fully acquainted with the literature on tattoo milieux and with the academic debate regarding them. One of the main critiques of contemporary neo-tribal tattooing identifies this subculture under the rubric of 'modern primitive', and suggests that its practice reproduces old primitivist ideas. However, many of those involved today in body modification do not identify themselves in these terms and, although it is important to acknowledge that the wider spectrum of contemporary 'tribal' references does, almost inevitably, include neo-primitivist understandings, the milieux at present are too diverse to be reduced to what is, in fact, a reductionist critique. I argue that the 'modern primitive' label has been seized

upon by commentators who have not considered how aptly it captures the contemporary practices, personal histories and motivations of the protagonists, and the ways that these have changed since the publication of the now notorious anthology *Modern Primitives* in 1989.[1] This chapter attempts to rebut the critique, in particular through a consideration of the commodification of tattoos. I defend the contemporary movement from the charge that it is embedded above all in normative definitions of consumer culture.

Since the publication of *Modern Primitives* in 1989 by the alternative arts press Re/Search,[2] there has been some discussion among social scientists regarding the identity and motivations of European and American individuals involved in the body modification movement. One of the main criticisms has been that such movements are involved in the facile idealization of the exotic 'Other'. In consequence, so the argument goes, they perpetuate classic primitivist assumptions. Modern primitives are, according to Klesse, a 'legacy of colonialism in late imperial culture'.[3] It is easy to feel confused about the identity of 'modern primitives', considering the multiple

117 Fakir Musafar, 1959, from *Modern Primitives*.

assigned by non-body modifier individuals, 'in the know', rather than used as a self-expression of identity.

Rather than being rigid and inflexible, individual and group identities have always been involved in a constant dialectical process involving the other, as both the Polynesian revival and the changing global tattoo community shows. 'Individual identity is located within a two-way social process, an interaction of "ego" and "other", inside and outside. It is in the meeting of internal and external definition that identity, whether collective or individual, is created'.[4] Therefore, 'identification is never a unilateral process; at the very least there is always an audience'.[5] In that sense, publications from the 'modern primitive' movement could be regarded as internal definition, while academic work scrutinizing them is an external definition.

I would argue, however, that both should be conceptualized as external to the multiple body modification networks and to the individuals involved in these networks. Different features of these external definitions will coincide or differ from the internal definition of the individuals involved in body modification practices, giving rise either to negative or positive confirmation of the perceived internal identity. Therefore, considering that identification processes are constant, social scientists should be careful not to assign the label 'modern primitive' to any individual involved in body modification and who refers in some way or another to 'tribalism' or to an urge to modify their bodies.

Another aspect of the 'modern primitive' publications and term is that they are ironic. There is an awareness that nobody can be a 'primitive',

networks of which the tattoo community is formed. It seems that if there is such a thing as a 'modern primitive' movement, it is likely to be localized, on the west coast of the USA, and within the context of a network evolving around particular individuals such as Fakir Musafar. In London, home to a dynamic body modification community, I am still to find someone who would define her or himself as a 'modern primitive'. I am not suggesting that people in London were not inspired by the *Modern Primitives* publication, and subsequent work in that field, but that the identity marker 'modern primitive' seems to be almost always

118 Fakir Musafar, from *Modern Primitives*.

hence the addition of 'modern' to the term, and that the association of these two terms collapses a popular dichotomy. These publications are important media of self-promotion and self-expression rather than academically sanctioned arguments. Many of the contributors to *Modern Primitives*,[6] do not refer to themselves as 'modern primitives' but share some sensibilities with some aspects of the agenda of this particular network. Therefore caution should be applied when categorizing such networks, and one should be aware of the danger of objectifying the Other and denouncing such processes in the past while, at the same time, participating in current categorization of 'others'. Furthermore, I do not believe that irony invalidates personal narratives and embodied experiences as scholars such as Turner seem to imply.[7] If the ironists always hold their views of the world in doubt,[8] it is because, as Beck argues:

> Doubt . . . which not only serves science but now, applied reflexively, disrupts and destroys the latter's false and fragile clarities and pseudo-certainties, could become the standard for a new modernity which starts from the principles of precaution and reversibility. Contrary to a widespread mistake, doubt makes everything – science, knowledge, criticism and morality – possible once again, only different, a couple of sizes smaller, more tentative, personal, colourful and open to social learning. Hence it is also more curious, more open to things that are contrary, unsuspected and incompatible, and all this with the tolerance that is based in the ultimate final certainty of error.[9]

The term 'modern primitive' was coined by an individual called Fakir Musafar in the late 1970s to describe himself and a few other people who were following a similar personal path. Born in 1930, Fakir Musafar has been a pioneer in the practice of body modification, such as piercing and branding, and has been involved in modifying his body for the last 50 years. Now called 'the father of modern primitivism', Fakir Musafar spent a great time experimenting in secret. 'Unfortunately, I was driven into deep isolation and shame . . . for lack of any social sanction . . . I knew that if I let it be known what I felt and what I was doing, I would probably have been institutionalised'.[10] This led him to find, in past and present painful rituals from around the world, some form of sanction. He found social sanction in the fact that body modification behaviours were deemed acceptable, and often desirable, in diverse human cultures. In a way, this yearning for social sanction of types of behaviour considered too deviant in mainstream Western society could be interpreted as a plea for inclusion rather than exclusion. Body modification, then, could be seen not as a rebellious act but a confirmation of one's alterity. This is also a form of resistance but not a conflictual one.

Resistance has often been understood as a binary opposite of domination. However, if power is dispersed, multiple and relational, as Foucault argues, then resistance must also be diffuse, decentred – an integral part of power rather than its opposite. As Rosenblatt points out, resistance does not mean activities that 'escape existing systems of meaning';[11] acts are inevitably formed in relation to the society from whence they come.

119 Ashley, *Yvonne, occupation tattooist. Tattooed by Alex Binnie, Curly, Hannes, Theo Jak, Xed LeHead*, 2001.

He argues that so-called 'modern primitives' position themselves in a conflictual opposition to capitalist consumption and Christianity when in fact their beliefs reflect certain Christian ideas about the relationship of the individual self to society.[12]

I would disagree with Rosenblatt's assertion that modern primitives' own view is necessarily simplistically conflictual; it can also be seen as a plea for an inclusion of alterity within mainstream society.

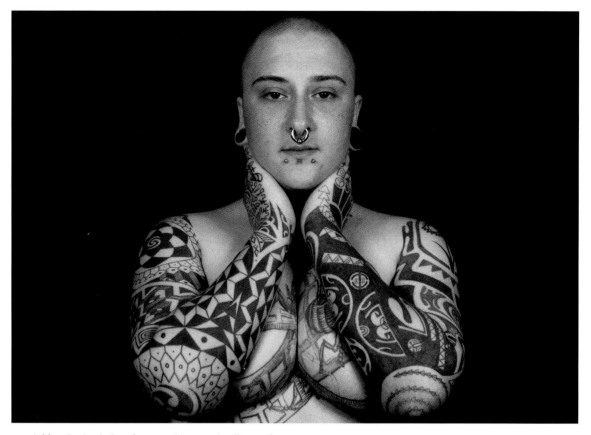

120 Ashley, *Benjamin Beard, occupation tattooist. Tattooed by Johnny Adams, Tony Clifton, Dan Gold, Matty Kaye, Dale Orton, Thomas Moison*, 2003.

This plea could also be perceived as a demand, a demand that the boundaries of what is civilized and what is primitive be collapsed into an ironic, contrary and problematic statement. Nonetheless, it is true that the discourse of Fakir Musafar reifies some popular Western primitive conceptions that are grounded in colonial discourse and gaze, as Klesse argues.[13] It is also true that a lot of tattoo artists and tattooed individuals do have fairly naïve and simplistic ideas about what tribal tattoos represent and what a Euro-American person becomes by taking them on. In that sense, Rosenblatt is right to argue that most references to primitive in the West have more to do with a perceived lost social sense of the self, of Euro-American individuals, than with any non-Western cultures.[14] It is, however, also important to note that the Western concept of the primitive has sometimes been taken as an identity marker by colonized population themselves. Furthermore, the tattoo and body modification milieu is heterogeneous. There seems to be a gulf between an

individual who is getting a pseudo tribal tattoo in Europe, in the absence of much knowledge of its origins and meanings, and who probably holds a fairly naïve set of New Age motivations, and the smaller network of people who are more actively part of a genuinely cross-cultural community, and who are engaged in something different from consumerist appropriation.

In California in the early 1970s Fakir Musafar went public and gave a performance of ritual piercing in a tattoo convention. From then on, his experimentation with body modification influenced and inspired different sub-cultural networks, sado-masochism (S&M) and punk, for example. That Musafar chose to give his first public performance at an event organized by the tattoo community is indicative of the strength of the tattooing networks at that time. From the 1960s onwards, as Benson argues, the tattoo community went through great changes 'increasing international communication, technical innovation and the work of a number of key individuals, many from art school backgrounds, radically transformed the possibilities of the medium'.[15] Through the 1980s an increasing interest developed among some tattoo artists for traditional tattoo designs from places where a tattoo tradition had been, or was still part of the cultural array of symbolic expressions. By the late 1980s the work of the Filipino-American tattoo artist Leo Zulueta, among a few others, became an inspiration worldwide in the development of such styles, and although he appears in the publication *Modern Primitives*, he does not refer to himself as one.[16] His work does not entail an underlying desire to be the 'Other'. Rather, he equates his research into traditional designs as conservation of an aesthetic tradition: 'all the old men having "primitive"-style tattoos are dead. . . . The last man to have a back piece like mine, who was over ninety years old, passed away a couple of years ago. This is why I really feel strongly about preserving those ancient designs'.[17] He also acknowledges the possibility that the 'original' meanings of these designs may never be understood in the contemporary setting. His work does not, however, entail a conservation of the designs in the butterfly collector's manner. They are preserved on their original medium, the human skin. It would also seem that for some tattooists, at least, the search is not for a mythical primitive 'Other' but for themselves. Leo Zulueta, for example, is half Filipino and grew up in Hawaii, suggesting perhaps that the inner motivations of body modifiers are complex, varied, and often rooted in personal cross-cultural biographies rather than mono-dimensional ones.

While the 'neo-tribal/black work' tattoo styles were developing momentum in North America and Europe, other tattoo communities were also involved in major evolutions. Tattooing was a prominent procedure throughout Polynesia, before its colonization. In French Polynesia, for example, Christian missions and the colonial authorities stopped the practice of tattooing for more than a century. Since the late 1970s, however, tattooing has been revived by Ma'ohi (native Polynesian) cultural agents (traditional dance troupes and other artists). It is now highly visible and a growing aspect of the local tourist industry. The traditional Tahitian and Marquesan designs that are tattooed today in French Polynesia are also important cultural and social identity markers (see Kuwahara, this volume).

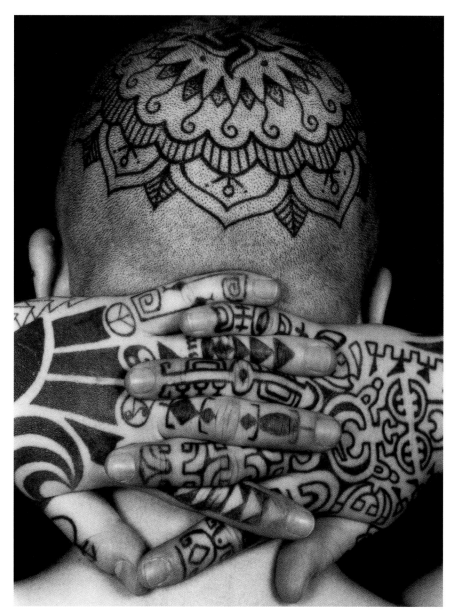

121 Ashley, *Benjamin Beard, occupation tattooist. Tattooed by Johnny Adams, Tony Clifton, Dan Gold, Matty Kaye, Dale Orton, Thomas Moison, 2003.*

During the last fifteen years, Ma'ohi tattoo artists have themselves been influenced and inspired by different cultural tattoo designs and styles, including Samoan and also North American and European 'black work'. Polynesian tattooists also became regular guests at tattoo conventions in North America and Europe. They forged strong relationships and created global networks with 'tribal' practitioners. A great influence throughout the 1990s was that of the late Paulo Sulu'ape from

Western Samoa, where there has been a continuity of practice throughout the colonial and post-colonial periods (see Mallon, this volume). Sulu'ape introduced many tattooists to traditional methods of tattooing and inspired many others by communicating the meanings and context of the Samoan designs he tattooed in many non-Samoan skins. In Tahiti, however, it is paradoxical that the forms and meanings of contemporary Ma'ohi tattoos are reconstructed from representations produced by explorers and colonial agents in the nineteenth century. In my view, 'authentic' Ma'ohi tattooists are therefore involved in a similar process of recontextualizing symbols as are the 'inauthentic' so-called modern primitives.

TATTOOS AND COMMODIFICATION

At this point, I would like to explore the involvement of tattoos in consumer culture since it is often used as a challenge to their authenticity. Through this discussion, I intend to develop further some of the points raised in this introductory section. It has been argued that tattoos, and body modifications in general, 'do not escape commodification',[18] that they 'can be purchased for money like other commodities'[19] and should 'be interpreted in the context of an increasingly trendy aestheticization and commodification of ethnic difference'.[20] On the other hand, it has also been argued that body modifications 'differ from other "free-floating" commodities, not only because of their status as permanent or "semi-permanent" modifications to the body, but also because of the necessary physicality of their production'[21] and the pain that accompanies such practices.[22] The

permanent aspect of tattoos render them 'the ultimate' in anti-fashion.[23] In other words, there are two views regarding tattoos and commodity. The first is that tattoos have been commoditized. Anyone can walk into a tattoo shop, choose a design, pay and come out with a new tattoo. The socio-cultural context of the design is irrelevant; it could be argued that the tattoo as a product is alienated. The second perspective considers tattoos to be potent anti-commodity symbols due to their non-exchangeability, their permanence and their personal nature. Although divergent, these two views do not contradict each other since they both focus on different times in the biography of a tattoo. There is a popular belief in Western culture that things are either commodities or are not. At one pole are things that 'represent the natural universe of commodities' and 'at the opposite pole we place people, who represent the natural universe of individuation and singularization'.[24] However, this is a relatively recent dichotomy.

Works by Appadurai[25] and Thomas[26] emphasize, in their respective definitions of commodities, the importance of context. Appadurai suggests that 'commodity . . . refers to things that, at a certain *phase* in their careers and in a particular *context*, meet the requirements of commodity candidacy'.[27] The commodity candidacy here is understood to mean 'the standards and criteria that define the exchangeability of things in any particular social and historical context'.[28] Anything, therefore, can become a commodity in the time of its existence as long as it meets the candidacy requirements of its context. When things do not meet the commodity candidacy, they become singular and have reached a different phase in their status. Thomas

presents commodities 'as objects, persons, or elements of persons, which are placed in a context in which they have exchange value and can be alienated. The alienation of a thing is its dissociation from producers, former users, or prior context'.[29] The alienability of things or persons is crucial to their status as commodities. If such dissociation cannot be attained, objects may become 'artefacts which tell a story'.[30] Furthermore Kopytoff's definition of commodities emphasizes the importance of the discrete nature of the exchange. This is 'in order to stress that the primary and immediate purpose of the transaction is to obtain the counterpart value'.[31] This is in contrast to gift exchanges where rules of relations of reciprocity should apply. At this point, however, it should be made clear that commodity exchange is not a feature of modern societies and gift exchange a feature of traditional societies. Both systems seem to exist, to varying degrees of popularity, in all human societies. The root of the commodity seems to lie in the action of exchange. Exchange, being at the root of human social life and a universal feature of it, makes commodities a universal aspect of culture.[32] The commodity status is therefore a flexible one; a phase in a biography, and commoditization a 'process of becoming'.[33] The commodity must be alienable from its origins and its exchange does not entail any further obligations or expectations. Moreover, there seems to be a constant conflictual relationship between the drive to extend the arena of commodity exchange, and widen the range of available commodity items, and a human need for the singularization of particular items or range of items. The former is inherent to the exchange technology, while the latter is motivated by individuality and culture.[34]

The rise, in the nineteenth century, of new exchange technologies[35] and of a materialist culture and new types of consumption, avid of products from all over the world,[36] was instrumental to a rapid expansion of the process of commoditization and, in turn, to the capitalist system. Appadurai,[37] quoting the work of Sombart, links this new type of consumption to the demands of the bourgeois and nobility classes for luxury goods. Luxuries should not be regarded as the opposite of necessities but rather as 'goods whose principal use is rhetorical and social, goods that are simply incarnated signs'.[38] Luxuries are part of a particular register of consumption rather than a special class of things.[39] Similarly, I would propose that tattoos are also part of a particular register of consumption. I do not want to argue that tattoos are luxury items reserved for the elites, but rather that they represent incarnated signs for marginal communities; a luxurious symbol of otherness.

There are five main attributes that should be displayed by incarnated signs as commodities. These are restriction to elites, complexity of acquisition, semiotic virtuosity, regulation by fashion, and 'a high degree of linkage of their consumption to body, person, and personality'.[40] While tattoos would not have to display all of these attributes to qualify as an incarnated sign involved in a particular register of consumption, I would argue that they do. Take, for example, the criterion of restriction to elites: although it is clear that they are not restricted to an elite *per se*, until recently their access was restricted to certain groups of people. Today, even if the restriction

seems have been removed to an extent, tattoos still have a certain degree of difficulty of access. To start with, tattoo artists' rates are not cheap. Another restriction can be the painful nature of the tattooing process, which may not appeal to all. And finally the prospective tattooee may consider the social restrictions imposed on future social interactions based on pre-conceptions of tattoos – for example, difficulty in finding employment. When the production technology of incarnated signs becomes more advanced and able to produce these articles in increased numbers and at a lower price, they become more accessible to anyone and therefore lose their restriction attribute.[41] This shift, from different spheres of exchange value, seems to manifest itself as a shift from issues of exclusivity to issues of authenticity.[42] I would like to propose that a similar shift has happened in the tattoo world.

Up to three decades ago, tattoos were mainly acquired by marginal groups. These were, in the West, soldiers, sailors, criminals and people involved in body modification, such as tattoo artists themselves. Most incarnated signs symbolized belonging to particular groups and/or the partaking of particular activities, for example, military regiments, port of calls, time in jail and allegiance to a pimp. Tattoos were the quasi-exclusivity of these groups. However, in the last fifteen years, tattoos have become part of popular culture. They are used in advertising campaigns to portray, among other things, sexual attractiveness. There has been an invasion, of the high streets in the West, of roses, dolphins, yin & yang, and other small tattoos. I would argue that the exclusivity of tattoos was threatened by a shift

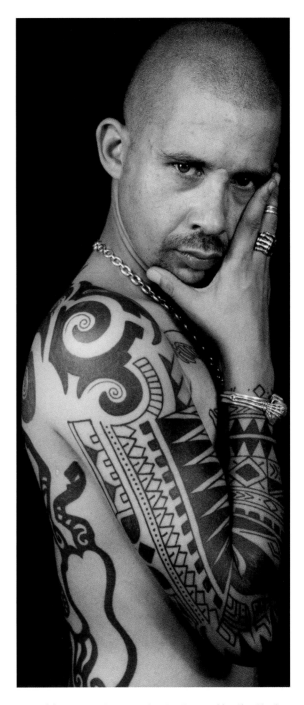

122 Ashley, *Kenny C, occupation DJ. Tattooed by Alex Binnie, Curly, Neil Ahern, 2000.*

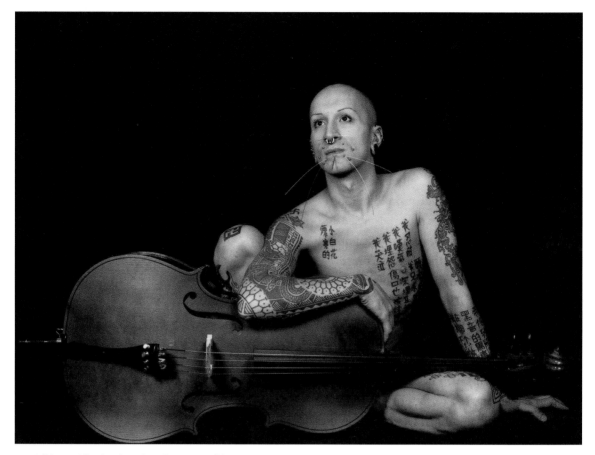

123 Ashley, *Michael with Violoncello. Tattooed by various artists including Xed LeHead,* 2003.

towards a perceived common, or more mainstream, sphere of exchange value. The shift from different spheres of exchange value moved, similarly to the one mentioned above, from issues of exclusivity to issues of authenticity, or rather here of authenticities. The first authenticity I am referring to has to do with authenticity of commitment. It could be argued that as small tattoos became more popular, people involved in the body modification movement had to engage more extensively with these embodied incarnated signs. Bigger

tattoos and body-suits, as well as extensive piercings, became a way to authenticate this commitment, one sign of this exclusivity being tattoos that cannot be hidden by clothes. The second authenticity has to do with the origin and process of tattooing itself.

As I noted earlier, an important aspect of the tattoo revival is the tribal and traditional styles and the tattoo artists involved in this style. Designs used as tattoos can be found worldwide and, in the late 1970s and '80s, some Western

tattoo artists started to use some of these designs as inspirations (for the longevity of this process of exchange and innovation, see Mallon, this volume). However, the cultural context of such design was mainly unrelated to its use in tattoo shops; the designs were alienated and therefore commoditized. However, some individuals involved in this revival wanted artefacts, designs that told stories, rather than alienated commodities, and travelled to encounter and engage with the places of origin of some of these designs. Oceania was one of the instrumental locations of these encounters. Authenticity became a question of context. Context includes here both the place in which, and the person from whom, one will get a tribal or traditional tattoo. Similar designs tattooed in Cardiff by a home-based tattoo artist; in London by a renowned tribal tattoo artist; in Auckland by a Maori tattoo artist; and in Madrid at a tattoo convention by a mixed race Polynesian tattoo artist with traditional tools all have greatly different degrees of authenticity.

It has been argued that 'traditional Maori . . . signs are woven into global consumerism, where they are endlessly modernised, producing a complex hybridisation of signs and messages'.[43] Rather than equating the presence of Maori tattoos with a destructive modernization, however, the development of the 'neo-tribal', also called 'black work', can be perceived as another period in that style. By this I mean that there can be no exact replicas of something. However rigid and static a ritual, a style or a practice may be to the outside observer, however rooted in tradition they may seem, the enactment will always be a reinterpretation of the past and therefore different from it. There is a

change from the use of these designs in their original context, but there is a certain continuity regarding their use as modes of embodied symbolic expressions in varied contexts.

It may be that these abstract designs, rather than the personal statement, attract many people, because the latter can be easily (mis)read. Furthermore, Phillips and Steiner[44] have argued that a possible way to define it may reside 'in the very process of collection, which inscribes, at the moment of acquisition, the character and qualities that are associated with the object in both individual and collective memories'.[45] The authenticity of a tattoo similarly may reside in that moment when, inscribed in the body, it acquires the character and qualities of the individual, and collective perceptions of the context from which it arose. In that sense, tattoos can be read adequately only through the context of their creation and the discourse used to convey the personal narrative attached to them, but this context does not rely on some originary, 'tribal' or traditional source. Furthermore, I agree with Sullivan's conclusion[46] that

> bodily inscription is not so much a writing with or on the body (both of which assume a body-subject that pre-exists writing), but rather it is an infinite (re)writing and (re)reading of the body-subject in and through its relations with carnal sensuosity of the Other and the world, and with culturally and historically specific social fictions.[47]

It could therefore be argued that tattoos are in fact constant changing processes that can be 'read' synchronically.

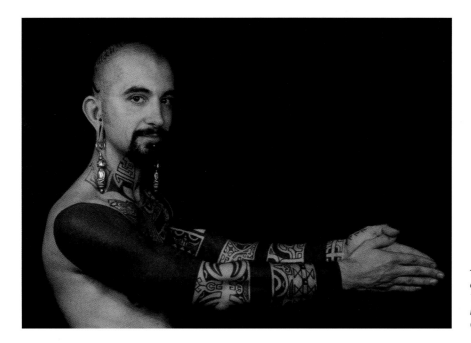

124 Ashley, *Chris Higgins,*
occupation tattooist.
Tattooed by various artists
including himself and
Curly, 1999.

The absence of reciprocity relations, inherent in the discrete nature of commodity exchange, does not mean that such exchanges will be non-personal encounters. For example, as Thomas explains,[48] in New Georgia ritual knowledge, and to an extent ritual agency, can be 'purchased' from specialists. The names of these specialists are important to the purchasers and it could be assumed that there was an ongoing particular relationship between the two. However, although 'the practice of ritual may often have involved reference to the source of knowledge, to the empowering authority, . . . in such contexts the allusion to the name figures as authentication and validation, rather than as the expression of longer-term indebtedness'.[49] This is similar to the way that some tattoos gain authenticity. The name of the tattoo artist is important but does not imply that there is any relationship beyond the particular

time spent acquiring the tattoo. The nature of the exchange can vary, however, according to context. There are a number of differences in the nature of the exchange depending on the identities of prospective tattooed individuals and their relationship with the tattoo artist. The price of a tattoo is usually a negotiation, and may or may not involve money. Furthermore, tattoo artists' rates do not seem to be influenced greatly by market forces. Thus it could also be possible that tattooing exchanges are sometimes more akin to Firth's 'exchange by private treaty', a situation in which something like price is arrived at by some negotiated process other than the impersonal forces of supply and demand.[50] Therefore, it seems that the nature of the exchange of tattoos can vary, depending on context and individual perceptions, from commodity exchange to gift exchange via exchange by private treaty.

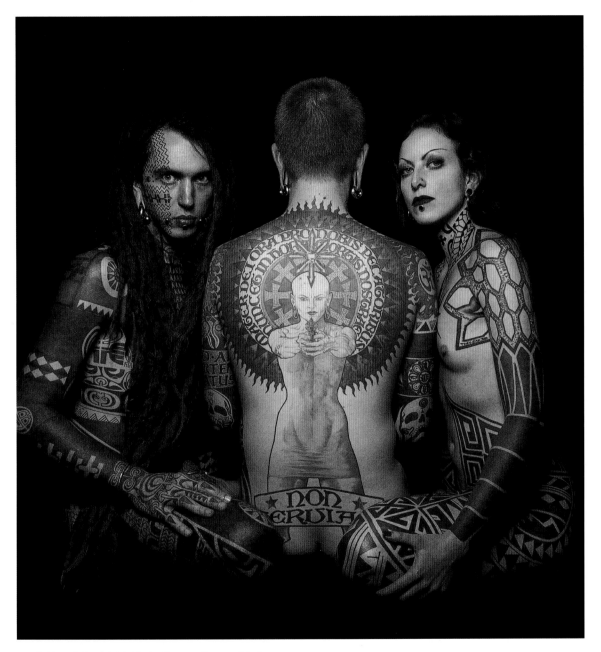

125 Ashley, (*left to right*) *Mario, Hannes, Yvonne. Mario:*
occupation tattooist, body piercer. Tattooed by Curly, Mackie,
Paulo Suluape, Xed LeHead, Yvonne. Hannes: occupation
tattooist. Tattooed by himself, Xed LeHead, Yvonne. Yvonne:
occupation tattooist. Tattooed by Alex Binnie, Curly, Hannes,
Theo Jak, Xed LeHead, 2001.

Individual perceptions of the nature of the exchange have a great influence, I believe, on determining the status of a tattoo in the commodity spheres. When the prospective tattooed individual chooses a template design and does not engage in any further exchange relations with the tattoo artist, except by name for authentication purposes, the tattoo can be perceived as commoditized. According to this view, a tattoo is a commodity at the time of its exchange and becomes a singularized symbol once decommoditized. The fact that it cannot be exchanged could also classify it as a terminal commodity; that is, not intended for further exchange.[51] However, one of the interesting aspects of the exchange of tattooing is that, most of the time, it is not directly the tattoo that is valued, but rather the time of the tattoo artist. It could be argued that what is bought is the skill and expertise of the artist and that therefore it is these that are commoditized rather than the tattoo itself. Furthermore, in a sense, the tattoo as an object does not exist until after the exchange: until it is finished. Up to that point it is only the Platonic form of a tattoo. Once finished, it will become a singular entity and therefore will move out of the commodity phase of its biography. In other words, the tattoo is only a commodity during its own process of becoming a singular entity – prior to its birth. None the less, many people will use the financial cost of a tattoo as one of its defining markers. There seems to be no doubt that exclusivity is symbolized through financial restriction. This view, in a sense, assigns to the singular tattoo an identity marker normally associated with commodities, price being a primary symbol of a discrete transaction. Thus, my point is that a tattoo is never really commoditized. On the one hand, it is the skill and time of the tattoo artists that are commoditized, not the tattoo itself. And on the other hand, it is sometimes given the identity of a commodity, as a symbol of exclusivity on financial grounds, when it has already become a singular entity.

Complex societies are prone to yearn for singularization.[52] It is interesting to note that the rise in popularity of tattoos, and of body modifications in general, coincides with different expansions of the spheres of values and increased momentum towards wider commoditization/ommodification. It seems difficult to decide if this is mainly due to a shift in the practice of tattooing towards a different sphere of value or if it emanates from an attraction towards a symbol of embodied singularization. The Western perspective that polarizes people and things, the singular and the commodity, considers the human body to be the most singularized entity. Tattoos will therefore assume a particular place in that polarity. Furthermore, 'power often asserts itself symbolically precisely by insisting on its right to singularize an object, or a set or class of objects'.[53] Therefore, individuals can symbolically assert their power by their attempts to singularize objects. Thus, tattoos could be perceived as a relevant medium for such symbolic expressions. None the less, there seems to be a paradox in the sense that, however singularized the personal information contained in a tattoo may be, the mainstream use of this particular media will tend to pull it away from its regime of consumption, and lessen its potency as a symbol of embodied singularization.

My analysis therefore leads me towards a view that tattoos themselves are not commodities. However, a phase of their biographies is commoditized; that is, in the process of becoming. What seems therefore to be engaged in the battle between commoditization and singularization is the nature of the exchange; in a sense tattooing rather than tattoos. Depending on the context and on the protagonists involved, and their respective perceptions of the nature of the exchange, tattooing could be classified either as commodity exchange, gift exchange or exchange by private treaty. This flexibility seems to enable the tattoo communities to deal with the popularity of the practice, and offers an array of possible relationships to choose from during complex encounters with a wide range of individuals. This is why, I feel, it is futile to describe 'traditional' tattoos as expressions of 'thick/hot' social relationships, and contemporary tattoos as only able to create, and stem from, 'thin/cold' ones.[54]

Furthermore, tattoos, and body modifications in general, demand a positive engagement with pain and suffering. This, I believe, indicates that a particular type of relationship may be forged through such experiences. This is because the 'particularly un-negotiable sensation which is pain when involved in ritual, 'acts to embed . . . a connection within a larger network of interpersonal ties . . . a network of relationships'.[55] These webs of relationships involve multidimensional connections among people, places and the social, cultural and historical narratives attached to them, and evolve within the symbolic, aesthetic and political spheres at play in the human condition.

In the Euro-American world, body modification is considered a matter of choice, but body modifications are only optional, in fact, as long as one does not want to belong to a body modification network. Within those networks, they arguably remain a form of initiation ritual.[56] In this context, however, the transformation of the person has to do less with coming of age and more with an acceptance of personal alterities and a symbol of a 'capacity for intense experience'.[57] In this, pain is instrumental because its 'social signification . . . is to give a sharper dimension to memory by welding the community through the same references'.[58] If, further, as Jackson has argued,[59] the world of constant pain cannot be understood by non-sufferers, because pain 'shatters language',[60] it could be that these group references exist at the pre-objective level of experience, before it is expressed through language. It can be argued that pain, because it is experienced through the body, can be conceived as an emotion and as such 'contains much that is indeterminate and inchoate, [and so] it is often poorly served by everyday-world language'.[61] This experience, which can be said to be shared beyond any narratives, could act as a perceived inter-subjectivity across culture and time. This could also account for the 'primal urge' to modify their bodies often cited by body modifiers.

The last point I would like to make is that there is an important aspect of the relationship between pain and tattoos that is clear in the popular adage: 'pain is unavoidable, suffering is optional'. This is a demand not only for the tattooee to engage positively with the painful experience, but also, I believe, a more general demand

of a shift of values away from those preached by a form of Protestant humanism that denies the individual its capacity to suffer. Therefore, 'body modification initiates its adepts into a cruel ritual system incommensurable with mainstream religious practice'.[62] It is, however, crucial to understand that the point is not solely in the pain but also, and in some ways more importantly, in its relief. 'There is a power, innate to all pain, after the relief, an initiatic dimension, a solicitation to live more intensely the consciousness of existence . . . [pain] gives a sense of life's price . . . [and] is a radical principle of metamorphosis'.[63] This seems to be a recurrent theme raised by my informants. As Stephen, one of them, puts it: 'I feel a lot more alive after each tattoo session. It is almost like a doctor, but not to make you better but to make you feel alive. This is why I get tattooed more and more. It is the sensation of pinching yourself to know if you are awake.'

Finally, I would like to suggest that, although some body modifiers' discourse expresses a kind of 'corporeal absolutism',[64] their tentative assertions of symbolic power over their suffering bodies may have the effect that 'by controlling this violence, by sculpting it with devotion at the heart of the self, [human beings] subordinate their condition rather than submit to it'.[65]

This article has shown that the ironic term 'modern primitive' cannot be used as a blanket identity marker to describe these global cross-cultural networks. Through the discussion on issues of commodification, I attempted to show the complexity and heterogenous nature of the global tattooing community. The level to which such networks are involved in consumer culture and society as a whole tend to imply that, at least for some body modifiers, the agenda is inclusion of their alterity rather than simplistic rebellion.

Embodied Exchanges and their Limits

Nicholas Thomas

In a recent documentary on tattoo, one of the interviewees is a German woman. She enthuses about the topic. She leans close to the camera and says: 'Once you have one tattoo, you will want more.' This is a deceptively simple statement, but one that arguably speaks volumes about contemporary Euro-American tattooing. It tells us, specifically, what motivates and requires tattooing, and what ontological register tattoos occupy. People get tattoos, in this conception, because they have an individual desire or appetite for them. They are things that you 'want'. They are also things that can exist in a series. One gets one, then another, and then another.

It is obvious that a tattoo such as the *pe'a* is not generally obtained because it is merely wanted. It, like many other Polynesian body modifications, is obtained because it or they are cosmologically or socially required (if nevertheless also desired), in one specific sense or another. And it will also be apparent that although the *pe'a* is made up of a distinct components, it consists neither of a series of those components nor as an element in a series itself. It is a unity and a totality, not a form susceptible to numeration. The same may be said of

the *malu*, even though the woman's form may appear, superficially, to be composed out of a set of discrete elements.

Hence, if a Euro-American subject obtains a *pe'a* or *malu* among other tattoos, he or she arguably draws that form away from its cultural predicates. This drawing away, abstraction from, or appropriation, is in any case present in the fact that the Euro-American subject approaches either the male or female Samoan tattoo, not as something socially required, but as one among a range of 'tattoos', one among a possible repertoire of 'neo-tribal' and other tattoos that may be available for a desiring subject's acquisition. Just *how* available a Samoan tattoo may be to a non-Samoan man or woman is another matter. To acknowledge that *pe'a* and *malu* are not simply there for the taking from tattoo studios – but have been taken on, rather, by non-Samoans who, like Fomison, occupy certain relationships with Samoans, already complicates a line of argument that might be developed, on the basis of the juxtaposition I have made, between the cultural underpinnings of Samoan and Euro-American tattoos.

126 Mark Adams,
*28.7.2000. Tuhoe Embassy,
Taneatua, Bay of Plenty.
Niki Caro, Andrew Lister,
Tim Worrall. Su'a Suluape
Paulo, Tufuga Ta Tatau.
Tim Worrall, Tohunga
Ta Moko,* 2000,
photograph.

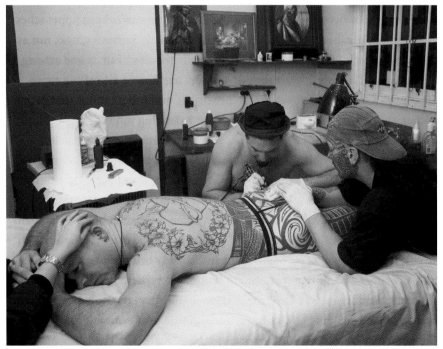

127 Mark Adams,
*28.7.2000. Tuhoe Embassy,
Taneatua, Bay of Plenty.
Niki Caro, Andrew Lister,
Tim Worrall. Su'a Suluape
Paulo, Tufuga Ta Tatau.
Tim Worrall, Tohunga
Ta Moko,* 2000,
photograph.

That juxtaposition is consistent with a classical, culturally relativist anthropology that would locate *tatau* and tattoo within different cultural orders. It is moreover consistent with some (but not all) indigenous Polynesian understandings, which situate Samoan *tatau* or Maori *ta moko* in domains that are integrated and distinct. The model that underlies these understandings of difference is, of course, that of language: it is self-evident that Samoan and Maori are different from each other and different from English, and we can see the negotiation between them as a matter of inherently imperfect translation. This way of understanding cultural variety is both implicitly persuasive and manifestly problematic. Language itself is the most compelling of metaphors, and at one level nothing seems more natural than modelling cultural upon linguistic difference. This is not the place to rehearse either the valid aspects or the many real pitfalls of these assumptions in general. The point can merely be made that the case of tattooing – or rather that of *tatau*/tattoo – sits uneasily within these terms. A Euro-American person does not bear a 'translation' of the *pe'a* but the *pe'a* itself, yet a *pe'a* that has been at least partially, and perhaps very profoundly recontextualized.

The examples reviewed in this book suggest that it is vital to position cultural forms in terms different to those presumed by the longstanding debates around cultural relativism. Relativism was always explicitly or implicitly opposed to universalism, whereby sexual mores, psychological attitudes or art symbols were always from one perspective locally distinctive valuations, or from the other the effects of structural, cognitive or biological constants. The materials considered here are cross-cultural from the start, which is to say neither culturally unique nor universal. Each Polynesian *tatau* tradition represented a particular transformation of others. Each modern *tatau* and tattoo practice drew upon, differentiated itself from, and sustained or forgot antecedent practices. These transformations were possible and are possible because tattoo practices and tattoos have possessed cross-cultural efficacy and salience as well as culturally specific meaning. That cross-cultural efficacy has entailed the potential for their interested recognition and misrecognition, the possibility that they may be adopted or appropriated rather than ignored.

The cases considered in this book, moreover, also displace the comparative operation from theory to history. Those interested in cross-cultural analysis have, as it were, been beaten to the game by Rutherford and Sulu'ape as well as many before, between and since. Those actors, who applied or assumed cross-cultural tattoos, engaged in translation, or rather transposition and recontextualization. They pre-empted the question of whether and how *tatau* could be taken from one cultural milieu into another – by simply doing it.

If we recognize that *tatau* was even, in its varied pre-colonial Polynesian expressions, always already a cross-cultural, historically shaped adaptation, that does not alter the point that, within specific societies, it assumed particular values and meanings – meanings that may indeed be as coherent and distinctive as the Tahitian, Samoan and Maori languages. To acknowledge this would seem only to take us back to the point that I have

made and retreated from – that the Samoan tattoo specifically has a singular motivation and logic, even an ontology, which the tattoo form itself can be abstracted from, but which is not susceptible to translation.

It remains important to affirm this point – that different modes of tattooing may be fundamentally distinct in their predicates, in the notions of the person, the body, and society, that underlie them. But, just as languages may diverge, merge or otherwise change, the absoluteness of this distinct integrity may become historically compromised. It is evident that since at least the mid-twentieth century, when Groves produced his drawings, that the classic Samoan *pe'a* could coexist with other tattoo (not *tatau*) forms. And that has clearly become far more common more recently. This does not mean that the *pe'a* or *malu* no longer has its own highly distinctive qualities, but that those qualities cannot be associated with one culture that is located in Samoa, and juxtaposed with another that is located in Europe or America. It is evident rather that both logics may appear, in compromised forms, on the one body. This instance might appear only as one of what anthropologists used to call 'acculturation', otherwise labelled syncretism, creolization or hybridity.

But at this point it needs to be recalled that Samoan *tatau* is only one among many Poly-nesian practices. In Tahiti, *tatau* incorporated both a unitary whole – the standard blacked buttocks and arches – *and* potentially a series of idiosyncratic elements. In other words, the art form already incorporated distinctive predicates. It is vital that we do not underestimate the complexity and heterogeneity of Pacific art – which cannot be recognized purely as a collectively motivated practice, which may be culturally or ontologically juxtaposed to Western values. If we accept that the form the Western tattoo took – that is, that of the individually desired, individual motif – already existed within the Polynesian tattoo world it is not only our understanding of indigenous tattoo traditions that must change. 'Translation' seems, less than ever, the right term. Nor is it any longer obvious that the Europeans who take on 'neo-tribal' tattoos necessarily perpetrate an invidious distortion of indigenous values. In some cases they certainly do, but in others they may not. The issue can be adjudicated only by talking about which people, when, in the contexts of what cross-cultural dealings. Kabris's case is not the same as Rutherford's, and Rutherford's is not the same as Fomison's. To look at tattooing now – to look at *tatau*/tattoo now – is like looking through a kaleidoscopic device. When you turn the tube, every element of the world changes, to fall into place – or not – in a new way.

REFERENCES

NICHOLAS THOMAS: INTRODUCTION

1 Clinton R. Sanders, *Customizing the Body: The Art and Culture of Tattooing* (Philadelphia, PA, 1989), p. 14.

2 Margo de Mello, *Bodies of Inscription: A Cultural History of the Modern Tattoo Community* (Durham, NC, 2000), p. 45.

3 The first book-length published account of the voyage was an anonymous work attributed to James Magra, *A Journal of a Voyage Round the World* (London, 1771). This described *tatau* as follows: 'Both sexes indent or prick the flesh about and below the hips in a multitude of places, with the points of sharp bones, and these indentures they fill with a dark blue or blackish paint, which ever after continues, and discolours the skin in those places, rendering it black. This practice is universal among them, and is called tat-tow, a term which they afterwards applied to letters when they saw us write, being themselves perfectly illiterate' (p. 44). For further evidence that Tahitians applied the idea of tattooing to writing, see Nicholas Thomas, *Discoveries: The Voyages of Captain Cook* (London, 2003), p. 236. The anonymous account was followed by Sydney Parkinson's *Journal of a Voyage* (London, 1773) and the official edition of Byron's, Carteret's, Wallis's and Cook's voyages, John Hawkesworth, *An Account of the Voyages Undertaken by the Order of His Present Majesty for Making Discoveries in the Southern Hemisphere* (London, 1773). Early journalistic references to tattooing include a salacious allusion in *The Covent-Garden Magazine, or Amorous Repository*, II (1773), p. 203.

4 For more extensive material, see Steve Gilbert, *The Tattoo History Sourcebook* (New York, 2000).

5 For the United States, see de Mello, *Bodies of Inscription*; for an excellent comparative discussion, see Susan Benson, 'Inscriptions of the Self: Reflections on Tattooing and Piercing in Contemporary Euro-America', in *Written on the Body*, ed. Jane Caplan (London, 2000), pp. 234–55.

6 For Cook and the Russian voyagers, see further citations in this introduction below, and Douglas's and Govor's chapters. The main source for Rutherford is [J. L. Craik], *The New Zealanders* (London, 1830).

7 Cf. Alfred Gell, *Wrapping in Images: Tattooing in Polynesia* (Oxford, 1993), pp. 40–41. For the complexity of Pacific historiography, see, for example, Bronwen Douglas, *Across the Great Divide* (Amsterdam, 1998), and Nicholas Thomas, *In Oceania: Visions, Artefacts, Histories* (Durham, NC, 1997).

8 Jane Caplan, 'Introduction', in *Written on the Body*, p. xvi.

9 Caplan, 'Introduction', p. xx.

10 Gell, *Wrapping in Images*, pp. 18–20 and *passim*.

11 Caplan, 'Introduction', pp. xviii–xix; Simon P. Newman, 'Reading the Bodies of Early American Seafarers', *William and Mary Quarterly*, LV (1998), pp. 59–82, citing p. 61 n. 9; Ira Dye, 'The Tattoos of Early American Seafarers, 1796–1818',

Proceedings of the American Philosophical Society, CXXXIII (1989), pp. 520–54, especially pp. 522–3.

12 N.A.M. Rodger, *The Wooden World* (London, 1986); Marcus Rediker, *Between the Devil and the Deep Blue Sea* (Cambridge, 1987).

13 Dye, 'The Tattoos of Early American Seafarers', p. 523.

14 See, for example, Thomas, *Discoveries*.

15 Martin Terry, 'Encountering Dumont D'Urville', in Susan Hunt, Martin Terry and Nicholas Thomas, *Lure of the Southern Seas: The Voyages of Dumont D'Urville, 1826–1840* (Sydney, 2002), p. 23.

16 James Cook, 'Description of King Georges Island', discursive entry following 13 July 1769, printed in *The Journals of Captain James Cook*, ed. J. C. Beaglehole (Cambridge, 1955–67), vol. I, p. 125. C. P. Jones, in 'Stigma and Tattoo', in *Written on the Body*, p. 1, says that Cook's description was 'not published until 1893'. This is only correct in the sense that Cook's journal was not transcribed and published until that date; the passage in John Hawkesworth's *Account of the Voyages* (London, 1773) incorporates a polished version of Cook's account.

17 Banks, 'Manners and customs of S. Sea Islands', August 1769, printed in *The 'Endeavour' Journal of Joseph Banks*, ed. J. C. Beaglehole (Sydney, 1963), vol. I, p. 336.

18 Johann Reinhold Forster, *Observations Made during a Voyage Round the World* (London, 1778); ed. Nicholas Thomas, Harriet Guest, and Michael Dettelbach (Honolulu, 1996), p. 347.

19 De Mello, *Bodies of Inscription*, p. 45. For the Jerusalem pilgrims, see Juliet Fleming, 'The Renaissance Tattoo', in Caplan, *Written on the Body*, esp. pp. 80–81; and for an instance of pre-Cook tattooing of a sailor in America, see Wafer, quoted by Caplan, 'Introduction', pp. xvii–xviii.

20 In addition to Douglas's discussion, see, for early Tahiti, sources such as Teuira Henry, *Ancient Tahiti* (Honolulu, 1928), Douglas L. Oliver, *Ancient Tahitian Society* (Honolulu 1974), Thomas, *Discoveries*, and Anne Salmond, *The Trial of the Cannibal Dog* (London, 2003). The most extensive recent synthesis and analysis of information concerning Tahitian tattooing is in Gell, *Wrapping in Images*. The Tahitian term for 'native' employed by Gell is consistently misprinted and should be *maohi* not *moahi*.

21 For more extended discussion of the Cook voyage contacts, see Thomas, *Discoveries*, and Salmond, *Trial of the Cannibal Dog*.

22 For the theme of curiosity in this context, see Harriet Guest, 'Curiously Marked: Tattooing and Gender Difference in Eighteenth-century British Perceptions of the South Pacific', in *Written on the Body*, pp. 83–101.

23 Greg Dening, *Mr Bligh's Bad Language* (Cambridge, 1992), p. 81, quoted by Joanna White, see p. 75.

24 Gell, *Wrapping in Images*, p. 286.

25 Anne Salmond, *Two Worlds: First Meetings Between Maori and Europeans* (Auckland, 1991), pp. 143, 225.

26 V. Vale and Andrea Juno, eds, *Modern Primitives* (San Francisco, 1989).

27 Robert Goldwater, *Primitivism and Modern Painting* (New York, 1938); republished as *Primitivism and Modern Art* (Cambridge, MA, 1966).

PART ONE: HISTORIES AND ENCOUNTERS

1 BRONWEN DOUGLAS: 'CUREOUS FIGURES'

1 Clements Markham, ed. and trans., *The Voyages of Pedro Fernandez de Quiros, 1595–1606* (London, 1904), vol. I, pp. xi–xii, 16, 20.

2 Sydney Parkinson, *A Journal of a Voyage to the South Seas in his Majesty's Ship, the 'Endeavour'* . . . , ed. Stanfield Parkinson (London, 1773), p. 25.

3 Pedro Fernández de Quirós, 'An Account of the Journey Made by the *Adelantado* Alvaro de Mendaña de Neira for the Discovery of the Solomon Islands' (1596), in Antonio de Morga, *Sucesos de las Islas Filipinas* (1609), ed. and trans. J. S. Cummins (Cambridge, 1971), p. 98.

4 Morga, *Sucesos*, pp. 246, 266–7.

5 Charlton T. Lewis and Charles Short, *A Latin Dictionary: Founded on Andrews' Edition of Freund's Latin Dictionary* (Oxford, 1879), online http://www.perseus.tufts.edu/cgi-bin/ptext?doc=Perseus%3Atext%3A1999.04.0059%3Aentry%3D%2336256 (20 November 2003); Lesley Brown, ed., *The New Shorter Oxford English Dictionary on Historical Principles* (Oxford, 1993), vol. II, p. 2203.

6 William Dampier, 'A New Voyage Round the World', in *Dampier's Voyages*, ed. John Masefield (London, 1906), vol. I, p. 497.

7 Dampier, 'A New Voyage', pp. 494–500; John Masefield, 'Prince Jeoly, Dampier's Painted Prince', Appendix in *Dampier's Voyages*, p. 539.

8 Bronwen Douglas, 'Art as Ethno-historical Text: Science, Representation and Indigenous Presence in Eighteenth and Nineteenth Century Oceanic Voyage Literature', in *Double Vision: Art Histories and Colonial Histories in the Pacific*, ed. Nicholas Thomas and Diane Losche (Cambridge, 1999), pp. 65–99; Bronwen Douglas, 'Science and the Art of Representing "Savages": Reading "Race" in Text and Image in South Seas Voyage Literature', *History and Anthropology*, XI (1999), pp. 157–201.

9 Bernard Smith, *European Vision and the South Pacific, 1768–1850: A Study in the History of Art and Ideas* (Oxford, 1960); Bernard Smith, *Imagining the Pacific: In the Wake of the Cook Voyages* (Melbourne, 1992).

10 Johann Gottfried von Herder, *Outlines of a Philosophy of the History of Man* (1784–91), trans. T. Churchill (1800; New York, 1966), p. 162.

11 See, for example, the empirically based outburst against 'savage nations' by the anonymous translator of John Stockdale's English edition of the narrative of La Pérouse. Anon., 'The Translator's Preface', in Jean-François de Galaup de La Pérouse, *The Voyage of La Pérouse Round the World, in the Years 1785, 1786, 1787, and 1788*, ed. Louis-Antoine Milet-Mureau (London, 1798), vol. I, p. [4].

12 Brown, *New Shorter Oxford English Dictionary*, vol. I, p. 573.

13 For example, William Cummings, 'Orientalism's Corporeal Dimension', *Journal of Colonialism and Colonial History*, IV/2 (2003), online http://muse.jhu.edu/journals/journal_of_colonialism_and_colonial_history/4.2cummings.htm (1 September 2003); Harriet Guest, 'Curiously Marked: Tattooing, Masculinity, and Nationality in Eighteenth-Century British Perceptions of the South Pacific', in *Painting and the Politics of Culture: New Essays on British Art, 1700–1850*, ed. John Barrell (Oxford, 1992), pp. 101–34; Yves Le Fur, 'How Can One Be Oceanian? The Display of Polynesian "Cannibals" in France', in *Body Trade: Captivity, Cannibalism and Colonialism in the Pacific*, ed. Barbara Creed and Jeanette Hoorn (New York and Annandale, NSW, 2001), pp. 36–46.

14 Alfred Gell, *Wrapping in Images: Tattooing in Polynesia* (Oxford, 1993), p. 10.

15 Robertson, George, *The Discovery of Tahiti: A Journal of the Second Voyage of HMS Dolphin Round the World, Under the Command of Captain Wallis, RN, in the Years 1766, 1767 and 1768*, ed. Hugh Carrington (London, 1948), p. 211; John Hawkesworth, *An Account of the Voyages Undertaken by the Order of His Present Majesty for Making Discoveries in the Southern Hemisphere.* (London, 1773), vol. I, p. 262.

16 Philibert Commerson, 'Suite des apostilles', in *Bougainville et ses compagnons autour du monde, 1766–1769*, ed. Etienne Taillemite (Paris, 1977), vol. II, p. 499; Charles-Félix-Pierre Fesche, 'Journal', in *Bougainville et ses compagnons*, vol. II, p. 95.

17 Louis-Antoine de Bougainville, *Voyage autour du monde par la frégate du roi la Boudeuse et la flûte l'Etoile en 1766, 1767, 1768 & 1769* (Paris, 1771), pp. 215–16.

18 Fesche, 'Journal', p. 83.

19 Smith, *European Vision*, p. 256.

20 Smith, *Imagining the Pacific*, pp. 76–85; Rudiger Joppien and Bernard Smith, *The Art of Captain Cook's Voyages* (Melbourne, 1985–7), vol. I, pp. 6–8, 35.

21 London, British Library, Add. MS 9345, fol. 1ᵛ; Add. MS 23921, fol. 51cᵛ; Add. MS 23920, fol. 66 (a–d); Add. MS 15508, fols 41, 42. These sketches are reproduced in Joppien and Smith, *Art of Cook's Voyages*, vol. I, 1.54, 1.86 (d), 1.123, 1.124.

22 London, British Library, Add. MS 23921, fols 12, 17, 25(a), 21. See also Joppien and Smith, *Art of Cook's Voyages*, vol. I, pls 27, 28, 30, 1.93.

23 Joseph Banks, *The 'Endeavour' Journal of Joseph Banks, 1768–1771*, ed. J. C. Beaglehole (Sydney, 1962), vol. I, pp. 335–6; James Cook, *The Voyage of the 'Endeavour', 1768–1771*, ed. J. C. Beaglehole (Cambridge, 1955), p. 125.

24 James Morrison, *The Journal of James Morrison, Boatswain's Mate of the 'Bounty', Describing the Mutiny and Subsequent*

Misfortunes of the Mutineers Together with an Account of the Island of Tahiti, ed. Owen Rutter (London, 1935), pp. 220–21.

25 George Tobin, 17 April 1792, cited in Douglas Oliver, *Return to Tahiti: Bligh's Second Breadfruit Voyage* (Carlton, VIC, 1988), p. 82.

26 Banks, *'Endeavour' Journal*, vol. I, p. 335; Parkinson, *Journal*, pl. 7.

27 Joppien and Smith, *Art of Cook's Voyages*, vol. I, p. 35.

28 Parkinson, *Journal*, pp. 90, 109; pls 16 and 21 are Thomas Chambers's engravings of Parkinson's drawings.

29 Gell, *Wrapping in Images*, pp. 246–52; see also D. R. Simmons, *Ta Moko: The Art of Maori Tattoo* (Auckland, 1999), pp. 24, 32–48, 144.

30 Banks, *'Endeavour' Journal*, vol. I, pp. 407, 439; vol. II, p. 13; Cook, *Voyage of the 'Endeavour'*, pp. 212, 278–9; William Brougham Monkhouse, 'Journal', in Cook, *Voyage of the* Endeavour, p. 585; Parkinson, *Journal*, pp. 90, 97, 107.

31 Jean-François-Marie de Surville, 'Journal', in *The Expedition of the* St Jean-Baptiste *to the Pacific, 1769–1770*, ed. and trans. John Dunmore (London, 1981), p. 162.

32 Jean Pottier de l'Horme, 'Extrait du journal de Pottier de l'Horne [sic], lieutenant du vaisseau le St Jean Baptiste pour le voyage des découvertes dans le sud commencé en 1769 et fini en 1773', in *Historical Records of New Zealand*, ed. Robert McNab (Wellington, 1914), vol. II, pp. 322–4.

33 Gell, *Wrapping in Images*, p. 249; Simmons, *Ta Moko*, pp. 50–63, 144–8.

34 Joppien and Smith, *Art of Cook's Voyages*, vol. I, pp. 34–43.

35 Banks, Endeavour *Journal*, vol. I, p. 439; Monkhouse, 'Journal', pp. 573, 585; Pottier de l'Horme, 'Extrait du journal', p. 320; Surville, 'Journal', p. 162.

36 Cook, *Voyage of the 'Endeavour'*, p. 279.

37 Roland Barthes, *Mythologies*, trans. Annette Lavers (London, 1993), p. 110; W. J. T. Mitchell, *Iconology: Image, Text, Ideology* (Chicago, 1986), pp. 42–52.

38 Cook, *Voyage of the 'Endeavour'*, pp. 125, 278–9; Parkinson, *Journal*, pp. 25, 76, 90.

39 J. C. Beaglehole, 'Introduction: The Young Banks', in Banks, Endeavour *Journal*, vol. I, p. 41; Parkinson, *Journal*, p. 25.

40 Greg Dening, *Mr Bligh's Bad Language: Passion, Power and Theatre on the 'Bounty'* (Cambridge, 1992), p. 35.

41 John Elliott, 'The Memoirs of John Elliott', in *Captain Cook's Second Voyage: The Journals of Lieutenants Elliott and Pickersgill*, ed. Christine Holmes (London, 1984), p. 20.

42 Arthur Bowes Smyth, *The Journal of Arthur Bowes Smyth: Surgeon,* Lady Penrhyn, *1787–1789*, ed. Paul G. Fidlon and R. J. Ryan (Sydney, 1979), p. 105; George Hamilton, 'A Voyage Round the World', in *Voyage of HMS 'Pandora' Despatched to Arrest the Mutineers of the 'Bounty' in the South Seas, 1790–91* (1793), ed. Basil Thomson (London, 1915), p. 122.

43 Peter Heywood, cited in Dening, *Mr Bligh's Bad Language*, pp. 35–6.

44 W. H. Pearson, 'European Intimidation and the Myth of Tahiti', *Journal of Pacific History*, IV (1969), pp. 199–217.

45 Banks, *'Endeavour' Journal*, vol. I, pp. 309, 335–7, 382; vol. II, pp. 332–3.

46 Banks, *'Endeavour' Journal*, vol. I, pp. 407, 439; vol. II, pp. 13–14; see also Johann Reinhold Forster, *Observations Made During a Voyage Round the World* (1778), ed. Nicholas Thomas, Harriet Guest and Michael Dettelbach (Honolulu, 1996), p. 347; Gell, *Wrapping in Images*, pp. 242–4, 259–63; Monkhouse, 'Journal', p. 566; H. G. Robley, *Moko: The Art and History of Maori Tattooing* (London, 1896), pp. 26–32.

47 Banks, *'Endeavour' Journal*, vol. II, pp. 13–14.

48 Smith, *Imagining the Pacific*, p. 101; Joppien and Smith, *Art of Cook's Voyages*, vol. II, pp. 41–6.

49 George Forster, *A Voyage Round the World*, ed. Nicholas Thomas and Oliver Berghof (Honolulu, 2000), vol. I, pp. 122, 125; Johann Reinhold Forster, *The 'Resolution' Journal of Johann Reinhold Forster, 1772–1775*, ed. Michael E. Hoare (London 1982), vol. II, pp. 289, 290.

50 James Cook, *The Voyage of the 'Resolution' and 'Adventure', 1772–1775*, ed. J. C. Beaglehole (Cambridge, 1961), p. 279 and n. 3; Forster, *Voyage*, vol. I, p. 265.

51 Gell, *Wrapping in Images*, pp. 189–90; Nicholas Thomas, *Oceanic Art* (London, 1995), pp. 102–11.

52 Cook, *Voyage of the 'Resolution' and 'Adventure'*, p. 373, n. 1.

53 Forster, *Voyage*, vol. I, pp. 334, 340.

54 Charles Clerke, 'Log', in James Cook, *Voyage of the 'Resolution' and 'Adventure'*, p. 761.

55 Forster, *Voyage*, vol. I, p. 332.

56 Forster, *Voyage*, vol. I, pp. 332, 339.

57 Cf. Forster, *Observations*, pp. 155–6.

58 Cook, *Voyage of the 'Resolution' and 'Adventure'*, pp. 372, 374; Forster, *Voyage*, vol. I, pp. 329, 331; Monkhouse, 'Journal', p. 573.

59 George Vancouver, *A Voyage of Discovery to the North Pacific Ocean and Round the World, 1791–1795*, ed. W. Kaye Lamb (London 1984), vol. III, pp. 873–82.

60 David Samwell, 'Some Account of a Voyage to the South Sea's in 1776–1777–1778', in James Cook, *The Voyage of the 'Resolution' and 'Discovery', 1776–1780*, ed. J. C. Beaglehole (Cambridge, 1967), p. 1178.

61 Samuel M. Kamakau, *Ruling Chiefs of Hawaii* (Honolulu, 1961), pp. 159, 165–7.

62 Vancouver, *Voyage*, vol. III, p. 877.

63 Vancouver, *Voyage*, vol. III, pp. 877–9.

64 Greg Dening, *The Death of William Gooch: A History's Anthropology* (Carlton South, VIC, 1995), pp. 3–45; Kamakau, *Ruling Chiefs of Hawaii*, pp. 163–6; W. Kaye Lamb, 'Introduction', in Vancouver, *Voyage*, vol. I, pp. 130–31.

65 Gell, *Wrapping in Images*, pp. 275, 278–84.

66 Vancouver, *Voyage*, vol. III, p. 858.

67 Samuel Manaiakalani Kamakau, Ka Po'e Kahiko: *the People of Old*, trans. Mary Kawena Pukui, ed. Dorothy B. Barrère (Honolulu, 1964), p. 70; Kamakau, *Ruling Chiefs of Hawaii*, pp. 159, 165–6.

68 Kamakau, *Ruling Chiefs of Hawaii*, pp. 165–6.

1 Karl Steinen, *Die Marquesaner und ihre Kunst* (Berlin, 1925), vol. I, *Tatauierung*; Alfred Gell, *Wrapping in Images: Tattooing in Polynesia* (Oxford, 1993); Pierre Ottino-Garanger *et al.*, *Le Tatouage aux Iles Marquises:* te patu tiki ([Papeete, Tahiti], 1998).

2 Adam J. von Krusenstern, *Voyage Around the World in the Years 1803, 1804, 1805 & 1806 . . . on Board the Ships* Nadeshda *and* Neva *. . .*, trans. Richard Belgrave Hoppner (London, 1813); Urey Lisiansky, *A Voyage Round the World in the Years 1803, 4, 5 & 6 . . .* (London, 1814); George H. Langsdorff, *Voyages and Travels in Various Parts of the World . . .* (London, 1813); Ivan F. Kruzenshtern, *Atlas k puteshestviiu vokrug sveta kapitana Kruzenshterna* [Atlas to Captain Krusenstern's Voyage around the World] (St Petersburg, 1813).

3 Ermolai E. Levenshtern, *Vokrug sveta s Ivanom Kruzenshternom: Dnevnik leitenanta 'Nadezhdy' (1803–1806)* [Around the World with Ivan Kruzenshtern: Journal of a Lieutenant of the *Nadezhda*], ed. A. V. Kruzenshtern *et al.*, trans. T. K. Shafranovskaia (St Petersburg, 2003).

4 [Wilhelm] Tilezius, 'Izvestie o estestvennom i politicheskom sostoianii ostrova Nukaivu . . .' [News of the Natural and Political Conditions of Nukaivu Island . . .], *Tekhnologicheskii zhurnal*, III/4 (1806), p. 95. Except where otherwise indicated, all translations are my own.

5 [Wilhelm Gottlieb Tilesius von Tilenau], 'Skizzenbuch des Hofrath Dr Tilesius v. Tilenau Naturforschers der Krusensternischer Reise um die Welt in den Jahren 1803–1806', Russian State Library, Moscow, Manuscripts Department, fond 178, M 10693b.

6 Fedor Romberg, 'Pis'mo druz'iam 16 avgusta 1804 g. iz Petropavlovska-na-Kamchatke' [Letter by Fedor Romberg to his friends 16 August 1804 from Petropavlovsk-on-Kamchatka], Russian National Library, St Petersburg, Manuscript collection, Collection of Titov, okr. no. 791 (no. 2272), fol. 37.

7 Tilezius, 'Izvestie', pp. 106–8.

8 Fedor Shemelin, *Zhurnal pervogo puteshestviia rossiian vokrug zemnogo shara . . .* [Journal of the First Russian Voyage around the World] (St Petersburg, 1816), vol. I, p. 108; Fedor I. Shemelin, 'Zhurnal Rossiisko-Amerikanskoi Kompanii . . . prikazchika Fedora Ivanovicha Shemelina' [Journal of the Commissioner of the Russian-American Company Fedor Shemelin], Russian National Library, St Petersburg, Manuscript collection, F.IV.59, fols 116v–117.

9 Levenshtern, *Vokrug sveta*, p. 116.

10 V. P. Tokarev, *Khudozhniki Sibiri, XIX vek* [Siberian Artists, XIX century] (Novosibirsk, 1993), p. 28; *Sbornik materialov dlia istorii Imperatorskoi Sankt-Peterburgskoi Akademii khudozhestv za 100 let ee sushchestvovaniia* [Collection of Materials for the History of the Imperial St Petersburg Academy of Arts for 100 years of its Establishment] (St Petersburg, 1864), pp. 133–4.

11 [Tilesius von Tilenau], 'Skizzenbuch', fols 72v, 70v.

12 Levenshtern, *Vokrug sveta*, p. 126.

13 Nikolai P. Rezanov, 'Pervoe puteshestvie rossiian okolo sveta . . .' [The First Russian Voyage around the World . . .], *Otechestvennye zapiski*, LXV (1822), p. 393; Shemelin, *Zhurnal*, pp. 109–10.

14 Gegeon, 'Zapiski ieromonakha Gedeona o pervom russkom krugosvetnom puteshestvii i Russkoi Amerike, 1803–1808 gg' [Memoirs of the Archpriest Gedeon about the First Russian Voyage round the World and Russian America, 1803–1808], in *Russkaia Amerika: po lichnym vpechatleniiam missionerov, zemleprokhodtsev, moriakov, issledovatelei i drugikh ochevidtsev* (Moscow, 1994), p. 51.

15 Lisiansky, *Voyage*, pp. 70, 71, 80.

16 Langsdorff, *Voyages*, pp. 108–9.

17 Shemelin, *Zhurnal*, p. 118.

18 Ivan F. Kruzenshtern, *Puteshestvie vokrug sveta v 1803, 4, 5, i 1806 godakh, na korabliakh* Nadezhde i Neve [Voyage around the world in the years 1803, 4, 5 and 1806 on board the ships *Nadezhda* and *Neva*] (Vladivostok, 1976), p. 103.

19 [Tilesius von Tilenau], 'Skizzenbuch', fol. 81v.

20 Brigitta Hauser-Schäublin and Gundolf Krüger, eds, *James Cook: Gifts and Treasures from the South Seas: The Cook/Forster Collection, Göttingen/Gaben und Schätze aus der Südsee: Die Göttinger Sammlung Cook/Forster* (Munich and New York, 1998), p. 78.

21 Krusenstern, *Voyage*, pp. 167, 168, 153, 165.

22 Nicholas Thomas, *Marquesan Societies: Inequality and Political Transformation in Eastern Polynesia* (Oxford, 1990), p. 41.

23 Shemelin, *Zhurnal*, p. 118; Levenshtern, *Vokrug sveta*, p. 126.

24 Tilezius, 'Izvestie', p. 95; Krusenstern, *Voyage*, p. 157.

25 Krusenstern, *Voyage*, p. 169.

26 Langsdorff, *Voyages*, p. XIV. Tilesius remarked years later that this was a portrait of a priest but provided no further details: [Wilhelm] Tilesius, 'Üeber den Ursprung des bürgerlichen Lebens und der Staatsform . . .', in *Jahrbücher des Geschichte und Staatskunst* (Leipzig, 1828), vol. II, p. 163.

27 [Wilhelm Gottlieb von] Tilesius, 'Menschenfresser-Lied der Nukahiwer', *Allgemeine Musikalische Zeitung*, XVII (1805); Tilesius, 'Üeber den Ursprung', p. 163.

28 Steinen, *Marquesaner*, pp. 92, 140–1; Ottino-Garanger, *Le tatouage*, pp.139–40.

29 [Tilesius von Tilenau], 'Skizzenbuch', fol. 72.

30 Langsdorff, *Voyages*, p. 122.

31 Anon., 'Izvlechenie iz puteshestviia okolo sveta v 1803, 4, 5 i 1806 godakh . . .' [Extract from the Voyage around the World in 1803, 4, 5 and 1806 . . .], *Severnyi Merkurii*, XVIII (1810), p. 263.

32 Krusenstern, *Voyage*, p. 119.

33 Krusenstern, *Voyage*, p. 169; Lisiansky, *Voyage*, p. 75.

34 Anon., 'Izvlechenie', p. 263.

35 Edward Robarts, *The Marquesan Journal of Edward Robarts, 1797–1824*, ed. Greg Dening (Canberra, 1974), pp. 129–30.

36 Shemelin, 'Zhurnal', fol. 114v.

37 Rezanov, 'Pervoe puteshestvie', 65, pp. 391–2; Levenshtern, 'Vokrug sveta', pp. 115–16; Karl Espenberg, 'Journal of the

Voyage from Brazil to Kamchtka; extracted from a Letter of Dr Espenberg, dated the Harbour of St.Peter and St.Paul, August 24, 1804', *Philosophical Magazine*, xxii (1805), pp. 6–7.

38 [Wilhelm] Tilezius, 'O rogache bez briushnykh per'ev, novom rode iz Iuzhnogo okeana ili Tikhogo moria' [On *Balistes* without Abdominal Feathers, a New Species from the South Ocean or Pacific Sea], *Trudy Akademii nauk*, I (1821), p. 186; Tilezius, 'Izvestie', p. 90.

39 P. R. Freiberg, 'Krugosvetnoe puteshstvie iapontsev sto let tomu nazad' [Around the World Voyage of the Japanese a Hundred Years Ago], *Estestvoznanie i geografia*, III (1896), p. 290.

40 Langsdorff, *Voyages*, p. 122.

41 Tilezius, 'O rogache', p. 188.

42 Lisiansky, *Voyage*, p. 85; Iurii F. Lisianskii, *Puteshestvie vokrug sveta v 1803, 4, 5 i 1806 godakh na korable* Neva [Voyage around the World in the years 1803, 4, 5 and 1806 on the *Neva*] (Vladivostok, 1977), p. 74.

43 Levenshtern, *Vokrug sveta*, p. 116.

44 Levenshtern, *Vokrug sveta*, pp. 119, 121.

45 Kruzenshtern, *Puteshestvie*, p. 104; Krusenstern, *Voyage*, pp. 155–6.

46 Tilezius, 'Izvestie', p. 98.

47 [Georg] Langsdorff, 'Nachricht über die Tatowirung der Bewohner von Nukahiwa und der Washingtons-Insulaner, *Allgemeine Geographische Ephemeriden*, xxxiv (1811), p. 11.

48 Makar I. Ratmanov, 'Dnevnik, vedennyi vo vremia krugosvetnogo plavaniia I. F.Kruzenshterna na korable "Nadezhda"' [Journal Kept during the Round the World Voyage of I. F. Kruzenshtern on the Ship *Nadezhda*], in Russian National Library, St Petersburg, Manuscript department, f. 1000, sobr. otd. post., op. 2, no. 1146, fols 48v–49.

49 Tilezius, 'Izvestie', p. 99.

50 Ratmanov, 'Dnevnik', fol. 48v; Kruzenshtern, *Puteshestvie*, p. 104; Langsdorff, 'Nachricht', p. 11.

51 Tilezius, 'Izvestie', p. 99.

52 Langsdorff, 'Nachricht', p. 11; Tilesius, 'Üeber den Ursprung', p. 160; Ottino-Garanger, *Le Tatouage*, p. 251; Langsdorff, *Voyages*, p. xv.

53 Nicolai Tolstoy, *The Tolstoys: Twenty-four Generations of Russian History, 1353–1983* (London, 1983), p. 125.

54 Tolstoy, *The Tolstoys*, p. 125.

55 Tolstoy, *The Tolstoys*, p. 130.

56 Maria Kamenskaia, 'Vospominania' [Memoirs], *Istoricheskii vestnik*, LVII (1894), pp. 41–2.

57 Langsdorff, *Voyages*, p. xiv.

3 JOANNA WHITE: MARKS OF TRANSGRESSION

1 James Ledyard, *A Journal of Captain Cook's Last Voyage to the Pacific Ocean and in Quest of a North West Passage Between Asia and America; Performed in the Years 1774, 1775, 1776, 1778 and 1779* (Hartford, CT, 1783), p. 16.

2 Maori tattooing, though often involving intricate markings on the face and other parts of the body, was never carried out 'from head to foot', for example. See John Rickman, *Journal of Captain Cook's Last Voyage to the Pacific Ocean on* Discovery; *Performed in the Years 1776, 1777, 1778, 1778* (London, 1781), pp. 59–60, for a similar version of events.

3 Hamish Maxwell-Stewart and James Bradley, '"Behold the Man": Power, Observation and the Tattooed Convict', *Australian Studies*, XII (Summer 1997), pp. 71–97.

4 Alfred Gell, *Wrapping in Images: Tattooing in Polynesia* (Oxford, 1993), pp. 36–7.

5 Jane Caplan, 'Introduction', *Written on the Body* (London, 2000), p. xx.

6 A distinction is made here between voluntary tattooing and tattooing used as a punitive practice which is known to have been employed historically in Britain and other locations at various times. See, for example, Caplan, 'Introduction', p. xvi.

7 'Mark'd' was one of the contemporary terms used to describe permanent inscriptions on the body prior to the introduction of the word 'tattoo' as a direct consequence of the Cook voyages. For descriptions of early mariners' tattooing, see Marine Society Records, London, MSY/H/3, no. 43, cited in Roland Pietsch, 'Ships' Boys and Charity in the Mid-Eighteenth Century: The London Marine Society (1756–1772)', unpublished PhD thesis, University of London, 2003, p. 156, and Public Record Office, London, ADM 113/274–6.

8 See, for example, James Cook, *The Voyage of the 'Endeavour' 1768–1771*, ed. J. C. Beaglehole (Cambridge, 1955), p. 125, and Sydney Parkinson, *A Journal of a Voyage to the South Seas, in His Majesty's Ship 'Endeavour'* (London, 1773), p. 25.

9 During the voyages led by Cook these included Joseph Banks, Sidney Parkinson and John Ledyard.

10 Frederick Bennett, *Narrative of a Whaling Voyage Round the Globe from the Year 1833 to 1836* (London, 1840), p. 133. In the same account (pp. 306–7) Bennett also described receiving a further tattoo when the ship called at the Marquesas Islands.

11 For specific examples of this phenomenon, see Elena Govor, this volume.

12 Maxwell-Stewart and Bradley, '"Behold the Man"', p. 83.

13 Though their understanding of the *arioi* appears to have been flawed. See Gell, *Wrapping in Images*, pp. 147–50, for a discussion of *arioi* grades and related tattooing practices.

14 John Elliott, in *Captain Cook's Second Voyage: The Journals of Lieutenants Elliott and Pickersgill*, ed. Christine Holmes (London, 1984), p. 20.

15 See Samuel Leech, *Thirty Years From Home; or, A Voice from the Main Deck* (London, 1844), pp. 25, 49, for descriptions of the importance of the relationship between messmates.

16 The star motif on the breast clearly had particular appeal, re-emerging among the *Bounty* mutineers and in records of British sailors made later in the 1800s. Whether in these latter cases the individuals in question had visited the Pacific or the motif had, by this stage, been incorporated into the lexicon of

designs adopted by sailors, cannot be definitively ascertained.

17 Gell, *Wrapping in Images*, p. 10. In his use of the concept of *habitus*, Gell explicitly drew on the work of Pierre Bourdieu. See, for example, Bourdieu, *Outline of a Theory of Practice* (Cambridge, 1977), pp. 72–87.

18 Greg Dening, *Mr Bligh's Bad Language: Passion, Power and Theatre on the 'Bounty'* (Cambridge, 1992), p. 81.

19 Simon Newmann, 'Reading the Bodies of Early American Seafarers', *William and Mary Quarterly*, 3rd series, LV (January 1998), pp. 59–82; Ira Dye, 'The Tattoos of Early American Seafarers', in *Proceedings of the American Philosophical Society*, CXXXIII/4, (1989), pp. 520–54. For an analysis of convict tattooing, see Maxwell-Stewart and Bradley, '"Behold the Man"', pp. 71–97.

20 Bligh explicitly detailed how the information provided on the tattoos of the mutinous members of his crew was based on 'the recollections of the persons with me, who were best acquainted with their marks'. Public Record Office, London, ADMI 5328.

21 *Ibid.*

22 Dening, *Mr Bligh's Bad Language*, p. 36.

23 As reported in the *Sydney Gazette and New South Wales Advertiser*, 17 July 1819.

24 Public Record Office, ADMI 5328.

25 Gell, *Wrapping in Images*, p. 101.

26 See, for example, Jane Caplan, 'Ornament or Crime: Styling the Fin-de-Siècle Tattoo'. Unpublished paper presented at the Anglo-American Historians' Conference, London, July 2003.

27 The impact on the sailors of the new relationships that they had cultivated in Tahiti was highlighted by Bligh, who conveniently attributed the mutiny to the crew's intimate associations with women on the island. See *The Times*, 19 March 1790.

28 Ian Campbell, 'Gone Native' in Polynesia: Captivity Narratives and Experiences from the South Pacific* (Westport, CT, 1998), p. 155.

29 James F. O'Connell, *A Residence of Eleven Years in New Holland and the Caroline Islands*, ed. Saul H. Riesenberg (Canberra, 1972), p. 108.

30 Horace Holden, *A Narrative of the Shipwreck, Captivity and Sufferings of Horace Holden and Benj H. Nute; who were cast away in the American ship 'Mentor', on the Pelew Islands, in the year 1832; and for two years afterwards were subjected to unheard-of sufferings among the barbarous inhabitants of Lord North's Island* (Boston, MA, 1836) p. 45. For further examples, see also William Diapea's narrative (under the pseudonym John Jackson) in the Appendix of John Elphinstone Erkine, *Journal of a Cruise among the Islands of the Western Pacific* (London, 1853), p. 412; Samuel Patterson, *Narrative of the Adventures and Sufferings of Samuel Patterson, Experienced in the Pacific Ocean, and Many Other Parts of the World, with an Account of the Feegee, and Sandwich Islands* (Palmer, 1817), pp. 83–4; and John Twyning, *Shipwreck and Adventures of John P. Twyning among the South Sea Islanders* (London, 1850), p. 51.

31 William Lockerby, *The Journal of William Lockerby, Sandalwood Trader in the Fijian Islands during the Years 1808–1809*, ed. Everard Im Thurn and Leonard Wharton (London 1925), p. cvi.

32 Greg Dening, *Islands and Beaches: Discourses on a Silent Land: Marquesas, 1774–1880* (Honolulu, 1980), p. 129.

33 See James Morrison, *The Journal of James Morrison, Boatswain's Mate of the 'Bounty', describing the mutiny & subsequent misfortunes of the mutineers together with an account of the island of Tahiti*, ed. Owen Rutter (London, 1935), p. 48, for an account that reveals how the importance of the indigenous interpretation of status and subsequent treatment was explicitly recognized by the *Bounty* mutineers, who, on their return to Tahiti after the mutiny made uniforms out of sails in order to maintain the standing that they had previously held among the local population.

34 The poor treatment of crew who were taken in by lower-ranking natives is alluded to by Twyning, *Shipwreck and Adventures*, p. 57, E. H. Lamont, *Wild Life among the Pacific Islanders* (London, 1867), p. 38, and Lockerby, *The Journal*, p. 25, for example.

35 Dening, *Islands and Beaches*, pp. 129, 155.

36 Vanessa Smith, *Literary Culture and the Pacific* (Cambridge, 1998), p. 19.

37 Twyning, *Shipwreck and Adventures*, p. 70.

38 Erkine, *Journal of a Cruise*, p. 440.

39 See William Mariner, *An Account of the Natives of the Tonga Islands in the South Pacific Ocean. With an original grammar and vocabulary of their language. Compiled and arranged from the extensive communications of Mr William Mariner, several years resident in those islands*, ed. John Martin (London, 1818), vol. I, p. 140, and Archibald Campbell, *Voyage round the World from 1806 to 1812* (London, 1816), p. 140. The precariousness of the beachcombers' situation worsened further when missionaries arrived, bringing new skills and materials, despite the frequent dependence of missionaries on beachcombers for practical support during the early years.

40 Maude, *Of Islands and Men* (Melbourne, 1968), p. 161.

41 Dening, *Islands and Beaches*, p. 155.

42 Or, alternatively, they opted to undertake this painful process themselves. See Leonard Shaw, 'A Brief Sketch of the Sufferings of Leonard Shaw on Massacre Island', in Benjamin Morrell, Jr, *A Narrative of Four Voyages, to the South Sea, North and South Pacific Ocean, Chinese Sea, Ethiopia and South Atlantic Ocean, Indian and Antartic Ocean. From the year 1822 to 1831* (New York, 1832), p. 445, for a particularly taxing account of this exercise.

43 Holden, *A Narrative*, pp. 50–51.

44 Gell, *Wrapping in Images*, pp. 51, 140

45 Keatonui (*c.* 1750–1818) was an important chief in the Nuku Hwa. See also Elena Govor, this volume.

46 Jennifer Terrell, 'Notes and Documents: Joseph Kabris and his notes on the Marquesas', *Journal of Pacific History*, XVI (1982),

pp. 108–9.

47 O'Connell, *A Residence of Eleven Years*, p. 116.

48 O'Connell, *A Residence of Eleven Years,*, p. 118. See also George Bruce, 'Life of a Greenwich Pensioner, 1776–1817', Mitchell Library, Sydney, manuscript A1618, p. 84, for a further example of how becoming tattooed enabled beachcombers to marry into Pacific communities.

49 See Bourdieu, *Outline of a Theory of Practice*, pp. 171–83.

50 Terrell, 'Joseph Kabris', citing Patrick O'Reilly (Paris, 1962), p. 109.

51 *Ibid.*

52 Gell, *Wrapping in Images*, p. 208.

53 See, for example, Mariner, *An Account*, vol. I, p. 142. Beach-combers' immunity to *tapu* was even, on occasion, exploited by host communities. See for example Twyning, *Shipwreck and Adventures*, p. 125.

54 Morrison, *The Journal*, p. 75.

55 Mariner, *An Account*, vol. I, p. 159. Mariner appears to have been given relative freedom due to the understanding he had established with those in power concerning his different cultural background. This may explain why there is no evidence that he was tattooed. In contrast, in his Introduction to Mariner's account, the editor, John Martin, described the appearance of Higgins, one of Mariner's crewmates: 'He is beautifully tattowed from the hips nearly to the knees, agreeably to the custom of the Tonga people. Upon them it appears of a black colour, but upon a white man it causes the skin to resemble soft blue satin. The neatness, and I might also say, the mathematical precision with which the pattern is executed, far surpasses the expectation of all who see it for the first time' (p. xii).

56 See Georg H. von Langsdorff, *Voyages and Travels in Various Parts of the World during the Years 1803, 1804, 1805, 1806, and 1807* (London, 1813), p. 98. See also A. J. von Krusenstern, *Voyage Around the World in the Years 1803, 1804, 1805 & 1806, on Board the Ships 'Nadeshda' and 'Neva'*, trans Richard Belgrave Hoppner (London, 1813), p. 172.

57 Langsdorff, *Voyages and Travels*, p. 122.

58 Terrell, 'Joseph Kabris', p. 102.

59 Edward Tagart, *A Memoir of the Late Captain Peter Heywood, RN, with Extracts from his Diaries and Correspondence* (London, 1832), p. 83.

60 Tagart, *A Memoir of the Late Captain Peter Heywood*.

61 Holden, *A Narrative*, p. 50.

62 See Morrison, *The Journal*, p. 220; O'Connell, *A Residence of Eleven Years*, p. 117; Terrell, 'Joseph Kabris', p. 109; and George Vason, *An Authentic Narrative of Four Years' Residence at Tongataboo, One of the Friendly Islands, in the South Sea* (London, 1810), p. 178.

63 Gell, *Wrapping in Images*, p. 10.

64 See the Diary of William Suddy, 6 January 1798. Council for World Mission Archives: South Sea Journals Box 1, SOAS, University of London.

65 Gell, *Wrapping in Images*, pp. 104, 107; Mariner, *An Account*, vol. II, pp. 253–4; see William Diapea, *Cannibal Jack: The True Autobiography of a White Man in the South Seas* (London, 1928), p. 219, for a singular description of Tongan men proudly 'airing' their new tattoos.

66 Vason, *An Authentic Narrative*, p. 179.

67 Dening, *Islands and Beaches*, p. 155.

68 See Mariner, *An Account*, II, p. 19, for a vivid example. See also Elena Govor, this volume.

69 Tagart, *A Memoir*, p. 83.

70 Langsdorff, *Voyages and Travels*, p. 148.

71 George Vancouver, *Voyage of Discovery to the North Pacific Ocean, and Round the World* (London, 1801), p. 175.

72 Vason, *An Authentic Narrative*, p. 204.

73 H. W. Bruce, 'A Winter Passage round Cape Horn, and Visit to the Marquesas Islands, by Her Majesty's Ship *Imogene*', *Nautical Magazine and Naval Chronicle*, VII (1838), p. 586, cited in Maude, *Of Islands and Men*, p. 162.

74 Bruce, 'Life of a Greenwich Pensioner', p. 102.

75 Herman Melville, *Typee; or, A Narrative of a four months' residence among the natives of a valley of the Marquesas Islands; or, A Peep at Polynesian life* (London, 1847).

76 Melville, *Typee*, pp. 241–3.

77 George Craik, *The New Zealanders* (London, 1830), p. 135.

78 *Ibid.*, p. 278.

79 O'Connell, *A Residence of Eleven Years*, pp. 43–4.

80 Jared Sparks, *Travels and Adventures of John Ledyard* (London, 1834), pp. 226–7.

81 Sparks, *Travels and Adventures*, p. 267.

82 Maxwell-Stewart and Bradley, '"Behold the Man"', p.78.

4 ANNE D'ALLEVA: CHRISTIAN SKINS

1 M. Rosenbaum and A.M. Silberman, eds, *Pentateuch with Targum Onkelos, Haphtaroth and Rashi's Commentary: Leviticus* (New York, 1965), p. 89b.

2 Bernard Smith, *European Vision and the South Pacific* (New Haven, CT, 1984), p. 42.

3 Albert Wendt, 'Tatauing the Post-colonial Body', *Span*, 42–3 (1996), pp. 15–29.

4 Michel Foucault, 'Nietzsche, Genealogy, History', in *The Foucault Reader*, ed. Paul Rabinow (New York, 1984), pp. 76–100.

5 On comparing the Society Islands and Samoa, see F. Allan Hanson, 'Political Change in Tahiti and Samoa: An Exercise in Experimental Anthropology', *Ethnology*, 12 (1993), pp. 1–13.

6 John Davies, *The History of the Tahitian Mission, 1799–1830*, ed. Colin W. Newbury (Cambridge, 1961), p. 41.

7 William Ellis, *Polynesian Researches during a Residence of Nearly Eight Years in the Society and Sandwich Islands* (London, 1831), pp. 263, 266.

8 William Ellis, *Polynesian Researches during a Residence of Nearly Six Years in the South Sea Islands* (London, 1829), p. 463.

9 William Crook, Continuation of the Journal of Willm. Pascoe

Crook (Wilkes Harbour, Papeete, 20 June–22 December 1821), Council for World Mission Archives (South Seas Journals, Box 4, Folder 58), School of Oriental and African Studies, London.

10 James Montgomery, ed., *Journal of Voyages and Travels by the Rev. Daniel Tyerman and George Bennet, Esq., Deputed from the London Missionary Society to Visit their Various Stations in the South Sea Islands, China, India, etc., between the Years 1821 and 1829* (Boston, MA, 1832), vol. I, p. 161.

11 Ellis, *Polynesian Researches* (1829), pp. 435–6.

12 Ellis, *Polynesian Researches* (1831), p. 266.

13 Montgomery, *Journal of Voyages and Travels*, I, p. 68.

14 John Williams, *A Narrative of Missionary Enterprises in the South Sea Islands* (London, 1837), p. 112.

15 René-Primevère Lesson, *Voyage autour du monde, entrepris par ordre du gouvernement, sur la corvette La Coquille* (Paris, 1839), I, p. 443; J. A. Moerenhout, *Travels to the Islands of the Pacific Ocean*, trans. Arthur R. Borden, Jr (Lanham, MD, 1993), p. 174.

16 Ellis, *Polynesian Researches* (1829), p. 436.

17 *Ibid.*

18 Michel Foucault, *Discipline and Punish: The Birth of the Prison* (New York, 1979), p. 14.

19 Moerenhout, *Travels to the Islands*, p. 174.

20 Lesson, *Voyage autour du monde*, p. 443.

21 J. M. Orsmond, Journal from 9 July 1820 to 16 February 1821, Church World Mission Archives (South Seas Journals, Box 4, Folder 55), School of Oriental and African Studies, London.

22 J. M. Orsmond, Borabora Journal from 23 September 1822 until [blank], Council for World Mission Archives (South Seas Journals, Box 4, Folder 64), School of Oriental and African Studies, London.

23 Ellis, *Polynesian Researches* (1829), pp. 467–8.

24 Niel Gunson, *Messengers of Grace: Evangelical Missionaries in the South Seas, 1797–1860* (Melbourne, 1978), p. 213.

25 William Crook, Missionary Journal of W. P. Crook, Tahiti (Bogue Town, Taiarapu, 22 October–20 December 1823), Council for World Mission Archives (South Seas Journals, Box 5, Folder 70), School of Oriental and African Studies, London.

26 *Ibid.*

27 J. M. Orsmond, Journal, Eimeo [Mo'orea], 22 February–28 October 1824, Council for World Mission Archives (South Seas Journals, Box 5, Folder 75), School of Oriental and African Studies, London.

28 Montgomery, *Journal of Voyages and Travels*, I, p. 69.

29 Otto von Kotzebue, *A New Voyage Round the World, in the Years 1823, 24, 25 and 26* (London, 1830), pp. 174–5.

30 Charles Darwin, *Voyage of the Beagle* (New York, 1989), p. 293–4.

31 Louis Padel, Diary (entry 31 August 1846), Archives of the Marist Fathers, Rome.

32 A .W. Murray, *Forty Years' Mission Work in Polynesia and New Guinea, from 1835 to 1875* (London, 1876), p. 224.

33 George Turner, *Nineteen Years in Polynesia: Missionary Life, Travels and Researches in the Islands of the Pacific* (London, 1861), pp. 183–4.

34 A. W. Murray, Letter to the Reverend A. Gidman, 7 January 1842, Council for World Mission Archives (South Seas Journals, Box 9), School of Oriental and African Studies, London.

35 Richard Lovett, *The History of the London Missionary Society, 1795–1895* (London, 1899), p. 378.

36 John Williams, Letter of 6 July 1823, quoted in Gunson, *Messengers of Grace*, p. 319.

37 A. W. Murray, *Missions in Western Polynesia* (London, 1863), p. 465.

38 William Miles, Letter to William Ellis, Apia, Samoa, 4 November 1839, Council for World Mission Archives (Incoming Correspondence, Box 12, Folder 6), School of Oriental and African Studies, London; Thomas Heath, Letter to William Ellis, Manono, 3 May 1839, Council for World Mission Archives (Incoming Correspondence, Box 12, Folder 6), School of Oriental and African Studies, London.

39 Thomas Heath *et al.*, Letter to the Directors of the London Missionary Society, Birnie Bay (Apia), Upolu, 13 June 1836, Council for World Mission Archives (Incoming Correspondence, Box 10, Folder 9), School of Oriental and African Studies, London.

40 George Platt, Letter to William Ellis, Sapapali'i, Savai'i, 16 February 1836, Council for World Mission Archives (Incoming Correspondence, Box 10, Folder 9), School of Oriental and African Studies, London.

41 Charles Hardie, Letter to the Foreign Secretary of the London Missionary Society, Savai'i, 2 September 1840, Council for World Mission Archives (Incoming Correspondence, Box 14, Folder 6), School of Oriental and African Studies, London.

42 Malama Meleisea and Penelope Schoeffel Meleisea, eds, *Lagaga: A Short History of Western Samoa* (Suva, 1987), pp. 61–2; Richard P. Gilson, *Samoa, 1830–1900: The Politics of a Multi-Cultural Community* (Melbourne, 1970), p. 82.

43 Sione Latukefu, *Church and State in Tonga: The Wesleyan Methodist Missionaries and Political Development, 1822–1875* (Canberra, 1974), p. 225.

44 Gilson, *Samoa, 1830–1900*, pp. 84–5.

45 *Ibid.*

46 Sharon Tiffany, 'The Politics of Denominational Organization in Samoa', in *Mission, Church and Sect in Oceania*, ed. James A. Boutilier *et al.* (Lanham, MD, 1978), pp. 423–56.

47 'J'ai des familles entières qui attendent qu'un des leurs qui n'est past tatoué ait subi l'opération qui, chez eux, passe pour un grand crime (théologie des ministres qui ont, maintes et maintes fois, faussé la conscience de ces pauvres gens)'; Leon Gavet, Letter to Monsieur Roux, Falefa, Upolu, 10 December 1860, Archives of the Marist Fathers, Rome.

48 Léon Gavet, Journal (entry for 25 December 1859), Archives of the Marist Fathers, Rome.

49 'Il y a peut-être de cent chefs veulent avoir chacun leur missionaire . . . il suffit qu'un chef ait son missionaire pour que

l'autre ne veuille plus s'unir à lui, car ce serait s'abaisser devant son égal'; Louis Violette, Letter dated Lealatele, Savaii, 26 April 1848), Archives of the Marist Fathers, Rome.

50 Colin Newbury, 'Aspects of Cultural Change in French Polynesia: The Decline of the Ari'i', *Journal of the Polynesian Society*, LXXVI (1967), pp. 7–26; Douglas L. Oliver, *Ancient Tahitian Society* (Honolulu, 1974), III, pp. 1217–36.

51 Thomas Heath, Letter to Peter Turner on behalf of the LMS missionaries, Apai, Manono, 21 June 1836, Council for World Mission Archives (Incoming Correspondence, Box 10, Folder 9), School of Oriental and African Studies, London.

52 Gunson, *Messengers of Grace*, pp. 289–90.

53 Thomas H. Hood, *Notes of a Cruise in HMS 'Fawn', in the Western Pacific in 1862* (Edinburgh, 1863), p. 124; Augustin Kramer, *The Samoa Islands: An Outline of a Monograph with Particular Consideration of German Samoa*, trans. Theodore Verhaaren (Honolulu, 2000), p. 68.

54 Joseph Banks, *The 'Endeavour' Journal of Joseph Banks, 1768–1771*, ed. J. C. Beaglehole (Sydney, 1962), pp. 335–6; Ellis, *Polynesian Researches* (1831), pp. 265–6.

55 Ellis, *Polynesian Researches* (1831), p. 262.

56 Oliver, *Ancient Tahitian Society*, III, p. 433.

57 E. S. Handy and Willowdean Handy, *Samoan House Building, Cooking, and Tattoing* (Honolulu, 1924) pp. 22–3.

58 Davies, *The History of the Tahitian Mission*, p. 328.

59 Teuira Henry, *Ancient Tahiti* (Honolulu, 1928), pp. 234–5.

60 Linden A. Mander, *Some Dependent Peoples of the South Pacific* (New York, 1954), p. 83; see also Hanson, 'Political Change in Tahiti and Samoa', pp. 3–4; Douglas L. Oliver, *The Pacific Islands* (Garden City, NY, 1961), p. 213.

61 Felix M. Keesing, *Modern Samoa: Its Government and Changing Life* (London, 1934), pp. 49, 300.

62 Murray, *Forty Years. Missionary Work*, p. 224.

5 ANNA COLE: GOVERNING TATTOO

1 Elspeth Probyn, 'Eating Skin', in *Thinking Through the Skin*, ed. Sara Ahmed and Jackie Stacey (London, 2001), pp. 87–104.

2 Alfred Gell, *Wrapping in Images: Tattooing in Polynesia* (Oxford, 1993), pp. 1–3.

3 Gell, *Wrapping in Images*, p. 18.

4 Jane Caplan, 'Introduction', *Written on the Body: The Tattoo in European and American History* (London, 2000), p. ix.

5 Ni Ni Myint, *Burma's Struggle Against British Imperialism, 1885–1895* (Rangoon, 1983).

6 For a survey of these sources, see Noel Singer, 'Tattoo Weights From Burma', *Arts of Asia*, XIIX (1988), pp. 70–79, and Clare Anderson, '*Godna*: Inscribing Indian Convicts in the Nineteenth Century', in *Written on the Body*, pp. 102–18.

7 See, for example, the large ethnographic survey by L. K. Ananthakrishna Iyer, *The Mysore Tribes and Castes* (Mysore, 1935), vol. I; J. C. Clark, 'Burmese Tatu', *Man*, XXXII (1932), pp. 67–70. J. G. Scott, *Gazetteer of Upper Burma and the Shan*

States (Rangoon, 1900), vols I and II/2; John Nisbet, *Burma under British Rule – and Before* (London, 1901), vol. XI, p. 2.

8 R. H. Major, 'The Travels of Nicolo Conti in the East in the Early Part of the Fifteenth Century', in *India in the Fifteenth Century*, ed. R. J. Major (London, 1857), pp. 13–18.

9 John Nisbet, *Burma under British Rule – and Before* (London, 1901), vol. II, pp. 196–7.

10 Nisbet, *Burma under British Rule*, p. 199.

11 Singer, 'Tattoo weights of Burma', p. 70.

12 Symes cited in Richard Hakluyt, *The Principal Navigations, Voyages, Traffiques & Discoveries of the English Nation* (London, 1927), pp. 298–309.

13 Robert Fletcher, *Tattooing among Civilized People* (Washington, DC, 1883), pp. 16–17

14 Iyer, *Mysore Tribes*, p. 343.

15 Myint, *Burma's Struggle Against British Imperialism, 1885–1895*, p. 67.

16 Singer, 'Tattoo Weights from Burma', pp. 70–79.

17 Iyer, *The Mysore Tribes*; Nisbet, *Burma under British Rule*, p. 101; Singer, 'Tattoo weights of Burma', p. 74.

18 Gambier Bolton, 'Pictures on the Human Skin', *The Strand Magazine*, XIII (1897), pp. 60–67.

19 Bolton, 'Pictures on the Human Skin', p. 70.

20 'Proceedings in the matter of the alleged branding of a Burmese Woman on her forehead by order of a Police Officer', *Home (Police) Department*, India Office Records, Judicial and Police Department (October 1889), nos 1–14, pp. 35–53. See also H. J. White Esq. to Inspector General of Police, Burma (4 October, 1889), Judicial and Police Department, 2072/ 132/143. India Office Archives, British Library.

21 'Report of the District Superintendent, Mandalay, Home Police Department, Burma, *Proceedings*, 35 (October 1889), India Office Archives, British Library.

22 J. A. Godley, 'Under Secretary of State for India, to the Chief Commissioner to the Secretary to the Government of India Home Department' (11 October 1889), Home Department, India, India Office Archives, British Library; for newspaper coverage of the event, see, for example, *The Times* (London), 1 and 15 July, 24 September 1889; *Rangoon Gazette*, 3 June, 15 and 17 July, 20 and 27 August 1889.

23 'Proceedings in the matter of the alleged branding of a Burmese woman on her forehead by order of a Police Officer', *Home (Police) Department*, India Office Records, Judicial and Police Department (October 1889), nos 1–14, p. 51.

24 R. Martin Esq., District Superintendent of Police, Mandalay, to the Personal Assistant to the Inspector-General of Police, Burma, no. 814–12A, unofficial letter dated 3 July 1889, India Office Record, British Library.

25 C. P Jones, 'Stigma and Tattoo', in *Written on the Body*, pp. 1–17; Mark Gustafson, 'The Tattoo in the Later Roman Empire and Beyond', in *Written on the Body*, pp. 17–32.

26 See Jane Caplan, 'National Tattooing: Traditions of Tattooing in Nineteenth-Century Europe', in *Written on the Body*,

pp. 156–74.

27 See Charles W. MacQuarrie, 'Insular Celtic Tattooing: History, Myth and Metaphor', in *Written on the Body*, pp. 32–46.

28 Clare Anderson, '*Godna*', p. 107.

29 See Clare Midgely, *Gender and Imperialism* (Manchester, 1998); Antoinette Burton ed., *Gender, Sexuality and Colonial Modernities* (London, 1999).

30 'Proceedings in the matter of the alleged branding of a Burmese woman on her forehead by order of a Police Officer', *Home (Police) Department*, India Office Records, Judicial and Police Department (September–December 1889), British Library, P/3354, p. 41.

31 'Proceedings' (September–December 1889), p. 56.

32 'Proceedings' (September–December 1889), p. 44.

33 Clare Anderson, '*Godna*', p. 110.

34 See Caplan's discussion of Gell, in *Written on the Body*, 'Introduction', p. xv.

35 Harriet Guest, 'Curiously Marked: Tattooing and Gender Different in Eighteenth-century British Perceptions of the South Pacific' in *Written on the Body*, pp. 83–102.

PART TWO: CONTEMPORARY EXCHANGES

6 PETER BRUNT: THE TEMPTATION OF BROTHER ANTHONY

1 James Belich, *Paradise Reforged: A History of the New Zealanders From the 1880s to the Year 2000* (London and Auckland, 2001), p. 391.

2 Tony Fomison and Noel McGreevy interview, unpublished transcript, March 1981.

3 Simon During, 'Here's Trouble: Some Comments on Tony Fomison and his Work', in *Fomison: What Shall We Tell Them?*, ed. Ian Wedde (Wellington, 1994), p. 42.

4 Marianna Torgovnick, '"The Blood is One Blood": D. H. Lawrence and Tony Fomison', in *Fomison: What Shall We Tell Them?*, ed. Ian Wedde (Wellington, 1994), p. 53.

5 Keith Stewart, 'In Ya Face', *The Listener*, 12 February 1994, p. 46.

6 John Pule, *Stamp* (July 1992), p. 11. John Pule is an immigrant New Zealand artist from Niue.

7 During, 'Here's Trouble', p. 49.

8 Quoted in Michael Horton, 'A True Original', *New Zealand Monthly Review*, 1990, p. 26.

9 During, 'Here's Trouble', p. 41.

10 On this subject, see especially Evan Te Ahu Poata-Smith, 'He Pokeke Uenuku i Tu Ai: The Evolution of Contemporary Maori Protest', in *Nga Patai: Racism and Ethnic Relations in Aotearoa/New Zealand*, ed. Paul Spoonley, David Pearson and Cluny Macpherson (Palmerston North, 1996), pp. 97–116.

11 Robert Young, *Postcolonialism: An Historical Introduction* (Oxford, 2001), p. 44. See also Arif Dirlik, *The Postcolonial Aura: Third World Criticism in the Age of Global Capitalism* (Boulder, CO, 1997); Michael Hardt and Antonio Negri, *Empire* (Cambridge and London, 2000); and Natalie Melas, 'Re-imag-

ining the Universal', in *Unpacking Europe: Towards a Critical Reading*, ed. Salah Hassan and Iftikhar Dadi (Rotterdam, 2001), pp. 134–51.

12 Ian Wedde, 'Tracing Fomison', in *Fomison: What Shall We Tell Them?*, ed. Ian Wedde (Wellington, 1994), pp. 38–9.

13 Garth Cartwright, 'Recent Work by Tony Fomison', *Art New Zealand*, LII (1989), p. 68.

14 Alfred Gell, *Wrapping in Images: Tattooing in Polynesia* (Oxford, 1994), p. 9.

15 Gell, *Wrapping in Images*, p. 59. See also pp. 91–5.

16 Jean-Jacques Rousseau, *The Social Contract and Discourses*, trans. G. D. H. Cole (London, 1973), p. 182.

17 Sigmund Freud, 'The Economic Problem of Masochism' (1924), in *On Metapsychology: The Theory of Psychoanalysis* (London, 1984), p. 416.

18 Michel Foucault, *Discipline and Punish* (Harmondsworth, 1979), p. 25; quoted in Gell, *Wrapping in Images*, p. 3.

19 Gell, *Wrapping in Images*, p. 4.

20 Gell, *Wrapping in Images*, p. 29.

21 Gell, *Wrapping in Images*, p. 30.

22 *The Catholic Encyclopedia*, http://www.newadvent.org/cathen/

23 Kaja Silverman, *Male Subjectivity at the Margins* (London and New York, 1992), p. 197.

24 Wedde, 'Tracing Fomison', pp. 35–9.

25 Silverman, *Male Subjectivity at the Margins*, p. 197.

26 There are too many references to the press coverage of Fomison's life to list them all here, but see for example, Murray Horton, 'Something Nasty in the Woodshed', *Canta*, February–March 1974; and Murray Horton and Lara Strongman, 'A True Original', *New Zealand Monthly Review* (1990). For an insightful critique of biographical writing on Fomison, see Natasha Conland, *Telling Pictures: Narrative and Tony Fomison*, MA Thesis, University of Auckland 1998.

27 Silverman, *Male Subjectivity at the Margins*, pp. 197–8.

28 Gell, *Wrapping in Images*, p. 27 (my emphasis).

29 As reported by Anne Fenwick, 'Put Art First', *Listener & TV Times*, 5 March 1990, p. 121.

30 Conversation with Mark Adams, Auckland, 26 March 2003.

31 Fuimaono Tuiasau, 'Interview with Fuimaono Tuiasau', in *Fomison: What Shall We Tell Them?*, ed. Ian Wedde (Wellington, 1994), p. 84.

32 Rod Edmond, *Representing the South Pacific: Colonial Discourse from Cook to Gauguin* (Cambridge, 1997).

33 Shirley Grace, Personal diary, entry recorded for 21 September 1989. My gratitude to Amy Gruar, Grace's daughter, for permission to read and quote from her late mother's diary.

34 John Cambell, *The Missionary's Farewell* (London, 1838), p. 21. Quoted in Lydia Wevers, *Country of Writing: Travel Writing and New Zealand, 1809–1900* (Auckland, 2002), p. 63.

1 Carl Marquardt, trans., *Die Tatowirung beider Geschlechter in Samoa/The Tattooing of Both Sexes in Samoa*, English Translation by Sibyl Ferner (1899; Papakura, 1984), p. 21.

2 Albert Wendt, 'Afterword: Tatauing the Post-Colonial Body', in *Inside Out: Literature, Cultural Politics and Identity in the New Pacific*, ed. V. Hereniko and R. Wilson (Lanham, MD, 1999), p. 401. One ethnologist makes a strong distinction between the *malu* and the *pe'a*. Based on his fieldwork in the 1920s, Te Rangi Hiroa (Peter Buck) pointed out that as well as being less elaborate and involving less ceremony, 'the tattooing of a girl is often used as an opportunity for a student to try his prentice hand', although 'For the daughter of a high chief . . . an expert artist would be requisitioned'. Te Rangi Hiroa, 'Samoan Material Culture', *Bernice P. Bishop Museum Bulletin*, LXXV (1930), p. 656. This might have been the case in the 1920s, but at the time of writing attitudes have shifted with the *malu* being more significant than before.

3 Te Rangi Hiroa (Peter Buck), 'Samoan Material Culture', *Bernice P. Bishop Museum Bulletin*, LXXV (1930), p. 655.

4 George Turner, *Samoa: A Hundred Years Ago and Long Before* (London, 1884), p. 89; W. T. Pritchard, *Polynesian Reminiscences; or, Life in The South Pacific Islands* (London, 1866), p. 145.

5 Martin Dyson, 'Journal (1858–65)', 17 January 1862, held at Hocken Library, Dunedin, New Zealand.

6 T. O'Meara, *Samoan Planters: Tradition and Economic Development in Polynesia* (Fort Worth, 1990), p. 74; J. Grimwade, 'Tattoo Tricks Catch On Again among Samoans', *Pacific Islands Monthly*, September 1993, pp. 42–3. R. C. Green, 'Early Lapita Art from Polynesia and Island Melanesia: Continuities in Ceramic, Barkcloth and Tattoo Decorations', in *Exploring the Visual Art of Oceania*, ed. S. Mead (Honolulu, 1979), pp. 13–31.

7 Patrick Vinton Kirch, *On the Road of the Winds: An Archaeological History of the Pacific Islands before European contact* (Berkeley, CA, 2000).

8 G. R. Summerhayes, 'The Face of Lapita', *Oceania*, XXXIII (1988), p. 100.

9 Green, 'Early Lapita Art', p. 16.

10 Alfred Gell, *Wrapping in Images: Tattooing in Polynesia* (Oxford, 1993); G. B. Milner, 'Samoan Tattoos and Structural Analysis', *Man*, x (1973), pp. 307–8; Ministry for Youth, Sports and Cultural Affairs, *Samoa Ne'i Galo Talatu'u ma Tala o le Vavau a Samoa (A Compilation of Oral Traditions and Legends of Samoa)*, I (1998), pp. 158–64.

11 For a historical account of tattooing in Fiji, see Basil Thomson, *The Fijians: A Study of the Decay of Custom* (London, 1908), pp. 217–20. For a general discussion of unorthodox theories relating to the origins of Pacific peoples, see Kerry Howe, 'Maori/Polynesian Origins and the New Learning', *Journal of the Polynesian Society*, CVIII (1999), pp. 305–25.

12 A. Sharp, ed., *The Journal of Jacob Roggeveen* (Oxford, 1970), p. 151.

13 Nicholas Thomas, *Oceanic Art* (London, 1995), p. 100.

14 Adrienne Kaeppler, 'Exchange Patterns in Goods and Spouses: Fiji, Tonga and Samoa', *Mankind*, XI (1978), pp. 246–52.

15 Pritchard, *Polynesian Reminiscences*, p. 146.

16 J. B. Stair, *Old Samoa; or, Flotsam and Jetsam from the Pacific Ocean* (1897; Papakura, 1983), p. 160.

17 Sunderland, Letter, 25 September 1851, Council for World Mission Archives (South Seas Letters), on microfilm, Alexander Turnbull Library, Wellington, New Zealand MS–02–038.

18 T. H. Hood, *Notes of a Cruise in HMS 'Fawn' in the Western Pacific in the year 1862* (Edinburgh, 1863), p. 124.

19 Augustin Kramer, *The Samoan Islands* (Auckland, 1995), vol. II, p. 68.

20 Archibald Lundie, *Missionary Life in Samoa, as Exhibited in the Journals of the Late George Archibald Lundie, during the Revival in Tutuila in 1840–41* (New York, 1859), p. 232.

21 Hood, *Notes of a Cruise in HMS 'Fawn'*, p. 124; Pritchard, *Polynesian Reminiscences*, p. 146.

22 Sunderland, Letter, 25 September 1851.

23 Te Rangi Hiroa, ' Samoan Material Culture', p. 644.

24 Judith Huntsman, ed., *Tonga and Samoa: Images of Gender and Polity* (Christchurch, 1995).

25 Pritchard, *Polynesian Reminiscences*, p. 145.

26 Te Rangi Hiroa, 'Samoan Material Culture', p. 661; Richard M. Moyle, *Traditional Samoan Music* (Auckland, 1988), pp. 146–7; E.S.C. Handy and W. C. Handy, 'Samoan House Building, Cooking and Tattooing', *Bernice P. Bishop Museum Bulletin*, 15 (Honolulu, 1924), p. 24.

27 Groves quoted in Noel L. McGrevy, '"O Le Tatatau" Traditional Samoan Tattooing', Culture Consultants Ltd (unpublished manuscript) (Auckland, 1989), p. 122.

28 Felix von Luschan, *Beitrag zur Kenntniss der Tattowirung in Samoa* (Berlin, 1897), p. 553.

29 Keneti Su'apa'ia, *Samoa, the Polynesian Paradise: An Introduction to Ancient and Modern Samoa and the Polynesian Triangle* (New York, 1962), pp. 76–7.

30 J. Grimwade, 'Tattoo Tricks', p. 42.

31 John Williams in *The Samoan Journals of John Williams, 1830 and 1832*, ed. R. Moyle (Canberra, 1984) p. 114.

32 E. J. Wakefield, *Adventure in New Zealand from 1839 to 1844 with Some Account of the Beginning of the British Colonisation of the Islands* (New Zealand, 1908), p. 322.

33 Pritchard, *Polynesian Reminiscences*, pp. 202–3.

34 N. A. Rowe, *Samoa under the Sailing Gods* (London and New York, 1930), p. 85.

35 Wendt, 'Afterword: Tatauing the Post-Colonial Body', p. 409.

36 Elizabeth Davis, 'Metamorphosis in the Culture Market of Niger', *American Anthropologist*, CI/3 (1999), p. 492.

37 V. Vale and Andrea Juno, *Modern Primitives: An Investigation of Contemporary Adornment and Ritual* (San Francisco, 1989).

38 Apelu Tunumafono, 'Reviving an Old Art for $35,000', *Pacific Islands Monthly*, January 1982, p. 23.

39 *Tatau: Maohi tattoo*, original text Dominique Morvan, English trans. Jane Cooper (Auckland, 1993).

40 Ian Wedde, ed., *Fomison: What Shall We Tell Them?* (Wellington, 1994), p. 84.

41 Thomas, *Oceanic Art*, p. 114.

42 Te Rangi Hiroa, 'Samoan Material Culture', p. 656.

43 Olivia Partsch, 'Malu: Samoan Women's Tattoo', unpublished research paper (Wellington, 1993), p. 54.

44 Margo DeMello, *Bodies of Inscription: A Cultural History of the Modern Tattoo Community* (Durham, NC, 2000), p. 37.

45 DeMello, *Bodies of Inscription*, p. 101.

46 Sia Figiel, *They Who Do Not Grieve* (Auckland, 1999); Wendt, 'Afterword: Tatauing the Post-Colonial Body', pp. 399–412.

47 For example, Van der Ryn, *Tatau: What One Must Do*, (Berkeley, CA, 1997), University of California Extension Center for Media and Independent Learning [video recording]; Makerita Urale, *Savage Symbols* [video recording], produced and directed by Makerita Urale [Beta SP, 2000]; Gisa Schleelein, *Tatau Samoa*, Director Producer: Carl Ludwig Rettinger Distributor: Lichtblick Film [35 mm] 2001.

48 Te Rangi Hiroa, 'Samoan Material Culture', pp. 658–61.

49 Sean Mallon, interview with Sulu'ape Freewind, Saleapaga, Samoa, 2001.

50 Sean Mallon, interview with Sulu'ape Michel Thieme, Amsterdam, 2002.

51 Sean Mallon interview with Sulu'ape Petolo, Samoa, 2002.

52 *Tatau/Tattoo: Embodied Art and Cultural Exchange Conference.* Victoria University, Wellington, 2003.

8 MAKIKO KUWAHARA: MULTIPLE SKINS

1 All tattooists are men as are their friends, and Tahitians who get heavily tattooed, frequent tattooists' places, and stay there for a long time are men. Half of the clients for most tattooists are women, but it is rare that female clients regularly visit the tattooists after they are tattooed. Thus, the relationships that are predominant at the site of tattooing are those between men.

2 For further studies on *taure'are'a*, see Deborah A. Elliston, 'En/gendering Nationalism: Colonialism, Sex, and Independence in French Polynesia', PhD thesis, New York University (New York, 1997); Laure-Hina Grépin, '*Taure'are'a* le temps de l'amusement: l'adolescent polynésien entre tradition et modenité', in *Mythes et réalités en Polynésie*, ed. Serge Dunis (Papeete, 2000), pp. 114–34; John Kirkpatrick, 'Taure'are'a: A Liminal Category and Passage to Marquesan Adulthood', *Ethos*, xv/4 (1979), pp. 382–405; Christine Langevin, *Tahitiennes de la tradition à l'intégration culturelle* (Paris, 1990).

3 See Anna Laura Jones, 'Women, Art and the Crafting of Ethnicity in Contemporary French Polynesia', *Pacific Studies*, xv/4 (1992), pp. 137–54.

4 See Bruno Saura, *Des Tahitiens, des Français, leurs représentations réciproques aujourd'hui* (Papeete, 1998).

5 Eighty per cent of their clients are French military personnel and gendarmes.

6 *Kokoro* means 'penis' in Tahitian and 'heart' in Japanese. All Tahitians know this. *Mafatu* means 'heart'.

7 While Tahitian men include their male friends in the fictive family structure, they call women, not 'sister' or *soeur*, but *copine* ('girlfriend').

8 Hawaiki Nui is an annual canoe race, which takes place in the Society Islands.

9 Most tattooists know the works of the tattooists who are not really their friends because they have clients who come for modification and covering-up the old tattoos. Tattooists observe not only a bad tattoo but also the beautiful work of tattoos that have already been marked on the bodies of clients.

10 *Le truck* is the public bus, in which the passengers sit on the bench seats, facing each other.

11 Some male Tahitians make money by selling marijuana (that contained in one matchbox costs from CFP 3,000 to CFP 5,000).

12 During my fieldwork, I was staying at le Foyer de Jeune Fille, a girls-only dormitory run by the Evangelical Church.

13 Pipipe is a tattooist, mostly working at his home or that of the tattooee. Pipipe has a speaking problem since birth and does not have a telephone. Most of Pipipe's clients, however, do not find it a problem. They just drop in and get tattooed, or arrange the time when Pipipe is at home.

14 While networking by artisan-based and salon-based tattooists has developed, the tattooists working on the streets or at the residence remain outside the network.

15 Tupuna has a real name, which is Edie, but his friends call him 'Tupuna'. Many young men hanging around in Outumaoro have a nickname and call each other by the nickname rather than by a real name.

16 A tattooist's association was founded in 2000 after the International Tattoo Festival in Raiatea. It aims to organize the second Festival and to protect the rights over Polynesian tattoo motifs and designs. Currently only the full-time tattooists are members of the association; there are always many young people starting tattooing and they usually take some time to get in touch with older tattooists. In this sense, the gap between the full-time professional tattooists and part-time amateur tattooists has been extended through establishing the association.

17 A tattooist in Moorea learned the traditional technique from a Samoan tattooist and started tattooing with the traditional tools.

9 LINDA WAIMARIE NIKORA, MOHI RUA AND NGAHUIA
TE AWEKOTUKU: WEARING MOKO

1 He Tangi Mo Te Rangihiroa of Tuhourangi, 'A Lament for Te Rangihiroa', in *Nga Moteatea – He Maramara Rere No Nga Waka Maha: The Songs – Scattered Pieces from Many Canoe Areas*, ed. Apirana Ngata (Wellington, 1928), p. 48.
2 Joseph Banks, *The 'Endeavour' Journal of Joseph Banks, 1768–1771*, ed. J. C. Beaglehole (Sydney, 1962), vol. II, pp. 13–14.
3 Nico H. Frijda and A. Tcherkassof, 'Facial Expression as Modes of Action Readiness', in *The Psychology of Facial Expression*, ed. J. A. Russell and J. M. Fernandez-Dols (Cambridge and Paris, 1997), pp. 78–103; Diane S. Berry, 'What Can a Moving Face Tell us?', *Journal of Personality and Social Psychology*, LVIII (1990), pp. 1004–14.
4 William Yate, *An Account of New Zealand and of the Formation of the Church Missionary Society's Mission in New Zealand* (London, 1835), p. 148.
5 Eric Hall McComick, ed., *Augustus Earle: Narrative of a Residence in New Zealand. Journal of a Residence in Tristan da Cunha* (Oxford, 1966), p. 71.
6 *Ibid.*, p. 124.
7 John Rawson Elder, ed., *The Letters and Journals of Samuel Marsden, 1765–1838* (Dunedin, 1932), p. 167.
8 John L. Nicholas, *Narrative of a Voyage to New Zealand Performed in the Years 1814 and 1815 in Company with Rev. Samuel Marsden, Principal Chaplain of New South Wales* (London, 1817), vol. I, pp. 360–61.
9 Arthur S. Thomson, *The Story of New Zealand: Past, Present, Savage and Civilized* (London, 1859), pp. 77–8.
10 Ngahuia Te Awekotuku, 'Ta Moko: Maori Tattoo', in *Goldie*, ed. Roger Blakely and David Bateman (Auckland, 1997), p. 112.
11 Roger Blakely and David Bateman, eds, *Goldie* (Auckland, 1997).
12 Gottfried Lindauer *et al.*, *Maori Paintings: Pictures from the Partridge Collection of Paintings, Auckland Art Gallery by Gottfried Lindauer* (Honolulu, 1965).
13 Te Awekotuku, 'Ta Moko', p. 113.
14 Michael King, *Face Value: A Study of Maori Portraiture* (Dunedin, 1975).
15 Mohi R. Rua, 'Moko Maori Facial Tattoos: The Experience of Contemporary Wearers' (MsocSci, unpublished thesis, Waikato, 2003).
16 His study was the precursor to our much more ambitious, comprehensive and current Marsden Funded Project, *Ta Moko – Culture, Body Modification and the Psychology of Identity* (Waikato, 2001), see http://psychology.waikato.ac.nz/mpru/moko/index.htm.
17 Ngahuia Te Awekotuku, 'Maori: People and Culture', in *Maori: Art and Culture*, ed. Ngahuia Te Awekotuku *et al.* (Auckland and London, 1996), pp. 26–49.
18 Augie Fleras and Paul Spoonley, *Recalling Aotearoa: Indigenous Politics and Ethnic Relations in New Zealand* (Melbourne and Oxford, 1999).
19 James Cowan, 'Maori Tattooing Survivals: Some Notes on Moko', *Journal of Polynesian Society*, XXX (1921), p. 242.

10 CYRIL SIORAT: BEYOND MODERN PRIMITIVISM

1 V. Vale and Andrea Juno, eds, *Modern Primitives* (San Francisco, 1989).
2 *Ibid.*
3 Christian Klesse, '"Modern Primitivism": Non Mainstream Body Modification and Racialized Representation', in *Body Modification*, ed. Mike Featherstone (London, Thousand Oaks and New Delhi, 2000), p. 34.
4 Richard Jenkins, *Rethinking Ethnicity* (London, Thousand Oaks and New Delhi, 1997), p. 54.
5 *Ibid.*, p. 57.
6 Vale and Juno, *Modern Primitives*.
7 Bryan S. Turner, 'The Possibility of Primitiveness: Toward a Sociology of Body Marks in Cool Societies', in *Body Modification*.
8 Turner, 'The Possibility of Primitiveness'.
9 Ulrich Beck, 'The Reinvention of Politics: Towards a Theory of Reflexive Modernization', in *Reflexive Modernization: Politics, Tradition and Aethetics in the Modern Social Order*, ed. Ulrich Beck, Anthony Giddens and Scott Lash (Cambridge, 1994), p. 33.
10 Fakir Musafar in Armando R. Favazza, MD, *Bodies Under Siege*, 2nd edn (Baltimore, MD, and London, 1996), p.325.
11 Daniel Rosenblatt, 'The Antisocial Skin: Structure, Resistance and "Modern Primitive" Adornment in the United States', *Cultural Anthropology*, XII/3 (1997), p. 292.
12 Rosenblatt, 'Antisocial Skin', p. 292.
13 Klesse, 'Modern Primitivism', p. 34.
14 Rosenblatt, 'The Antisocial Skin'.
15 Susan Benson, 'Inscriptions of the Self: Reflections on Tattooing and piercing in Contemporary EuroAmerica', in *Written on the Body*, ed. Jane Caplan (London, 2000), p. 240.
16 Vale and Juno, *Modern Primitives*.
17 Leo Zulueta in *Modern Primitives*, p. 99.
18 Klesse, 'Modern Primitivism', p. 21.
19 Klesse, 'Modern Primitivism'.
20 Klesse, 'Modern Primitivism'.
21 Paul Sweetman, 'Anchoring the (Postmodern) Self? Body Modification, Fashion and Identity', in *Body Modification*, p. 62.
22 Benson, 'Inscriptions of the Self', p. 240.
23 Sweetman, 'Anchoring the (Postmodern) Self?', p. 62.
24 Igor Kopytoff, 'The Cultural Biography of Things: Comoditization as Process', in *The Social Life of Things: Commodities in Cultural Perspective*, ed. Arjun Appadurai (Cambridge, 1986), p. 64.
25 Arjun Appadurai, ed., *The Social Life of Things: Commodities in Cultural Perspective* (Cambridge, 1986).
26 Nicholas Thomas, *Entangled Objects: Exchange, Material*

Culture and Colonialism in the Pacific (Cambridge, MA, and London, 1991).

27 Appadurai, *The Social Life of Things*, p. 16.
28 Appadurai, *The Social Life of Things*, p. 14.
29 Thomas, *Entangled Objects*, p. 39.
30 Thomas, *Entangled Objects*, p. 103.
31 Kopytoff, 'The Cultural Biography of Things', p. 69.
32 Kopytoff, 'The Cultural Biography of Things', p. 69.
33 Kopytoff, 'The Cultural Biography of Things', p. 73.
34 Kopytoff, 'The Cultural Biography of Things', p. 73.
35 Kopytoff, 'The Cultural Biography of Things', p. 73.
36 Appadurai, *The Social Life of Things*.
37 Appadurai, *The Social Life of Things*.
38 Appadurai, *The Social Life of Things*, p. 38.
39 Appadurai, *The Social Life of Things*.
40 Appadurai, *The Social Life of Things*, p. 38.
41 Appadurai, *The Social Life of Things*.
42 Appadurai, *The Social Life of Things*.
43 Turner, 'The Possibility of Primitiveness', p. 40.
44 Ruth B. Phillips and Christopher B. Steiner, 'Art, Authenticity and the Baggage of Cultural Encounter', in *Unpacking Culture: Art and Commodity in Colonial and Postcolonial Worlds*, ed. Ruth B. Phillips and Christopher B. Steiner (Berkeley, CA, 1998).
45 Phillips and Steiner, 'Art, Authenticity . . .', p. 19.
46 Nikki Sullivan, *Tattooed Bodies: Subjectivity, Textuality, Ethics and Pleasure* (Westport, CT, and London, 2001).
47 Sullivan, *Tattooed Bodies*, p. 8.
48 Thomas, *Entangled Objects*.
49 Thomas, *Entangled Objects*.
50 Appadurai, *The Social Life of Things*, p. 19.
51 Kopytoff, 'The Cultural Biography of Things'.
52 Kopytoff, 'The Cultural Biography of Things'.
53 Kopytoff, 'The Cultural Biography of Things', p. 73.
54 Turner, 'The Possibility of Primitiveness'.
55 Michael Houseman, 'Painful Places: Ritual Encounters With One's Homelands', *Journal of the Royal Anthropological Institute*, IV (1998), p. 449.
56 Eric Gans, 'The Body Sacrificial', in *The Body Aesthetic*, ed. Tobin Siebers (Ann Arbor, 2000).
57 Gans, 'The Body Sacrificial', p. 165.
58 David Le Breton, *Anthropologie de la Douleur* (Paris, 1995), p. 211.
59 Jean Jackson, 'Chronic Pain and the Tension between the Body as Subject and Object', in *Embodiment and Experience*, ed. T. J. Csordas (Cambridge, 1994).
60 Elaine Scarry, *The Body in Pain: The Making and Unmaking of the World* (New York and Oxford, 1985).
61 Jackson, 'Chronic Pain and the Tension Between the Body as Subject and Object', p. 222.
62 Eric Gans, 'The Body Sacrificial', p. 164.
63 Le Breton, *Anthropologie de la Douleur*, p. 218.
64 Benson, 'Inscriptions of the Self'.
65 Le Breton, *Anthropologie de la Douleur*, p. 173.

Ahmed, Sarah, and Jackie Stacey, *Thinking through the Skin, Transformations: Thinking Through Feminism* (London and New York, 2001)

Anderson, Clare, *Legible Bodies: Race, Criminality and Colonialism in South Asia* (London, 2004)

Anzieu, D., *The Skin-Ego: A Psychoanalytic Approach to the Self* (New Haven, CT, 1989)

Beaglehole, J. C., *The 'Endeavour' Journal of Joseph Banks, 1768–1771* (Sydney, 1962)

Bell, Leonard, *The Maori in European Art: European Representations of the Maori from the Time of Captain Cook to the Present Day* (Wellington, 1980).

Bougainville, Louis-Antoine, *Voyage autour du monde par la frégate du roi la Boudeuse et la flûte l'Etoile en 1766, 1767, 1768 & 1769* (Paris, 1771)

Bradley, J., and H. Maxwell-Stewart, '"Behold the Man": Power, Observation and the Tattooed Convict', *Australian Studies*, XII/1 (Summer 1997), pp. 71–97

Caplan, Jane, ed., *Written on the Body: The Tattoo in European and American History* (London, 2000)

Cook, James, *The Journals of Captain James Cook*, ed. J. C. Beaglehole, 3 vols (Cambridge, 1955–67)

Darwin, Charles, *Voyage of the 'Beagle'* (New York, 1989)

Douglas, Bronwen, *Across the Great Divide: Journeys in History and Anthropology* (Amsterdam, 1998)

Dye, Ira, 'The Tattoos of Early American Seafarers, 1796–1818', *Proceedings of the American Philosophical Society*, CXXXIII (1989), pp. 520–54

Ellis, William, *Polynesian Researches during a Residence of Nearly Six Years in the South Sea Islands* (London, 1829)

Forster, George, *A Voyage Round the World…during the Years 1772, 1773, 1774 and 1775* (London, 1777)

Forster, Johann Reinhold, *Observations Made during a Voyage Round the World* (1778), ed. Nicholas Thomas, Harriet Guest and Michael Dettelbach (Honolulu, 1996)

Foucault, Michel, *Discipline and Punish: The Birth of the Prison* (New York, 1979)

Gell, Alfred, *Wrapping in Images: Tattooing in Polynesia* (Oxford, 1993)

—, *Art and Agency: An Anthropological Theory* (Oxford, 1998)

Governar, A., *American Tattoo* (San Francisco, 1996)

Hambly, W. D., *The History of Tattooing and Its Significance with Some Account of Other Forms of Corporal Marking* (London, 1925)

Joppien, Rudiger, and Bernard Smith, *The Art of Captain Cook's Voyages*, 3 vols (Melbourne, 1985–7)

Keesing, Felix M., *Modern Samoa: Its Government and Changing Life* (London, 1934)

Kotzebue, Otto von, *A New Voyage Round the World, in the Years 1823, 24, 25, and 26* (London, 1830)

Kramer, Augustin, *The Samoa Islands: An Outline of a Monograph with Particular Consideration of German Samoa*, trans. Theodore Verhaaren (Honolulu, 2000)

Kruzenshtern, Ivan F., *Atlas k puteshestviiu vokrug sveta kapitana Kruzenshterna* [Atlas to Captain Krusenstern's Voyage around the World] (St Petersburg, 1813).

Langsdorff, George H., *Voyages and Travels in Various Parts of the World during the Years 1803, 1804, 1805, 1806, and 1807* (London, 1813)

Latukefu, Sione, *Church and State in Tonga: The Wesleyan Methodist Missionaries and Political Development, 1822–1875* (Canberra, 1974)

Lesson, René, *Voyage autour du monde, entrepris par ordre du gouvernement, sur la corvette 'La Coquille'* (Paris, 1839)

Lisiansky, Urey, *A Voyage Round the World in the Years 1803, 4, 5 & 6 . . .* (London 1814)

Lovett, Richard, *The History of the London Missionary Society, 1795–1895* (London, 1899)

Mallon, S., *Samoan Art and Artists* (Honolulu, 2002)

Mariner, William, *An Account of the Natives of the Tonga Islands in the South Pacific Ocean. With an original grammar and vocabulary of their language. Compiled and arranged from the extensive communications of Mr William Mariner, several years resident in those islands*, ed. John Martin (London, 1818), volume I

Meleisea, Malama, and Penelope Schoeffel Meleisea, eds, *Lagaga: A Short History of Western Samoa* (Suva, 1987)

Montgomery, James, ed., *Journal of Voyages and Travels by the Rev. Daniel Tyerman and George Bennet, Esq., Deputed from the London Missionary Society to Visit their Various Stations in the South Sea Islands, China, India, etc., between the Years 1821 and 1829* (Boston, MA, 1832)

Newman, S., 'Reading the Bodies of Early American Seafarers', *William and Mary Quarterly*, 3rd series, LV (1998), pp. 52–82

O'Hanlon, M., *Reading the Skin: Adornment, Display and Society among the Wahgi* (London, 1989)

Parry, A., *Tattoo: Secrets of a Strange Art as Practised among the Natives of the United States* (New York, 1933, reprinted 1971)

Quirós, Pedro Fernández de, 'An Account of the Journey Made by the *Adelantado* Alvaro de Mendaña de Neira for the Discovery of the Solomon Islands' (1596), in Antonio de Morga, *Sucesos de las Islas Filipinas* (1609) ed. and trans. J. S. Cummins (Cambridge, 1971)

Robertson, George, *The Discovery of Tahiti: A Journal of the Second Voyage of HMS 'Dolphin' Round the World, Under the Command of Captain Wallis, RN, in the Years 1766, 1767 and 1768*, ed. Hugh Carrington (London, 1948)

Robley. H. G., *Moko or Maori Tattooing* (London, 1896; reprinted Auckland, 1987)

Rubin, A., ed., *Marks of Civilisation: Artistic Transformations of the Body* (Los Angeles, 1988)

Sahlins, M., *Islands of History* (Chicago, 1985)

Sanders, C., *Customizing the Body: The Art and Culture of Tattooing* (Philadelphia, 1989)

Schiffmacher, H., and B. Riemschneider, eds, *1000 Tattoos* (Cologne, 1996)

Sharp, A., ed., *The Journal of Jacob Roggeveen* (Oxford, 1970)

Smith, Bernard, *European Vision and the South Pacific* (New Haven, CT, 1984)

—, *Imagining the Pacific: In the Wake of the Cook Voyages* (Melbourne, 1992)

Steinen, K. von der, *Die Marquesaner und ihre Kunst* (Berlin, 1925)

Thomas, Nicholas, *Oceanic Art* (London, 1995)

—, *Discoveries: The Voyages of Captain Cook* (London, 2003)

Turner, George, *Nineteen Years in Polynesia: Missionary Life, Travels and Researches in the Islands of the Pacific* (London, 1861)

Vale, V. and A. Juno, eds, *Modern Primitives: An Investigation of Contemporary Adornment and Ritual* (San Francisco, 1989)

Vancouver, George, *A Voyage of Discovery to the North Pacific Ocean and Round the World, 1791–1795*, ed. W. Kaye Lamb (London, 1984), volume III

Vason, George, *An Authentic Narrative of Four Years' Residence at Tongataboo, One of the Friendly Islands, in the South Sea* (London, 1810)

Williams, John, *A Narrative of Missionary Enterprises in the South Sea Islands* (London, 1837)

PETER BRUNT teaches Art History at Victoria University of Wellington. His research and writing focus on artists engaged in cross-cultural interactions in the Pacific since the mid-eighteenth century. His most recent publication is a chapter entitled 'Since "*Choice!*": Exhibiting the "New Maori Art"', in *On Display: New Essays in Cultural Studies* (2003). He also co-curated the exhibition *Pe'a: Photographs by Mark Adams* at the Adam Art Gallery, Victoria University of Wellington (2003).

ANNA COLE is the Research Co-ordinator of the 'Tatau/Tattoo: Embodied Art and Crosscultural Exchange' project funded by the Getty Fund (USA) and Arts and Humanities Research Board (UK). She has published in the area of race and gender and has recently co-edited the collection *A Certain Degree of Rage: 'White' Women and Aboriginal History* (forthcoming), with Fiona Paisley and Victoria Haskins.

ANNE D'ALLEVA is Associate Professor of Art and Art History and Women's Studies at the University of Connecticut. Her publications include *Arts of the Pacific Islands* (1997) and *Look! Art History Fundamentals* (2003), as well as a forthcoming book on gender and the visual arts in post-contact Tahiti. Her current research focuses on missionaries and cultural change in early nineteenth-century Tahiti.

BRONWEN DOUGLAS is a Senior Fellow in the Research School of Pacific and Asian Studies at The Australian National University. She has been writing about cross-cultural encounters in Oceania for more than 30 years. She is the author of *Across the Great Divide: Journeys in History and Anthropology* (1998) and about 40 articles. She is at present working on the history of race in Oceania and completing a book entitled *Indigenous Presence and the Science of Race: Encountering 'Savages' in Oceania, 1600–1850*.

ELENA GOVOR is Research Associate on the Tatau/Tattoo Project and post-doctoral fellow in Pacific and Asian History at The Australian National University. Her research interests are in Oceanic ethnohistory, Russian archives on Oceania, and the history of early Russian immigration to Australia and the South Pacific. She is the author of *Australia in the Russian Mirror* (1997) and *My Dark Brother* (2000), and has recently completed *Russian Anzacs in Australian History*. In 2002 she undertook detailed research in Russia on Russian voyagers' representations of tattoo in Polynesia and is planning a book on the first Russian expedition to Nukuhiva (Marquesas) in 1804.

MAKIKO KUWAHARA completed a doctoral thesis at The Australian National University in 2003 and is now a Research Fellow in the Department of Anthropology at Goldsmiths College, University of London. Her research interests are the body and body modifications, youth cultures, prison cultures and gender studies. Her forthcoming publications include *Making Multiple Skins: Tattooing in French Polynesia*.

SEAN MALLON is Senior Curator Pacific Cultures at the Museum of New Zealand Te Papa Tongarewa. He is the author of *Samoan Art and Artists / O Measina a Samoa* (2002) and *Pacific Art Niu Sila: The Pacific Dimension of New Zealand's Contemporary Arts* (2002), co-edited with Pandora Fulimalo Pereira.

LINDA WAIMARIE NIKORA is a Lecturer in Psychology and Director of the Maori and Psychology Research Unit at the University of Waikato, Hamilton, New Zealand. She is co-leading the Marsden funded project, *Ta Moko: Culture, Body Modification and the Psychology of Identity*. With a background in community, social and cross-cultural psychology, her teaching and research interests are various but centre mainly on issues of Maori identity, Maori development, Maori migration and indigenous psychologies.

MOHI RUA is a Research Coordinator with the Maori and Psychology Research Unit at the University of Waikato, Hamilton, New Zealand. His graduate thesis involved case studies of Maori who had taken on traditional facial *moko* and was the forerunner to the Marsden-funded project, *Ta Moko: Culture, Body Modification & the Psychology of Identity*.

CYRIL SIORAT is a doctoral student in the Department of Anthropology at Goldsmiths College, University of London. He is currently conducting fieldwork in tattoo communities in the Pacific and Europe. His main interests are relationships between tattoos, socio-cultural identity and suffering.

NGAHUIA TE AWEKOTUKU is a Professor at the Maori and Psychology Research Unit, University of Waikato, Hamilton, New Zealand. She is a co-leader of the Marsden-funded project, *Ta Moko: Culture, Body Modification and the Psychology of Identity*. She has been a Maori cultural activist for more than three decades. Ngahuia directed the museum restoration of Te Winika, a carved war canoe, in the 1980s, and served as a governor for the NZ Film Archive, the National Art Gallery, and Te Papa Tongarewa/the Museum of New Zealand. For many years she lectured in Art History and Museum Studies. Currently she is a member of the Council of Creative New Zealand / Toi Aotearoa. Her interests include body modification, ritual, sexuality and transgression, and issues of indigenous reality, arts and traditional knowledge. She has published both fiction and non-fiction in national and international anthologies, books and academic journals.

NICHOLAS THOMAS is Professor of Anthropology at Goldsmiths College, University of London. Since the 1980s he has worked on Pacific art, culture and history, and specifically on cross-cultural exchanges linking the Pacific and Europe. His books include *Entangled Objects* (1991), *Colonialism's Culture* (1994), *Oceanic Art* (1995), *Possessions* (1999) and *Discoveries: The Voyages of Captain Cook* (2003). He co-curated *Skin Deep: The History of Tattooing* for the National Maritime Museum in 2002, and is currently working on a major exhibition on art and cultural exchange in Oceania for the Hayward Gallery, London.

JOANNA WHITE has been working as an anthropologist for the past ten years, and has carried out long-term ethnographic work in South-East Asia. She is currently studying for her doctorate in Pacific-European cross-cultural exchange at Goldsmiths College, University of London.

ACKNOWLEDGEMENTS

This book emerges from a research project, 'Tatau/tattoo: Embodied art and cultural exchange', generously funded by the Arts and Humanities Research Board (2001–5) and the Getty Grant Program (2002–4). The editors and contributors are tremendously appreciative of these bodies' support for a possibly offbeat project involving participants from Samoa, New Zealand, Japan, Australia, the USA and Britain, and not only cross-disciplinary collaboration, but work between scholarship, curatorial practice, video, photography and tattooing itself. It is important to signal that the project was, in the first instance, stimulated by the practice of the great and controversial Samoan *tufuga ta tatau* ('tattooist'), the late Paulo Sulu'ape II, and by Mark Adams's images of Sulu'ape's practice and those of related contemporary Samoan *tatau* artists. While the larger project aimed to contextualize the singular dynamism of contemporary Samoan tattooing through a wider account of Pacific and European exchanges since the eighteenth century – that perforce demanded reflection on what cultural exchange in the domain of body arts entailed and effected – another of the project's publications, forthcoming from Te Papa Press, presents Adams's work on Sulu'ape more extensively. Here, we also thank Ashley Vanes and Greg Semu for their permission to include their photographic work, as well as all the many archivists and curators who provided us with access to collections and enabled us to reproduce images. Thanks particularly to Lissant Bolton, Stephen Coppel and Jenny Newell at the British Museum, and Christina Hellmich and Dan Finamore at the Peabody Essex Museum, Salem. Special thanks also to Michael Leaman for his enthusiasm regarding this book.

Nicholas Thomas would like to thank colleagues at Goldsmiths College for their support in hosting the project, especially Anna Cole for her work as co-ordinator. All those involved – Lisa Taouma, Keone Nunes, Unasa Va'a and Karl Broome, as well as those represented in this book – have contributed to an unusually rewarding collaboration. Thanks also to Nigel Rigby of the National Maritime Museum, Sophie Macintyre of the Adam Art Gallery at Victoria University and Zelda Cheatle in London for facilitating linked exhibitions. Special thanks also to Annie Coombes for her critical intellectual stimulus and everything else.

Anna Cole thanks Cassi Plate and Nicholas Thomas for valuable feedback on her draft, and Bronwen Douglas and George Butler for much appreciated support throughout the editorial process. For her quick and helpful picture research many thanks to Jocelyne Dudding, Photograph and Manuscript Collections, Pitt Rivers Museum.

Anne D'Alleva would like to thank the *Tatau*/Tattoo group, especially Bronwen Douglas, for a challenging and engaging collaboration. In addition, Steven Ball, Shigeyuki Kihara, Thérèse Mangos, Rosanna Raymond and Lisa Taouma all contributed to her better understanding of *tatau*, Samoa, Tahiti and missionary histories. Father Carlo Maria Schianchi very kindly opened the Marist Archives; the archives staff of the School of Oriental and African Studies were also very helpful. Nicholas Thomas and Anna Cole saw through the writing of this essay, and it is the better for their attentions. Thanks also to the Rinaldi family in Rome and Liam Browne and Piotr Piecha in London for their hospitality; and finally very special thanks to Cathy Bochain, who tended the home fires during the research and writing of this piece.

Elena Govor would like to thank Olga Fedorova, Tamara Shafranovskaia, Makiko Kuwahara and Nicholas Thomas for assistance with access to research materials and to Bronwen Douglas for advice and help in editing her draft.

Sean Mallon would like to thank Su'a Sulu'ape Paulo, Su'a Suluape Petelo, Tauatele Fosi Levi, Sulu'ape Freewind, Sulu'ape Uili Tasi, Sulu'ape Michel Thieme, Mark Adams, Niko Besnier and Vishvajit Pandya, Teresia Teaiwa, Noel McGrevy and the staff of Te Aka Matua Library Museum of New Zealand Te Papa Tongarewa.

Peter Brunt thanks Mark Adams, Leonie Brunt, Sean Mallon, his colleagues in Art History at Victoria University of Wellington, Nicholas Thomas and Anna Cole.

Ngahuia Te Awekotuku, Linda Waimarie Nikora and Mohi Rua would like to acknowledge the Marsden Fund, which is the major financial contributor supporting the Ta Moko Project, based at the University of Waikato.

The editors, authors and publishers wish to express their thanks to the below sources of illustrative material and/or permission to reproduce it.

Photos courtesy of Mark Adams: 1, 2, 3, 69, 80, 81, 126, 127; Archives nationales, Paris (Section Marine): 22 (MAR-4JJ 143:25); photos © Ashley: 119, 120, 121, 122, 123, 124, 125; Auckland Art Gallery: 74; Bancroft Library, University of California, Berkeley: 8 (PIC 1963.002:1030), 14 (PIC 1963.002:1007), 15 (PIC 1963.002:1010), 16 (PIC 1963.002:1008); photos reproduced by permission of the Bancroft Library, University of California, Berkeley: 8, 14, 15, 16; Bank of New Zealand Collection, Wellington: 77; photo David Cook: 78; Fletcher Challenge Collection, Auckland: 70; Bernice P. Bishop Museum, Honolulu: 29 (CP76805); British Library, London: 12 (Add. Ms. 23920, f. 56), 18 (Add. Ms. 9345, f. 1 verso), 19 (Add. Ms. 23921, f. 51c verso), 20 (Add. Ms. 23920, f. 55), 21 (Add. Ms. 23920, f. 54[a]), 23 (Add. Ms. 23920, f.67[c]), 24 (Add. Ms. 23920, f.66[a]), 68 (India Office Records, Home [Police Department]); photos © British Library Reproductions: 4, 11, 12, 17, 18, 19, 20, 21, 23, 24, 37, 46, 65, 66, 68; British Museum, London (photos © British Museum): 84 (Ethnographic Department), 85 (Ethnographic Department), 108 (Prints and Drawings Room, Ms 1840.11.14, p. 76), 109 (Prints and Drawings Room, Ms 1840.11.14, p. 78); photo Buffalo and Erie County Library: 47; Eesti Ajalooarhiiv (Estonian Historical Archives), Tartu: 32 (F.1414-3-3, f. 78), 38 (F.1414-3-3, f. 242 verso), 39 (F.1414-3-3, f. 93); courtesy of the artist's estate (Tony Fomison): 70, 71, 72, 73 (owned by the estate), 74, 75, 76, 77, 78, 79; courtesy of the Shirley Grace estate: 82; Joy Gray Collection, Plimmerton: 71; Tim and Andrew Greenhough Collection, Nelson: 76; Institut für Ethnologie der Universität Göttingen (Völkerkundliche Sammlung, Sammlung Cook/Forster): 36; Hamish Keith Collection, Auckland: 76; photos Makiko Kuwahara: 96, 97, 98, 99, 100, 101, 102, 103, 104, 105; photos John McIvor: 73, 74, 76; photos Sean Mallon: 88, 89, 90, 91, 92, 93, 94, 95; Jancis Meharry Collection, Christchurch: 79; photo by Pili Mo'o: 115; National Library of Australia, Canberra: 7, 25 (N F1341), 27 (PIC R 747 LOC647-650), 28 (FRM NK1426), 40 (Pictorial Collection, PIC U5802 NK6612), 48 (Rex Nan Kivell Collection), 106 (Rex Nan Kivell Collection), 107 (Rex Nan Kivell Collection); photos reproduced by permission of the National Library of Australia: 7, 9, 10, 25, 27, 28, 30, 35, 40, 44, 48, 106, 107; photo Lloyd Park: 79; Peabody Essex Museum, Salem, Mass.: 56; Pitt Rivers Museum Collection, Oxford: 110, 111 (1938.35.1881); photo Craig Potton: 76; Public Record Office, London (photo, Public Record Office Image Library): 45 (ADMI/1506, pp. 1-2); photo Michael Roth: 77; Russian State Library, Moscow (Manuscripts Department; Fond 178, M 10693b): 31 (f. 70 verso), 33 (f. 72 verso), 34 (f. 71 verso), 41 (f. 24 recto), 42 (f. 86 recto), 43 (cover verso); Sarjeant Art Gallery, Wanganui: 72; photos courtesy Greg Semu: 86, 87; Service Historique dela Marine, Vincennes: 50, 54, 57, 58, 59, 60, 61, 62, 63, 64; State Library of New South Wales, Sydney (Dixson Library): 13; State Library of New South Wales, Sydney (Mitchell Library): 26 (PXD 11, f.32b), 51, 52, 53, 55; photo in the collection of the Ta Moko project, © 2003: 113; photo by Tangaroatuane: 12; photo Marcel Tromp, © 2003: 114; Waikato Museum of Art and History, Hamilton, New Zealand: 78; photo City Gallery, Wellington, New Zealand: 71; photo Richard Wotton: 72.